The Palace Museum's Essential Collections

CHINESE CERAMIC WARE
in
MONOCHROME GLAZE

The Commercial Press

Chinese Ceramic Ware in Monochrome Glaze

Consultant	Geng Baochang 耿寶昌
Chief Editor	Lü Chenglong 呂成龍
Deputy Chief Editors	Han Qian 韓倩 , Xu Wei 徐巍
Editorial Board	Sun Yüe 孫悦 , Gao Xiaoran 高曉然
Photographers	Hu Chui 胡錘 , Liu Zhigang 劉志崗 , Zhao Shan 趙山 , Feng Hui 馮輝
Translators	Tang Hoi-chiu 鄧海超 , Veronica Ng Ho-yi 吳可怡
Editorial Consultant	Hang Kan 杭侃
Project Editors	Xu Xinyu 徐昕宇 , Wang Yuechen 王悦晨
Cover Design	Zhang Yi 張毅
Published by	The Commercial Press (Hong Kong) Ltd. 8/F., Eastern Central Plaza, 3 Yiu Hing Rd, Shau Kei Wan, Hong Kong http://www.commercialpress.com.hk
Printed by	C & C Offset Printing Co., Ltd. C & C Building, 36 Ting Lai Road, Tai Po, N.T., Hong Kong
Edition	First Edition in October 2016

© 2016 The Commercial Press (Hong Kong) Ltd.

ISBN 978 962 07 5678 8

Printed in Hong Kong

Introducing the Palace Museum to the World

SHAN JIXIANG

Built in 1925, the Palace Museum is a comprehensive collection of treasures from the Ming and Qing dynasties and the world's largest treasury of ancient Chinese art. To illustrate ancient Chinese art for people home and abroad, the Palace Museum and The Commercial Press (Hong Kong) Ltd. jointly published *The Complete Collection of Treasures of the Palace Museum*. The series contains 60 books, covering the rarest treasures of the Museum's collection. Having taken 14 years to complete, the series has been under the limelight among Sinologists. It has also been cherished by museums and art experts.

After publishing *The Complete Collection of Treasures of the Palace Museum*, it is understood that westerners, when learning about Chinese traditional art and culture, are particularly fond of calligraphy, paintings, ceramics, bronze ware, jade ware, furniture, and handicrafts. That is why The Commercial Press (Hong Kong) Ltd. has discussed with the Palace Museum to further co-operate and publish a new series, *The Palace Museum's Essential Collections*, in English, hoping to overcome language barriers and help more readers to know about traditional Chinese culture. Both parties regard the publishing of the series as an indispensable mission for Chinese history with significance in the following aspects:

First, with more than 3,000 pictures, the series has become the largest picture books ever in the publishing industry in China. The explanations show the very best knowledge from four generations of scholars spanning 90 years since the construction of the Museum.

Second, the English version helps overcome language and cultural barriers between the east and the west, facilitating the general public's knowledge of Chinese culture. By doing so, traditional Chinese art will be given a fresher image, becoming more approachable among international art circles.

Third, the series is going to further people's knowledge about the Palace Museum. According to the latest statistics, the Palace Museum holds more than 1.8 million pieces of artifacts (among which 228,771 pieces have been donated by the general public and purchased or transferred by the government since 1949). The series selects nearly 3,000 pieces of the rare treasures, together with more than 12,000 pieces from *The Complete Collection of Treasures of the Palace Museum*. It is believed that the series will give readers a more comprehensive view of the Palace Museum.

Just as *The Palace Museum's Essential Collections* is going to be published, I cannot help but think of Professor Qi Gong from Beijing Normal University; famous scholars and researchers of the Palace Museum Mr. Xu Bangda, Mr. Zhu Jiajin, and Mr. Liu Jiu'an; and well-known intellectuals Mr. Wu Kong (Deputy Director of Central Research Institute of Culture and History) and Mr. Xu Qixian (Director of Research Office of the Palace Museum). Their knowledge and relentless efforts are much appreciated for showing the treasures of the Palace Museum to the world.

Looking at History through Art

YANG XIN

The Palace Museum boasts a comprehensive collection of the treasures of the Ming and Qing dynasties. It is also the largest museum of traditional art and culture in China. Located in the urban centre of Beijing, this treasury of ancient Chinese culture covers 720,000 square metres and holds nearly 2 million pieces of artifacts.

In the fourth year of the reign of Yongle (1406 A.D.), Emperor Chengzu of Ming, named Zhu Di, ordered to upgrade the city of Beiping to Beijing. His move led to the relocation of the capital of the country. In the following year, a grand new palace started to be built at the site of the old palace in Dadu of the Yuan Dynasty. In the 18th year of Yongle (1420 A.D.), the palace was complete and named the Forbidden City. Since then the capital of the Ming Dynasty moved from Nanjing to Beijing. In 1644 A.D., the Qing Dynasty superceded the Ming empire and continued using Beijing as the capital and the Forbidden City as the palace.

In accordance with the traditional ritual system, the Forbidden City is divided into the front part and the rear part. The front consists of three main halls, namely Hall of Supreme Harmony, Hall of Central Harmony, and Hall of Preserving Harmony, with two auxiliary halls, Hall of Literary Flourishing and Hall of Martial Valour. The rear part comprises three main halls, namely Hall of Heavenly Purity, Hall of Union, Hall of Earthly Tranquillity, and a cluster of six halls divided into the Eastern and Western Palaces, collectively called the Inner Court. From Emperor Chengzu of Ming to Emperor Puyi, the last emperor of Qing, 24 emperors together with their queens and concubines lived in the palace. The Xinhai Revolution in 1911 overthrew the Qing Dynasty and more than 2,000 years of feudal governance came to an end. However, members of the court such as Emperor Puyi were allowed to stay in the rear part of the Forbidden City. In 1914, Beiyang government of the Republic of China transferred some of the objects from the Imperial Palace in Shenyang and the Summer Palace in Chengde to form the Institute for Exhibiting Antiquities, located in the front part of the Forbidden City. In 1924, Puyi was expelled from the Inner Court. In 1925, the rear part of the Forbidden City was transformed into the Palace Museum.

Emperors across dynasties called themselves "sons of heaven", thinking that "all under the heaven are the emperor's land; all within the border of the seashore are the emperor's servants" ("Decade of Northern Hills, Minor Elegance", *Book of Poetry*). From an emperor's point of view, he owned all people and land within the empire. Therefore, delicate creations of historic and artistic value and bizarre treasures were offered to the palace from all over the country. The palace also gathered the best artists and craftsmen to create novel art pieces exclusively for the court. Although changing of rulers and years of wars caused damage to the country and unimaginable loss of the court collection, art objects to the palace were soon gathered again, thanks to the vastness and long history of the country, and the innovativeness of the people. During the reign of Emperor Qianlong of the Qing Dynasty (1736–1796), the scale of court collection reached its peak. In the final years of the Qing Dynasty, however, the invasion of Anglo-French Alliance and the Eight-Nation Alliance into Beijing led to the loss and damage of many art objects. When Puyi abdicated from his throne, he took away plenty of the objects from the palace under the name of giving them out as presents or entitling them to others. His servants followed suit. Up till 1923, the keepers of treasures of Palace of Established Happinesss in the Inner Court who actually stole the objects, set fire on them and caused serious damage to the Qing Court col-

lection. Numerous art objects were lost within a little more than 60 years. In spite of all these losses, there was still a handsome amount of collection in the Qing Court. During the preparation of construction of the Palace Museum, the "Qing Rehabilitation Committee" checked that there were around 1.17 million items and the Committee published the results in the *Palace Items Auditing Report*, comprising 28 volumes in 6 editions.

During the Sino-Japanese War, there were 13,427 boxes and 64 packages of treasures, including calligraphy and paintings, picture books, and files, transferred to Shanghai and Nanjing in five batches in fear of damages and loot. Some of them were scattered to other provinces such as Sichuan and Guizhou. The art objects were returned to Nanjing after the Sino-Japanese War. Owing to the changing political situation, 2,972 pieces of treasures temporarily stored in Nanjing were transferred to Taiwan from 1948 to 1949. In the 1950s, most of the antiques were returned to Beijing, leaving only 2,211 boxes of them still in the storage room in Nanjing built by the Palace of Museum.

Since the establishment of the People's Republic of China, the organization of the Palace Museum has been changed. In line with the requirement of the top management, part of the Qing Court books were transferred to the National Library of China in Beijing. As to files and essays in the Palace Museum, they were gathered and preserved in another unit called "The First Historical Archives of China".

In the 1950s and 1960s, the Palace Museum made a new inventory list for objects kept in the museum in Beijing. Under the new categorization system, objects which were previously labelled as "vessels", such as calligraphy and paintings, were grouped under the name of "Gu treasures". Among them, 711,388 pieces which belonged to old Qing collection were labelled as "old", of which more than 1,200 pieces were discovered from artifacts labelled as "objects" which were not registered before. As China's largest national museum, the Palace Museum has taken the responsibility of protecting and collecting scattered treasures in the society. Since 1949, the Museum has been enriching its collection through such methods as purchase, transfer, and acceptance of donation. New objects were given the label "new". At the end of 1994, there were 222,920 pieces of new items. After 2000, the Museum re-organized its collection. This time ancient books were also included in the category of calligraphy. In August 2014, there were a total of 1,823,981 pieces of objects in the museum's collection. Among them, 890,729 pieces were "old", 228,771 pieces were "new", 563,990 were "books", and 140,491 pieces were ordinary objects and specimens.

The collection of nearly two million pieces of objects is an important historical resource of traditional Chinese art, spanning 5,000 years of history from the primeval period to the dynasties of Shang, Zhou, Qin, Han, Wei, and Jin, Northern and Southern Dynasties, dynasties of Sui, Tang, Northern Song, Southern Song, Yuan, Ming, Qing, and the contemporary period. The best art ware of each of the periods has been included in the collection without disconnection. The collection covers a comprehensive set of categories, including bronze ware, jade ware, ceramics, inscribed tablets and sculptures, calligraphy and famous paintings, seals, lacquer ware, enamel ware, embroidery, carvings on bamboo, wood, ivory and horn, golden and silvery vessels, tools of the study, clocks and watches, pearl and jadeite jewellery, and furniture among others. Each of these categories has developed into its own system. It can be said that the collection itself is a huge treasury of oriental art and culture. It illustrates the development path of Chinese culture, strengthens the spirit of the Chinese people as a whole, and forms an indispensable part of human civilization.

The Palace Museum's Essential Collections Series features around 3,000 pieces of the most anticipated artifacts with nearly 4,000 pictures covering eight categories, namely ceramics, jade ware, bronze ware, furniture, embroidery, calligraphy, paintings and rare treasures. The Commercial Press (Hong Kong) Ltd. has invited the most qualified translators and academics to translate the Series, striving for the ultimate goal of achieving faithfulness, expressiveness, and elegance in the translation.

We hope that our efforts can help the development of the culture industry in China, the spread of the sparkling culture of the Chinese people, and the facilitation of the cultural interchange between China and the world.

Again, we are grateful to The Commercial Press (Hong Kong) Ltd. for the sincerity and faithfulness in their co-operation. We appreciate everyone who has given us support and encouragement within the culture industry. Thanks also go to all Chinese culture lovers home and abroad.

Yang Xin former Deputy Director of the Palace Museum, Research Fellow of the Palace Museum, Connoisseur of ancient calligraphy and paintings.

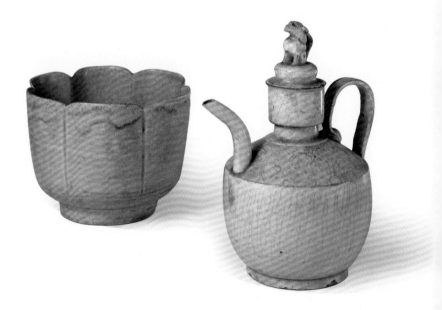

Contents

L ist of Ceramic Ware

W ARE IN CELADON GLAZE

1 **Jar**
with carved and incised design of string patterns in celadon glaze

2 **Jar**
with two loops and carved and incised design of wave patterns in celadon glaze

3 ***Chunyu* Musical Instrument**
with carved and incised design of cloud and thunder patterns in celadon glaze

4 **Vase**
with two loops and carved and incised design of deformed phoenixes in celadon glaze

5 **Vase**
with a plate-shaped mouth, two loops and carved and incised design of string patterns in celadon glaze

6 **Jar**
in the shape of a granary in celadon glaze

7 **Equestrian Riding on a Chimera (*Pixie*)**
in celadon glaze

8 **Ewer**
with a spout in the shape of a ram's head, a plate-shaped mouth and two loops with brown spots in celadon glaze

9 ***Zun* Vase**
with design of upright and inverted lotuses in celadon glaze

10 **Ewer**
with a single handle and carved and incised floral designs in celadon glaze

11 **Vase**
with a plate-shaped mouth, four loops and carved and incised design of lotus petals in celadon glaze

12 **Ewer**
with a phoenix-head and a dragon-shaped handle in celadon glaze

13 **Eight-lobed Vase**
in *mise* (secret colour) olive green celadon glaze

14 **Ewer**
in celadon glaze

15 **Ewer**
in celadon glaze

16 **Covered Box**
with carved and incised design of a lotus in celadon glaze

17 **Covered Jar**
with flanged ears in celadon glaze

18 **Three-legged *Zun* Jar**
with design of string patterns in sky blue celadon glaze

19 **Supporting Plate**
for the three-legged *Zun* jar in sky blue celadon glaze

20 **Bowl**
in sky blue celadon glaze

21 **Round Washer**
in sky blue celadon glaze

22 **Plate**
in imitation of Ru ware in celadon glaze

23 ***Gu* Vase**
in imitation of Ru ware in celadon glaze

24 **Alms Bowl**
in imitation of Ru ware in celadon glaze

25 **Round Washer**
in imitation of Ru ware in celadon glaze

26 **Washer**
in the shape of a peach in imitation of Ru ware in celadon glaze

27 **Vase**
in light greenish-blue celadon glaze

28 **Vase**
with design of string patterns in light greenish-blue celadon glaze

29 **Foliated Washer**
in the shape of a hollyhock in greenish-blue celadon glaze

30 **Round Washer**
in greenish-blue celadon glaze

31 ***Cong* Vase**
in imitation of Guan ware in celadon glaze

32 **Square Vase**
with tubular ears in imitation of Guan ware in celadon glaze

33 **Hexagonal Square Vase**
with tubular ears in imitation of Guan ware in celadon glaze

34 **Square Vase**
with tubular ears in imitation of Guan ware in celadon glaze

35 **Covered Jar**
in the shape of a purse with a rat-shaped knob in imitation of Guan ware in celadon glaze

36 **Garlic-head Vase**
with design of string patterns in relief in imitation of Guan ware in celadon glaze

37 **Narcissus Basin**
in imitation of Guan ware in celadon glaze

38 **Vase**
decorated with string patterns in relief in celadon glaze

39 ***Zun* Jar**
with three legs and design of string patterns in relief in celadon glaze

40 **Incense-burner**
with ears in the shape of a fish in celadon glaze

41 **Flower Pot**
in the shape of a begonia in celadon glaze

42 **Plate**
in the shape of a chrysanthemum in celadon glaze

43 **Bowl**
in the shape of chrysanthemum petals in imitation of Ge ware in celadon glaze

44 **Lobed Vase**
with tubular ears in imitation of Ge ware in celadon glaze

45 **Octagonal Stem-cup**
in imitation of Ge ware in celadon glaze

46 **Cup**
in the shape of chrysanthemum petals in imitation of Ge ware in celadon glaze

47 **Long-neck Vase**
in imitation of Ge ware in celadon glaze

48 **Vase**
with a plate-shaped mouth and applique design of three goats in imitation of Ge ware in celadon glaze

WARE IN GREEN GLAZE

253 **Water-pot**
in *langyao*-green glaze

254 **Bowl**
in peacock green glaze

255 *Gu* **Vase**
in peacock green glaze

256 **Three-legged Flower Pot Basin**
in the shape of a water-chestnut flower in peacock green glaze

257 *Zun* **Vase**
with elephant-shaped ears and imitated designs of ancient bronze ware in relief in peacock green glaze

258 **Pottery Jar**
with animal-headed ears and design of string patterns in relief in green glaze

259 **Flask**
with looped-ears and carved design of tribal dances in relief in yellowish-green glaze

260 **Pillow**
with carved and incised banana leaves in watermelon green glaze

261 **Jar**
decorated with carved and incised phoenixes in watermelon green glaze

262 **Plate**
with carved and incised dragons and phoenixes amidst eight auspicious symbols supported by lotus sprays in watermelon green glaze

263 **Set of Cup and Plate**
with carved and incised design of *panchi*-dragons in lake-water green glaze

264 **Vase**
with a garlic-head shaped mouth, *ruyi* cloud-shaped ears and carved design of floral scrolls in relief in onion green glaze

265 **Bowl**
in okra green glaze

266 **Plate**
with carved and incised design of waves and key-fret patterns in turquoise green glaze

267 *Meiping* **Vase**
with carved design of phoenixes amidst lotuses in relief in turquoise green glaze

268 *Zun* **Vase**
in the shape of a lantern with carved design of dragons amidst clouds and waves in relief in turquoise green glaze

269 **Flower Pot Basin**
in the shape of a bundled bamboo trunk in turquoise green glaze

270 **Bowl**
with okra green glaze on the exterior and turquoise green glaze in the interior

WARE IN BROWN GLAZE

271 **Tea Bowl-stand**
in brown glaze

272 **Plate**
in brown glaze

273 *Zun* **Vase**
with designs of egrets and lotuses reserved in white on a ground in brown glaze

274 *Meiping* **Vase**
with design of flowers in a flower pot reserved in white on a ground in brown glaze

275 **Block-shaped Bowl**
in brown glaze

276 **Lobed Vase**
in the shape of a melon and with applique gilt design of peaches in brown glaze

WARE IN CHANGGUAN GLAZE

277 **Flower-watering Pot**
with design of chrysanthemum petals in relief in *changguan* glaze

278 *Zun* **Vase**
with ears in the shape of bulls in *changguan* glaze

279 **Vase**
with a straight neck in *changguan* glaze

280 **Incense-burner**
with animal-mask shaped ears in *changguan* glaze

281 **Incense-burner**
with three legs, animal-mask shaped ears and design of drum nails in *changguan* glaze

282 *Zun* **Vase**
with two loops in iron-rust glaze

WARE IN OTHER GLAZES

283 **Vase**
with holes for fastening a ribbon in glaze in imitation of ancient jade

284 **Plate**
with character "*shou*" (longevity) medallions held by *chi*-dragons in blue enamel in gilt glaze

285 **Covered Incense-burner**
with three legs in glaze in imitation of bronze

286 **Covered Bowl**
with design of chrysanthemum petals and gilt imperial poems in glaze in imitation of red lacquer ware

287 **Shallow Bowl**
with brocade ground of jujube flowers in glaze in imitation of carved red lacquer ware

288 **Flower-basin**
with gilt design of floral and fruit sprays in glaze in imitation of wood textures

289 **Incense-burner**
in the shape of a drum in glaze in imitation of marble

290 **A Set of Twelve Plates**
in the shape of a chrysanthemum in twelve monochrome glazes

Subtleness and Lyricism – Monochrome Ceramic Ware

LÜ CHENG LONG

There is a wide repertoire of ancient Chinese ceramics and to facilitate research, they could be broadly classified into two major types of polychrome and monochrome ware. Polychrome ware has been discussed in *Chinese Ceramic Ware in Polychrome Glaze*, and the present volume focuses on the study of monochrome ceramic ware.

DEFINITION AND PRODUCTION TECHNIQUES OF WARE IN MONOCHROME GLAZE

Colour glazes refer to the glazes added with colourants and fired in designated temperature and atmosphere to produce glazes with different colours. Colourant is a kind of material with metallic elements that would generate colour. For example, if the glaze is added with colourant with designated iron content, it would generate green colour during firing; if added with colourant with designated copper content, it would generate red colour; and if added with colourant with designated cobalt content, it would generate blue colour and so on.

Monochrome ware refers to various types of ceramic ware covered with one single colour glaze. Such ware is either without decorations or just decorated with carved, incised, molded or cut designs. Although a small amount of the ware is further decorated with painted polychrome designs over the glaze or under the glaze, painted polychrome designs only play a sub-ordinary role in such ware as compared with their dominant colour glazes.

Glaze is an essential element in ceramic production. Chinese ceramic ware in colour glazes appeared much earlier than painted polychrome ware. Dating back to the earliest monochrome ware which was the proto-porcelain ware in celadon glaze produced in the Shang Dynasty, other colour glazes such as black glaze, white glaze, suffused colour glaze, brown glaze, yellow glaze, green glaze, red glaze, blue glaze, aubergine glaze, *changguan* glaze, glazes in imitation of natural objects and others, were produced in subsequent periods which highly enriched the art of Chinese ceramics.

The process of producing monochrome ware includes choice of glaze, mixing of glaze, grinding and slip production, application of glaze and firing. Colouring, in particular the firing of high-temperature fired colour glazes, is very complicated. The formula of mixing glaze, firing temperatures and durations, firing atmospheres and the density of particles in the glaze would also affect glaze colours and have to be carefully controlled and manipulated in order to achieve the ideal glaze colours.

In general, the production techniques of high- and low-temperature fired glaze are different and at

the same time, the locations and quality of materials used are also different, thus leading to differences in the production and mixing of colour glazes. Taking Jingdezhen kiln as an example, the basic traditional high-temperature fired glaze was the lime glaze with lime as solvent and such lime glaze had a higher content of metallic oxidized materials. During high-temperature firing, it would become less adhesive and more fluid and as a result, the degree of transparency, shininess and plasticity would be better achieved after firing.

Application of glaze is an important process and different glazing techniques have to be used in accordance with different types of colour glazes and biscuits to assure that the thicknesses of the glaze layers fit the pastes in order to obtain the desired colouring effects. In the production of high-temperature fired colour glazed ware, glazes would usually apply directly to the raw biscuits or fired biscuits. In the production of low-temperature fired colour glaze ware, glazes would usually apply to the white porcelain ware or biscuits that have been fired. Glazing techniques include dripping, pouring, splashing, spraying and washing or wiping.

Firing is the last process which is most difficult to control. The production of monochrome ware is regarded as the "art of firing" and the glaze colours would fluctuate due to the changes of firing conditions. It is said that "Formula of production is like pregnant, modelling is giving birth to a piece of ware, but whether it would survive or die depends on firing". Potters who were responsible for firing at the Jingdezhen kiln (commonly nicknamed "masters who safeguarded the kiln" commanded skilful firing techniques and they only used their eyes to watch and observe the fire in the kiln for controlling the production process. In the *Poems on Ceramic Production at Jingdezhen Kiln*, Gong Shi of the Daoguang period of the Qing Dynasty, described, "Fire rises to the sky in the kiln day and night, (potters) watch the smokes with red and clear eyes. They examine the right timing to control firing, and such secrets of production techniques could only be handovered to their followers personally". We learnt that before firing, potters would hold sacrificial ceremonies to the deity of the kiln in the ancient times, and among different professions of potters, potters who controlled the firing process had the highest pay. These two conditions exemplified that close attention was given to firing and its mysterious attributes in the past.

CATEGORIES OF MONOCHROME WARE

In accordance with the firing temperature, monochrome glazes can be divided into high-temperature fired glazes and low-temperature fired glazes. High-temperature fired glazes are often fired at 1250°C or above, and the ware is often glazed directly on the raw biscuits and only fired for one time in the kiln. This type of glazes include white, celadon, bright red, sky-clearing blue (sacrificial blue), brown and black glaze. Low-temperature fired glazes are often mixed with a higher degree of fluxing agents in the glazes, and fired at a temperature from 700 to 1250°C, and the ware is often glazed on the fired biscuits or already glazed raw biscuits for a second firing in the baking atmosphere. This type of glazes includes yellow, watermelon green, rouge red, aubergine, turquoise green glazes. High-temperature fired glazes have the characteristics of solid surface, deep, stable and shiny colour, high viscosity of the glaze and paste and stable chemical conditions. Low-temperature fired glazes have the characteristics of smooth and flat glaze surface, shininess, stable colour, less solidity and lower viscosity of the glaze and paste.

In terms of organic analysis, colouring of monochrome ware can be divided into three types: ionized colouring, colloid colouring and crystallized colouring. For example, celadon glaze belongs to the type of ionized colouring, high-temperature fired copper red and low-temperature fired golden-red glazes belong to the type of colloid colouring, and the *changguan* glaze belongs to the type of crystallized colouring.

In terms of colours, monochrome ware can be divided into the groups of ware in celadon glaze, ware in suffused colour glaze, jun glaze, copper red flambé

glaze, ware in white glaze, ware in black glaze, ware in red glaze, ware in yellow glaze, ware in blue glaze, ware in aubergine glaze, ware in green glaze, ware in brown glaze, ware in *changguan* glaze and so on.

For further discussion, I would introduce monochrome ware in accordance with their glaze colours in the following paragraphs.

Ware in celadon glaze

Celadon glaze is the earliest high-temperature fired glaze produced in China and the world. Counting from the proto-porcelain ware in celadon glaze in the mid-Shang Dynasty, it has a history of over three thousand years. Even counting from the genuine porcelain ware in celadon glaze produced in the Eastern Han Dynasty, it has a history of over one thousand and eight hundred years. In the category of various monochrome ware, ware in celadon glaze has the longest and continuous production history and the largest scale of production.

The emergence of high-temperature fired celadon ware in the Shang Dynasty was due to the provision of high-temperature firing kiln which successfully fired ware in a high temperature of over 1200°C. After this type of kilns was used for a long time, potters discovered that the lime ash left by the fuel would condense on the surfaces of molded pottery shards and the kiln chamber walls and formed a transparent and shiny glassy layer. Inspired by such a discovery, potters intentionally applied a thick liquid layer mixed with ashes of plants or wood on the ware and then fired the ware in the kiln. After experiments, potters successfully produced a new type of celadon glaze fired in high temperature – lime glaze with wood or plant ash.

However, this type of glaze had its weaknesses, for example, the glaze liquid lacked adhesiveness and was difficult to apply on the ware, potassium carbonate in the ashes of wood and plants melted in water and led to unstable chemical condition of the glaze, the narrowing down of the range of firing temperatures which results in difficulty in getting control, and also the serious shrinking of glaze. After considerable observations and explorations, potters found that if clay, lime clay or limestone was added, these problems could be solved, and finally lime glaze was produced. From the Shang and Zhou dynasties to the Northern Song Dynasty, the glaze on celadon ware was lime glaze. In the Southern Song Dynasty, potters founded that if ash lime content was reduced and replaced by china stone, then although the fluidity and transparency of the glaze would be reduced, the glaze could have a jade-like quality instead. As a result, alkali lime glaze was produced. The lime glaze and alkali lime glaze then had become two major types of high-temperature fired celadon glazes on ancient Chinese ceramics.

In history, kilns at various regions in China produced a wide repertoire of well-known celadon ware with reference to the features of porcelain materials available locally and the aesthetic pursuit of different periods. For example, the Ou kiln in the Jin Dynasty produced "light blue silk-like celadon ware". The Yue kiln in the Tang Dynasty produced "*mise* (secret-colour) celadon ware". In the Northern Song Dynasty, the Ru kiln produced "light sky blue celadon ware" and the Yaozhou kiln produced "olive green celadon ware". In the Southern Song Dynasty, the Guan kiln produced "bluish-green celadon ware", the Longquan kiln produced "plum green celadon ware" and "bluish-green celadon ware", and the Imperial Kiln in Jingdezhen of the Ming and Qing dynasties produced "feather green celadon ware", "*dongqing* celadon ware", "pea green celadon ware" and "apple green celadon ware" which were highly esteemed and had profound impact on the industry of ceramics. For instance, the three-legged *zun* jar decorated with string patterns in sky blue celadon glaze (plate 18) is covered with light sky blue celadon glazed in both the interior and exterior with shiny and translucent colour and small ice-crackles with a touch of naturalism, which represents a refined and a very rare piece of extant Ru ware in celadon glaze.

Ware in suffused colour glaze, Jun glaze, flambé glaze and robin's egg glaze

Ware in suffused colour glaze

Ware in suffused glaze refers to the ware in suffused colour glaze, which was first produced in the Tang Dynasty. The characteristic was to decorate

the grounds in black, yellow, yellowish-brown or tea-dust glaze with flambé patches in sky blue or moon white glaze, or suffused with colour splashes in black, brown, grey, blue or moon white glaze.

Ware in suffused colour glaze included jars, ewers, vases, plates, bowls or waist-drums, with the most common types confined to ewers and jars. Some of the ware was decorated with colour glazed patches in a rather tidy manner, and some was decorated with colour glazes splashed in a spontaneous and free manner. Most of these decorations were applied on the shoulders and bellies of the ware, or sometimes with the whole piece fully covered with these decorations. With the colour glazed backgrounds, these decorations were highlighted like clouds, mists, leaves or waves with distinctive visual effects.

After the Tang Dynasty, the Tiedian kiln in Jinhua, Zhejiang in the Yuan Dynasty and the Shiwan kiln in Guangdong in the Ming and Qing dynasties had produced a large amount of imitated ware in suffused colour glaze, such as the washer in the shape of a Manchurian catalpa leaf in Jun blue glaze (plate 95) which is thickly potted with an innovative form and decorated with suffused colour glaze with a touch of charm and naturalism.

Ware in Jun glaze

Ware in Jun glaze was first produced in the Jun kiln in Yuzhou, Henan, which started its production not later than the Jin Dynasty and was one of the famous ancient kilns of China. In the Northern Song Dynasty, Yuzhou was named Yangzhai district and under the jurisdiction of the Yingchang prefecture, Beilu, Xingxi. In the 24th year of the Dading period, Jin Dynasty, it was renamed Junzhou. Jun kiln was named after Junzhou or the ancient site Juntai in the city.

The most distinctive accomplishment of the Jun kiln was the innovative production of "Jun glaze", a kind of high-temperature fired monochrome glaze. Different from the transparent celadon glaze, it was a kind of opacified glaze and could be classified into three types: a monochrome sky blue or moon white glaze, a combination of copper red mottles on a sky blue glazed ground, and the copper red flambé glaze.

Jun ware was fired for two times in the kiln.

The first time was to fire the biscuits first at a low temperature of around 1000°C, and then to glaze and fire them a second time in high-temperature reduction atmosphere at a temperature of 1250 – 1270°C. Historical records and extant artifacts reveal that the Yixing kiln in the Ming Dynasty and the Jingdezhen kiln in the Qing Dynasty had produced a large amount of imitated Jun ware. The Yixing kiln in the Ming Dynasty produced principally imitated Jun ware in sky blue glaze, which was known as "Yi Jun ware". Type forms include a type of vases with a goose-shaped neck (plate 106), washer in the shape of a lotus (plate 107) and others. In the Yongzheng period, the Jingdezhen kiln started to produce imitated Jun ware. In the eighth month of the autumn of the 6th year of the Yongzheng period (1728), the Director of the Department of Imperial Household Tang Ying (1682 – 1756) was also appointed as the Director General of the Imperial Kiln in Jingdezhen to supervise ceramic production. He was particularly keen in imitating the colour glazes of various ancient kilns (basically the Ru, Guan, Ge, Ding and Jun kilns of the Song and Yuan dynasties), and had made significant achievements in imitating Jun glaze. In the third month of the 7th year of the Yongzheng period, he sent Wu Yaopu, an official of the Imperial Kiln to Junzhou, Henan to study the formula of producing Jun glaze. In the seventh month of the same year, records of imitated Jun ware produced in the Jingdezhen Imperial Kiln first appeared in the archive records of the Department of the Imperial Household. Similar records of imitated Jun ware were also found in later historical records.

From extant ware, there were two types of imitated Jun ware produced in the Imperial Kiln in Jingdezhen in the Yongzheng and Qianlong periods. The first type had their forms and glaze colour exactly imitated after the imperial Jun ware. The flower-pot stand with three legs and design of drum nail patterns in imitated rose purple glaze (plate 110) was an imitated piece of Jun ware with reference to the extant original Jun ware sent to Tang Ying in Jingdezhen for reproduction, which revealed a high standard of production with similar size, form and even the same number of two borders of drum-nail

patterns in relief on the exterior wall of the flower-pot stand of the original piece. The second type was the imitated Jun ware with "red mottles on a sky blue ground" produced in the Yongzheng period, which was the so-called "ware in new aubergine glaze" recorded in the book *Taocheng Jishi* (*Chronicles of Ceramic Industry*) written by Tang Ying. During production, a layer of sky blue glaze would be applied as the ground, on which copper red mottles would be wiped. After firing, the sky blue glaze would generate a pure, shiny and translucent colour with copper red mottles in different shapes and appearances on the surface of the glaze.

Ware in flambé glaze

Owing to the various colourants in glaze, during oxidized and reduction firing atmospheres in the kiln, different unexpected colours and artistic effects would be attained after firing. As these were accidental outcomes and people did not know the reasons how such aesthetic effects came out, they thought that the effects were results of the variations of firing, and called such effect as "kiln variation effect (flambé)".

Ware in flambé glaze was an innovative type of ware derived from firing imitated Jun ware in the Jingdezhen Imperial Kiln in the Yongzheng period and was also known as "Jun red-splashed glaze". The production technique was to apply a layer of imitated copper red glaze on the raw biscuit first, on which a layer of glaze with designated portions of cobalt, iron and manganese was further added (known as "splashed glaze"). These two layers of liquid glazes could be isolated on the ware which was then baked in a reduction firing atmosphere at a high temperature of around 1300°C. During reduction firing, copper in the glaze would generate red colour, iron would generate green colour, cobalt would generate blue colour and manganese would generate aubergine colour. When the glazes melted and dripped during firing, different colours would suffuse and produce unexpected artistic visual effects with variations of shapes and colour tones. The most esteemed effects were the splashes and streaks in red and blue colours resembling the colour of flame, which was known as "flame red" or "flame blue". The vase with a flat belly and design of

string borders in relief in flambé glaze in the collection of the Palace Museum (plate 111) is a typical and representative piece of ware of this type.

The most distinctive characteristic of flambé glaze is the variations of glaze colours. Even if the form, technical application of glaze, and the glaze materials on any two pieces were the same, the pieces would have different colours if their firing locations in the kiln were not the same.

There was tens of type forms of ware in flambé glaze produced in the Yongzheng period, reflecting the special favour of Emperor Yongzheng for this type of ware. Ware in flambé glaze of the early Qianlong period still maintained the features of Yongzheng ware in flambé glaze; however, later the artistic effects were visualized with patches in red, blue and moon white suffused colours, and finally had become red glaze with considerable colour changes but less moon blue and blue colours.

Ware in Robin's egg glaze

In the Yongzheng period, the Imperial Kiln in Jingdezhen also produced a new type of ware in "Robin's egg glaze (Lujun glaze, literally means Jun glaze fired in a furnace), which refers to imitated Jun glaze fired in a low-temperature furnace. Actually it was a kind of low-temperature fired flambé glaze in imitation of Yijun ware and was popularly produced in the Yongzheng and Qianlong periods. The production technique was to fire biscuits in high temperature first and then glaze would be applied and fired again in low temperature in a small furnace. In the book *Nanyao Biji* (*Notes on the Jingdezhen Kiln*), Zhang Jiuyue (1721 – 1803) of the Qing Dynasty recorded that, "The type of Lujun glaze (Robin's egg glaze) was fired in a furnace. During dripping of colours, the red mottles were the best, with the green mottles ranked the next". People sometimes compared these two colours with the "vegetarian dish" and "meat dish" in Chinese cookery. The "vegetarian dish" refers to ware in green mottles only (green symbolizes vegetables) whereas the "meat dish" refers to the ware in red mottles (red symbolizes meat) only. On the other hand, a type for Yixing purple clay ware in Robin's egg glaze was produced in the Qianlong period, most

of which was teapots.

Ware in white glaze

Following the production of celadon and black glazes, white glaze was another high-temperature fired monochrome glaze which was produced in the Northern Dynasties with maturity reached in the Sui Dynasty, the quality and quantity of which were comparable to the contemporary white glazes. After the Sui Dynasty, new types of ware in white glaze emerged, among them ware in white glaze produced in the Xing kiln in the Tang Dynasty, ware in greenish-white glaze produced in the Jingdezhen kiln in the Song Dynasty, ware in white glaze produced in the Ding kiln in the Song and Jin dynasties, ware in egg white glaze produced in the Jingdezhen kiln in the Yuan Dynasty, ware in sweet white glaze produced in the Imperial Kiln in Jingdezhen in the Yongle and Xuande periods of the Ming Dynasty, and ware in white glaze produced in the Dehua kiln in the Ming Dynasty, had won high esteem. In addition, the Imperial Kiln in Jingdezhen had produced a large amount of imitated Ding ware in white glaze in the Ming and Qing dynasties. On the other hand, the Jingdezhen Imperial Kiln also produced a large amount of ware imitating the sweet white glazed ware of the Yongle and Xuande periods of the Ming Dynasty in the Qing Dynasty.

It is noteworthy that the colour of Chinese ancient ware in white glaze was not the colour of glaze, but came from the colour of the paste and slip. If the clay of the paste had a good quality with few particles such as oxidized iron and others, the paste would have a pure white colour, on which a layer of transparent colour could be applied. The white ware produced in the Xing kiln, Ding kiln and Gong kiln of the Sui and Tang dynasties, the white ware produced in the Ding kiln in the Song Dynasty, in the Jingdezhen kiln and the Dehua kiln in the Yuan, Ming and Qing dynasties were all covered with transparent glaze directly on the pastes and fired in a high-temperature baking atmosphere in the kiln. However, if the quality of the paste was not pure and good enough and had a greyish-black or yellowish-brown tint, a layer of pure clay with less oxidized iron content, which was known as "slip", would be applied to the paste first to cover the paste with impurities, and then covered with transparent glaze. Ware in white glaze produced in the Chefeng kiln, Inner Mongolia and Jiangguantun kiln, Liaoning in the Liao Dynasty, ware in white glaze produced in the Cizhou kiln in the Song and Yuan dynasties, and ware in white glaze of the Cizhou-type kilns in Shanxi, Shandong and Henan belonged to the latter category.

Decorative techniques on ware in white glaze included carving, incising, cutting, openwork, applique designs, painted designs, etc., and each decorative technique was represented by respective kilns. For example, decorative techniques of Ding ware in white glaze were versatile, but the molded designs were of the best quality among ware decorated with molded designs by other kilns in the same period. Other representative decorative techniques included the cut designs of the ware in white glaze produced in the Dongyangyu kiln and the incised designs on a sgraffito ground on the ware in white glaze produced in the Dengfeng kiln of the Northern Song Dynasty.

Ware in black glaze

Black glaze was a high-temperature fired monochrome glaze produced in parallel with the celadon glaze. Archaeological findings reveal that ware in celadon glaze and black glaze was fired in the same kiln by increasing oxidized iron content in the glaze to produce ware in black glaze. Scientific analysis shows that the oxidized iron content in ancient black glaze was around 3% to 9%, while the content of which in celadon glaze was about 2%. As black glaze could fully cover the colour of the paste, the requirements for the quality of the paste were not so strict.

Ware in black glaze had appeared in the late Eastern Han Dynasty and developed rapidly in the Eastern Jin Dynasty. Ware in black glaze produced in the Deqing kiln, Zhejiang in the Eastern Jin Dynasty was characterized by even and shiny layers of black colour that resembled the colour of black lacquer. Other than the Deqing kiln, the Yuhong kiln was another important kiln for producing black glazed ware in the Eastern Jin Dynasty. Kilns which produced ware in black glaze increased significantly in

the Tang Dynasty and were found in Henan, Shaanxi, Shanxi, Anhui, Shandong and others, amongst which the Gong kiln in Henan, the Yaozhou kiln in Shaanxi, the Shouzhou kiln in Anhui and the Zibo kiln in Shandong were more famous. Ware in black glaze was popularly produced in the Song and Yuan dynasties. Black glazed ware produced in the Ding kiln, Hebei and the Dongyangyu kiln in Henan had the distinctive feature of the colour of the white paste contrasted with black glaze. To meet the aesthetic requirements of tea drinking in the Song Dynasty, the Jian kiln and Mount Wuyi kiln in Fujian and the Jizhou kiln in Hebei had produced a large number of tea bowls in black glaze decorated with constellation mottles, partridge's feather mottles, hare's fur mottles, tortoise-shell mottles and brown splashes, or with paper-cut designs, leaves designs and gilt designs which were much esteemed by the literati class. For example, the type of tea bowls such as the tea bowl in hare's fur black glaze (plate 160) had been praised by Cai Xiang in his poem "Tasting Tea" that "Purplish new tea bowls in hare's fur glaze (were produced), brew tea with clear spring water and wait for the crab's eyes (bubbles) to appear". Mei Yaochen in his poem also described that "The purplish tea bowl in hare's fur black glaze is beautiful enough; clear spring water would suffice (for tea brewing) and no need to boil until shrimp bubbles appear". In the Song and Yuan dynasties, the Jingdezhen kiln also fired black glazed ware yet only a limited number was produced. In the Jin and Yuan dynasties, various kilns in Shanxi had produced a large amount of ware in black glaze, among which most was wine vases with small mouths and large bellies.

In the Ming and Qing dynasties, the Jingdezhen kiln and the Cizhou-type kilns in Hebei and Henan had produced ware in black glaze. Little ware in black glaze was produced in the Jingdezhen kiln in the Ming Dynasty, and extant ware was very rare. In the Qing Dynasty, the Jingdezhen kiln had produced ware in black glaze which was known as "ware in mirror black glaze". It was a kind of glaze mixed with mirror black clay with 13.4% oxidized iron content produced near Jingdezhen and after firing, the colour would become shiny mirror black. Such ware in mirror black glaze was produced in the Kangxi, Yongzheng and Qianlong periods with the Kangxi ware ranking the best, and the quality of Yongzheng and Qianlong ware was a bit declined with less quantity produced.

Ware in red glaze

There were high-temperature and low-temperature fired red glazes with the former referring to copper red glaze and the latter referring to iron red glaze and golden-red glaze.

High-temperature fired copper red glaze

High-temperature fired copper red glaze uses oxidized copper as colourant and after the glaze is applied on the raw paste, the ware would be fired for one time in a high-temperature from 1250 to 1280°C. During high-temperature firing, the colouring of copper ion is very sensitive to the temperature and firing atmosphere. On the other hand, during melting in high temperature, the copper red glaze would become more adhesive and as a result, the range of firing temperatures would be narrowed down and difficult to control. Thus successful firing of copper red glaze was rather difficult to attain.

Ware in high-temperature fired copper red glazed designs began to appear on the ware produced in the Changsha kiln, Hunan in the Tang Dynasty, which was accidently produced and not artificially well controlled with the colour turning dense and dark. Ware in high-temperature fired copper red glaze was only professionally produced in the Jingdezhen kiln in the Yuan Dynasty, which included stem-cups, burial figures, etc. but only limited numbers were produced and the glaze colour was not even and brilliant.

Ware in high-temperature fired copper red glaze of the Ming Dynasty was also known as "ware in bright red glaze", which inherited the legacy of Yuan copper red glazed ware with progressive developments. The production of such ware started in the Hongwu period and continued through the Jiajing period with the largest number and best quality ware produced in the Yongle and Xuande periods, which was highly esteemed. In the book *Kuitian Waisheng (A Review of Dynastic Affairs)* written by Wang Shimao in the 17th year of the Wanli period

(1589), he described that "(Ware in bright red glaze) was produced in the Ministry of Imperial Household in the Yongle and Xuande periods and has now become very precious. In those periods, ware in sweet white glaze and palm eyes was regarded as common, decorations on porcelain ware were often rendered with soleimani underglaze blue, and ware in bright red glaze was very valuable". Ware in bright red glaze of the Yongle and Xuande periods was characterized by pure and clear glaze surface without cracks, deep and stable colour tones, and a tidy white border rim on the mouth, which was known as "common rush mouth". A typical example is the plate in bright red glaze of the Yongle period (plate 173) on which the mouth rim has a tidy border in white formed during dripping of copper red glaze, which produces an aesthetic contrasting effect with brilliant ruby-like red glaze on the body with a touch of charm and luxuriance.

Since the Xuande period, less ware in copper red glaze was produced and successfully produced ware had become rare. The main reasons were due to the loss of the production techniques and the exhaust of bright red glaze materials. Since the Jiajing period, although the court had repeatedly urged the Jingdezhen Imperial Kiln to produce the ware again, the production techniques were never revived and the only alternative was to produce ware in overglaze iron red glaze instead. In the book *Daming Huidian* (*Code of Great Ming Dynasty*), it was recorded that "In the 2nd year of the Jiajing period, (The Court) ordered Jiangxi (Jingdezhen kiln) to fire ware, among which, ware in bright red glaze would be replaced by ware in iron red glaze". In the book *Kuitian Waisheng*, it was also recorded that "In the Jiajing period...bright red clay was exhausted, and only iron red glaze could be produced instead. Without any alternative, the court agreed reluctantly". After the Longqing period, production of ware in high-temperature fired copper red glaze had nearly come to a complete halt.

In the Kangxi period of the Qing Dynasty, with the repeated trails and experiments of the Imperial Kiln in Jingdezhen, production of ware in high-temperature fired copper red glaze was gradually revived, and three new types, sky red (sacrificial red), *langyao*-red and cowpea red glaze, were created.

Ware in sky-clearing red glaze

Sky-clearing red glaze was imitated after the bright red glaze of the Ming Dynasty with its name coming from the book *Taocheng Jishi* (*Chronicles of Ceramic Industry*), "The glaze was imitated after the sky-clearing red glaze of the ancient Xuande period with two types: bright red glaze and ruby red glaze". The characteristics of this type of glaze were that there was no dripping or cracks on the glaze surface, but with unapparent orange-peel marks. The colour of glaze was stable and deep with high aesthetic appeal. Production of ware in sky-clearing red glaze had started in the Kangxi period, and was continued in the subsequent periods. Such ware was commonly produced in the Kangxi, Yongzheng and Qianlong periods and was noted for the best quality and large quantity.

Emperor Yongzheng had a strong favour for the ware and repeatedly ordered the Imperial Kiln in Jingdezhen to fire such ware. Sometimes he even expressed his discontent on the ware produced. For example, in the *Statistic Report of Artifacts* produced in various imperial workshops of the Inner Court of the Qing Dynasty, "On the 17th day of the eighth month, the Yuanmingyuan Palace of Summer Retreat reported that the Clerk Haiwang had taken out five shards of a plate's rim in sky-clearing red glaze on the 14th day of this month for inspection. The Emperor (Yongzheng) commented that 'The glaze should be thicker, but those produced recently were thin and the reason of such a defect was unknown. Now you take these shards to Nian Xiyao and advise him to take reference of these shards to produce ware in sky-clearing glaze with the same quality. By imperial order'."

In the Qianlong period, the court had sent examples to the Imperial Kiln in Jingdezhen to follow and fire ware in sky-clearing red glaze for several times. In addition to the Imperial Kiln, other local kilns with high production standards also produced such ware. However, mastery of the firing skills was

difficult to command, as described by Gong Shi in his book *Jingdezhen Taoge* (*Poems on the Ceramic Industry in Jingdezhen*), "Imperial ware in sky-clearing red glaze in the past was highly esteemed as it was most difficult to produce ware with perfection. Time has to be spent in both snowy days and sunny days to reach a consummate state of perfection of skills, because a hundred different colours would come out despite the same formula of firing was applied".

Ware in langyao-red glaze

Ware in *langyao*-red glaze was also known as "*lang* red glaze" and "red *lang* glaze" which was a new type of red glaze produced on the foundation of imitating ware in bright red glaze of the Xuande period, Ming Dynasty in the Kangxi period. Such type of red glaze was believed to have been produced during the service of Lang Tingji (1663 – 1715), Governor of Jiangxi, who also took up the post as the Director General of the Imperial Kiln in Jingdezhen from the 44th year (1705) to the 51st year (1712) of the Kangxi period.

Compared with the sky-clearing red glaze, the colour of *langyao*-red glaze was even brighter and more brilliant. The production technique was to apply the glaze directly on the raw paste, and then fired the paste in a high temperature of over 1300°C in the reduction atmosphere for one time. The characteristics include a thick, clear and transparent glaze layer with dripping effect, glassy textures and large ice-crackles on the surface. In describing ware in *langyao*-red glaze, it is often said that "The glaze dripped beyond the mouth to the foot, but stopped just above the foot tidily". For example, on the vase with design of borders of string patterns in relief in *langyao*-red glaze (plate 191), the body is covered with red glaze from top to bottom, with the red colour becoming dense and more luxuriant downwards and condensing thickly at the foot rim in a blackish-red colour. On the other hand, owing to dripping, the glaze runs thin at the mouth rim, exposing the white paste. The exterior bases of ware in *langyao*-red glaze were often glazed with a colour resembling rice soup or with a light greenish tint, as well as ice-crackles, which were known as "bases in rice soup colour" or "bases in apple green colour".

The firing requirements of ware in *langyao*-red glaze, including firing temperature and atmosphere, were stringent and it was difficult even to have one piece successfully produced. Only a limited number could be achieved from the bulk of ware under production. Therefore, there was the saying, "If you want to be poor, then engage yourself in producing ware in *langyao*-red glaze". Thus such ware was highly treasured.

Ware in cowpea red glaze

Cowpea red glaze was also a new type of glaze produced in the Imperial Kiln in Jingdezhen based on the foundation of imitating ware in bright red glaze in the Kangxi period. Cowpea red glaze got its name as the colour is like the colour of the skin of the cowpea. However, extant ware is in different colour tones and a number of descriptions such as "dahongpao" (grand red robe)", "zhenghong" (precise red), "wawalian" (baby's face), "taohuapian" (peach-blossom petal), "begonia red", "meirenqi" (colour of a beauty), "meirenzui" (drunken beauty), "meirenji" (smile of a beauty) and others have been adopted. Also, the colour which turned greyish-red was called "skin of a baby mouse" or "skin of an elm tree". Owing to partial oxidization of glaze, green mottles which were described as "moss green" or patches in green known as "apple green" would appear in the glaze.

Cowpea red and *langyao*-red glazes were two distinctive glazes in the repertoire of monochrome ware. If ware in *langyao*-red glaze was noted for luxuriant and brilliant colours, then ware in cowpea red glaze was much credited for soft and subtle colour tones which exuded a lofty charm of lyricism. If we compared the seal paste cover in *langyao*-red glaze (plate 192) with the seal paste box in cowpea red glaze (plate 199), we would sense the difference in aesthetic appeal. Probably it was considered that only small and delicate objects would harmoniously match the aesthetic charm of cowpea red glaze, therefore no objects in large sizes in cowpea red glaze were produced in the Kangxi period.

Ware in low-temperature fired iron red glaze

This type of glaze was a low-temperature fired red

glaze with oxidized iron as colourant. It is produced from iron vitriol and after heating and cleaning, lead powder would be added to produce the iron red glaze. The firing temperature of iron red glaze is around 900°C and easier to control for producing a stable colour.

The use of iron red glaze had begun in the Ding kiln and Cizhou kiln in the Song and Jin dynasties, and was first used in the Jingdezhen kiln in the Yuan Dynasty. Prior to the mid-Ming period, iron red glaze was mostly used as a colour enamel over the glaze and found on the ware with designs in red and green enamels, *doucai* enamels, *wucai* enamels and mixed colour enamels. In the Jiajing period of the Ming Dynasty, the production techniques of high-temperature fired copper red glaze had been lost and as an alternative, potters used iron red glaze as a replacement. From the Kangxi to the Qianlong period of the Qing Dynasty, progressive developments were made in the production of ware in iron red glaze with various innovations.

Iron red glaze could be applied with splashing, sufflation, patting and rubbing techniques. According to the difference of colours and glaze application techniques, iron red glaze could be classified into two types: splashed-red glaze and coral red glaze. Splashed-red glaze first appeared in the Ming Dynasty as the glaze was splashed on the ware with a brush. Splashed-red glaze usually had an uneven thinner layer with traces of brushing found, but the colour was translucent and refreshing. Coral red glaze was first produced in the Kangxi period of the Qing Dynasty and had become more popular in the Yongzheng and Qianlong periods. The production technique was to glaze the ware with iron red glaze by sufflation on a white glaze. After firing, an even and shiny red colour with a yellowish tint would be achieved, resembling the colour of natural coral, and thus named coral red glaze.

Ware in golden-red glaze

Golden-red glaze has gold as colourant and is a kind of low-temperature fired enamel baked in a temperature of around 800°C in the furnace. The content of gold in the glaze is minimal with only around 1% to 2%. As golden-red glaze was applied with sufflation technique on white glazed ware and since the technique was introduced from Europe, it was known as "foreign red glaze by sufflation", "foreign golden-red glaze" and "western red glaze". The red colour was like the colour of rouge and thus it was also known as "rouge red". In Europe, it was named "Chinese rose red" or "rose red". Both colours in deep and light red were found, with the colour in light named "rouge red water" colour and colour in even and lighter red named "light pink", whereas those with the colour deeper than the rouge red water colour named "rouge purple".

Golden-red glaze was utilized as a kind of overglaze enamel and first appeared on the ware with opaque enamel designs of the late Kangxi period. In the late Kangxi period, it was used on monochrome ware and continuously produced in subsequent periods.

In the Yongzheng and Qianlong periods, both the quality and quantity of ware in golden-red glaze were enhanced. Ware in golden-red glaze produced in the Yongzheng period included vases, jars, plates, bowls, cups and others, which were characterized by small and delicate forms with thin pastes. Among them, those with light pink colour were only confined to the Yongzheng period with colour scheme resembling peach-blossom petals with a touch of delicacy and charm. The quality of ware in golden-red glaze produced in the early Qianlong period could still match the standard of Yongzheng ware, but the production of golden-red glazed ware significantly declined afterwards and could not match that of the former periods both in terms of quality and quantity.

Ware in yellow glaze

High-temperature fired yellow glaze

Common high-temperature fired iron yellow glaze

During high-temperature reduction firing, lime glaze with suitable content of oxidized iron would generate pale green colour, greenish-grey colour or yellowish-green colour. However, if fired in high-temperature oxidizing atmosphere, it would generate yellow colour. The Shouzhou kiln in Anhui, the Baituzhen kiln in Xiao district, the Mixian kiln and the Jiaxian kiln in Henan, the Yuhuagong kiln in

Tongchuan, Shaanxi, the Hunyuan kiln in Shanxi, the Quyang kiln in Hebei and the Changsha kiln in Hunan had produced high-temperature fired iron yellow glazed ware with the best quality ware produced in the Shouzhou kiln, which was most esteemed. Lu Yu (733 – 804) of the Tang Dynasty had given a description on the ware as "Shouzhou yellow glazed ware" in his book *Classic of Tea*.

Rice yellow glaze

Rice yellow glaze was also known as rice colour glaze, which was a kind of high-temperature fired yellow glaze with oxidized iron as colourant. The colour was soft with a whitish tint in yellow, which resembled the colour of rice, hence the name. Historical records reveal that the Jingdezhen kiln had started to produce ware in rice yellow glaze in the Song Dynasty, and the Jingdezhen kiln in the Qing Dynasty produced two imitated types in light and deep yellow. The deep yellow glaze has a reddish tint in the rice yellow colour whereas the light yellow glaze has a whitish tint in the rice yellow colour. The Jingdezhen kiln had started to fire ware in rice yellow glaze in the Kangxi period and continued in the subsequent periods with the best quality and most abundant ware produced in the Yongzheng period.

Low-temperature fired yellow glaze

Low-temperature fired iron yellow glaze

Low-temperature fired yellow glaze was a kind of transparent glaze with oxidized iron as colourant and oxidized lead as fluxing agent, which first appeared on the glazed pottery ware of the Western Han Dynasty and had been found on the ware of later dynasties. However, prior to the Ming Dynasty, low-temperature fired yellow glaze was mostly applied on pottery ware in yellowish-brown or deep yellow colour. In the Jingdezhen kiln of the Ming Dynasty, low-temperature fired yellow glaze (pouring yellow glaze) was applied on porcelain pastes and also the colour tones ranged from deep to light yellow colour tones; however, the principal colour was bright yellow.

Ware in yellow glaze was produced in all periods of the Ming Dynasty. Extant ware reveals that ware in yellow glaze produced in the Xuande and Chenghua

periods had been finely produced; however, the ware in yellow glaze produced in the Hongzhi and Chengde periods were the most esteemed. In particular, ware in yellow glaze, such as the *zun* vase, with design of gilt borders of string patterns in yellow glaze (plate 215), which is characterized by pure and even colour and a smooth glaze surface resembling the quality of chicken's oil with a clear, shiny and bright colour tone, reveals the highest standard of yellow glazed ware in the Chinese ceramic history.

Ware in yellow glaze applied by the pouring technique in the Qing Dynasty was mostly for imperial use. Such imperial ware in yellow glaze was produced in different periods. The imperial courts had stringent regulations and guidelines for the production of ware in yellow glaze and only the Emperor, Empress and concubines or other designated nobles were permitted to use such ware. For example, the flower-pot with carved and incised design of peonies in yellow glaze (plate 222), was specially produced by the Imperial Kiln in Jingdezhen in the 10th year of the Guangxu period (1884) as a tributary vessel to celebrate the 50th birthday of Empress Dowager Cixi. On the other hand, to avoid the leakage of the techniques in producing ware in yellow glaze and maintain the mechanism of producing such ware intact, even damaged or inferior ware in yellow glaze had to be sent to the capital for disposal, reflecting the strict mechanism in producing such ware.

Low-temperature fired antimony yellow glaze

This type of low-temperature fired antimony yellow glaze was first produced in the Imperial Kiln in the Kangxi period and was named as it was because oxidized antimony imported from the West was used as colourant. The characteristic was that the glaze layer was not transparent and had become opacified. However, the colour of this type of yellow glaze was more subtle and soft than that of the pouring yellow glaze, and thus named "light yellow glaze". Its colour also looked like the colour of egg-yolk and thus named "egg-yolk glaze". In the historical records of the Qing Dynasty, it was also named "western yellow" and "foreign yellow", and it was also known as "lemon yellow" if the colour was similar to the colour

"lemon yellow" if the colour was similar to the colour of lemons. Ware in light yellow glaze was produced in the Kangxi, Yongzheng, Qianlong and Jiaqing periods and continued through the Daoguang period.

Ware in blue glaze

Blue glazes include low-temperature fired cobalt blue glaze, high-temperature fired cobalt blue glaze, snow-flake blue glaze, peacock blue glaze and sky blue glaze. The colourant is basically oxidized cobalt, but with different fluxing agents. The fluxing agent for low-temperature fired cobalt blue glaze and snow-flake blue glaze was oxidized lead. The high-temperature fired cobalt blue glaze was a kind of high-temperature fired alkali lime glaze with oxidized calcium, oxidized potassium and oxidized sodium as fluxing agents. The fluxing agent of peacock blue glaze was potassium nitrate. The sky blue glaze was also a kind of high-temperature fired alkali lime glaze with less oxidized cobalt content in the glaze as compared with high-temperature fired cobalt blue glaze.

Ware in low-temperature fired cobalt blue glaze

Low-temperature fired cobalt blue glaze was first found on low-temperature fired pottery ware in lead glaze produced in the Gong district kiln in Henan in the Tang Dynasty, which was used as a glaze on *sancai* (three-colours) ware, but seldom used for fully glazing a piece of ware, and the colour was often uneven. In the Yuan, Ming and Qing dynasties, this glaze was also used on architectural elements in glassy colour glaze of the court.

Ware in high-temperature fired cobalt blue glaze

Cobalt blue glaze was applied on the raw paste and fired in a temperature of around 1280 to 1300°C in the kiln for one time. The production technique and the type forms of ware in high-temperature fired cobalt blue glaze were basically similar to those of the ware in high-temperature fired copper red glaze with the characteristics that the glaze would not drip or crack, and the colour was even and stable. When

holding sacrificial ceremonies to heaven, emperors of the Ming Dynasty often used this type of ware in blue glaze, and thus they were known as ware in "sacrificial-blue" glaze. In the past, people often named the blue colour as green colour, and thus this type of ware was also known as "sacrificial-green" ware. Sometimes the glaze was named "sapphire blue" glaze as its colour was brilliant like the colour of sapphire. On the other hand, Tang Ying named this type of glaze "sky-clearing blue" or "sky-clearing green" glaze.

Ware in high-temperature fired cobalt blue glaze was first produced in the Jingdezhen kiln in the Yuan Dynasty and had been popularly produced in the Imperial Kiln in Jingdezhen in the Ming and Qing dynasties. Only a limited number of this type of ware was produced in the Yuan Dynasty, which was usually decorated with gilt designs or designs reserved in white, as represented by the plate with design of dragons reserved in white in blue glaze (plate 232). From the Hongwu period to the Wanli period of the Ming Dynasty, the Imperial Kiln in Jingdezhen had continuously produced such ware, among which, the one produced in the Xuande period was highly esteemed as one of the three famous types of monochrome ware of the Xuande period. The book *Nanyao Biji* (*Notes on the Jingdezhen Kiln*) recorded that "The Xuan (de) kiln….had three superior types of ware in sky-clearing red, sky-clearing blue and sweet white glazes produced". The plate with molded and incised design of dragons amidst clouds in sky-clearing blue glaze (plate 234) with finely and skillfully produced paste and glaze is a representative piece of ware of this type. Production of ware in sky blue glaze had started in the Shunzhi period and continued in the subsequent periods. The book *Taocheng Jishi* (*Chronicles of ceramic industry*) listed this glaze as one of the fifty-seven types of glazes and enamel colours newly produced or in imitation of ancient glazes.

Ware in Mohammedan blue glaze

Mohammedan blue glaze was first produced in the Imperial Kiln in Jingdezhen in the Jiajing period of the Ming Dynasty. Similar to high-temperature fired sky-clearing blue glaze, oxidized cobalt blue was

uses as colourant, and the term Mohammedan blue was derived with the use of imported "Mohammedan blue" material for glazing. Without the dense colour tone of sky-clearing blue glaze, the Mohammedan blue glaze had a colour in light blue with a greyish tint.

Ware in snow-flake blue glaze

Snow-flake blue glaze was a kind of high-temperature fired cobalt blue glaze with the characteristics of irregular deep blue mottles spread on the light blue or white glazed ground, which looked like sprinkled water splashes in blue, hence the name "sprinkled-blue glaze". Alternatively, if the glaze appeared in light blue or with white mottles on a deep blue glazed ground, which looked like snow-flakes, then it would be called as "snow-flake blue" glaze.

Ware in snow-flake blue glaze was first produced in the Imperial Kiln in Jingdezhen in the Xuande period of the Ming Dynasty, and continued in the Zhengde and Jiajing periods with less ware produced. In general, the quantity of ware in snow-flake glaze in the Ming Dynasty was rather limited. In the Kangxi period of the Qing Dynasty, progressive development was realized with the quantity and quality of this type of ware enhanced. Ware in snow-flake blue glaze of the Kangxi period was often decorated with gilt designs exuding a luxuriant and elegant charm. However, the gilt designs have been peeled off nowadays and only traces of designs are visible. Ware in snow-flake glaze of the Yongzheng period was modeled after the colour of lapis lazuli with a dense greenish-brown colour, which was known as "ghost's face green". After the Yongzheng period, this type of ware was seldom produced.

Ware in sky blue glaze

Sky blue glaze was first produced in the Jingdezhen Kiln in the Kangxi period of the Qing Dynasty. Although it was a kind of high-temperature fired cobalt blue glaze, the content of oxidized cobalt was less than that of sky-clearing blue glaze. The colour looked like blue sky and thus came its name.

The characteristic of sky blue glaze was its stable,

soft and subtle colour, which was reputed together with the famous cowpea red glaze of the Kangxi period. As this type of sky blue was easier to produce than the cowpea red glaze, more ware in this glaze was produced than the one in cowpea red glaze.

Ware in sky blue glaze was much favoured by the Qing court and had been produced from the Kangxi period to the subsequent periods. In terms of quantity and quality, production of this type of ware reached its zenith in the Kangxi, Yongzheng and Qianlong periods. In the Yongzheng period, over sixty type forms had been produced but after the Qianlong period, the quantity and quality of such ware declined significantly.

Ware in peacock blue glaze

Peacock blue glaze was a kind of mid-temperature fired glaze with oxidized cobalt as colourant and potassium nitrate as fluxing agent. The glaze was clear and transparent and the colour resembled the blue colour of peacock's feathers, hence the name "peacock blue" glaze. Peacock blue glaze was applied on white glazed ware or directly on fired biscuits without glazing. However, ware with the glaze directly applied to the pastes had the defect that the glaze and paste would not adhere firmly with the glaze often peeled off. Compared with ware in peacock green glaze, the type forms and quantity of ware in peacock blue glaze were less.

Ware in aubergine glaze

This type of glaze in purplish colour of eggplants was known as "aubergine glaze" which was a kind of low-temperature fired glaze with oxidized manganese as colourant. There were two types of aubergine glazes with a deep or light colour. Deep aubergine colour resembled the colour of ripe eggplants and light aubergine colour resembled the colour of young eggplants. As the glaze was applied with pouring technique, it was also known as "pouring aubergine glaze".

Ware covered with aubergine glaze was first produced in the Imperial Kiln in Jingdezhen in the Xuande period of the Ming Dynasty and also produced in the Wanli period of the Ming Dynasty.

Such type of ware in aubergine glaze had become more popular in the Kangxi, Yongzheng and Qianlong periods of the Qing Dynasty.

Ware in green glaze

Ware in langyao-green glaze

Langyao-green glaze was also known as "green *langyao*" glaze which was a kind of high-temperature fired green glaze with oxidized copper as colourant and named after the Lang (Tinji) kiln in the Kangxi period when it was first produced. Compared with ware in *langyao*-red glaze, this type of ware was less. This glaze was probably an alternative type of glaze produced during firing of ware in *langyao*-red glaze, which was the result of accidental oxidization of *langyao*-red glaze after firing with a greenish tint appearing on the glaze surface. As the colour looked like green apples, it was also known as "apple green" with the characteristics of a thick, shiny, clear glaze layer and glassy quality. The surface of such glaze often carried small ice-crackles which resembled ice-crackles on Ge ware in celadon glaze of the Song Dynasty, and was thus also known as "green Ge glaze".

Ware in *langyao*-green glaze was very rare and the value was about ten times more than that of the ware in *langyao*-red glaze. In the early 20th century, such ware was much favoured by Europeans and in particular the French who had paid huge sums of money to acquire the ware, which led to the production of many faked and imitated ware.

Ware in peacock green glaze

Peacock green glaze was known as "*falü*" (imitated green), "*facui*" (imitated emerald-green), "jade glaze" or "auspicious emerald green ", which was a kind of mid-temperature fired glaze with oxidized copper as colourant and potassium nitrate as fluxing agent. The formula of mixing the glaze was similar to the low-temperature fired lead glaze produced since the Han Dynasty, and the difference was only in the choice of fluxing agent. As the colour was in bright and shiny green, which resembled the colour of peacock feathers, it was known as "peacock green glaze".

Ware in peacock green glaze was first produced in the local kilns in North China in the Song and Jin dynasties. Since the Yuan Dynasty, the Jingdezhen kiln had started to produce ware in peacock green glaze. This type of ware was produced in the Yongle, Xuande, Chenghua and Zhengde periods, with the one produced in the Zhengde period most esteemed. However, such ware was only produced in a limited number in the Ming Dynasty.

In terms of quantity and quality, the production of ware in peacock green glaze had reached its zenith in the Kangxi, Yongzheng and Qianlong periods of the Qing Dynasty. For example, the *Gu* vase in peacock green glaze (plate 255) is covered with peacock green glaze with small ice-crackles both in the interior and on the exterior. It is fashioned with a delicate and elegant form with concise and simple decorations and pure glaze colour, representing a refined piece of its type. In the Yongzheng and Qianlong periods, production of the type forms of ware in peacock green glaze had been reduced and in particular, ware in peacock green glaze of the Qianlong period was characterized by thinner glaze layers and pastes not as fine as those of the Kangxi and Yongzheng periods.

Ware in watermelon green glaze

Melon green glaze was a kind of low-temperature fired glaze with oxidized copper as colourant and oxidized lead as fluxing agent. As the colour was bright green which resembled the colour of the skin of watermelons, it was known as "watermelon green glaze". The production technique was to apply the glaze by pouring directly on the fired biscuit and it was also known as "pouring watermelon green glaze".

Ware in watermelon green glaze was first produced in the Jingdezhen kiln in the Xuande period of the Ming Dynasty and continued in the subsequent periods, with the best produced in the Jiajing period. In the Qing Dynasty, the Jingdezhen kiln also produced a large amount of such ware as imitations of ancient ware.

Ware in West Lake water glaze, onion green glaze, okra green glaze and turquoise green glaze

These four types of glazes were low-temperature fired glazes with oxidized copper as colourant and

had a soft and subtle green tone. The West Lake water glaze was so-named as the colour was in light green resembling the colour of water in the West Lake. The onion green glaze was so-named as the colour was verdant green resembling the colour of onions. The turquoise green was so-named as the colour was like that of the turquoise stone, and the okra green was so-named as the colour had a greenish-yellow tint resembling the colour of okra.

Ware in West Lake water glaze was first produced in the Kangxi period. Ware in onion green and orka green glazes was first produced in the Yongzheng period and only confined to that period. Ware in West Lake water glaze and orka green glaze was mostly small delicate ware such as bowls, plates, cups and dishes fashioned in a refined manner with light and thin pastes and even and clear glaze. The most popular ware in orka green glaze of the Yongzheng period included small bowls and small plates with the interior glazed in white and the exterior glazed in hibiscus green with a touch of delicacy and charm. Ware in turquoise green glaze was first produced in the Yongzheng period and in large numbers in the Qianlong period.

Ware in brown glaze

This type of glaze referred to the sesame brown glaze, which was abbreviated as brown glaze and also known as glaze in persimmon colour, which was a kind of high-temperature fired glaze with oxidized iron as colourant. As *zijin* clay which contained oxidized iron was used for making the glaze, such glaze was also known as *zijin* (purplish-gold) glaze.

In the Song Dynasty, most kilns in North China had produced ware in brown glaze, with the one produced in the Ding kiln, the Xiuwu kiln and the Yaozhou kiln most credited for their tidy type forms and shiny and translucent glaze. The Jingdezhen kiln had started to produce ware in this type of *zijin*-brown glaze in the Hongwu period and continued in the subsequent periods, with the one produced in the Xuande period most esteemed. Such ware was produced nearly in every period of the Qing Dynasty and in particular in the Yongzheng and Qianlong periods. The ware in brown glaze produced in the Imperial Kiln in Jingdezhen was regarded as a kind of ware in imitation of ancient glaze. The book *Taocheng Jishi* (*Chronicles of Ceramic Industry*) recorded that "The type of *zijin*-brown glaze has two colours: in red and in yellow". Reddish *zijin*-brown glaze referred to the colour with a deep red tint and yellowish *zijin*-brown glaze referred to the colour with a light yellowish tint.

Ware in changguan glaze

Changguan glaze was a kind of crystallized glaze with iron or magnesium content produced in the Imperial Kiln in Jingdezhen in the Qing Dynasty exclusively for court usage. In accordance with different levels of crystallization, colours and potters' manipulation, a variety of glazes known as "eel green", "eel yellow", "tea-dust", "old monk's robe" came into being.

Historical records reveal that this type of *changguan* glaze was produced by imitating the ware produced in the Changguan kiln. The book *Taocheng jishi* (*Chronicles of ceramic industry*) recorded that, "In imitating ware of the Changguan kiln, there were three types of glazes known as 'eel yellow, snake skin green and yellow mottle'. Yellow mottle glaze actually referred to the tea-dust glaze with yellowish sprinkles in the dark greenish glazed ground of the vessel, which looked like mixing tea-dust with the glaze.

As the firing of crystallized glaze was closely associated with the glaze formula, grinding, firing temperatures and firing atmosphere in the kiln chamber, warming time and cooling time required, variations of glaze colours would appear and new types of *changguan* glazes came into being, such as those glazes that were named "big tea leaves", "fresh mandarin orange", "turtle skin", "tortoise green", "crab-shell green", "eel yellow", etc.

Ware in other glazes

There are other monochrome glazes which could not be grouped in the above categories and they would be introduced here. These glazes include glaze in imitation of ancient jade, gold and silver glazes, glaze in imitation of lacquer, glaze in imitation of wood textures, glaze in imitation of

marble stones and in particular glazes in imitation of other crafts.

To adopt the artistic styles of other medium and crafts to decorate porcelain ware was a superb decorative technique of potters in the Imperial Kiln in Jingdezhen in the Yongzheng and Qianlong periods. These artistic ceramic works fully imitated and captured the essence of the original textures and colours of other objects, which revealed that potters and ceramic artists had fully mastered the mixing formulas of various glazes and control of the required firing temperatures and atmospheres in the kiln during the production process.

Ware in glaze in imitation of ancient jade

Glaze in imitation of ancient jade was a kind of high-temperature fired monochrome glaze first produced in Imperial Kiln in Jingdezhen in the Yongzheng period with the characteristics of irregular yellowish-white mottles on a brown glazed ground, or greenish mottles on a greyish-white glazed ground, which resembled the textures of ancient jade ware and was also known as "glaze in imitation of old jade".

Ware in glaze in imitation of gold and silver ware

Ware in gold and silver glaze was first produced in the Imperial Kiln in Jingdezhen in the Kangxi period, which was known as "gold-wash" or "silver-wash" ware in historical documents. The production technique was to apply mixed gold or silver powder on the ware with white pastes by washing or wiping. After low-temperature firing, a most luxuriant and elegant aesthetic effect similar to that of the genuine gold and silver ware would be achieved. As gold and silver were valuable, the production of ware in gold or silver glaze was very costly and the production scale was limited.

Ware in glaze in imitation of lacquer ware

Glaze in imitation of lacquer ware was a new type of low-temperature fired glaze produced in the Imperial Kiln in Jingdezhen in the Qing Dynasty, and ware in this type of glaze could be classified into ware in glaze in imitation of red lacquer ware (also known as glaze in imitation of Fujian lacquer ware with leather bodies), ware in glaze in imitation of carved lacquer ware, ware in glaze in imitation of black lacquer ware in gilt designs, ware in glaze in imitation of ware with inlaid mother-of-pearl designs, ware in imitation of lacquer ware in interweaved bamboo strip designs and others. Among such ware, the more common one was ware in glaze in imitation of red lacquer ware and carved lacquer ware with oxidized iron as colourant, which was first produced in the Qianlong period.

The production technique of ware in glaze in imitation of red lacquer ware was to apply glaze with a colour similar to red lacquer on the high-temperature fired biscuit and then baked it in the low temperature. In terms of the form and glaze colour, the covered bowl in the shape of chrysanthemum petals and decorated with gilt design of imperial poem in glaze in imitation of red lacquer (plate 286) of the Qianlong period was finely fashioned to simulate the original look of genuine lacquer ware.

Glaze in imitation of carved lacquer ware was also known as glaze in imitation of red lacquer ware with cut decorations. The production technique was to carve the decorations on a potted biscuit which was half dry. After firing the biscuit in high temperature, glaze in imitation of red lacquer would be applied on the biscuit and fired again in low temperature in a baking atmosphere.

Ware in glaze in imitation of wood textures

Ware in glaze in imitation of wood textures was first produced in the Yongzheng period and continued in the subsequent periods. The production technique was to paint wood textures, such as tree's annual rings, tree knobs and flaws on tree branches, on the high-temperature fired biscuit in different colour glazes. After firing again in low temperature, naturalistic simulated wood textures would appear with high artistic achievements and it is difficult to differentiate the porcelain ware from original wood.

Ware in glaze in imitation of marble

Marble is a kind of precious stone used for tiling the floors of Imperial buildings in the past. The

production technique of this type of glaze in the Imperial Kiln in Jingdezhen in the Qianlong period was to apply glazes and colour enamels simulating the textures and original colours of marble on the fired biscuit. After firing again in the low-temperature baking atmosphere, an artistic effect with colours and textures simulating genuine marble would be achieved.

ORGANICS OF COLOUR GLAZES AND APPRECIATION OF MONOCHROME WARE

Owing to prescribed absorbance and reflection of light by different glazes (in particular the metallic elements in the glaze), different monochrome glazes would generate different colours. The metallic elements in traditional Chinese colour glazes include iron, copper, cobalt, manganese, magnesium and others. In the Kangxi period, with the import of opaque enamels from Europe, potters gradually mastered the control of other metallic elements such as antimony, gold, etc. for colour glazing purposes.

Other than the designated formulas in mixing different glazes, glaze colouring also depends much on the firing temperatures and atmospheres in the kiln chamber. For example, glaze with the right proportion of oxidized copper would generate green colour in oxidizing firing atmosphere and red colour in reduction firing atmosphere. The glaze colours of the Ge ware of the Song Dynasty include greyish-green, bluish-green, fired-rice yellow and others. In fact, their glaze formulas are the same, but different colours have been produced due to the different locations in putting the ware in the kiln as the ware would be fired in different temperatures and atmospheres. Strictly speaking, we are not able to find any two or more pieces of monochrome ware with exactly the same glaze colour, in particular in the category of high-temperature fired monochrome ware.

In conclusion, the beauty of monochrome ware depends on the harmonious blending of artificial control and natural outcomes of firing different colour glazes. Compared with polychrome ware, monochrome ware may facilitate us to better understand the essence of Chinese ceramic art and the resonance of subtleness and lyricism revealed on such ware.

The Palace Museum has collected some 360,000 pieces of Chinese ceramic ware, among which, about 320,000 pieces are refined ware produced by the five famous kilns of the Song Dynasty as well as produced by the Imperial Kiln (Guanyao) in the Ming and Qing dynasties, which are originally collected by Imperial Court of the Qing Dynasty. In this volume, 290 pieces (sets) of fine monochrome ware are selected and classified into twelve categories to facilitate readers and audience to fully appreciate the art of monochrome ware: monochrome ware with the beauty of simplicity and purity, monochrome ware in suffused and flambé glaze with the beauty of fantasy, ware with unexpected beauty created by defects and flaws, and ware with the beauty of harmony between ceramic forms and glaze colours.

WARE IN CELADON GLAZE

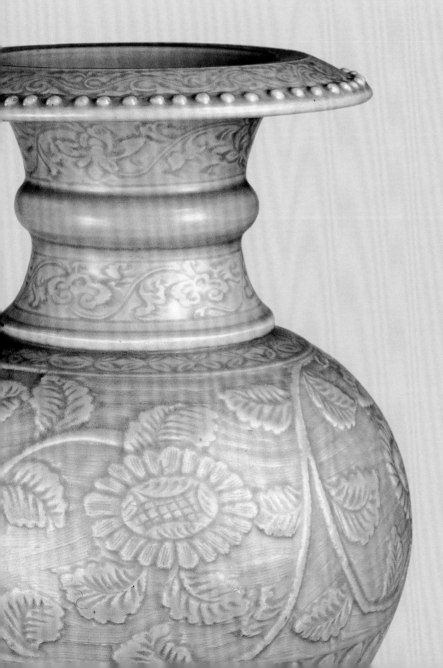

1

Jar
with carved and incised design of string patterns in celadon glaze

Proto-porcelain ware
Shang Dynasty

Height 31.4 cm
Diameter of Mouth 20 cm
Diameter of Base 9.3 cm

The jar has a flared mouth, a short neck, a tapering shoulder, and a belly tapering downwards to a round base. The jar is covered with thin greyish-celadon glaze. The shoulder is decorated with several borders of string patterns. This jar is damaged and traces of conservation are found on the body.

Experts describe ware in celadon glaze, which was high-temperature fired ware produced from the Shang Dynasty to the Western Han Dynasty with the term "proto-porcelain ware". It was the forerunner of Chinese porcelain ware and had great significance in the history of ceramic ware. Such type of ware utilized porcelain clay to fashion the biscuit and its surface was then covered with lime glaze and fired in a high temperature at around 1,200°C. Compared with pottery ware, proto-porcelain ware was very different in physical characteristics in terms of chemical composition and physical condition, and the features were very close to the later porcelain ware. Yet if compared with the matured porcelain ware produced in the mid and late Eastern Han Dynasty, the production technique and quality of the proto-porcelain ware had not reached the standards of the matured porcelain ware, and was only a transitional type of ware before the formal production of porcelain ware.

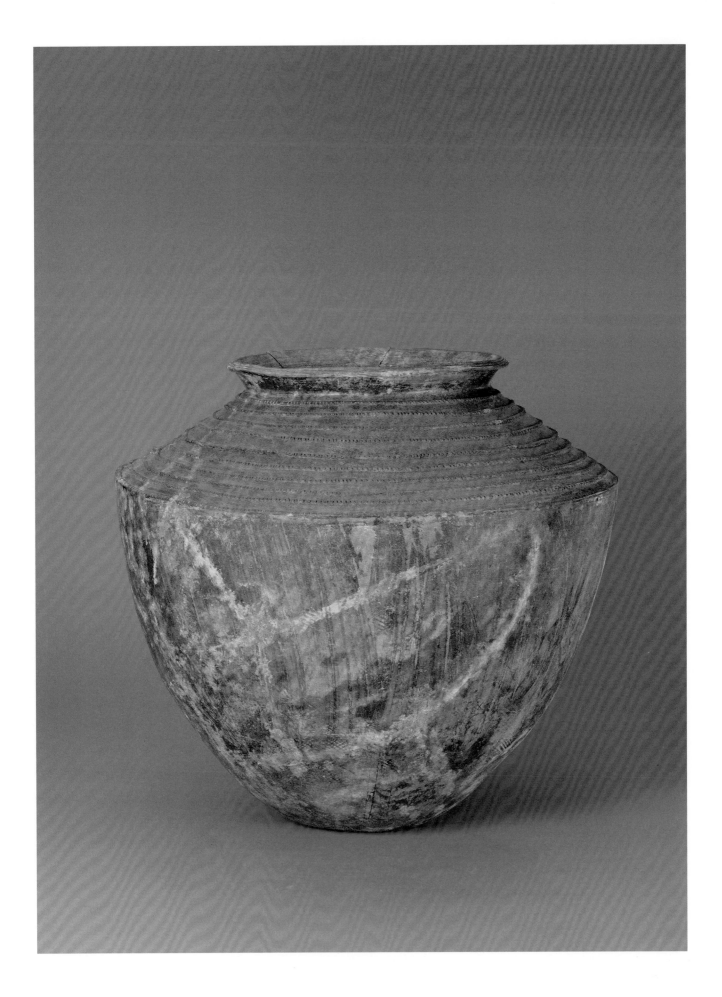

2

Jar
with two loops and carved and incised design of wave patterns in celadon glaze

Proto-porcelain ware
Western Zhou Dynasty

Height 13.2 cm
Diameter of Mouth 8.4 cm
Diameter of Foot 8.3 cm
Unearthed at Luoyang, Henan

The jar is in the shape of a fish basket with a contracted mouth, a slanting shoulder, a globular belly tapering downwards, and a flared ring foot. On the symmetrical sides of the shoulder are two horizontal loops half-round in shape. The body is covered with celadon glaze. The shoulder is incised with designs of waves and string patterns.

This type of jars was only unearthed at the tomb sites of the Western Zhou Dynasty, and thus should be dated to the Western Zhou Dynasty. Compared with the proto-celadon ware of the Shang Dynasty, the quality of the paste and glaze of this type of ware were enhanced, reflecting the production standard of the proto-celadon ware in the Western Zhou Dynasty.

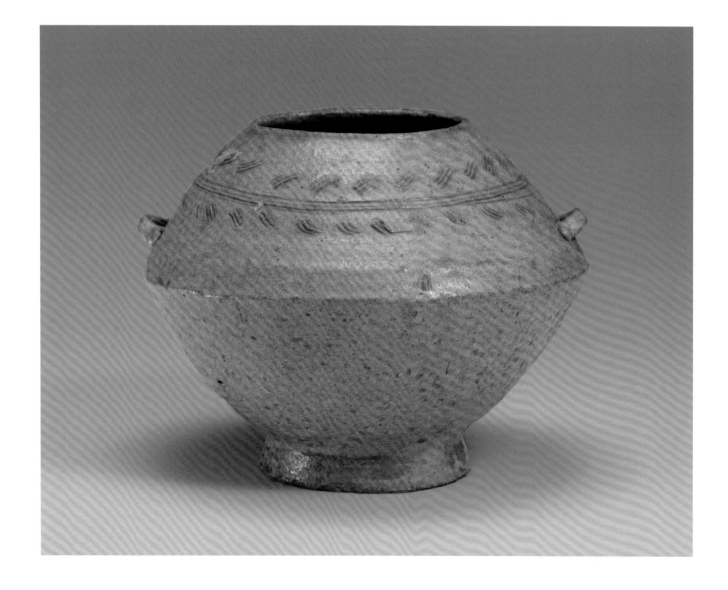

3

Chunyu Musical Instrument

with carved and
incised design of cloud
and thunder patterns
in celadon glaze

Proto-porcelain ware
Warring States period

Height 33.8 cm
Diameter of Upper Ring 14.5 cm
Diameter of Foot 12.7 cm

The *chunyu* musical instrument is hollow inside and tube-shaped with a round upper part and a hollow lower part. On the flat top is a ring-shaped knob for hanging. The body is covered with a thin layer of greyish-celadon glaze. On the knob are carved string patterns, whereas the shoulder is decorated with deformed cloud and thunder patterns.

Chunyu was a kind of ancient ritual musical instruments, which chimed when hit with a small hammer, and most of which were produced with bronze. This ware is an imitation of the original bronze type. Ritual musical instruments were often symbols of power, position, and status in ancient China.

In the Warring States period, proto-celadon ware was mostly produced in the southern part of the Yangtze River. A great amount of such ware was produced and unearthed at Jiangshan, Shaoxing, Xiaoshan, and other regions in the Zhejiang province with abundant type forms showing a comprehensive chronological development of this type of ware. Among such ware, there were pieces in imitation of bronze ritual musical instruments used by the nobles, daily utensils used by the layman, pieces in imitation of bronze weapons, agricultural tools, etc. The use of this type of ware for burial purposes was a common practice of the Yue tribe at the time and signified a distinctive cultural phenomenon.

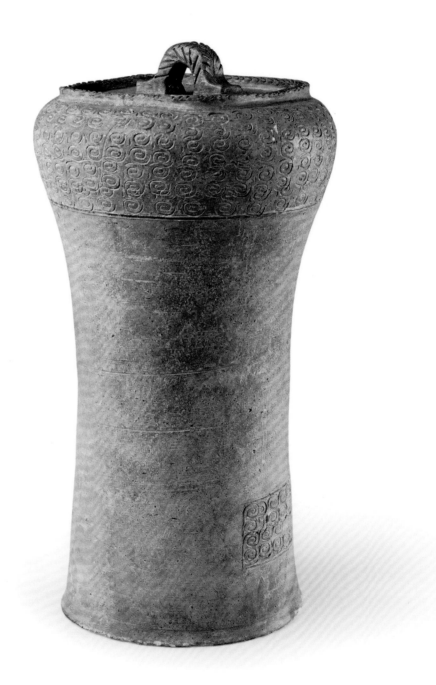

4

Vase
with two loops and carved
and incised design
of deformed phoenixes
in celadon glaze

Proto-porcelain ware
Western Han Dynasty

Height 32.6 cm
Diameter of Mouth 14.3 cm
Diameter of Foot 14 cm

The vase has a flared mouth, a narrow neck, a slanting shoulder, a globular belly, and a concave foot. On the symmetrical sides of the shoulder are two vertical loops half-rounded in shape. The shoulder, the upper part of the belly, and the interior of the vase are covered with celadon glaze with the paste exposed at the neck and the lower part of the belly. The upper and the lower parts of the neck are decorated with a border of wave patterns respectively. The shoulder and the upper part of the belly are decorated with three borders of string patterns in relief, and painted with brownish glaze. In between the first border of string patterns and wave patterns and in between the first border and the second border of string patterns are carved and incised designs of phoenixes. The lower part of the belly is decorated with carved and incised borders of string patterns.

This vase is thickly fashioned with an archaic flavour and the designs are incised and carved in a fluent manner. The rather uneven layer of celadon glaze has a yellowish tint, representing a type of transitional ware before the emergence of matured celadon ware in the Eastern Han Dynasty. Similar ware has been unearthed at the tomb sites of the Western Han Dynasty.

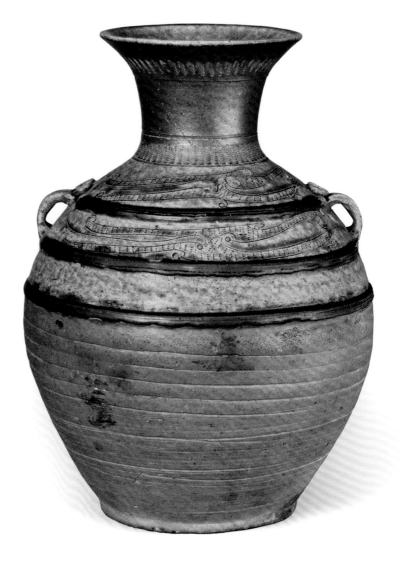

5

Vase
with a plate-shaped mouth,
two loops and carved
and incised design of
string patterns
in celadon glaze

Eastern Han Dynasty

Height 24.5 cm
Diameter of Mouth 11.5 cm
Diameter of Base 9 cm

The vase has a plate-shaped mouth, a narrow neck, a slanting shoulder, a globular belly tapering downwards, and a flat base. On the symmetrical sides of the shoulder are two vertical loops. Both the interior and exterior are covered with celadon glaze which stops above the base on the exterior wall. The neck and the shoulder are decorated with carved and incised design of wave patterns whereas the belly is decorated with carved and incised design of massive borders of string patterns.

The body of this vase is potted with even thickness, and the glaze is shiny and translucent, representing a type of ware with better quality and quantity developed from proto-porcelain ware. Scientific studies show that in various aspects, celadon ware unearthed from the Eastern Han tomb sites has reached the standards of modern porcelain ware. In this connection, celadon ware of the Eastern Han Dynasty is generally recognized as the earliest porcelain ware of China.

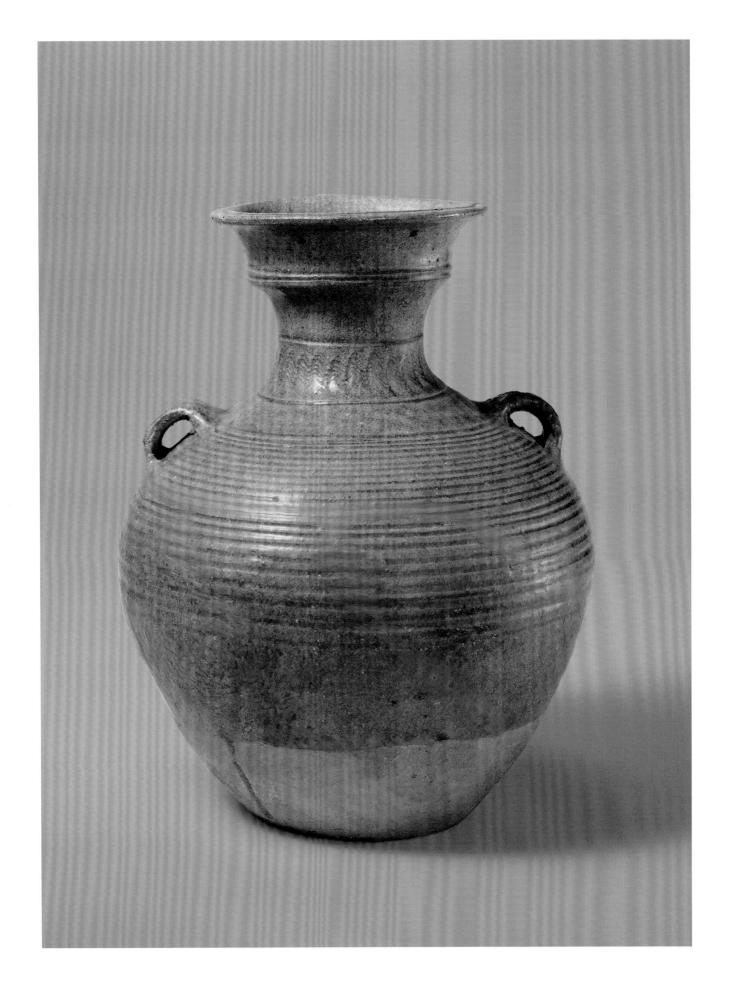

6

Jar
in the shape of a granary in celadon glaze

Three Kingdoms period
Wu Kingdom

Height 46.4 cm
Diameter of Mouth 29.1 cm
Diameter of Base 16 cm
Unearthed at a tomb of the Wu Kingdom,
Three Kingdoms period at Shaoxing,
Zhejiang in 1935

The paste of the jar has a greyish-white tint and the body is covered with an uneven layer of celadon glaze, whereas the flat base is unglazed. The upper part of the jar is sculptured with various decorations, including five conjoined jars on the top with various decorations. A mouse is climbing out from the mouth of the large jar in the middle. Surrounding the large jar are four small jars with their mouths clustered with birds seeking for food. Surrounding the five jars are various decorations of towers, gates, figures, and animals in applique. In the middle is a three-tiered high tower, and on the two sides of the lower tier are two dogs guarding the doors. On the eaves of the third tier are birds resting, mice seeking for food, etc. On each side of the high tower is a gate, beneath which are eight musicians playing music with various instruments. The lower part of the granary is fashioned in the shape of a jar, and on its shoulder is a tortoise supporting an epitaph with inscriptions which literally means "The third year of the Yongan period is noted for prosperity and wealth. It is a good for blessing nobles with progeny and long life that would be everlasting". Surrounding the tortoise are various decorations of figures, deer, pigs, tortoises, dogs, fish, and dragons with inscriptions "*fei*", "*lu*", "*ju*", "*wuzhong*", and others.

This ware was a burial object. "Yongan" was the reign of Sun Xiu, Emperor Jing of the Wu Kingdom, Three Kingdoms period, and the third year of Yongan corresponded to 260 A.D. This type of jars in the shape of a granary was derived from five conjoined jars in vogue in the Eastern Han Dynasty, and were commonly found in the tombs of the Three Kingdoms period (Wu Kingdom) and the Western Jin Dynasty, with two type forms produced with porcelain and red clay. On the other hand, these jars were never identical in terms of forms and decorations, and had no longer been found in the tombs of the Eastern Jin Dynasty, thus representing a typical repertoire of ware with period characteristics.

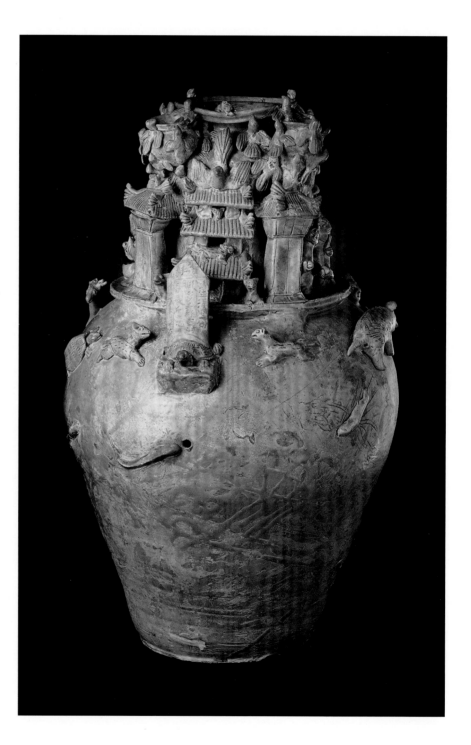

7

Equestrian Riding on a Chimera (*Pixie*)
in celadon glaze

Western Jin Dynasty

Height 25.5 cm
Length 20 cm
Width 11 cm

This piece is modeled after the form of a figure riding on a chimera and is covered with celadon glaze. The figure wears a tall hat and is looking to the front with beards incised on the face, which looks like an equestrian from West Asia. He is riding on a chimera shaped like a lion. The chimera has a fierce outlook with a wide opened mouth showing teeth and bulging eyes. Both the equestrian figure and the chimera are decorated with stamped circle patterns. The interior of the tall hat is hollow for inserting something.

It is generally agreed that celadon ware in the shape of animals of the Western Jin Dynasty for insertion purposes was candle-stands. Such type of ware was modeled in various forms, such as a goat, a chimera in the shape of a lion, and an equestrian riding on a chimera in the shape of a lion. There are only four known pieces of this type of equestrian riding on a chimera extant, and this piece is one of them. A chimera is a mythical beast in ancient Chinese mythology, which looks like a lion with wings, and ware modeled after the shape of a chimera might have the symbolic meaning of wiping away evil.

This work was produced in the Yue kiln, Zhejiang in the Western Jin Dynasty. It is a refined piece of celadon ware of the Western Jin Dynasty with a creative new form and enlivened modeling. In the Western Jin Dynasty, ceramic industry in South China flourished at a rapid pace with production scale increased, type forms more abundant, and varieties most versatile in the Six Dynasties period, and the quality was also much enhanced. Most of such ware was used as burial objects at the time.

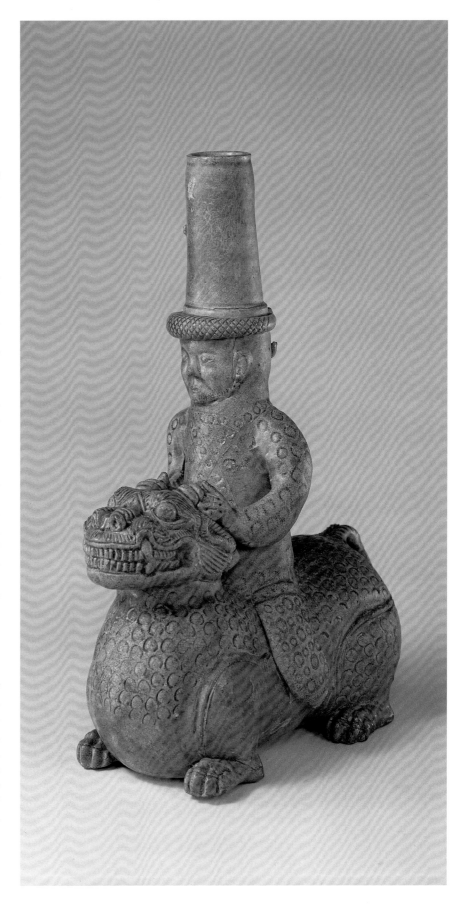

8

Ewer
with a spout in the shape of a ram's head, a plate-shaped mouth and two loops with brown spots in celadon glaze

Eastern Jin Dynasty

Height 23.8 cm
Diameter of Mouth 10.8 cm
Diameter of Base 10.8 cm

The ewer has a plate-shaped mouth, a small neck, a slanting shoulder, a globular belly, and a slightly convex flat base. On one side of the shoulder is a spout in the shape of a ram's head, and on the other side is a curved handle connecting the mouth and the shoulder. On another two symmetrical sides of the shoulder are two horizontal small semi-round shaped loops. The whole body is evenly covered with pure celadon glaze. The ram's head and the two loops are further painted with brown spots, and the shoulder is carved and incised with two borders of string patterns.

Most of the celadon ewers of the Eastern Jin Dynasty were chicken-head ewers, and the number of ram-head ewers was quite rare. Ram-head ewers like this one which was finely modeled and covered with pure and even celadon were rare and refined ware of its type. Celadon ware painted with brown spots had first appeared in the late Western Jin Dynasty and became more popular in the Eastern Jin Dynasty, showing a period characteristic of Eastern Jin celadon ware.

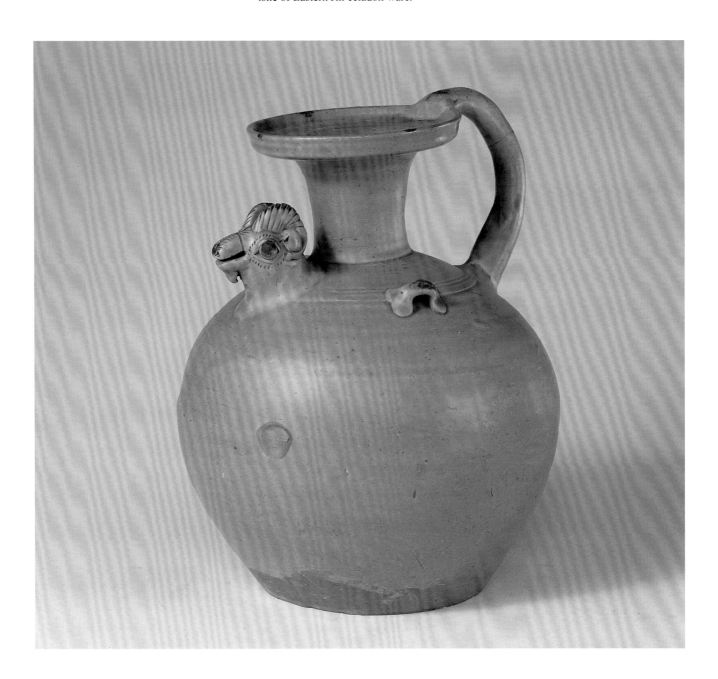

9

Zun Vase
with design of upright and
inverted lotuses
in celadon glaze

Northern Dynasties

Height 67 cm
Diameter of Mouth 19 cm
Diameter of Foot 20 cm
Unearthed at a tomb of the Northern
Dynasties at Jing county, Hebei in 1948

The vase has a flared mouth, a long neck, a globular belly, and a flared hollow high stem foot. At the joining area of the shoulder and the neck are six vertical loops twisted with twin clay strips. The body is covered with celadon glaze with glassy quality and ice-crackles. The interior of the ring foot is unglazed. The vase is decorated with eleven layers of designs. The three layers at the neck are decorated with applique designs of flying apsaras, *baoxiang* floral rosettes, and dragon medallions from top to bottom. In between the decorative borders are string patterns in relief. The belly is decorated with applique and carved designs of three layers of inverted lotus petals, two layers of upright lotus petals, and one layer of Bodhi-tree leaves. The shank is decorated with carved design of inverted lotus petals in relief.

This *zun* vase is one of the four lotus *zun* vases unearthed at the tomb sites of the *Feng* and *Zu* families at Jing county, Hebei. The vase has a large body and decorated with luxuriant and elaborated decorations with various techniques of applique, molding and carving in relief. The decorative designs of lotus petals, floral medallions, flying apsaras, and others are associated with the historical background of Buddhist culture in the Southern and Northern Dynasties. The chemical components of the paste and glaze are different from those of the celadon ware produced in Southern China, representing the typical characteristic of Northern celadon ware and a refined example of Northern celadon ware.

The lotus *zun* vase was a kind of burial objects with Buddhist attributes. It was popularly produced from the mid-Southern and Northern Dynasties to the early Sui Dynasty, corresponding to over 100 years of the mid-fifth century to the late sixth century. The late Northern and Southern Dynasties period was the blooming period of such type of ware, which was commonly unearthed at various regions in South and North China.

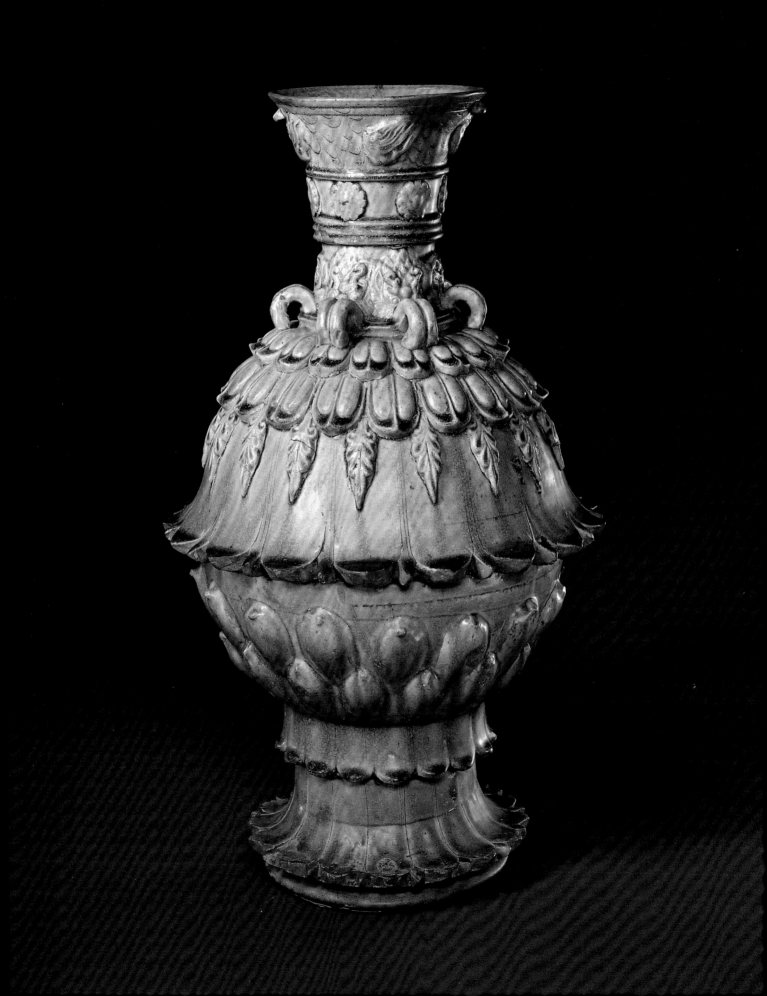

10

Ewer
with a single handle
and carved and incised floral
designs in celadon glaze

Southern Dynasties

Height 21.3 cm
Diameter of Mouth 11 cm
Diameter of Foot 12.4 cm

The ewer has a round mouth with an everted rim, a short neck, a slanting shoulder, a globular belly, and a cake-shaped solid foot. On two symmetrical sides of the shoulder are two vertical loops, and on the other two sides is a tubular short spout and a curved handle respectively. The interior and exterior of the ewer are covered with celadon glaze with transparent and glassy quality and ice-crackles. The body is decorated with three layers of designs, including upright and inverted lotus petals at the shoulder and the lower belly, and acanthus patterns at the globular belly. The decorative designs are separated by borders of string patterns.

Since its introduction into China in the Eastern Han Dynasty, Buddhism had greatly flourished in the Southern and Northern Dynasties, and the trend was also reflected in the production of ceramics. In this period, Buddhist decorative designs such as lotus flowers, lotus petals, acanthus patterns, and others were very popular, showing a distinctive decorative style of the period.

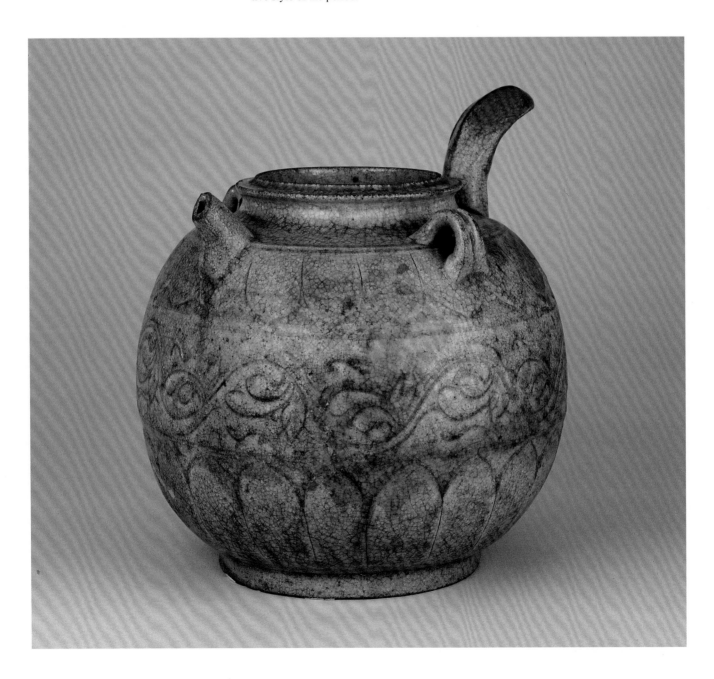

11

Vase
with a plate-shaped mouth,
four loops and carved
and incised design of lotus
petals in celadon glaze

Sui Dynasty

Height 43 cm
Diameter of Mouth 15 cm
Diameter 13.5 cm

The vase has a plate-shaped mouth, a short neck, a slanting shoulder, a globular belly tapering downwards, and is flared near the flat base. The shoulder has four vertical loops twisted with twin clay strips. The body is layered with white slip and is then covered with celadon glaze which stops above the base. On the surface of the glaze are small ice-crackles. The body is decorated with incised and molded floral designs. The neck and the shoulder are decorated with incised and molded design of circles. The upper part of the shoulder is decorated with inverted lotus petals, whereas the lower part is decorated with acanthus patterns. Both the upper and the lower parts of the belly are decorated with inverted lotus petals, whereas the middle part is decorated with acanthus patterns. Each layer of decorations is separated by a border of string patterns.

This type of vases with a plate-shaped mouth and four loops in celadon have been found in the site of the Huainan kiln, Anhui, as well as tomb sites of the Sui Dynasty in Anhui, which shows that this vase should have been produced in the Huainan kiln at Anhui in the Sui Dynasty.

In mixing grinded pottery clay or porcelain clay with water to turn it to thick liquid, and then applying it on the pottery paste or porcelain, the surface of the ware would have a thin layer of clay liquid in colours of white, red, or grey. In terms of technical production, this layer is known as "pottery coat", slip, or biscuit-protection glaze, which is a kind of decorative method on porcelain ware.

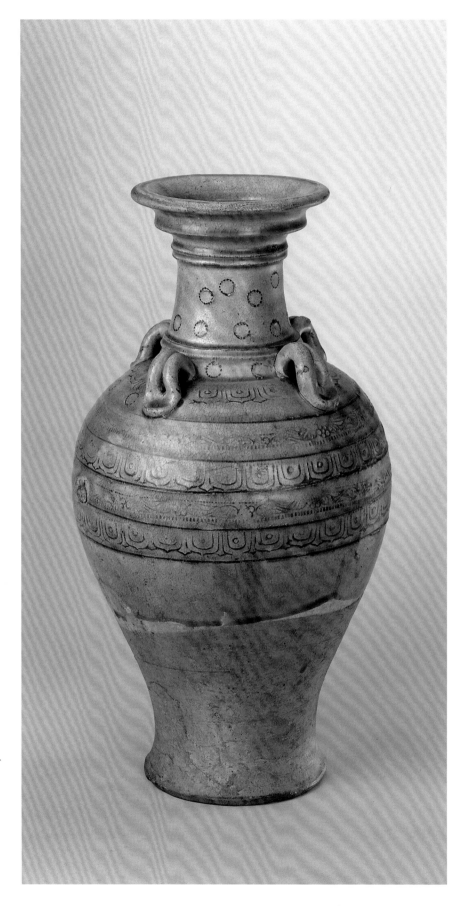

12

Ewer
with a phoenix-head and a
dragon-shaped handle
in celadon glaze

Tang Dynasty

Overall Height 41.3 cm
Length of Spout 9.3 cm
Diameter of Foot 10.2 cm

The ewer has a flared mouth, a short neck, a slanting shoulder, an oval belly, and a ring foot. The cover fits the mouth to form a phoenix-head so that the whole ewer looks like a standing phoenix. The handle is fashioned in the shape of a standing dragon with its mouth holding the mouth rim of the ewer, whereas its front legs stretch on the shoulder and the hind legs standing on the trumpet-shaped base. The body is covered with celadon glaze with small ice-crackles. The ewer is further decorated with applique and incised and carved designs. On the upper belly are six round panels encircled by bead chains, in which are applique figures of lokapalas with different postures. The lower belly is decorated with six *baoxiang* floral rosettes. The mouth rim, the neck, the shoulder, and the leg are decorated with bead chains, lotus petals, foliage scrolls, descending leaf patterns, and others, which are separated by borders of string patterns.

The paste of this ewer is thickly potted and the glaze is also thick with strong glassy quality, showing the characteristics of the Northern celadon ware produced since the Northern Dynasties. The luxuriant and sophisticated designs exude a strong exotic flavour. From the Six Dynasties period to the Tang Dynasty, the communication between China and various countries in the Western Territories had much intensified. At the time a type of metal ewer with cover in the shape of a bird-head was introduced into China from Central Asia and West Asia, and thus brought about the emergence of this new type of ceramic phoenix-head ewers. This piece belongs to one of the most refined pieces, and it reveals a blending of the stylistic features of the gold and silver ware of the Sassanid Empire (226 – 642 A.D.) and the traditional motifs of dragons and phoenixes of China. With the luxuriant decorations rendered in applique, molding, incising, and carving techniques, this ware fully illustrates the consummate technical skills of the potters in the Tang Dynasty.

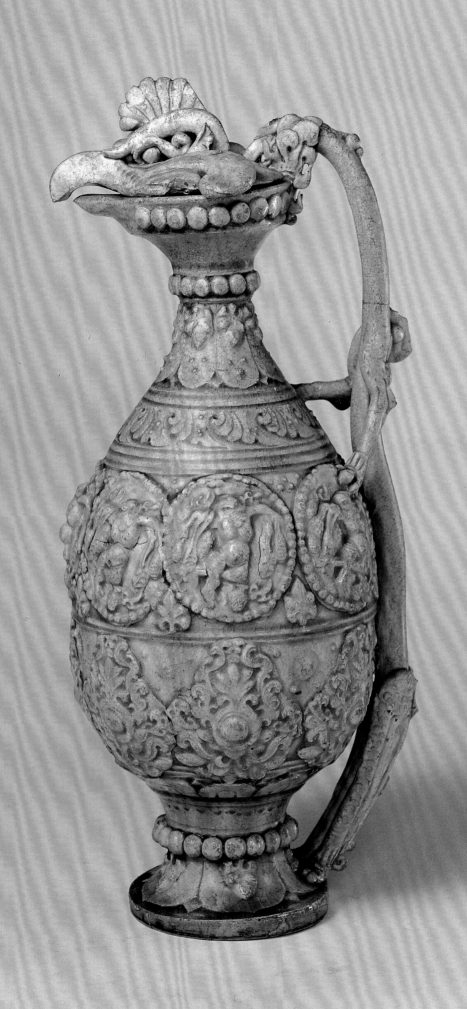

13

Eight-lobed Vase
in *mise* (secret colour)
olive green celadon glaze

Yue ware
Tang Dynasty

Height 22.5 cm
Diameter of Mouth 1.7 cm
Diameter of Foot 7.2 cm

The eight-lobed vase has a small mouth, a narrow long neck, a sphere-shaped belly, and a ring foot. The refined paste has a greyish-white tint. The body is covered with thin and even celadon glaze. At the area between the neck and shoulder are three borders of string patterns in relief. A character *qi* (seven) is incised at the base of the foot.

If knocked by a finger, the vase will give a clear sound, which shows that when compared with the common celadon ware produced by the Yue kiln, this type of ware has a genuine porcelain quality. In 1987, an eight-lobed vase with the form, size, and glaze colour similar to this vase was unearthed at the underground cellar of the site of the pagoda of the Tang Dynasty at Famen Monastery, Fufeng, Shaanxi. In the 1950s, shards of this type of eight-lobed vases in olive green celadon glaze were unearthed at the site of the Yue kiln of the late Tang period.

The Yue kiln was the most famous kiln for producing celadon ware, and it was also known as the "*mise*" (secret colour) kiln. The Yue kiln got its name as it was located at the region of the Yuezhou (the area near the Shanglin Lake, Cixi, Zhejiang). In the historical records of the late Tang, the Five Dynasties, and the Song Dynasty, the term "*mise*" porcelain ware was frequently found. Such a term *mise* for describing Yue ware had first appeared in a poem *Mise Yueqi* (Yue ware in *mise* glaze) written by the Tang poet Lu Guimeng (? – ca. 881), which described it as "The Yue kiln fired ware in the time of breeze and dew in autumn, and had produced ware with the colour of jade like the thousand green peaks".

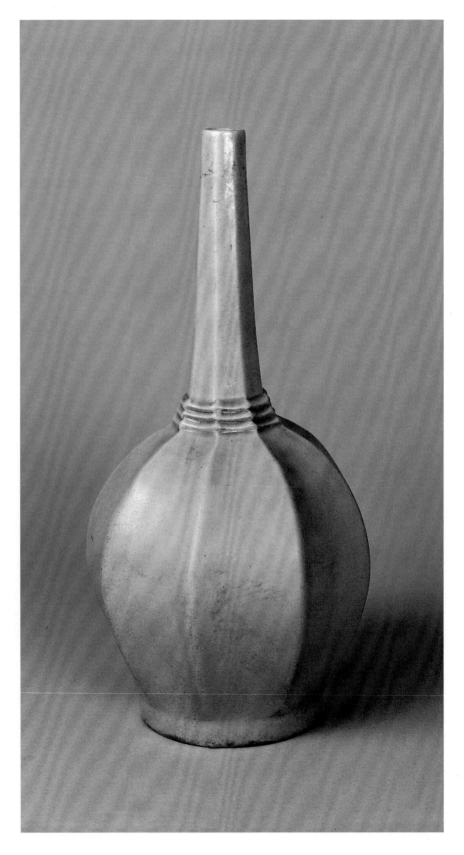

14

Ewer
in celadon glaze

Yue ware
Tang Dynasty

Height 13.4 cm
Diameter of Mouth 5.9 cm
Diameter of Foot 7.3 cm
Unearthed at a tomb of the Tang Dynasty
at Shaoxing, Zhejiang in 1936

The ewer has a flared mouth, a narrow neck, a slanting shoulder, a globular belly, and a shallow ring foot. The technique of firing the ware with the leg wrapped and supported by nails is used, and five spur marks are found on the ring foot. On the two symmetrical sides of the neck are an eight-lobed short spout and a curved handle. The body is covered with translucent and shiny celadon glaze with a yellowish tint and small ice-crackles in the interior and on the exterior.

In the Tang Dynasty, this type of vessels with a spout and a handle was known as "ewer". There were two pieces of these ewers unearthed at the tomb of the wife of Wang Fujun (Shuwen), Beihai, vice-president of the Board of Revenue of the Tang Dynasty, at Shaoxing, Zhejiang in 1936. On an epitaph brick in the tomb, the inscription "The fifth year of the Yuanhe period (810 A.D.)" was found, proving the date of this ewer. It was used by the family members of an official of the fourth grade. It represents the production level of *mise* olive green celadon glaze of the Yue kiln in the early ninth century, and it has also provided a standard example for dating Yue *mise* olive green celadon ware.

15

Ewer
in celadon glaze

Yue ware
Five Dynasties

Height 19.7 cm
Diameter of Mouth 9.7 cm
Diameter of Foot 7.6 cm
Qing court collection

The ewer has a flared mouth, a short neck, a slanting belly, a long and round five-lobed belly in the shape of a melon, and a shallow ring foot. On one side of the ewer is a curved spout, and on the other side is a curved handle in between the area of the mouth and shoulder. On the two symmetrical sides of the shoulder are two vertical loops. The body is covered with celadon glaze with small ice-crackles. At the end of the spout the glaze is condensed with flambé effect.

Compared with ewers of the Tang Dynasty, ewers of the Five Dynasties are produced with more rational proportions with the spout elongated for better functional use, as shown by this example.

16

Covered Box
with carved and incised design of a lotus in celadon glaze

Yue ware
Five Dynasties to
Northern Song Dynasty

Height 4.8 cm

Diameter of Mouth 8.8 cm
Diameter of Foot 5.4 cm

The box has a round mouth and a deep curved belly linking to the flared high ring foot. The slanting side of the cover is narrow and straight with a slightly bulging top. The upper and the lower parts of the box are fitted with interlocking rims. The paste has a greyish-white tint, and both the interior and the exterior of the box are covered with celadon glaze with a yellowish tint. The mouth rims and the interior of the cover are unglazed. The surface of the cover is decorated with design of a lotus seed pod and lotus seeds surrounded by lotus petals carved in relief. The body of the box is decorated with a border of carved and incised string patterns.

Boxes of various shapes represent a common type form of Yue celadon ware. Types of small boxes with a diameter of around 10 cm were medicine boxes, spices boxes, or cosmetic boxes. In the production process, ware with a high foot was not stable and could not be supported well during firing. However, a lot of ware with a high ring foot was found among the ceramic ware of the Tang Dynasty and Five Dynasties, as such ware generally copied the type forms of gold and silver ware.

The standard colour of celadon Yue ware should be green. However, most of the Yue ware of the Tang Dynasty and Five Dynasties often carried a greyish-green or yellowish-green tint. The reason was due to the difference in firing temperatures and atmospheres (yellow glaze was fired in oxidized flame, whereas celadon glaze was fired in reduction flame), and such a phenomenon showed that potters of the time had not fully mastered the control of different firing atmospheres.

17

Covered Jar
with flanged ears in celadon glaze

Five Dynasties

Overall Height 18.6 cm
Diameter of Mouth 7.2 cm
Diameter of Foot 8.2 cm
Unearthed at a tomb of the Southern Han
period at Panyu, Guangdong in 1954

The jar has an upright mouth, a wide shoulder tapering downwards, and a ring foot. On the shoulder is a symmetrical pair of square loops with holes. It has a round concave cover with an upright mouth. The interior and exterior of the jar are covered with celadon glaze with small ice-crackles on the surface. A distinctive feature of this jar is that there are two symmetrical long bolts with holes on the two sides of the cover. When the cover is fitted to the mouth of the jar, these two bolts would be inserted into the two loops respectively on the shoulder for fastening strings or inserting a blot to lock the cover and the jar.

This jar was one of the four covered jars with flanged ears unearthed at a tomb site at the Southern Han period (917 – 971 A.D.) at Shima village, Panyu, Guangdong in 1954. Southern Han Kingdom was a provincial state in the Guangdong in the Five Dynasties and Ten Kingdoms period. Covered jars with ears similar to this jar were rather popular in the Jiangnan region in the Five Dynasties. They were represented by the ware produced in the Yue kiln in Zhejiang and Changsha kiln in Hunan, used as burial objects in the tombs of the Five Dynasties in Changsha.

18

Three-legged *Zun* Jar
with design of string patterns
in sky blue celadon glaze

Ru ware
Northern Song Dynasty

Height 12.9 cm
Diameter of Mouth 18 cm
Distance between Legs 17.8 cm
Qing court collection

The jar is imitated after the bronze *zun* container of the Han Dynasty. It has an upright mouth, a tubular belly, a flat base, and is supported by three animal-shaped legs. The interior and exterior are covered with translucent light sky blue celadon glaze with small ice-crackles. The exterior base has five small spur marks in the size of sesame seeds. The exterior side is decorated with two borders of string patterns in relief near the mouth rim and the foot respectively. The belly is decorated with three borders of string patterns in relief.

Three-legged *zun* jar is a famous type form of Ru ware. Only two pieces are extant and the quality of this one is even better than the other one. Ru kiln was one of the five major kilns of the Song Dynasty and was located at the present Baofeng county, Henan. In the Song Dynasty, Baofeng county was under the jurisdiction of Ruzhou and thus came the name Ru kiln. The production of celadon ware in the Ru kiln was noted for its exquisite craftsmanship, in particular the quality of the glaze which had layers of ice-crackles with a naturalistic and graceful charm, reflecting the pursuit of subtleness and lyricism of the Song literati class. Among many types of the ware produced in the Northern Song Dynasty, Ru ware had been chosen for imperial use, and this was much associated with the aesthetic taste of Zhao Ji, Emperor Huizong of the Northern Song Dynasty.

19

Supporting Plate
for the three-legged *Zun* jar
in sky blue celadon glaze

Ru ware
Northern Song Dynasty

Height 3.6 cm
Diameter of Mouth 18.3 cm
Distance between Legs 16.7 cm
Qing court collection

The plate has an upright mouth, a flat base, and three animal-shaped legs. The body is covered with light sky blue celadon glaze with ice-crackles on the surface. The exterior base has five small spur marks and is inscribed with an imperial poem written by Emperor Qianlong of the Qing Dynasty. At the end of poem is an inscription of "imperial inscription in the summer of the year *wuxu* of the Qianlong period" and a seal mark "*dechongfu*". The *wuxu* year corresponded to the 43rd year of the Qianlong period (1778).

This ware is the only extant ware of its type. In the past, it was known as "three-legged washer" or "three-legged plate". Yet with reference to the excavated proto-type bronze *zun* containers which were often accompanied by supporting plates to form complete sets in the Han Dynasty, this piece should be renamed "supporting plate for the three-legged *zun* jar, Ru ware" and used together with the three-legged *zun* jar illustrated at Plate 18.

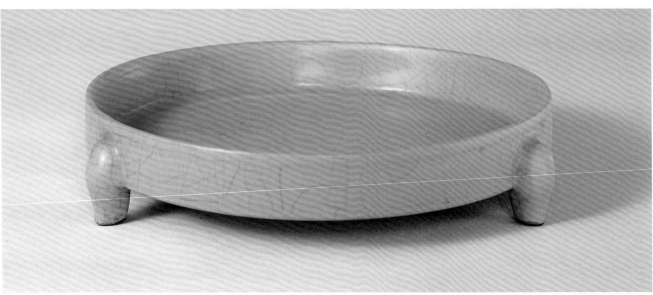

20

Bowl
in sky blue celadon glaze

Ru ware
Northern Song Dynasty

Height 6.7 cm
Diameter of Mouth 17.1 cm
Diameter of Foot 7.7 cm
Qing court collection

The bowl has a flared mouth, a deep curved belly, and a slightly flared ring foot. The thin paste is finely potted and the body is covered with translucent and shiny light sky blue celadon glaze with small ice-crackles on the surface. The exterior base has five small spur marks in the size of sesame seeds and is inscribed with an imperial poem written by Emperor Qianlong of the Qing Dynasty. At the end of poem is an inscription "Imperial inscription in mid-spring of the *dingyou* year of Qianlong" and seal marks "*guxiang*" and "*taipu*". The dating "mid-spring of the *dingyou* year of Qianlong" corresponded to the second month of the 42nd year of Qianlong (1777).

Only two pieces of Ru bowls of the Song Dynasty are extant nowadays with similar sizes and this piece is one of them.

21

Round Washer
in sky blue celadon glaze

Ru ware
Song Dynasty

Height 3.3 cm
Diameter of Mouth 13 cm
Diameter of Foot 8.9 cm
Qing court collection

The washer has a wide mouth, a curved belly, and a slightly flared ring foot. The body is covered with shiny and translucent light sky blue celadon glaze with small ice-crackles. The exterior base has three small spur marks in the size of sesame seeds and is inscribed with a character "*yi*".

The character "*yi*" was inscribed by the Imperial Workshop of the Department of Imperial Household in the Qianlong period. Emperor Qianlong classified the antiques he favoured into different grades with the marks of "*jia*" (first grade), "*yi*" (second grade), "*bing*" (third grade), etc. for differentiation.

It was recorded in historical documents that agate powder was added to the glaze of the Ru ware. The chemical component of agate is SiO2. However, the chemical component of the glaze is also SiO2, and therefore the adding of agate powder would not much affect the quality of glaze. Various features such as "ice-crackles", "pastes with incense ash grey colour", and "spur marks in the size of sesame seeds" are important criteria for the authentication of Ru ware.

22

Plate
in imitation of Ru ware in celadon glaze

Ming Dynasty Xuande period

Height 4.2 cm
Diameter of Mouth 17.6 cm
Diameter of Foot 11 cm
Qing court collection

The plate has a flared mouth, a curved wall, and a ring foot. The body is covered with glaze in imitation of Ru celadon glaze. The glaze colour is greyish-green with a bluish tint and small ice-crackles. When examined sideways against light, it is found the orange-peel marks appear on the glaze surface. The exterior base is written with a six-character mark of Xuande in regular script in two columns within a double-line medallion in underglaze blue.

Ware in imitation of Ru celadon glaze was only produced in the Xuande Imperial Kiln in the Ming Dynasty with more focus on imitating the glaze colour rather than the forms of the ware, thus there were few pieces that could be mistaken as genuine Ru ware. On this plate, only the glaze colour is imitated from the Ru celadon glaze, and the form and inscriptions of this ware all belong to the style of the Xuande period. Similar examples have been unearthed at the Imperial Kiln site of the Xuande period, Ming Dynasty at Zhushan, Jingdezhen.

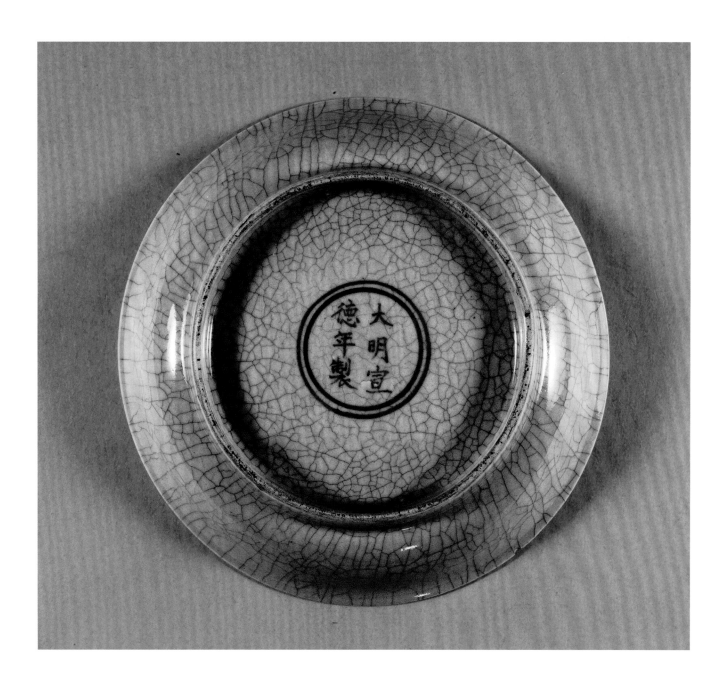

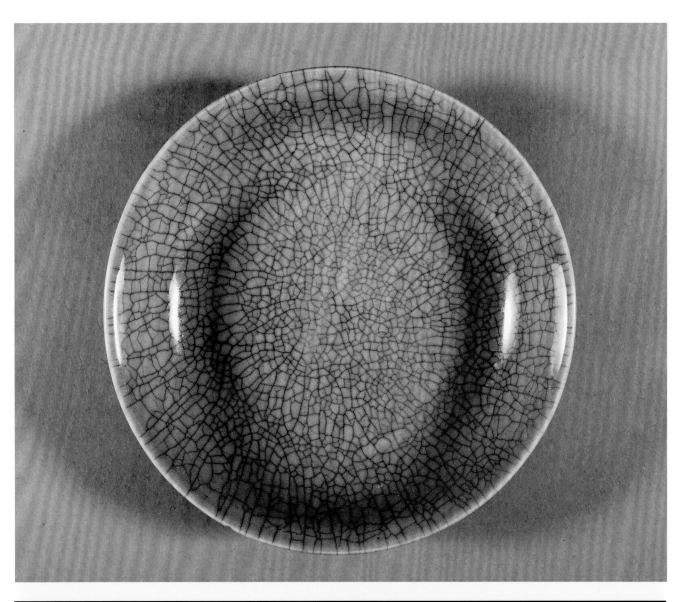

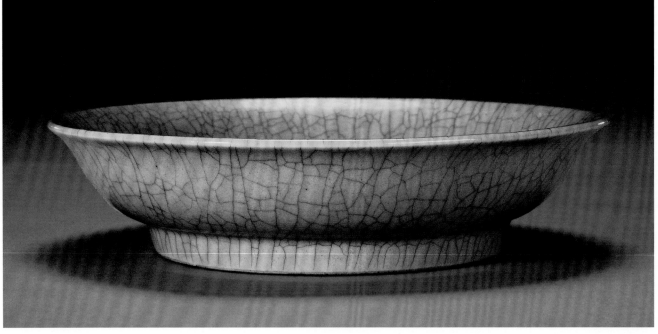

23

Gu Vase
in imitation of Ru ware
in celadon glaze

Qing Dynasty Yongzheng period

Height 25.2 cm
Diameter of Mouth 19.5 cm
Diameter of Foot 9.4 cm
Qing court collection

The vase has a flared mouth, a long neck, a long round belly with two contracted sections at the upper and lower parts, and a shallow flared ring foot. The body is covered with light sky blue celadon glaze in imitation of Ru celadon glaze with small ice-crackles. The exterior base is written with a six-character mark of Yongzheng in seal script in three columns in underglaze blue.

Among the imitated Ru celadon glazed ware of the Ming and Qing dynasties, the most successful examples came from the Imperial ware produced in the Jingdezhen Imperial Kiln of the Yongzheng period. However, there were still differences from the originals. Most of the Ru celadon glaze colours of the Northern Song Dynasty were not so transparent. The glaze was thick and translucent but not very shiny, whereas the Yongzheng imitations had strong glassy quality with shiny and brilliant appearance.

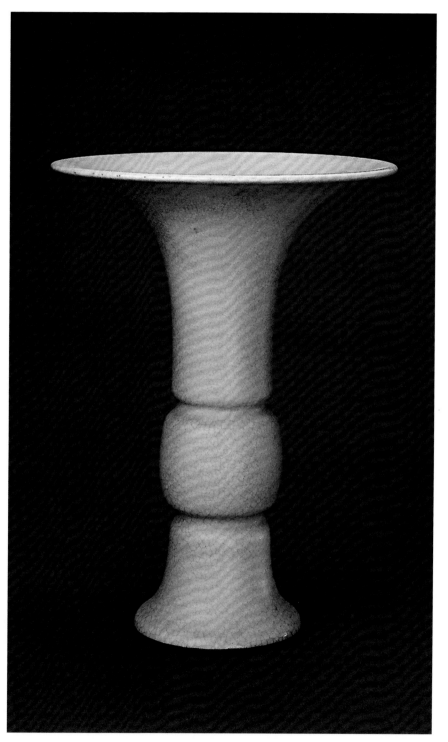

24

Alms Bowl
in imitation of Ru ware
in celadon glaze

Qing Dynasty Yongzheng period

Height 21.5 cm
Diameter of Mouth 26 cm
Diameter of Foot 15.8 cm
Qing court collection

The large bowl has a contracted mouth, a deep curved belly, and a shallow ring foot. It is matched with a stand with glaze simulating wood texture to form a set. The body is covered with sky blue celadon glaze with small ice-crackles in imitation of Ru celadon glaze. The exterior base is written with a six-character mark of Yongzheng in seal script in three columns in underglaze blue.

This alms bowl represents a new form produced in the Yongzheng period. The bowl and the stand are fired together to form a whole piece, and the stand is covered with glaze simulating wood textures in a naturalistic manner which matches harmoniously with the colour of Ru celadon glaze.

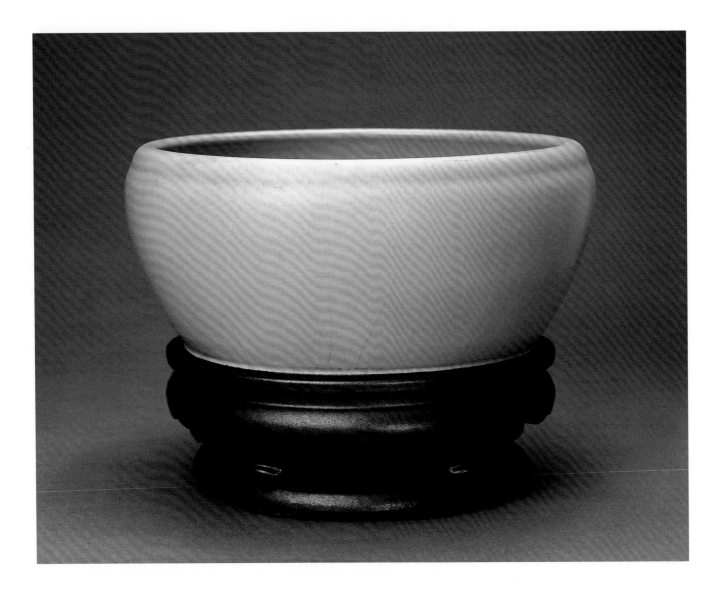

25

Round Washer
in imitation of Ru ware
in celadon glaze

Qing Dynasty Qianlong period

Height 5 cm
Diameter of Mouth 16.7 cm
Diameter of Base 13 cm

The washer has a round mouth, a shallow curved wall, and a flat base. The body is covered with greenish-grey celadon glaze with small ice-crackles in imitation of Ru celadon glaze.

A washer was a popular functional ware in the ancient time. It could be used for washing purposes, as a stationery item or as a decorative object. This washer in celadon glaze in imitation of Ru celadon glazed ware has captured the essence of the originals.

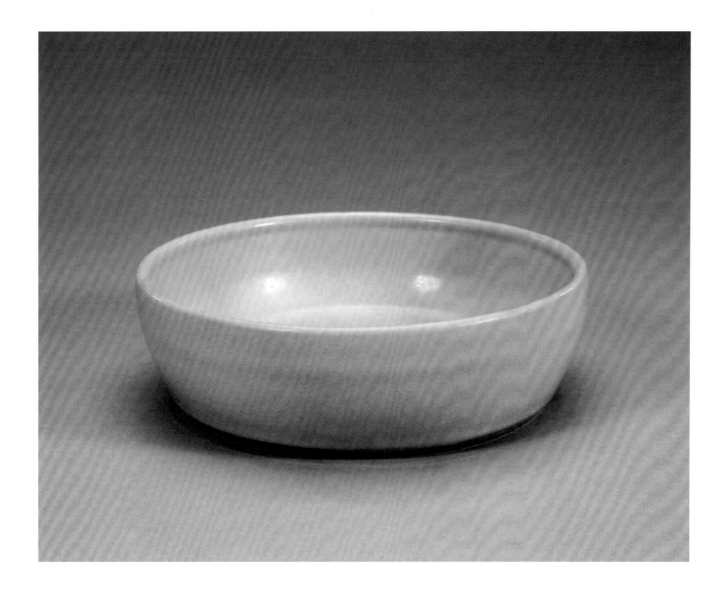

26

Washer
in the shape of a peach in
imitation of Ru ware
in celadon glaze

Qing Dynasty Qianlong period

Height 5.1 cm
Overall Length 16 cm
Overall Width 12.5 cm

The washer has a contracted mouth, a
shallow curved belly, and a flat base. It is
fashioned in the shape of a peach cut into
half, and the mouth rim is further decorated
with a small peach and a few leaves. The
body is covered with greenish-grey celadon
glaze with small ice-crackles in imitation
of Ru celadon glaze. The exterior base
is written with a six-character mark of
Qianlong in seal script in three columns in
underglaze blue.

Brush-washers were popularly produced
in the Song Dynasty. The Ru kiln, Guan kiln,
Longquan kiln, Yaozhou kiln, and others
had produced various types of washers. This
washer in celadon glaze in imitation of Ru
celadon glaze of the Northern Song Dynasty
is fashioned with a distinctive and creative
form.

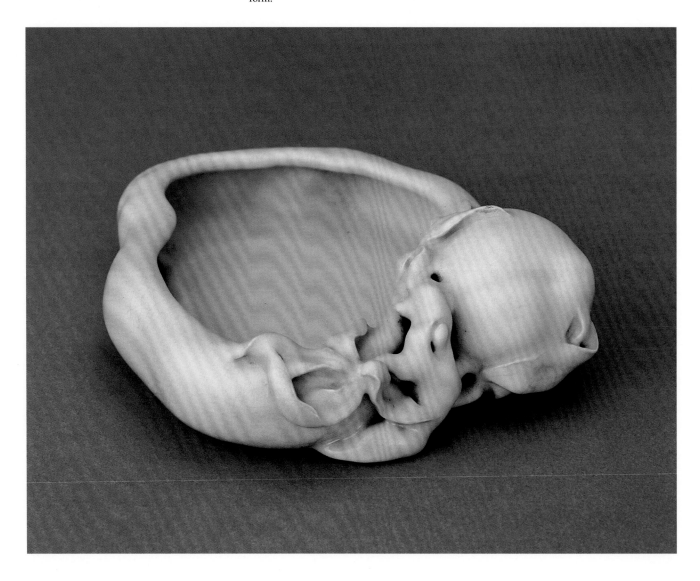

27

Vase
in light greenish-blue celadon glaze

Guan ware
Song Dynasty

Height 34.5 cm
Diameter of Mouth 9.9 cm
Diameter of Foot 14 cm
Qing court collection

The vase is in imitation of the bronze *Hu* vase of the Spring and Autumn period. It has an upright mouth, a long neck, a hanging belly, and a ring foot. The body is covered with thick greenish-blue celadon glaze in light colour which resembles the quality and elegance of jade ware. Ice-crackles in different sizes appear on the glaze surface. Underneath the mouth rim is a border of string patterns in relief.

This vase is fashioned with an archaic flavour. The ice-crackles appear like wave patterns with a touch of naturalism and gracefulness. It is a rare large vessel among the extant Guan ware of the Song Dynasty. The paste of Guan ware of the Song Dynasty was usually deeper in colour and covered with a thick layer of glaze. During baking or firing when the temperature increased, the glaze layer at the mouth rim would melt and become thin, exposing the purplish-brown colour of the paste. As the ware was fired by piling up in layers, in order to avoid the glaze and supporting cake sticking together, the glaze at the base would be scraped away, thus exposing the iron-black paste. These features were collectively known as "purple mouth and iron foot" found on Guan ware.

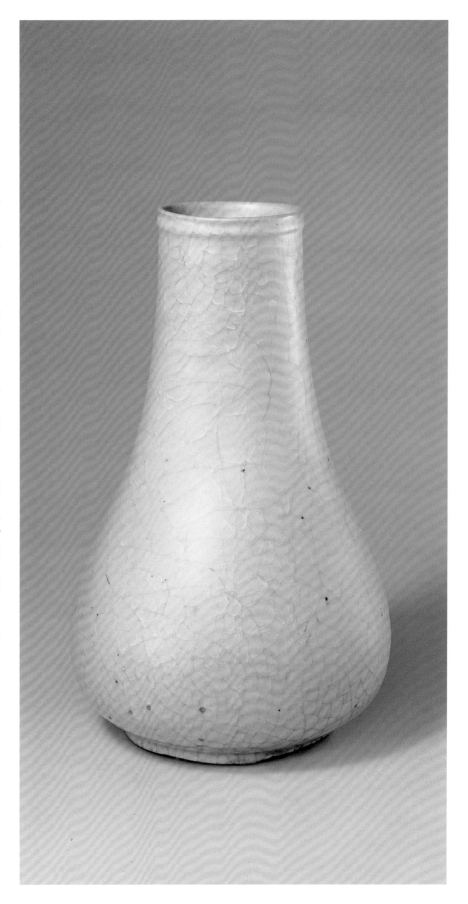

28

Vase
with design of string
patterns in light
greenish-blue celadon glaze

Guan ware
Song Dynasty

Height 33.6 cm
Diameter of Mouth 9.9 cm
Diameter of Foot 14.2 cm
Qing court collection

The vase is fashioned in the shape of bronze ware of the Han Dynasty with a washer-shaped mouth, a long neck, a slanting shoulder, a round belly, and a ring foot. On each of the two sides of the ring foot is a rectangular hole for fastening strings for carrying purposes. The body is covered with a thick layer of greenish-blue celadon glaze with large ice-crackles. The feature of "purple mouth and iron foot" is found. The neck, the shoulder, and the belly are decorated with seven borders of string patterns in relief.

This vase is a refined representative Guan ware of the Song Dynasty. Generally speaking, the Guan kiln referred to the kilns under the central or provincial government, which produced ware for use by the court or government offices. Yet the term could be narrowed down and referred to the Guan kilns under the central government, including the Guan kiln at Bianjing of the Northern Song Dynasty and the Xiuneisi Guan kiln and Jiaotanxia Guan kiln of the Southern Song Dynasty. Most of the Guan ware of the Song Dynasty covered with thick layers of glaze in greenish-blue colour was regarded as superior, and there were also colours in greenish-grey, greenish-yellow, etc. The glaze had a jade-like quality and the ware was usually not decorated in order to show the elegance of glaze colours. In addition to plates, bowls, washers, and other daily utensils, ceremonial and decorative objects with archaic forms were also produced. This was closely associated with the favour of archaism in the Song Dynasty, and the practice of using porcelain ware as sacrificial vessels in the Southern Song Dynasty.

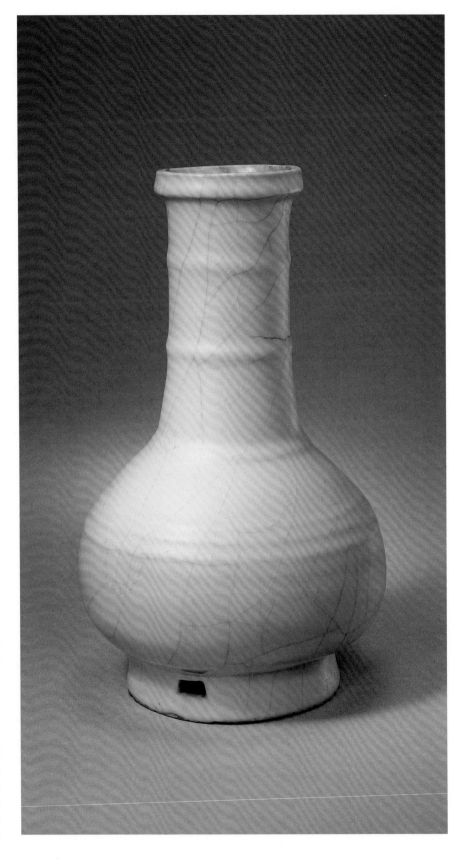

29

Foliated Washer
in the shape of a hollyhock in greenish-blue celadon glaze

Guan ware
Song Dynasty

Height 2.8 cm
Diameter of Mouth 14.6 cm
Diameter of Foot 8.8 cm
Qing court collection

The washer is fashioned in the shape of a hollyhock with six petals. It has a wide mouth, a foliated rim, a slanting belly, and a ring foot. The body is covered with thick greenish-blue celadon glaze with the glaze layer thinner at the mouth rim and the lobed areas, and the greyish-black paste is visible under the glaze. Rather large-sized ice-crackles spread over the body.

This washer is finely potted with petals fashioned evenly, and the mouth rim is also finely polished. In the Tang and Song dynasties, daily utensils such as bowls, plates, washers, and others were often modeled after the shapes of the water chestnut, the hollyhock, and other types of flowers with refreshing charm and creative forms, which were also quite similar to the forms of gold and silver ware in vogue in the periods.

Most of the Guan ware is covered with celadon glaze which bears ice-crackles in golden colour in different sizes and spaces. The book *Zunsheng Bajian* terms such a colour "eel-blood red". Ice-crackles would appear accidently during the firing process under two conditions. One condition is that during firing, the clay expands and spreads in a designated direction and leads to the change of the order of molecules. The second condition is that the expansion coefficients of the paste and glaze are different. After baking and during the cooling down process, the glaze layer contracts and cracks, thus crackles would appear. This is actually a defect of glaze; however, ice-crackles have been attributed as a kind of decorations instead. On the glaze surface of the Ru ware, Guan ware, and Ge ware, ice-crackles are often found and they are given various terms such as "ice-breaking crackles", "crab claw crackles", "ox-hair crackles", etc.

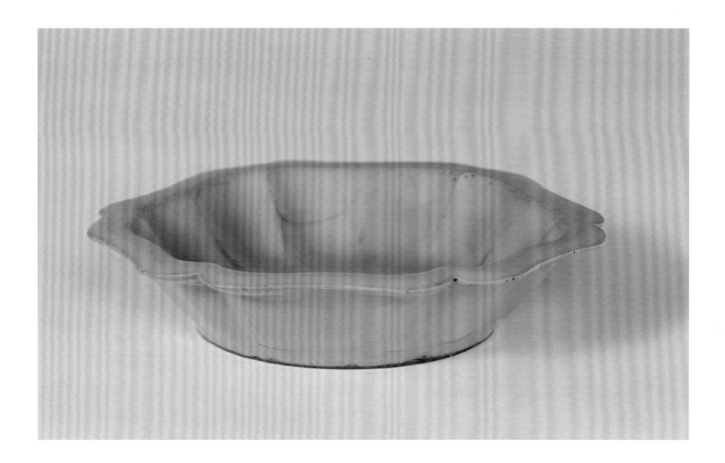

30

Round Washer
in greenish-blue
celadon glaze

Guan ware
Song Dynasty

Height 6.6 cm
Diameter of Mouth 22.6 cm
Diameter of Foot 19 cm

The washer has a wide mouth, a slanting straight wall, and a flat inner base linking to a wide and low ring foot underneath. The body is covered with translucent and pure greenish-blue celadon glaze. The side of the base of the ring foot is unglazed, exposing the paste. The surface is distributed with large ice-crackles which look like interweaving gold threads, and separated by layers of small ice-crackles. The exterior base is inscribed with a poem by Emperor Qianlong, at the end of which is inscribed "*Qianlong yuti*" with two square seal marks "*bazhengmaonian*" and "*ziqiangbuxi*". The poem was written in the *guichou* year of the Qianlong period, which was the 58th year (1793) of the Qianlong period. From the content of the poem, it is known that Emperor Qianlong had believed that the washer was produced by the Xiuneisi Guan kiln of the Song Dynasty.

This washer was for the use of the Song court. The form and decorations are exquisite, and the glaze colour and the shapes of ice-crackles in particular are among the best of the Guan ware of the Song Dynasty.

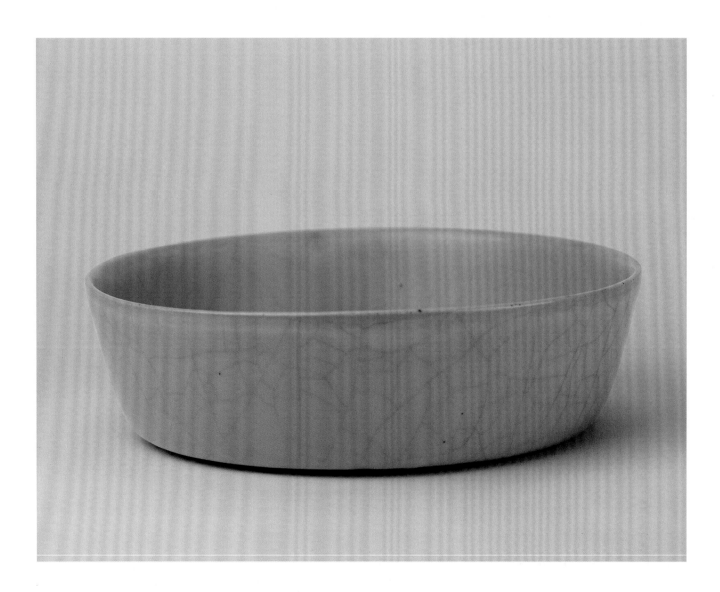

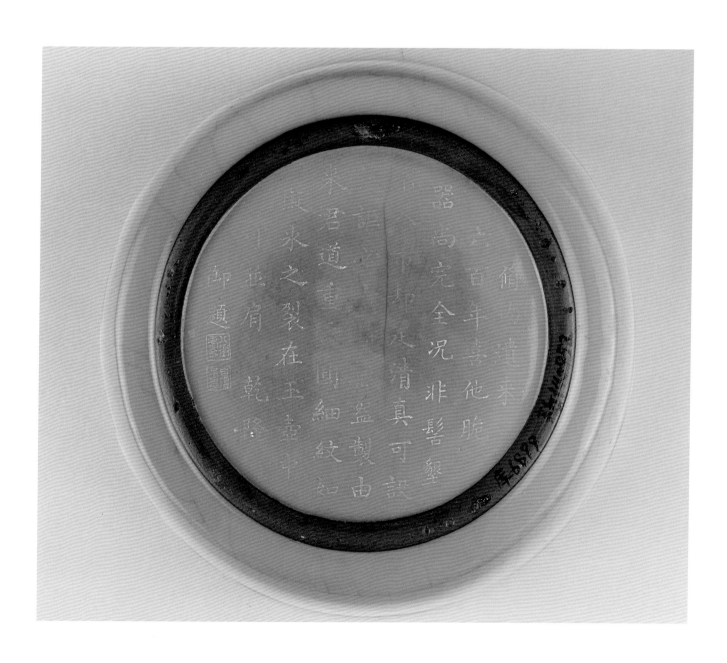

31

Cong Vase
in imitation of Guan ware in celadon glaze

Ming Dynasty

Height 33 cm
Diameter of Mouth 7.9 cm
Diameter of Foot 13 cm
Qing court collection

The vase is modeled after the shape of a jade *cong* with a small mouth, a square belly, and a ring foot. The square interior of the vase is hollow, and a triangular clay slab is added to each of the corners to strengthen the stability of the vase. The body is covered with greyish-green celadon glaze in imitation of Guan celadon glaze. The surface of the thick glaze has small yellowish-brown ice-crackles, and massive bubbles are found in the glaze. The foot rim is unglazed, exposing the brownish paste.

In the early Ming Dynasty, the court had collected a lot of Ru, Guan, and Ge ware, and the Imperial Kiln in Jingdezhen was ordered by the court to produce imitations of such ware. With reference to extant and unearthed ware, it was recorded that ware in imitation of Ru celadon glazed ware was only produced in the Xuande period, whereas ware in imitation of Ge celadon glazed ware was first produced in the Xuande period and continued afterwards, and ware in imitation of Guan celadon glazed ware was first produced in the Chenghua period and continued afterwards. Broken ware of the Chenghua period in imitation of Guan celadon glazed ware has been unearthed at the site of the Imperial Kiln in Jingdezhen, but no extant ware in perfect condition with a reign mark of the period is known. The Palace Museum has collected a lot of ware of the Ming Dynasty in imitation of Guan celadon glazed ware, all of which is without reign marks.

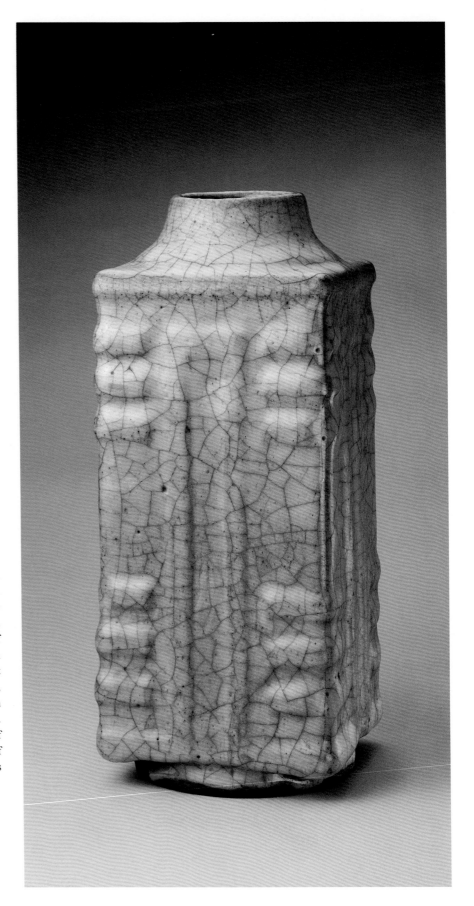

32

Square Vase
with tubular ears in imitation of Guan ware in celadon glaze

Ming Dynasty

Height 40.5 cm
Diameter of Mouth 21 x 17 cm
Diameter of Foot 23.5 × 20 cm
Qing court collection

The vase is modeled after the form of ancient bronze ware with an upright mouth, a slanting shoulder, a hanging belly, and a square ring foot. On the two symmetrical sides of the neck are two square tubular ears, and on the left and right sides of the ring foot are two rectangular holes for fastening strings. The body is covered with greenish-grey celadon glaze with yellowish-brown ice-crackles in different sizes in imitation of Guan celadon glazed ware. As the glaze layer melts during high-temperature firing, the purplish-brown paste is exposed at the mouth, and the rim of the ring foot is painted with brown glaze to imitate the characteristic "purple mouth and iron foot" of Guan ware. The exterior base is inscribed with a poem *In Praise of the Square Guan Vase* by Emperor Qianlong, followed by a short text to describe the story of writing this poem that Emperor Qianlong had collected this refined vase accidently, and he then thought of those lofty gentlemen with talents, who did not get a chance to be recognized. At the end of the text is an inscription "*guimao muchun yubi*" (written by the Emperor in the late Spring of the *kuimao* year and *Qian, Long* Xianzhang). *Guimao muchun* corresponded to the third month of the 48th year of the Qianlong period (1783).

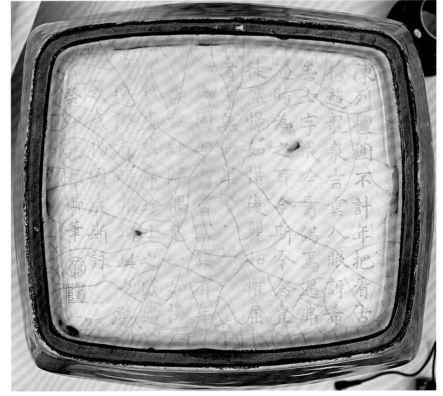

33

Hexagonal Square Vase

with tubular ears in imitation of Guan ware in celadon glaze

Qing Dynasty Yongzheng period

Height 45.5 cm
Diameter of Mouth 19.4 × 14.1 cm
Diameter of Foot 19.4 × 14.1 cm
Qing court collection

The vase is hexagonal square in shape and has a flared mouth, a narrow neck, a slanting shoulder, a straight belly tapering downwards, and a slightly flared hexagonal square ring foot. On the two symmetrical sides of the neck are two tube-shaped ears which are known as tubular ears. The body is covered with greenish-blue celadon glaze in imitation of Guan celadon glazed ware. The base of the foot is painted with brown glaze imitating the "iron-foot" of Guan ware. The exterior base is written with a six-character mark of Yongzheng in seal script in three columns in underglaze blue.

As recorded in the book *Taocheng Jishi* written by Tang Ying (1682 – 1756), Director General of the Imperial Kiln, in the Yongzheng period (1723 – 1735) of the Qing Dynasty, the Imperial Kiln in Jingdezhen had imitated and newly produced altogether fifty-seven types of glazes. One of them was glaze of Daguan (period) in imitation of "iron-bone", which actually referred to the glaze in imitation of Guan celadon glazed ware of the Song Dynasty ("Daguan" was the reign of Emperor Huizong, and it was said that the Xiuneisi Guan kiln was established at that time, thus the Guan celadon glaze produced at the time was known as "Daguan" glaze.) In the Yongzheng period, there were three kinds of glazes produced in imitation of Guan celadon glaze, including moon white, greenish-blue, and bright green glazes. This vase represents a refined example of ware in imitation of Guan celadon glazed ware in the Yongzheng period.

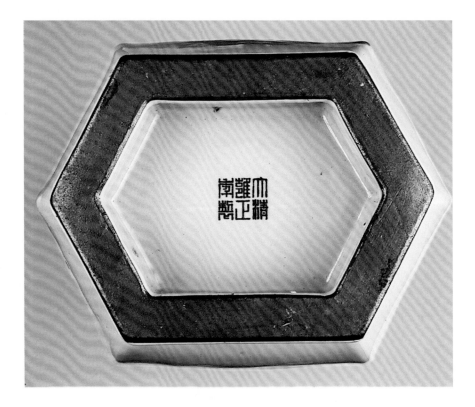

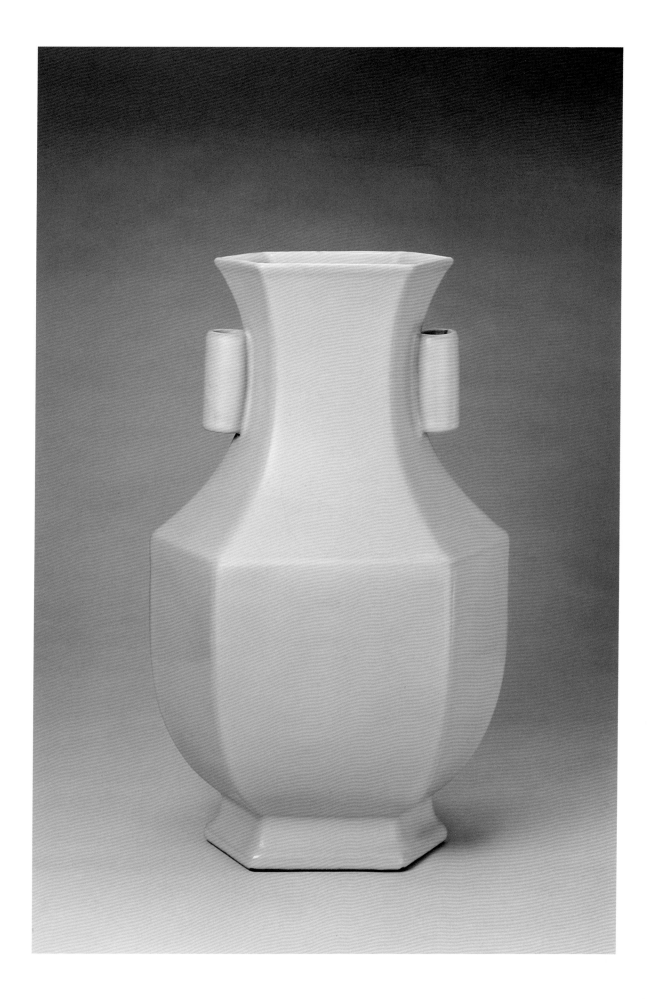

34

Square Vase
with tubular ears in imitation of Guan ware in celadon glaze

Qing Dynasty Yongzheng period

Height 20.7 cm
Diameter of Mouth 9.3 × 6.6 cm
Diameter of Foot 10.1 × 7.3 cm
Qing court collection

The vase is modeled after the shape of ancient bronze ware with an upright mouth, a long neck, a slanting shoulder, a globular belly, and a slightly flared square ring foot. On the two symmetrical sides of the neck are two tubular ears. The vase has a copper bladder inside. The body is covered with greenish-blue celadon glaze with large ice-crackles in imitation of Guan celadon glazed ware. The rim of the ring foot is unglazed, exposing the blackish-brown paste.

Ware in imitation of Guan celadon glazed ware produced by the Jingdezhen Imperial Kiln in the Yongzheng period either bore reign marks of the period or without reign marks. Those without marks were intended as imitations of Guan ware. In terms of the form, glaze colour, crackles on glaze, and treatment of the foot, this vase closely followed the style of the Guan ware of the Song Dynasty. The copper bladder inside the vase should have been added by the Imperial Workshop of the Qianlong period in order to keep water for flower arrangements.

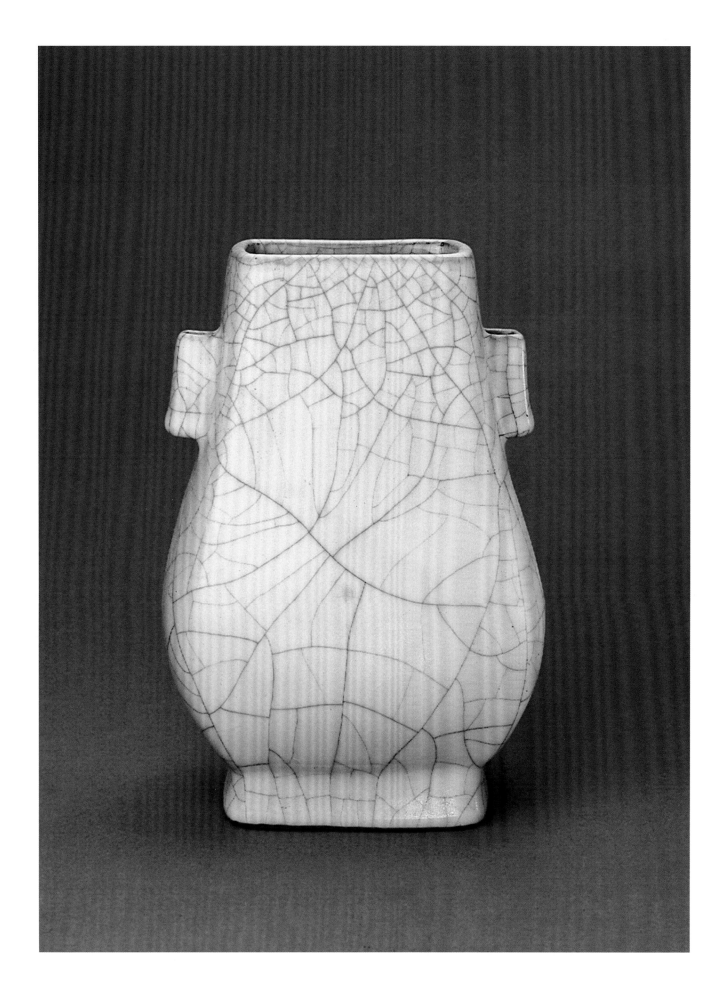

35

Covered Jar
in the shape of a purse with a
rat-shaped knob in
imitation of Guan ware
in celadon glaze

Qing Dynasty Yongzheng period

Height 13 cm
Diameter of Mouth 8.2 cm
Diameter of Foot 7.3 cm

The jar is in the shape of a purse fastened by a rope. It has a foliated mouth, a globular belly with an uneven surface, and a square ring foot. It has a matching cover on top of which is a knob in the shape of a rat. The body is covered with celadon glaze in imitation of Guan celadon glazed ware. The rim of the ring foot is painted with brown glaze. The exterior base is written with a four-character mark of Yongzheng in seal script in two columns in underglaze blue.

The vase is covered with a thick layer of shiny and translucent celadon glaze, which resembles that of the Guan ware of the Song Dynasty, yet the form is an innovative and creative form produced in the Imperial Kiln in Jingdezhen in the Yongzheng period.

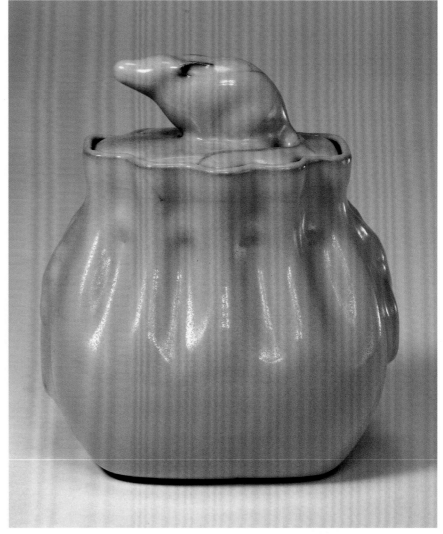

36

Garlic-head Vase
with design of string patterns in relief in imitation of Guan ware in celadon glaze

Qing Dynasty Qianlong period

Height 52.1 cm
Diameter of Mouth 9.3 cm
Diameter of Foot 17 cm

The vase has a garlic-head shaped mouth, a narrow neck, a slanting shoulder, a globular belly tapering downwards, and a ring foot. The body is covered with celadon glaze in imitation of Guan celadon glazed ware. The rim of the ring foot is unglazed. The neck and the shoulder are decorated with a border of string patterns respectively. The exterior base is written with a six-character mark of Qianlong in seal script in three columns in underglaze blue.

The garlic-head vase appeared very early and had already been found in the bronze ware of the pre-Qin period. Most of the garlic-head vases produced in the Imperial Kiln in Jingdezhen were decorative objects or flower containers.

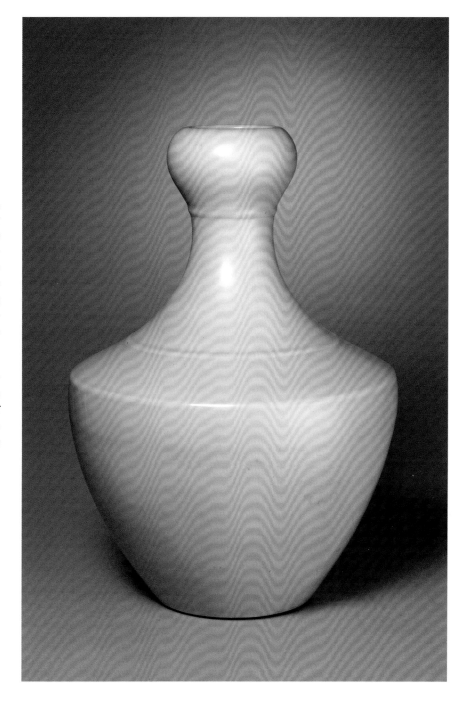

37

Narcissus Basin
in imitation of Guan ware in celadon glaze

Qing Dynasty Qianlong period

Height 6.7 cm
Diameter of Mouth 23.3 x 17 cm
Diameter of Foot 19.7 x 13.2 cm
Qing court collection

The oval-shaped narcissus basin has a flared mouth, a shallow curved wall, and a flat base, beneath which are four legs in the shape of *ruyi* cloud patterns. The body is covered with greenish-grey celadon glaze with large ice-crackles on the surface in imitation of Guan celadon glazed ware. The exterior base has six spur marks, and is inscribed with an imperial poem *In Praise of (Narcissus) Bowl* by Emperor Qianlong. At the end of the poem are an inscription "*Qianlong renchen yuti*" and a seal mark *langrun*. The *renchen* year of the Qianlong period corresponded to the 37th year of the Qianlong period (1772).

The Guan kiln was one of the five major kilns in the Song Dynasty. The Guan ware was noted for archaic forms, celadon glaze colours, and crackles, which exuded graceful and lyrical aesthetic appeal, and was much favoured by the Emperors of the Qing Dynasty. The production of imitated Guan ware had reached a very high standard in the Yongzheng and Qianlong periods, and it was difficult to differentiate the imitated ware without reign marks from the original Song ware. In terms of the form, glaze colour, and crackles, this narcissus bowl is very close to the Guan ware of the Song Dynasty, and represents a refined piece with high artistic merit.

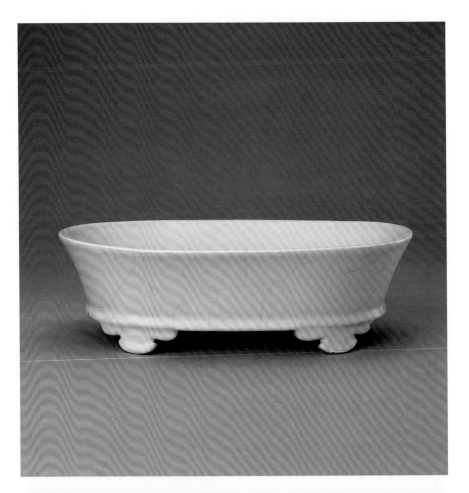

38

Vase
decorated with string patterns in relief in celadon glaze

Ge Ware
Song Dynasty

Height 20.1 cm
Diameter of Mouth 6.4 cm
Diameter of Foot 9.7 cm

The vase has a flared mouth, a slim long neck, a flat globular belly, and a ring foot. The body is covered with greenish-grey celadon glaze with crackles in iron black and golden-yellow spreading over the glaze surface, which is known as the characteristic "gold and iron threads". The neck is decorated with three borders of string patterns in relief, and the shoulder is decorated with one border of string pattern in relief.

This vase is fashioned in good proportion and exudes a pure and naturalistic charm. It is the only piece of this form among the extant Ge ware of the Song Dynasty, which is very rare.

Ru, Guan, Ge, Ding, and Jun kilns were known as the five major kilns of the Song Dynasty. However, the site of the Ge kiln has not been discovered yet. The earliest historical documents describing Ge ware came from the Yuan Dynasty, and the earliest Ge ware unearthed from dated tombs or sites was also dated to the Yuan Dynasty. Therefore, there have been different views on the production date and location of the Ge kiln. In terms of dating, there are views that they were produced in the Song Dynasty or Yuan Dynasty; and in terms of production site, there are views that they were produced in Hangzhou, Longquan, or in Northern China. In this publication, the traditional view that the production period was in the Song Dynasty is adopted.

39

Zun Jar
with three legs and design of
string patterns in relief
in celadon glaze

Ge ware
Song Dynasty

Height 13.6 cm
Diameter of Mouth 21.5 cm
Diameter of Foot 19 cm
Qing court collection

The jar has an upright mouth, a folded rim, a tubular belly, and a base with three animal-shaped legs. The paste is in deep greyish colour, and the body is covered with thick celadon glaze with large ice-crackles on the surface in the interior and on the exterior. The body is decorated with seven borders of string patterns.

Ge kiln had produced both wheel-made objects such as plates, bowls, and washers, as well as modeled objects such as vases, *zun* jars, incense-burners, etc., with the latter mostly modeled after ancient bronze ware. The shape of this *zun* jar was adopted from the cosmetic containers or wine containers of the Han Dynasty. However, in terms of function, it was used for burning incense and thus should be called *lian*-shaped incense burner or *zun*-shaped incense burner. In the Song Dynasty, it was known as "*lian*", "small *lian*", or "archaic *lian*". This type of ware was produced by the Ding kiln, Guan kiln, Ru kiln, Longquan kiln, and others in the Song Dynasty, and was continuously produced in the Ming and Qing dynasties.

40

Incense-burner
with ears in the shape of
a fish in celadon glaze

Ge ware
Song Dynasty

Height 8.3 cm
Diameter of Mouth 11.9 cm
Diameter of Foot 9.5 cm
Qing court collection

The incense-burner is modeled after the shape of the ancient bronze *gui* food-container and has a flared mouth, a short neck, a globular belly, and a ring foot. On the two symmetrical sides of the belly are two ears in the shape of a fish. The body is covered with greenish-grey celadon glaze with small crackles in iron red and golden-yellow colours spreading over the glaze surface in the interior and on the exterior. The exterior base has six irregular round spur marks.

This type of incense-burner was known as the fish-ear incense-burner with two ears fashioned in the shape of a fish, and was an esteemed type among Ge ware. Imitations had been produced in the Yuan, Ming, Qing and nowadays, but most of which had lost the aesthetic essence of the originals.

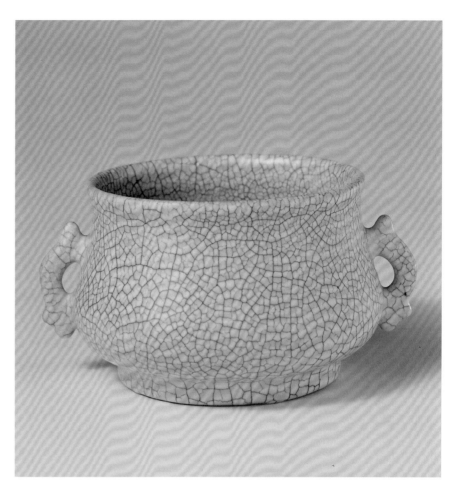

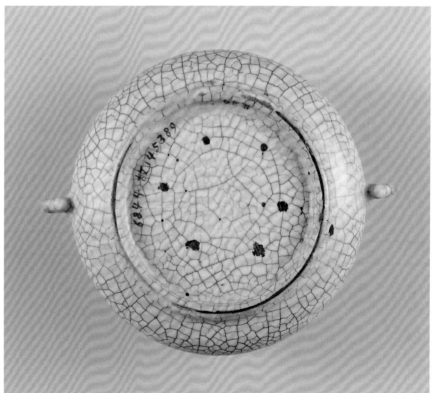

41

Flower Pot
in the shape of a begonia
in celadon glaze

Ge ware
Song Dynasty

Height 7.8 cm
Diameter of Mouth 14.6 × 12.5 cm
Distance between Legs 7.4 × 6 cm
Qing court collection

The flower pot is in the shape of a begonia with four petals and has a wide mouth, a folded rim on which is a ridge in relief, a deep belly with a wider upper part and a tapering lower part, and a flat base with four legs in the shape of *ruyi* cloud patterns. The body is covered with thick greenish-grey celadon glaze with ice-crackles in different sizes in the interior and on the exterior. The rim of the ring foot is unglazed, exposing the deep greyish paste. The interior base has five spur marks which should have been left by a piece of smaller ware put inside the flower pot while fired at the same time.

In terms of the paste, glaze colour, forms, decorations, and firing techniques, Ge ware had significant characteristics imitating Guan ware in the Song Dynasty. To highlight the aesthetic appeal of ice-crackles, there was the practice to paint the crackles on the glaze with natural plant pigments, such as ink or tea. As the size and depth of crackles varied, these colour materials would be absorbed with different effects produced, thus forming the so-called "gold and iron thread" patterns described in historical records.

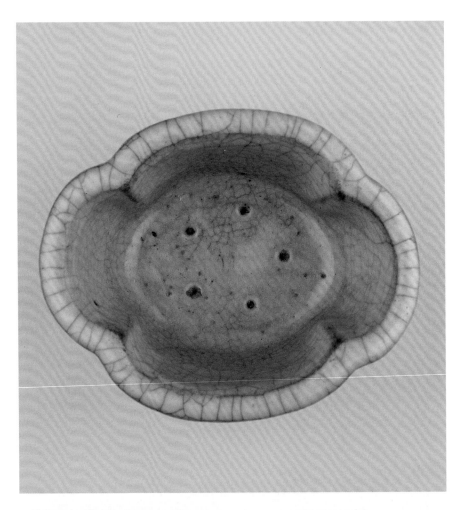

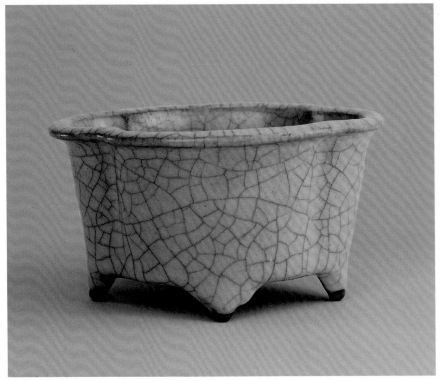

42

Plate
in the shape of a chrysanthemum in celadon glaze

Ge ware
Song Dynasty

Height 4.1 cm
Diameter of Mouth 16 cm
Diameter of Foot 5.6 cm
Qing court collection

The plate is in the shape of a chrysanthemum with fourteen petals and has a wide mouth, a curved belly, and a ring foot. The body is covered with greenish-grey celadon glaze with the so-called "gold and iron thread" ice-crackles spreading over the glaze surface. The rim of the ring foot is unglazed, exposing the black paste.

The form of this plate is finely fashioned. The entwining ice-crackles spread with a touch of naturalism and vividness, making this plate a refined piece of ware in the shape of flowers amongst similar types of ware in the shape of flowers in ancient ceramics.

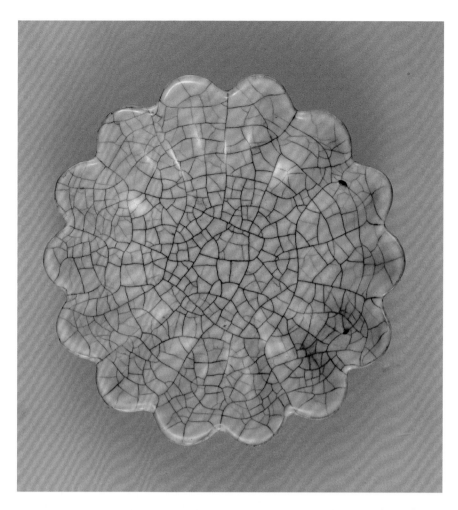

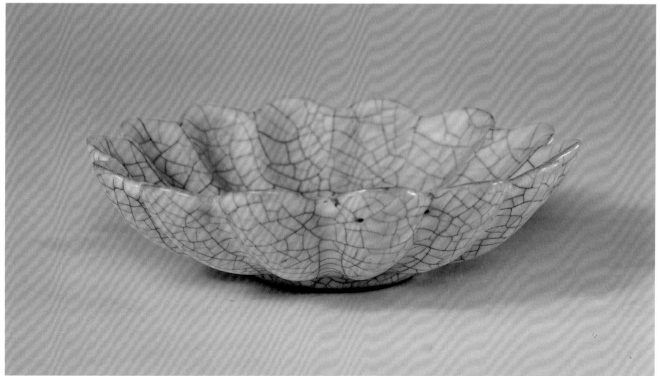

43

Bowl
in the shape of
chrysanthemum petals in
imitation of Ge ware
in celadon glaze

Ming Dynasty Xuande period

Height 7.3 cm
Diameter of Mouth 18.7 cm
Diameter of Foot 6.9 cm

The bowl is in the shape of chrysanthemum petals and has a wide mouth, a deep curved wall, and a ring foot. The body is covered with thick greenish-grey celadon glaze with ice-crackles in imitation of Ge celadon glaze. The exterior base is written with a six-character mark of Xuande in regular script in two columns within a double-line medallion in underglaze blue.

The earliest ware in imitation of Ge celadon glazed ware in the Ming Dynasty was produced in the Imperial Kiln in Jingdezhen in the Xuande period, including bowls in the shape of chrysanthemum petals, Ji Xin Wan (bowls decorated with chickens in the interior centre), plates in the shape of chrysanthemum petals, plates with foliated rims, plates with flared mouths, and others. Most of them carried reign marks. The glaze surface was not so shiny and had a feeling of fat oil similar to the glaze surface of Ge ware of the Song Dynasty.

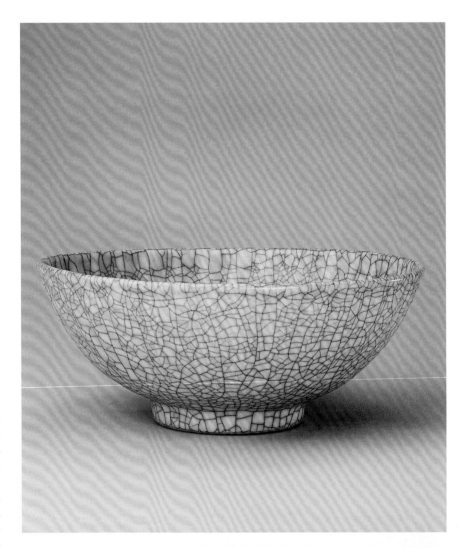

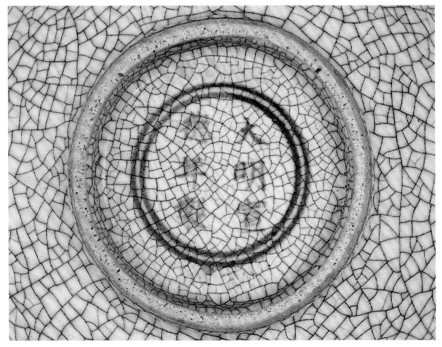

44

Lobed Vase
with tubular ears in imitation of Ge ware in celadon glaze

Ming Dynasty Chenghua period

Height 9.5 cm
Diameter of Mouth 2.1 cm
Diameter of Foot 3.1 cm
Qing court collection

The vase is fashioned with twelve lobes in the shape of a melon and has an upright mouth, a long neck, a globular belly, and a ring foot. On the two symmetrical sides at the neck are two tubular ears. The body is covered with greenish-grey celadon glaze with ice-crackles in yellow and black colours in imitation of "gold and iron thread" crackles on Ge celadon glazed ware. The exterior base is written with a six-character mark of Chenghua in regular script in two columns within a double-line medallion in underglaze blue.

The Imperial Kiln in Jingdezhen in the Chenghua period of the Ming Dynasty was noted for imitating Ge celadon glazed ware with technical competence and large scale of production. There is a substantial quantity of extant ware, and a large number of shards in imitation of Ge ware have been unearthed at the site of the Imperial Kiln.

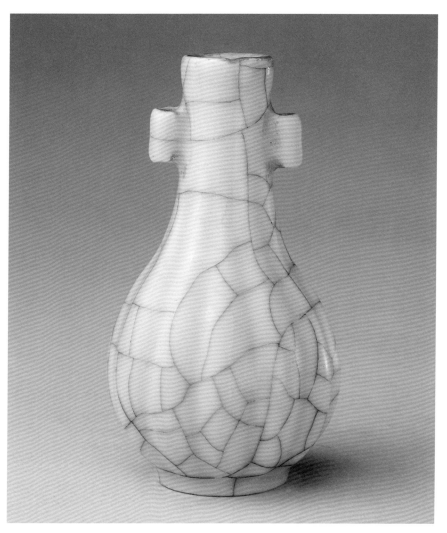

45

Octagonal Stem-cup
in imitation of Ge ware
in celadon glaze

Ming Dynasty Chenghua period

Height 9.7 cm
Diameter of Mouth 8 cm
Diameter of Foot 3.9 cm
Qing court collection

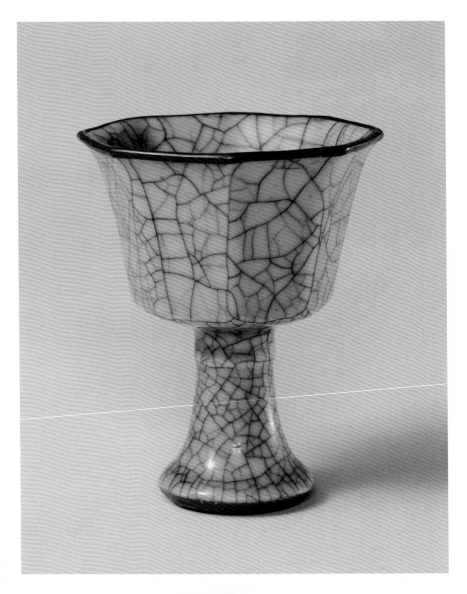

The octagonal cup has a flared mouth, a deep belly, and a folded base with a trumpet-shaped stem underneath. The paste is rather thick and the body is covered with thick, even, and shiny greenish-grey celadon glaze with large ice-crackles in black-grey colour and small ice-crackles in yellow colour. The mouth rim is painted with brown glaze, and the rim of the ring foot is painted with brownish-purple glaze. The interior of the stem is written with a horizontal six-character mark of Chenghua in regular script in underglaze blue from right to left.

This stem-cup has the characteristics of "gold and iron threads" and "purple mouth and iron foot" of Ge ware of the Song Dynasty finely imitated. However, the glaze is not so shiny and lacks the translucent jade-like quality of Ge ware. The colour of brown at the mouth and the foot is added artificially and lacks the naturalistic flavour of the original Ge ware.

46

Cup
in the shape of chrysanthemum petals in imitation of Ge ware in celadon glaze

Ming Dynasty Chenghua period

Height 5 cm
Diameter of Mouth 7.7 cm
Diameter of Foot 3.2 cm
Qing court collection

The cup is in the shape of sixteen chrysanthemum petals and has a wide mouth, a curved belly, and a ring foot. The body is covered with greenish-blue celadon glaze with large and spacious black ice-crackles and small massive yellow ice-crackles in imitation of Ge celadon glaze. The mouth rim and the foot rim are painted with brown glaze in order to imitate the characteristic of "purple mouth and iron foot" of the Ge ware of the Song Dynasty. The exterior base is written with a six-character mark of Chenghua in regular script in two columns within a double-line medallion in underglaze blue.

In terms of glaze colour and ice-crackles, this cup is a fine imitation of Ge ware and a representative imitated piece of Ge ware produced in the Chenghua period.

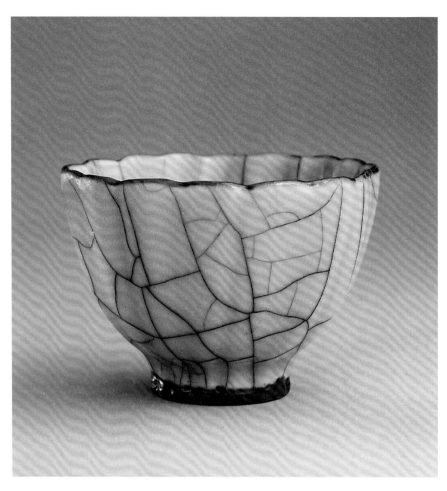

47

Long-neck Vase
in imitation of Ge ware
in celadon glaze

Qing Dynasty Kangxi period

Height 18.8 cm
Diameter of Mouth 3.4 cm
Diameter of Foot 6.4 cm
Qing court collection

The vase has an upright mouth, a long neck, a round belly, and a ring foot. The body is covered with celadon glaze with a yellowish tint and clustered small ice-crackles in various deep and light colour tones in imitation of Ge celadon glaze.

In the Yongzheng and Qianlong periods of the Qing Dynasty, the production of imitated Ge celadon ware was most intensive. Comparatively speaking, there is less ware in imitation of Ge celadon ware produced in the Kangxi period extant. This vase reveals that the techniques in imitating Ge celadon ware were still in an initial stage in the Kangxi period and had not reached a fully matured stage.

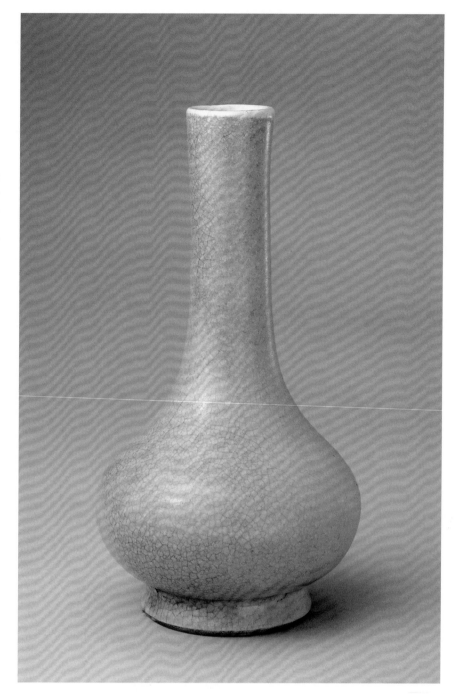

48

Vase
with a plate-shaped mouth
and applique design of three
goats in imitation of Ge ware
in celadon glaze

Qing Dynasty Yongzheng period

Height 27 cm
Diameter of Mouth 7.3 cm
Diameter of Foot 9.8 cm

The vase has a plate-shaped mouth, a long neck, a wide shoulder, a tapering belly, and a flared ring foot. The body is covered with celadon glaze with ice-crackles in imitation of Ge celadon glaze. The rim of the ring foot is painted with brown glaze. The body of the vase is decorated with four borders of string patterns, and the shank of the vase is decorated with three goats in applique and unglazed, exposing the paste. The exterior base is written with a six-character mark of Yongzheng in seal script in three columns in underglaze blue.

Except ice-crackles on the glaze surface, the form and glaze colour of this vase do not copy the Ge ware of the Song Dynasty closely. In particular, the decorative design of three goats at the shank of the vase is a new design created in the Yongzheng period, which is derived from the "*tai*" divinity symbol in *I Ching*, and carries the auspicious meaning of three *yang* (a pun for goats) will bring about prosperity and peace.

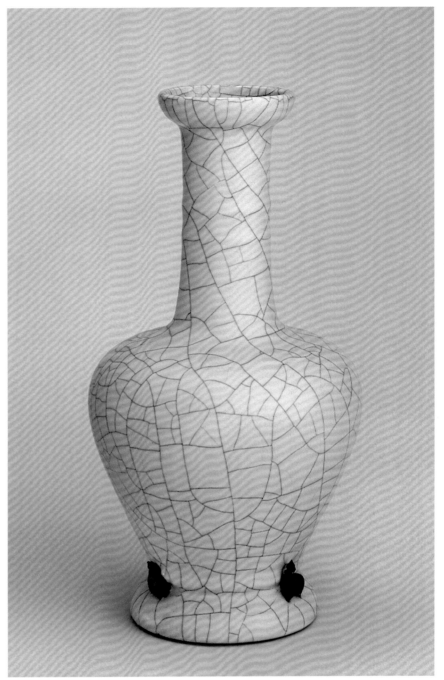

49

Square *Zun* Vase
with design of animal masks of ancient bronze ware in imitation of Ge ware in celadon glaze

Qing Dynasty Yongzheng period

Height 24.5 cm
Diameter of Mouth 12.3 × 9.5 cm
Diameter of Foot 10.8 × 8.2 cm

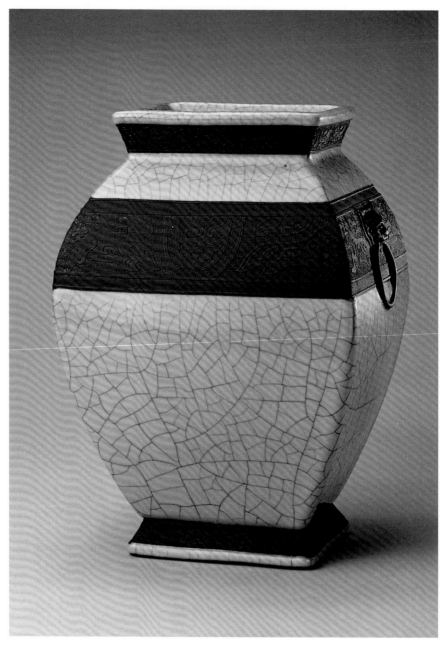

The *zun* vase has a square mouth, a flared mouth rim, a slanting neck, a slanting shoulder, a slightly globular square belly, and a flared square ring foot. On the two symmetrical sides of the shoulder are two ears in the shape of animal masks holding rings. Most of the body is covered with greenish-grey celadon glaze with large ice-crackles in imitation of Ge celadon glaze. The rim of ring foot is unglazed, exposing the paste. The neck, the shoulder, and the exterior wall of foot are decorated with an unglazed decorative border respectively, exposing the paste and looking like an iron belt. On the border are designs of *taotie* animal masks. The exterior base is written with a six-character mark of Yongzheng in regular script in three columns in underglaze blue.

Among the imitated Ge ware in celadon glaze produced in the Yongzheng period, this type of *zun* vases imitating ancient bronze ware is a new creative form. This piece is finely fashioned and decorated with luxuriant designs, representing a refined piece of imperial ware of the Yongzheng period.

50

Jar
in green glaze in imitation of
Ge ware
in celadon glaze

Qing Dynasty Yongzheng period

Height 23 cm
Diameter of Mouth 11 cm
Diameter of Foot 10.5 cm
Qing court collection

The jar has a rimmed mouth, a short neck, a slanting shoulder, a tapering belly, and a ring foot. The mouth rim and the interior of the jar are covered with white glaze with small ice-crackles. The exterior wall is covered with glassy watermelon green glaze, and underneath is another layer of glaze with small ice crackle. The rim of the ring foot is unglazed.

On this jar, a layer of watermelon green glaze has been added on the layer of celadon glaze, and after high-temperature firing, it is then again fired in a low-temperature baking atmosphere. It is known as "Ge ware in green glaze".

51

Long-neck Vase
in blue glaze
in imitation of Ge ware
in celadon glaze

Qing Dynasty Yongzheng period

Height 36 cm
Diameter of Mouth 8.5 cm
Diameter of Foot 13 cm

The vase has an upright mouth, a long neck, a globular belly, and a ring foot. The interior is covered with white glaze with ice-crackles. The exterior wall and the interior foot are covered with blue glaze, and underneath is another layer of glaze with small ice-crackles. The joining area between the neck and the shoulder is decorated with a border of string patterns in relief.

On this vase, a layer of cobalt blue glaze has been added on the layer of celadon glaze in imitation of Ge celadon glaze, and after high-temperature firing, it is then fired again in low-temperature baking atmosphere. It is known as "Ge ware in blue glaze".

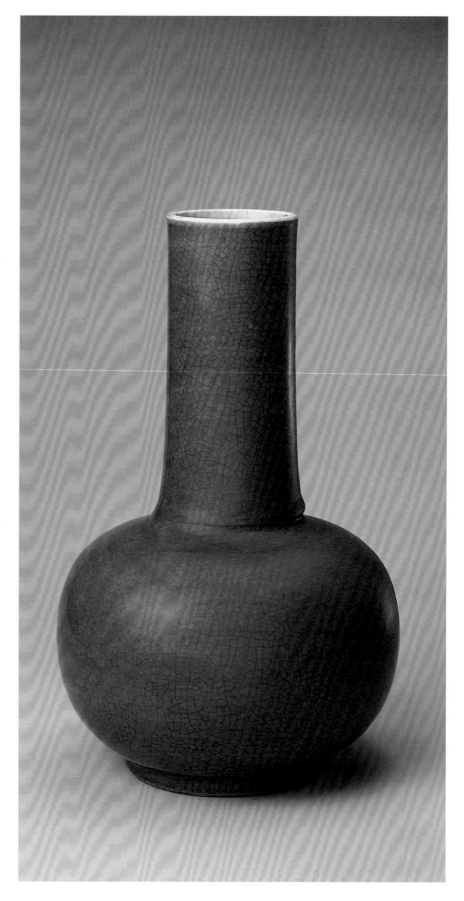

52

Washer
in the shape of a leaf in
imitation of Ge ware
in celadon glaze

Qing Dynasty Qianlong period

Overall Length 18 cm
Width 13.5 cm
Qing court collection

The washer is in the shape of a leaf
with veins visible. The body is covered
with greenish-grey glaze with ice-crackles
in black and yellow colours. The exterior
base has six spur marks and is written with
a six-character mark of Qianlong in seal
script in three columns in underglaze blue.

This brush-washer is fashioned in the
shape of a leaf with a touch of archaism
and creative rendering.

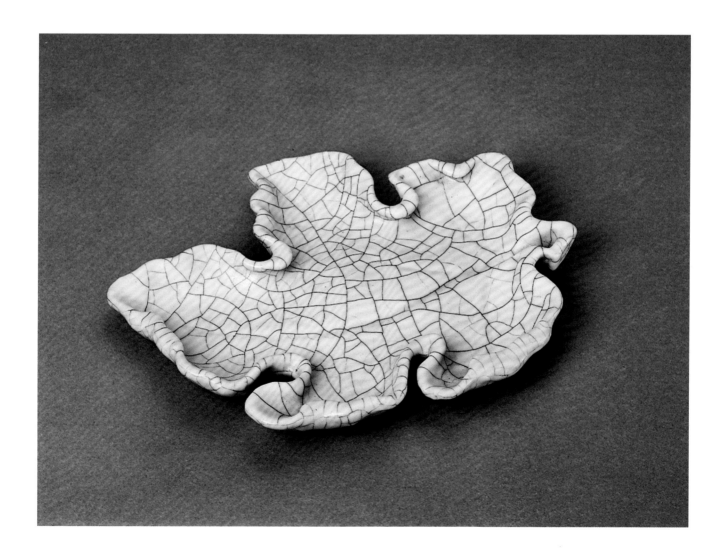

53

Meiping Vase

with design of lotus scrolls in relief in imitation of Ge ware in celadon glaze

Yixing ware
Ming Dynasty

Height 28.1 cm
Diameter of Mouth 4.9 cm
Diameter of Foot 14.2 cm

The vase has a rimmed mouth, a short neck, a wide shoulder, a round belly tapering downwards, a slightly flared foot, and a recessed flat base. The body is covered with shiny and translucent moon white glaze with small ice-crackles. The belly is carved with lotus scrolls in relief.

The Yixing kiln is located at the region of Dingshu town, Yixing, Jiangsu, which has started producing red pottery ware, grey pottery ware, and proto-porcelain ware since the Han Dynasty, and its production still continues nowadays. The Yixing kiln is well-known for producing purple clay ware, in particular in the Ming and Qing dynasties. It has also produced ware in imitation of Song porcelain ware.

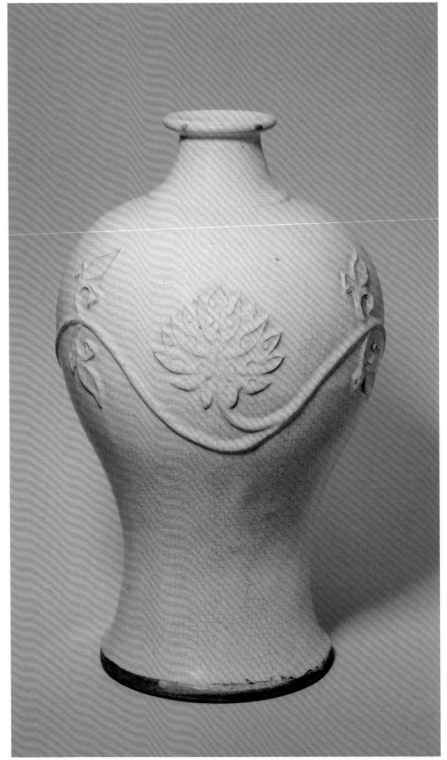

54

Incense-burner
in the shape of a square *ding* cauldron with four legs,
two ears and design of *taotie* animal masks in relief
in imitation of Ge ware in celadon glaze

Yixing ware
Ming Dynasty

Height 18.3 cm
Diameter of Mouth 15.3 × 11.7 cm
Distance between Legs 14.5 × 10 cm
Qing court collection

The incense-burner is modeled after the bronze *ding* cauldron of the Shang Dynasty, which has two upright ears, a square rim, a square belly, and four flat legs in the shape of *kui*-dragons on the underside. The body is covered with moon white glaze with small ice-crackles. The four sides of the belly are decorated with *taotie* animal masks and eight protruding flanges.

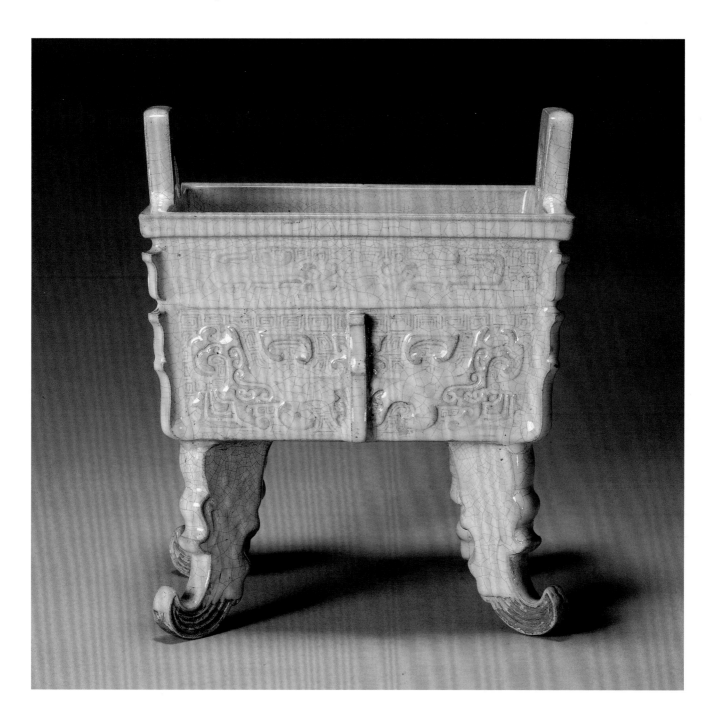

55

Jar
with carved and incised
design of lotus petals
in celadon glaze

Yaozhou ware
Five Dynasties to
Northern Song Dynasty

Height 10.3 cm
Diameter of Mouth 8.8 cm
Diameter of Foot 7.8 cm

The jar has an upright mouth, a short neck, a round shoulder, a globular belly, and a ring foot. The body is covered with thin green glaze. The interior of the ring foot is unglazed. The exterior wall is decorated with two layers of carved and incised design of lotus petals.

The Yaozhou kiln was a large-scale provincial kiln noted for producing celadon ware with carved designs in Northern China in the Song and Jin dynasties. Its site was located at the Tongchuan city, Shannxi province, and the major kiln was at the Huangbao town, Tongchuan which was also known as Tongguan in the past and under the jurisdiction of Yaozhou in the Song Dynasty, thus the kiln was called Yaozhou kiln. It was noted for producing celadon ware, as well as a small amount of ware in brown glaze and black glaze. From the Five Dynasties to the early Northern Song Dynasty, it had also come under influence of the Yue kiln which was well-known for producing high quality celadon ware. The form and glaze colour of this jar were rather close to those of Yue ware, and in particular the rendering of lotus petals in relief had been very popular on Yue celadon ware. However, when compared with the Yue celadon ware of the same period, the Yaozhou celadon ware was noted for the thick paste, decorations that were deeply carved or incised, and the decorative motifs that were more dimensional and sculptural with sharp contrast of glaze colours, which exuded strong aesthetic and decorative appeal of rendering in low relief.

56

Vase
with carved and incised
design of peony scrolls
in celadon glaze

Yaozhou ware
Northern Song Dynasty

Height 19.9 cm
Diameter of Mouth 6.9 cm
Diameter of Foot 7.8 cm

The vase has a small mouth, a flat everted rim, a short neck, a wide shoulder, a globular belly tapering downwards and slightly flared near the foot, and a shallow ring foot. The body is covered with celadon glaze and decorated with carved and incised designs under the glaze. The shoulder is decorated with three borders of string patterns in relief, whereas the belly is decorated with peony scrolls. The shank is decorated with overlapped lotus petals, and near the foot are incised designs of two borders of string patterns.

This vase is a representative piece of Yaozhou celadon ware with carved designs of the Northern Song Dynasty. The Yaozhou kiln in Northern China was well-known for producing celadon ware with carved and incised designs which ranked the best among various kilns of the Song Dynasty. The decorations were rendered with sharp and deep carving and incising techniques with fluent lines, luxuriant motifs, and sophisticated pictorial treatment with a touch of vigour.

57

Bowl
with carved and incised design of children at play in celadon glaze

Yaozhou ware
Northern Song Dynasty

Height 7.2 cm
Diameter of Mouth 18.7 cm
Diameter of Foot 5.5 cm

The bowl has a wide mouth, a deep curved belly, and a ring foot. The paste is greyish-white in colour and the body is covered with uneven celadon glaze, with the mouth rim and other areas where the glaze runs thin barely exposing the paste. The interior wall is carved and incised with three lotus scrolls and a child holding a flower's stem to play.

The motif of children at play depicts a variety of scenes of children playing joyfully. Such a motif is closely related to the wish of Chinese people for offspring, who will bring wealth and prosperity, and is thus very popularly used for decorative purposes. The motif of children at play had already appeared on Changsha ware of the Tang Dynasty, and was commonly found on Yaozhou ware, Ding ware, Cizhou ware, and Jingdezhen ware since the Song Dynasty. They were rendered with various techniques, such as painting, carving, incising, and molding, and children playing with lotus flowers were the most popular design at the time.

58

Covered Box
with carved and incised design of a spray of lotus in celadon glaze

Yaozhou ware
Northern Song Dynasty

Overall Height 3 cm
Diameter of Mouth 7.2 cm
Diameter of Foot 4.7 cm

The flat and round box has a round mouth, a shallow belly curved inwards, and a wide and low ring foot. It has a matching cover with the top slightly bulging and the side narrow and straight, fitting the mouth tight. The paste has a light greyish tint. Most of the body is covered with yellowish-green celadon glaze. The rims of the cover and the mouth, as well as the base, are unglazed, exposing the reddish paste. The surface of the cover is carved with a spray of lotus with five petals, encircled by a border of string patterns.

The craving techniques applied on Yaozhou ware include single-line incising and cut out decorations on the ground. Firstly, the potter would hold a cutter vertically and incise decorations. Then he would hold the cutter from a slanting angle and carve out decorations by removing the paste around these decorations, thus resulting in perspective layers of decorations on the ground. In such a way, a sense of space and dimensionality would be achieved. At various times, details such as flower petals, leave veins, and wave patterns would be finely incised with slim lines with a touch of realism. As celadon glaze would spread into the decorations fluidly during high-temperature firing, different colour tone gradations would be produced to complement the sharply cut decorations with a touch of vigour and naturalism.

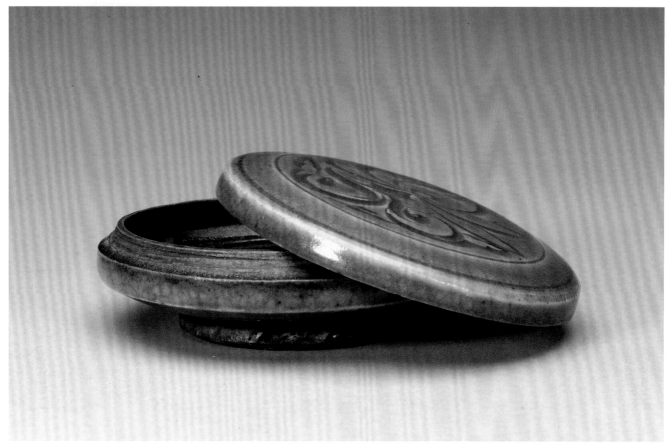

59

Vase
with tubular ears and design of string patterns in relief in celadon glaze

Longquan ware
Southern Song Dynasty

Height 31.5 cm
Diameter of Mouth 10 cm
Diameter of Foot 11.7 cm
Qing court collection

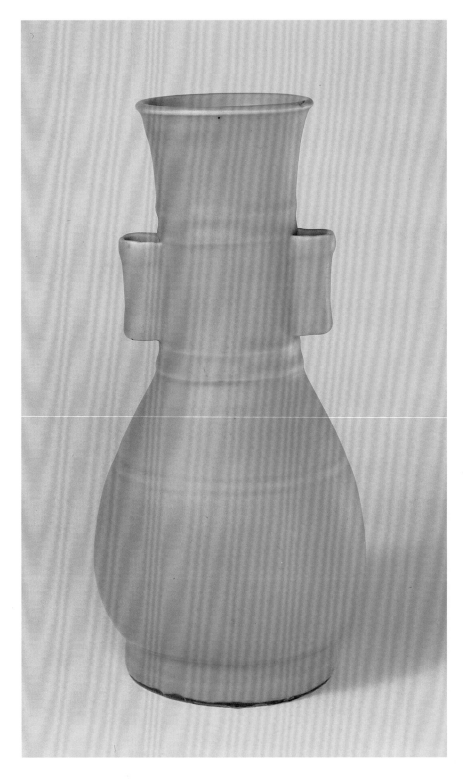

The vase has a flared mouth, a long neck, a slanting shoulder, and a ring foot. On the symmetrical sides of the neck are two tubular ears. The body is covered with thick and pure greenish-blue celadon glaze. The rim of the ring foot in unglazed, exposing the greyish-white paste. At the upper and lower sides of the ears are two borders of string patterns in relief, and the belly is decorated with two incised borders of string patterns.

The vase is fashioned in the form of the ancient bronze ware with a large size. It is glazed with pure and translucent celadon glaze, representing a high standard piece of Longquan ware of the Song Dynasty.

Longquan kiln was a large-scale provincial kiln well-known for producing celadon ware and its sites had been found at the present Longquan city, Zhejiang. In the Song, Yuan and Ming dynasties, Longquan was under the jurisdiction of Chuzhou and thus at the time, people also named the kiln Chuzhou kiln. In the Northern Song Dynasty, the Longquan kiln was basically engaged in producing ware in thin and transparent celadon glaze. In the Southern Song Dynasty, the Longquan ware had been noted for producing greenish-blue glaze and plum green celadon glaze, which were produced by replacing the traditional type of lime glaze with alkali lime glaze that would become adhesive during high-temperature firing and turn into celadon glaze with soft and translucent quality, resembling the quality of ancient jade ware and, at the same time, representing the most charming glaze colour found on Chinese celadon ware.

60

Cong Vase
in Celadon Glaze

Longquan ware
Southern Song Dynasty

Height 25.2 cm
Diameter of Mouth 6.2 cm
Diameter of Foot 6 cm
Qing court collection

The vase is fashioned in the form of an ancient jade *cong* with a contracted mouth, a short neck, a square column-shaped body, and a ring foot. The greyish-white paste is covered with plum green celadon glaze with the glaze colour turning thin at the areas in relief, and on the glaze surface are massive ice-crackles. The rim of the ring foot is unglazed, exposing the reddish paste. The four sides of the vase are decorated with various horizontal and vertical strokes in relief.

Jade *cong* was one of the major ritual vessels in ancient China. It appeared as early as the Neolithic period with the form symbolizing the round sky and square earth with the blessing of a peaceful and unified nation. In the Song Dynasty, favour of archaism was very popular, and the Longquan ware with shiny green glaze and jade-like quality had become the best choice for imitating ancient jade vessels. The original *cong* of the past was hollow in the inside, but in the Song Dynasty, potters had added a base to it, and thus it was known as the *cong* vase. In the Qing Dynasty, it was still a very popular type form, but the horizontal patterns on the body had become designs of the eight trigrams, and this type of vessels was known as the "vase with design of eight trigrams".

61

Vase
with a plate-shaped mouth and phoenix-shaped ears in celadon glaze

Longquan ware
Southern Song Dynasty

Height 17.5 cm
Diameter of Mouth 5.7 cm
Diameter of Foot 6.3 cm
Qing court collection

The vase has a plate-shaped mouth, a slim long neck, a slanting shoulder, a tubular belly and a ring foot. On two symmetrical sides of the neck are two phoenix-shaped ears. The greyish-white paste is covered with celadon glaze with ice-crackles on the surface. The glaze colour is as beautiful as green plums.

This type of vases with phoenix-shaped ears was highly esteemed in the Longquan celadon ware and was much favoured at the time.

The Longquan kiln of the Southern Song Dynasty produced a new type of alkali lime glaze which was translucent but not so transparent, and thus craved and incised designs were not suitable for decorative purposes. Instead, applique and relief decorative designs were applied. Covered with thick glaze, the designs merged with the ware, and as glaze would become fluid during high-temperature firing, the glaze layer on the relief designs would become thinner with the paste barely visible. As a result, the glaze colour would have tonal gradations. In parallel, at the rim of the ware and the turning corners at the shoulder, the belly and others, the glaze would also become thinner, showing barely visible white ribs.

62

Three-legged Incense-burner
in the shape of *li* tripod in celadon glaze

Longquan ware
Southern Song Dynasty

Height 10.5 cm
Diameter of Mouth 14.1 cm
Diameter of Foot 8.3 cm
Qing court collection

The incense-burner is fashioned in the shape of an ancient *li* tripod with a flat mouth, an everted rim, a contracted neck, a slanting shoulder, and a globular belly, and under the base are three legs in the shape of nipples. The greyish-white paste is covered with celadon glaze. The rim of the ring foot is unglazed, exposing the reddish paste. The shoulder is decorated with a border of string patterns in relief. The area from the belly to the foot is decorated with three vertical flanges in relief.

The *Li* tripod was a type of ancient cooking vessel. Pottery *li* tripods were first produced in the Neolithic period, and bronze *li* tripods had been popular in the Shang and Zhou dynasties. In the Song Dynasty, the favour in pursuit of archaism was very popular, and many kilns produced ware in imitation of ancient bronze ware, such as incense-burners in the shape of *ding* cauldrons, incense-burners in the shape of *gui* food-containers, incense-burners in the shape of *li* tripods, incense-burners in the shape of *lian* cosmetic containers, etc., which were used for burning incense. In his poem *Burning Incense*, Yang Wanli of the Song Dynasty described the imitation of bronze ware as "To model porcelain ware like *ding* cauldrons with glaze colour as green as water; cut silver slabs in the shape of leaves, which are as light as paper".

63

Zun Vase
with carved design of floral scrolls in relief in celadon glaze

Longquan ware
Yuan Dynasty

Height 72 cm
Diameter of Mouth 33 cm
Diameter of Foot 20.5 cm
Qing court collection

The *zun* vase has a trumpet-shaped mouth, a long neck, a wide shoulder, a globular belly tapering downwards, and a ring foot. The greyish-paste is covered with thick and translucent celadon glaze. The rim of the ring foot is unglazed, exposing the reddish paste. The upper neck is decorated with borders of string patterns, and the lower neck is decorated with floral sprays in low-relief. The shoulder and the upper belly is decorated with floral scrolls in low-relief, whereas the shank is carved with lotus petals.

This *zun* vase with a tall and large size is thickly and heavily potted, and decorated with craved, incised, and applique designs, revealing the high standard of producing Longquan ware in the Yuan Dynasty.

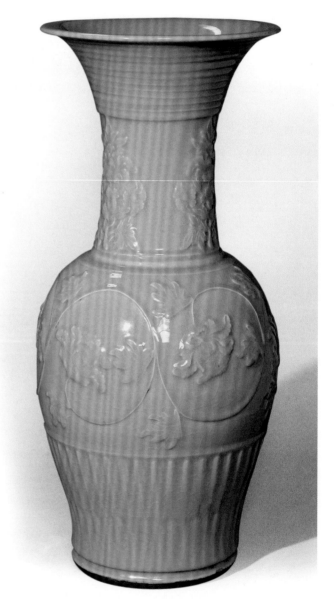

64

Pure Water Vase
in celadon glaze

Longquan ware
Yuan Dynasty

Height 48.2 cm
Diameter of Mouth 7.3 cm
Diameter of Foot 10.5 cm
Qing court collection

The pure water vase has an upright mouth, a long neck, a wide shoulder, a contracted belly which is slightly flared near the foot, and a ring foot. The interior and exterior are covered with pure greenish-blue glaze. The lower part of the neck has a protruding wheel-shaped ring.

The Longquan kiln of the Yuan Dynasty produced this type of vases with celadon glaze with a large ring at the neck, which was shaped like the Chinese character "*ji*" (luck), and thus it was known as "vases in the shape of a *ji* character". There is a substantial number of this type of Longquan pure water vases with celadon glaze of the Yuan Dynasty extant, but examples with large size and beautiful glaze colour like this one is very rare.

This type of pure water vases was a type of "kendi" vases with its name translated from "kundika" in Sanskrit and "kundi" in Hindustani and various other translations which carried the meaning of "vases or water vases". It was originally a type of daily utensils used by Indians, and was later used by Buddhist disciples with religious attributes for storing water for drinking or washing hands.

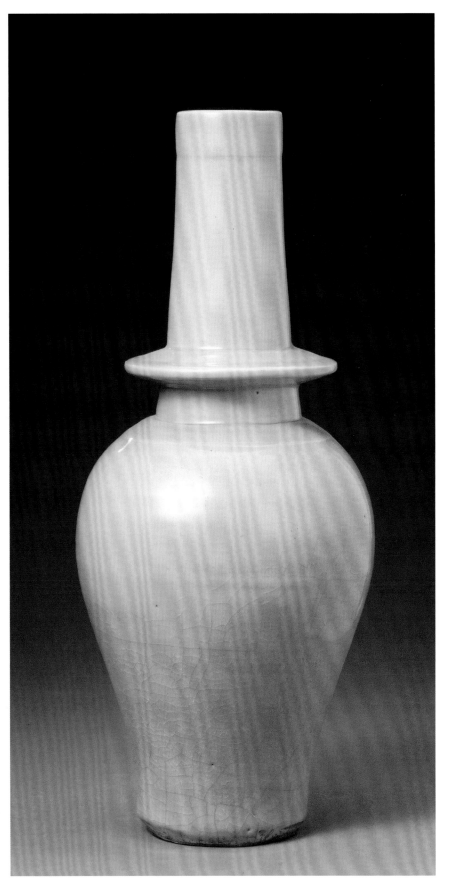

65

Pear-shaped Vase
in celadon glaze

Longquan ware
Yuan Dynasty

Height 33.5 cm
Diameter of Mouth 6.5 cm
Diameter of Foot 9.3 cm

The vase (*Yuhuchun*) has a trumpet-shaped mouth, a slim long neck, a slanting shoulder, a hanging belly, and a ring foot. The body is covered with shiny translucent celadon glaze. The rim of the ring foot is unglazed, exposing the reddish paste.

The pear-shaped vase (*Yuhuchun*) was stylized in the Song Dynasty, which represented a standard type of stylized ware popularly produced by various kilns in different regions for long time duration up to the present day. It could be used as a wine-container, a decorative object, or a flower vase. It might be derived from the pure water vases used by Buddhist disciples for ceremonial purposes in the Sui and Tang dynasties. Pear-shaped vases (*Yuhuchun*) used as wine-containers in the Yuan Dynasty were known as "huping" (wine-pot vases), and the images of which were often found on the banquet scenes depicted in the mural paintings in tomb sites or monasteries and temples of the Yuan Dynasty. Description of this type of ware could also be found in chapter 11, *Ceremonies and Rituals* in the book *Shilin Guangji* of the Yuan Dynasty.

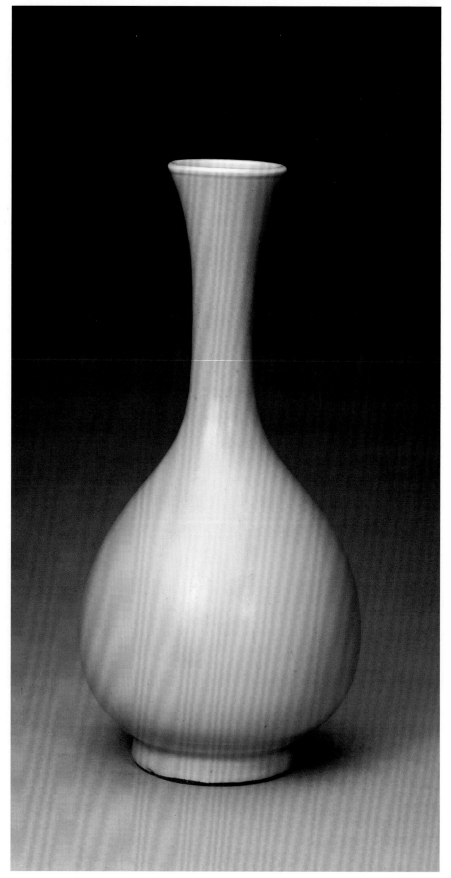

66

Ewer
in celadon glaze

Longquan ware
Yuan Dynasty

Height 25 cm
Diameter of Mouth 4.5 cm
Diameter of Foot 8.3 cm
Qing court collection

The ewer has an upright mouth, beneath which the body becomes wider, a hanging belly, and a slightly flared ring foot. On one side of the belly is a long curved spout and on the other side is a curved handle at the area between the neck and the belly. The ewer has a matching flat round cover on top of which is a pearl-shaped knob. The body is covered with even and pure celadon glaze.

Since the Six Dynasties, ewers had become a very popular type of ware with a variety of forms and styles. However, the form of this ewer was first created in the Yuan Dynasty with fluent linear configuration and was both functional and aesthetically fashioned. Similar type of ewers has also been found in the Yuan underglaze blue ware produced in Jingdezhen.

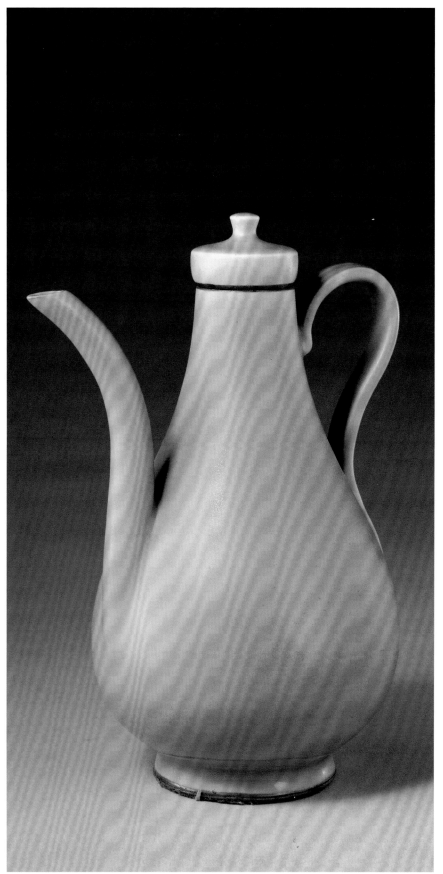

67

Meiping Vase
with cover and carved and
incised design of peach
flowers and bamboos
in celadon glaze

Longquan ware
Ming Dynasty

Overall Height 44.4 cm
Diameter of Mouth 6.1 cm
Diameter of Foot 11.4 cm

The *meiping* vase has a plate-shaped
mouth, a narrow neck, a round shoulder,
a belly tapering downwards and slightly
flared at the shank, and a ring foot. The
vase has a matching cover on which is
a round pearl-shaped knob. The body is
covered with celadon glaze and decorated
with carved and incised designs of peach
flowers and bamboos.

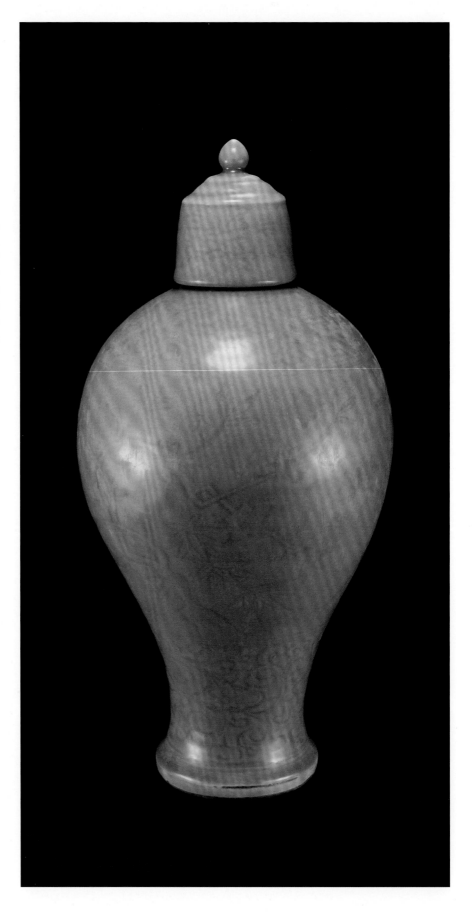

68

Pomegranate-shaped *Zun* Vase

with a folded rim and carved
and incised design of
chrysanthemum scrolls
in celadon glaze

Longquan ware
Ming Dynasty

Height 36.4 cm
Diameter of Mouth 18.4 cm
Diameter of Foot 15.5 cm

The vase is in the shape of a pome-
granate. It has a folded rim, a short neck,
a wide shoulder tapering downwards, and
a ring foot. The body is covered with cel-
adon glaze. The exterior wall is decorated
with carved and incised design of flowers.
The mouth rim is decorated with foliage
scrolls enclosed by nipple patterns in relief.
The upper neck is decorated with carved
design of lotus scrolls with the middle
part fashioned with a border of string
patterns, and the lower neck is decorated
with incised *lingzhi* fungi. The shoulder is
carved with design of coin patterns. The
belly is decorated with carved and incised
designs of chrysanthemum scrolls and near
the foot are decorations of chrysanthemum
petals.

The form of this *zun* vase is innovative
with pure shiny celadon glaze and vivid
decorative designs. The design of chrysan-
themum scrolls at the belly and the design
of chrysanthemum petals near the foot
are rather deeply carved with a low relief
dimensionality.

69

Ewer
in celadon glaze

Longquan ware
Ming Dynasty

Height 30 cm
Diameter of Mouth 8.4 cm
Diameter of Foot 9.3 cm
Qing court collection

The ewer has a flared mouth, a slim neck, a hanging belly, and a ring foot. On one side of the belly is a curved spout linked to the neck with a cloud-shaped flange. On the other side is a curved handle. The body is covered with celadon glaze.

The form of this ewer is similar to the underglaze blue ewer produced by the Jingdezhen kiln in the early Ming Dynasty and the ewer unearthed at the kiln site at Fengdongyan, Dayao village in the Longquan city, and thus the ewer in question could be dated to the early Ming Dynasty and produced at Fengdongyan, Dayao village in the Longquan city at the time.

70

Jar
carved with design of
lotus sprays in relief
in celadon glaze

Longquan ware
Ming Dynasty

Height 28.6 cm
Diameter of Mouth 12.7 cm
Diameter of Foot 10.7 cm
Qing court collection

The jar is fashioned in the shape of a lantern. It has an upright mouth, a round rim, a short neck, a tubular belly, a contracted base, and a ring foot. The jar has a matching canopy-shaped cover on top of which is a round pearl-shaped knob. The body is covered with celadon glaze. Owing to the placement of a gasket during firing, an unglazed ring appears at the base. The exterior wall is decorated with carved floral designs in five layers in relief from top to bottom. The neck is decorated with eight lozenge-shaped clouds, the shoulder with lotus scrolls, the belly with two borders of lotus sprays, and the shank with lotus scrolls. The exterior wall of the ring foot is decorated with lozenge-shaped cloud patterns. The surface of the cover is decorated with four lotus sprays in relief.

The covered jar is finely modeled with beautiful glaze colour and precisely rendered decorations, representing a refined piece of Longquan celadon ware of the early Ming Dynasty. As the diameters of the mouth and the foot are similar, and as the whole piece gives a feeling of vigour and sternness, it is also known as *zhuang* (strong) jar.

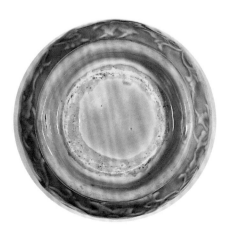

71

Plate
with carved and incised design of grapes in celadon glaze

Longquan ware
Ming Dynasty

Height 7.5 cm
Diameter of Mouth 50.6 cm
Diameter of Foot 33.2 cm
Qing court collection

The plate has a wide mouth, a curved wall with a slightly convex centre, and a ring foot. The body is covered with celadon glaze. The exterior base has an irregular unglazed ring due to the placement of a gasket during firing. The exterior wall is carved and incised design of floral and fruit sprays. The interior wall is carved and incised with two layers of decorations with the top layer decorated with floral sprays and the lower layer decorated with bamboo leaves and *lingzhi* fungi. The interior base is carved and incised with design of grapes.

This plate is thickly and heavily potted with a large size, and covered with shiny translucent celadon glaze with decorations precisely and delicately rendered. It should be an imperial ware with the design commissioned by the court for imperial use. Since the ring foot is fully glazed, the gasket used during firing should be of considerable height and should uplift the whole plate during firing.

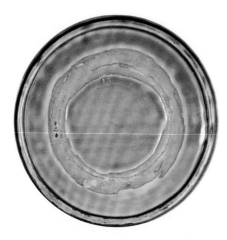

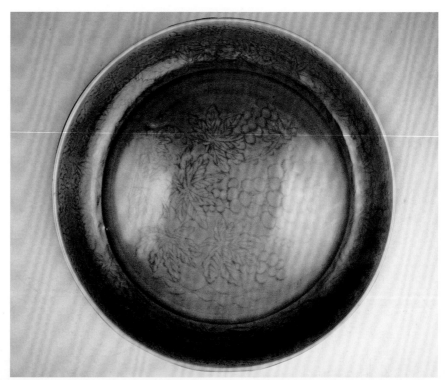

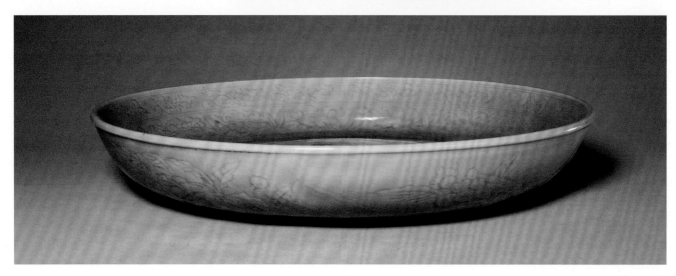

72

Bowl
with carved and incised design of lotus scrolls in imitation of Longquan ware in celadon glaze

Ming Dynasty
Yongle period

Height 6.3 cm
Diameter of Mouth 15.3 cm
Diameter of Foot 5 cm
Qing court collection

The bowl has a flared mouth, a deep curved belly, and a ring foot. The body is covered with celadon glaze and the colour of which is very similar to that of Longquan celadon ware. The interior wall is plain without decorations, and the exterior wall is carved and incised with design of lotus scrolls. Near the mouth rim are two borders of string patterns.

From the collection of the Qing court and the ware unearthed at the Imperial Kiln site in Jingdezhen, Ming Dynasty, the Imperial Kiln in Jingdezhen had started to produce imitated Longquan celadon ware in the Yongle period (1403 – 1424) of the Ming Dynasty, and the scale was further expanded in the Xuande period (1426 – 1435), which also explained the decline of the Longquan kiln since the mid-Ming period. The Imperial Kiln in Jingdezhen was not particularly skilled in producing celadon ware; however, as shown by this bowl, which had the colour comparable to the fine Longquan celadon ware at the time with its precisely potted form and purity of the paste, the production standard of the Imperial Kiln in Jingdezhen had even surpassed that of the Longquan kiln.

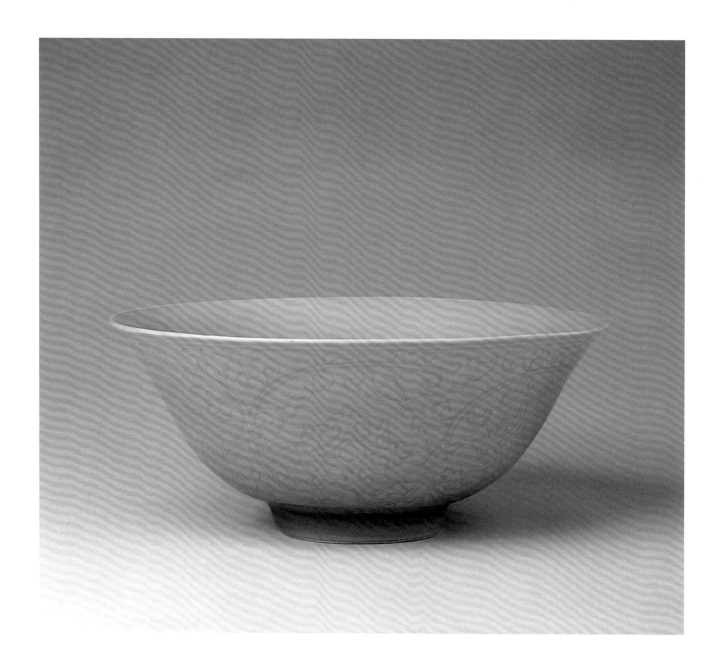

73

Foliated Plate
in imitation of Longquan ware in celadon glaze

Ming Dynasty Xuande period

Height 4.5 cm
Diameter of Mouth 21.5 cm
Diameter of Foot 14.5 cm

The plate has a foliated rim, a shallow curved wall, and a ring foot. The body is covered with a thick layer of imitated Longquan celadon glaze. The interior and exterior walls are decorated with eight S-shaped patterns along the petals of the hollyhock at the rim of the plate. The exterior base is written with a six-character mark of Xuande in regular script in two columns within a double-line medallion in underglaze blue.

The plate is potted with an elegant form with charming glaze colour, representing a refined piece of ware produced in the Imperial Kiln in Jingdezhen in imitation of Longquan celadon ware.

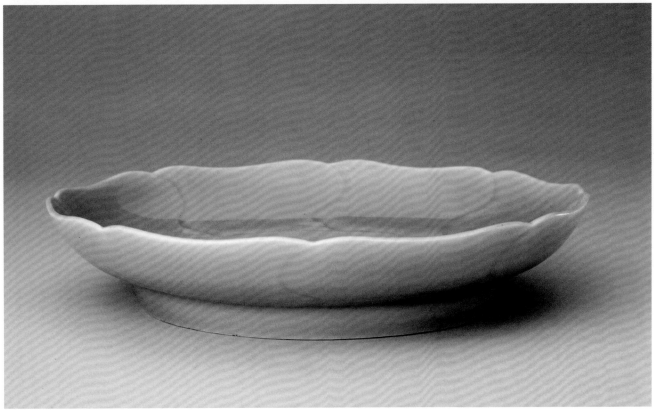

74

Vase
with a plate-shaped mouth
and carved and incised design
of *lingzhi* fungus scrolls
in imitation of Longquan
ware in celadon glaze

Ming Dynasty Jiajing period

Height 22.5 cm
Diameter of Mouth 10.6 cm
Diameter of Foot 9.5 cm

The vase has a rimmed mouth, a wide neck, a round belly, and a ring foot. The interior of the vase and the ring foot is covered with white glaze. The exterior wall is covered with imitated Longquan celadon glaze. Under the glaze are carved and incised designs of floral patterns. The shoulder is decorated with foliage scrolls, whereas the neck and belly with *lingzhi* fungi and the shank with deformed lotus petals. The exterior base is written with a six-character mark of Jiajing in regular script in two columns within a double-line medallion in underglaze blue.

The glaze colour and decorations on this vase are very similar to those of the Longquan celadon ware. However, the quality of the paste and the writing style of the reign mark show the distinctive features of the imperial ware produced in the Imperial Kiln in Jingdezhen.

75

Meiping Vase
with a plate-shaped mouth
and carved and incised design
of wave patterns in imitation
of Longquan ware
in celadon glaze

Qing Dynasty Kangxi period

Height 21.5 cm
Diameter of Mouth 6.2 cm
Diameter of Foot 8.5 cm

The vase has a plate-shaped mouth, a short narrow neck, a round shoulder, a tapering belly which is slightly flared near the shank, and a ring foot with two tiers inside. The body is covered with imitated Longquan celadon glaze. Under the glaze are carved and incised designs with the shoulder and upper belly incised with mat patterns and the lower belly with design of chrysanthemum petals. Near the foot are decorations of wave patterns.

76

Washer
in the shape of a lotus leaf in imitation of Longquan ware in celadon glaze

Qing Dynasty Yongzheng period

Height 7 cm
Diameter of Mouth 37 cm
Diameter of Base 30 cm

The washer is in the shape of a lotus leaf with a foliated rim and a flat base. The body is covered with imitated Longquan celadon glaze with greenish colour like jade and it has small ice-crackles.

There was a variety of brush washers in various shapes produced in the Imperial Kiln in Jingdezhen in the Yongzheng period. Those fashioned in the shape of a lotus leaf were usually of a refined quality with decorative appeal and functional use.

77

Jar
with carved design of
dragons amidst clouds
in relief in imitation of
Longquan ware
in celadon glaze

Qing Dynasty Qianlong period

Overall Height 31 cm
Diameter of Mouth 13.7 cm
Diameter of Foot 11.5 cm
Qing court collection

The jar has a rimmed mouth, a straight neck, a tubular belly, and a ring foot. It has a canopy-shaped cover on top of which is a round pearl-shaped knob. The body is covered with imitated Longquan celadon glaze. The exterior wall is carved with fierce dragons flying amidst clouds in low relief. The surface of the cover is carved with bats amidst clouds in low relief. The exterior base is carved with a six-character relief mark of Qianlong in seal script in three columns.

This jar is an imitation of the jar decorated with lotus sprays in relief in celadon glaze (Plate 70). In terms of the form, glaze colour, and carved designs, this jar reflects a high level of production quality.

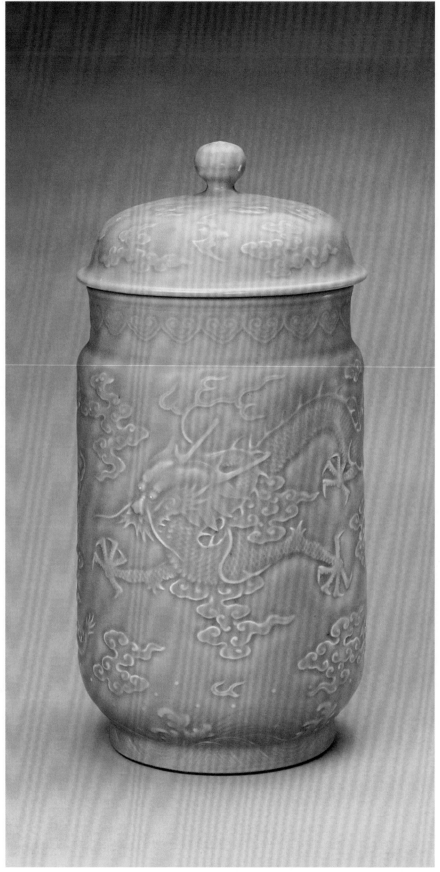

78

Covered Jar
with three loops
in bright green glaze

Ming Dynasty Yongle period

Height 10.4 cm
Diameter of Mouth 9.9 cm
Diameter of Foot 14.1 cm
Qing court collection

The jar has an upright mouth, a short neck, a round belly, and a ring foot. The shoulder is decorated with three applique supports in the shape of a begonia on which are three round loops with same intervals. The jar has a matching cover in the shape of a *gong* musical instrument with a convex surface. The interior of the jar and the ring foot are covered with greenish-white glaze, and the exterior wall of the jar is covered with bright green glaze.

This type of bright green glaze was a kind of high-temperature fired monochrome glaze first produced in the Imperial Kiln in Jingdezhen in the Yongle period. As the glaze colour resembled the bright green colour of bamboo skin, it was known as bright green glaze. Yongle ware in bright green glaze included flat jars and stem-cups with finely potted pastes with even thickness, and the feet of the ware were often finely treated. Their bodies were covered with bright green glaze without any decorations, representing a typical period characteristic of the Yongle period.

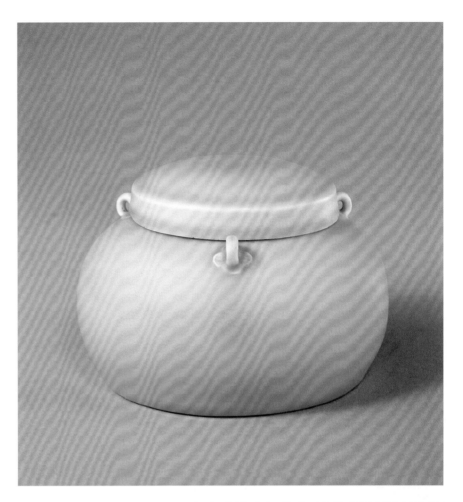

79

Stem-bowl
in *dongqing* celadon glaze

Ming Dynasty Yongle period

Height 11.3 cm
Diameter of Mouth 16 cm
Diameter of Foot 4.7 cm

The bowl has a flared mouth, a deep curved belly, and a thin base beneath which is a hollow stem in the shape of a bamboo trunk. The body is covered with even and pure *dongqing* celadon glaze. The glaze runs thin at the mouth rim and the joint area of the bamboo trunk, exposing the white paste.

The stem-bowl is finely fashioned with a graceful form and the stem is potted in the shape of a bamboo trunk, giving a harmonious charm to the ware and at the same time enhancing the stability of the ware.

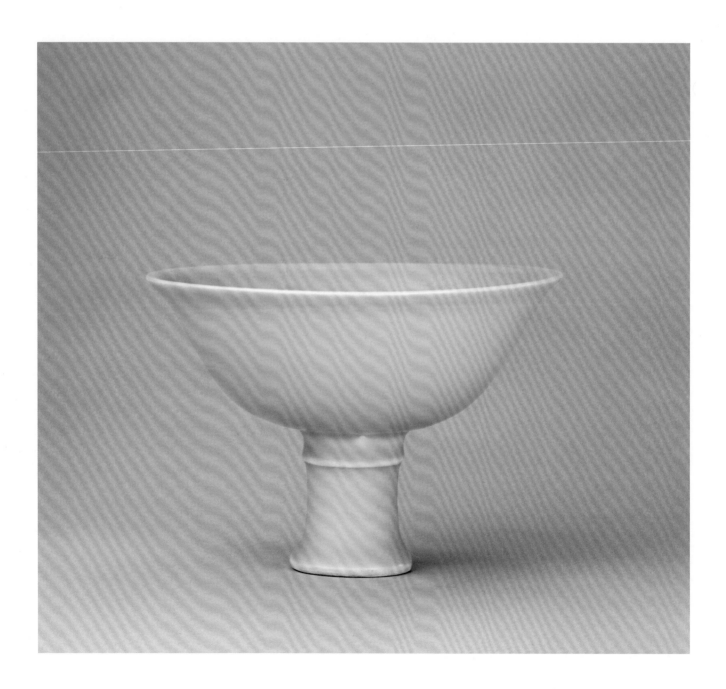

80

Vase
with carved design of
chrysanthemum petals in
relief in *dongqing*
celadon glaze

Qing Dynasty Kangxi period

Height 21.2 cm
Diameter of Mouth 5 cm
Diameter of Foot 4 cm
Qing court collection

The vase has a flared mouth, a slim
long neck, a slanting shoulder, a contracted
belly, and a ring foot. The body is covered
with light celadon glaze, and the interi-
or of the ring foot is covered with white
glaze. Near the base is a decorative border
of elongated chrysanthemum petals. The
exterior base is written with a six-character
mark of Kangxi in regular script in three
columns in underglaze blue.

This vase is covered with the *dong-
qing* celadon glaze which is a kind of high-
temperature fired celadon glaze with colour
deeper than greenish-blue and slightly
lighter than pea green celadon glaze.

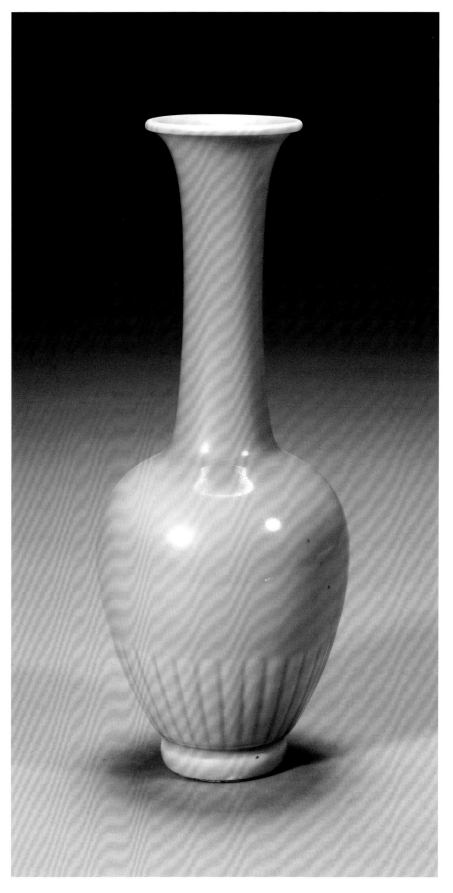

83

Vase
in apple green
celadon glaze

Qing Dynasty Kangxi period

Height 21.2 cm
Diameter of Mouth 8.4 cm
Diameter of Foot 8.9 cm
Qing court collection

The vase has a slightly flared mouth, a short neck, a slanting shoulder, an oval-shaped belly, a slightly contracted base, and a ring foot. The body is covered with apple green glaze with small ice-crackles. The interior of the ring foot is covered with white glaze. The exterior base is written with a six-character mark of Kangxi in regular script in three columns in underglaze blue.

This vase is finely fashioned with an elegant shape and covered with shiny and translucent celadon glaze with a greenish tint, which looks like the colour of apples, and thus is termed "apple green glaze".

84

Vase
with a lotus-shaped mouth,
animal mask-shaped ears
and carved design of
kui-dragons and phoenixes in
relief in greenish-blue
celadon glaze

Qing Dynasty Yongzheng period

Height 34 cm
Diameter of Mouth 2.5 cm
Diameter of Foot 10.5 cm
Qing court collection

The vase has a lotus-shaped mouth,
a slim long neck, a slanting shoulder,
a round belly, and a ring foot. The two
symmetrical sides of the shoulder are
decorated with ears in the shape of animal
masks. The body is covered with greenish-
blue celadon glaze. The body is carved
with designs in relief from top to bottom in
the sequence of lotus petals, banana leaves,
key-fret patterns, *kui*-phoenixes, and lotus
petals. The exterior base is written with a
six-character mark of Yongzheng in seal
script in three columns in underglaze blue.

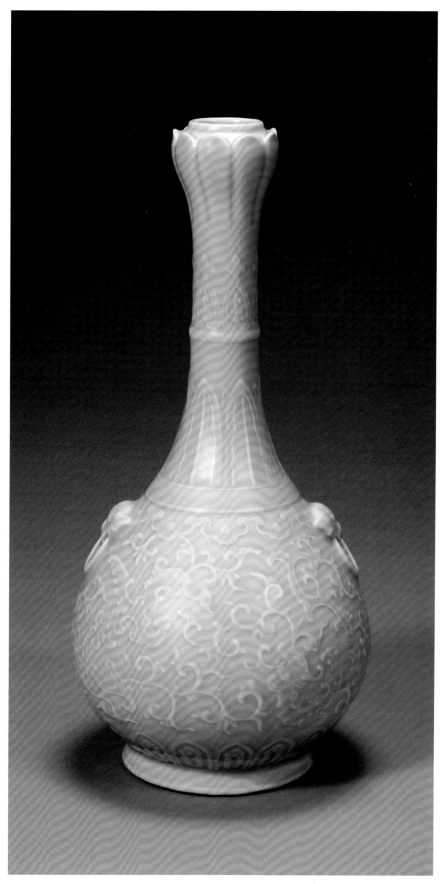

85

Garlic-head Vase

with *ruyi* cloud-shaped
handles and carved design of
lotus scrolls in relief
in greenish-blue celadon glaze

Qing Dynasty Yongzheng period

Height 22.9 cm
Diameter of Mouth 4.2 cm
Diameter of Foot 9.9 cm

The vase has a garlic-head shaped
mouth, a narrow neck, a globular belly, and
a ring foot. On the two symmetrical sides
of the shoulder are two ears in the shape
of *ruyi* clouds. The body is covered with
greenish-blue celadon glaze. The exterior
wall is decorated with various designs in
relief with the mouth decorated with lotus
scrolls, the neck with foliage scrolls, the
shoulder with *ruyi* clouds, the belly with
lotus scrolls, and the shank with lotus
petals. The exterior base is written with a
six-character mark of Yongzheng in seal
script in three columns in underglaze blue.

This type of vases was first produced
in the Imperial Kiln in Jingdezhen in the
Yongzheng period, and was also known as
the "*zun* vase with *ruyi* cloud-shaped ears",
which was found in the ware in underglaze
blue, *fencai* colour enamels, *doucai* colour
enamels, as well as ware in greenish-blue
celadon glaze and imitated Ru celadon
glaze.

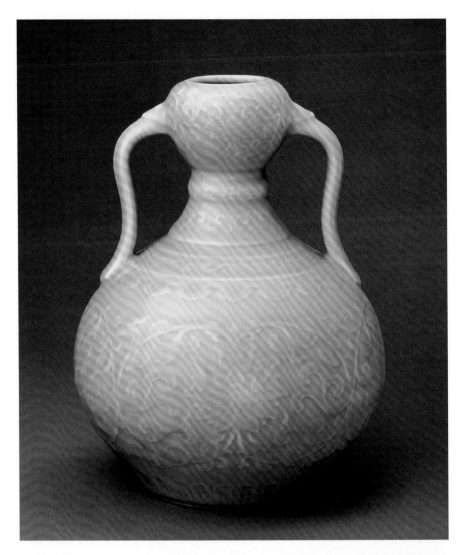

86

Zun Vase

with a flared mouth, lobed
sides and carved design of
kui-phoenixes and
decorative medallions in
relief in greenish-blue
celadon glaze

Qing Dynasty Yongzheng period

Height 34.3 cm
Diameter of Mouth 19.8 cm
Diameter of Foot 10.2 cm
Qing court collection

The *zun* vase is potted in the shape
of six lobes of flower petals. It has a long
flared mouth, a short neck, a flat round
belly, and a ring foot. The body is covered
with greenish-blue celadon glaze. The ex-
terior wall is decorated with various carved
designs in relief. The six lobed exterior side
of the mouth is decorated with deformed
phoenixes. On each of the two opposite
lobed sides at the belly are respectively
carved design of *chi*-tigers, *chi*-dragon
medallions, and twin-coin patterns. The
exterior base is written with a six-character
mark of Yongzheng in seal script in three
columns in underglaze blue.

This type of *zun* vases with an elegant
form and fluent linear configuration, re-
vealing creative fashioning without losing
charm of gracefulness, was first produced
in the Imperial Kiln in Jingdezhen in the
Yongzheng period.

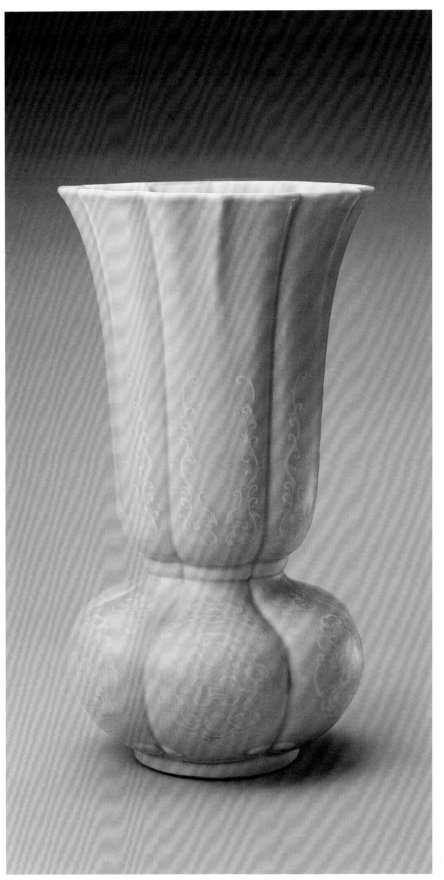

87

Vase

in the shape of a lantern with carved design of dragons and phoenixes in pursuit of pearls in relief in greenish-blue celadon glaze

Qing Dynasty Yongzheng period

Height 27.8 cm
Diameter of Mouth 9.3 cm
Diameter of Foot 9.2 cm

The vase has a flared mouth, an upright neck, a slanting shoulder, a tubular belly, and a ring foot. The body is covered with greenish-blue celadon glaze. The exterior wall is decorated with various motifs with the carved design of dragons and phoenixes in pursuit of pearls on the belly as the principal decoration. The exterior wall is written with a six-character mark of Yongzheng in seal script in three columns in underglaze blue.

As the form of this type of vases is fashioned in the shape of a lantern, it is known as the "lantern-shaped vase". This form first appeared in the early Ming period, and had become quite popular in the Yongzheng and Qianlong periods of the Qing Dynasty.

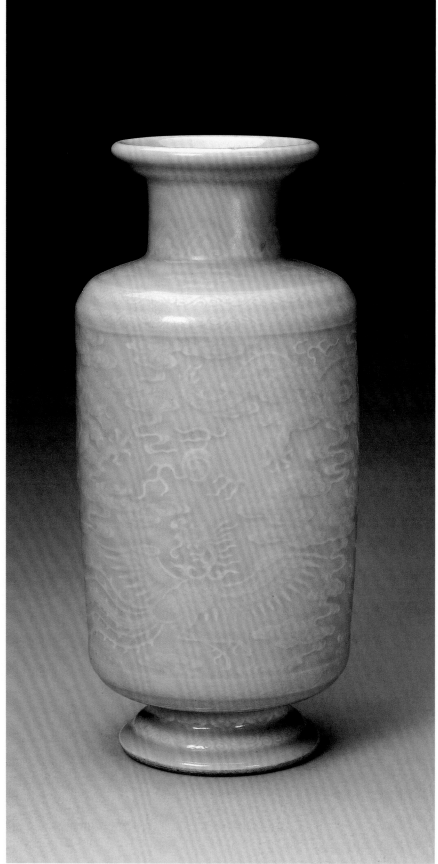

88

Zun Vase
in the shape of a fish-basket
and with carved
and incised design of weaved
bamboo patterns in
greenish-blue celadon glaze

Qing Dynasty Yongzheng period

Height 35.2 cm
Diameter of Mouth 20.3 cm
Diameter of Foot 23 cm

The *zun* vase has a plate-shaped mouth, a narrow neck, a flat round belly, and a ring foot. The body is covered with greenish-blue celadon glaze beneath which are carved and incised design of weaved bamboo patterns. The mouth and the shoulder are decorated with two borders of string patterns respectively.

This *zun* vase is fashioned in the shape of a fish-basket, and thus known as the "fish-basket vase". The decorative design of imitated bamboo weaving is rendered in a naturalistic manner resembling the original bamboo weaved fish basket, reflecting the prolific skills of potters at the time.

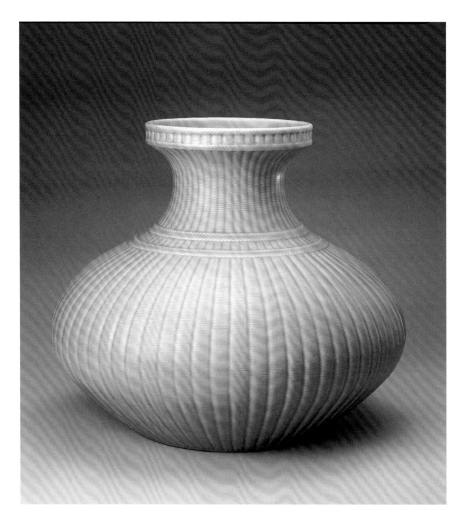

89

Celestial-sphere Vase
with carved design of
dragons amidst waves and
clouds in relief in
greenish-blue celadon glaze

Qing Dynasty Qianlong period

Height 58 cm
Diameter of Mouth 11.3 cm
Diameter of Foot 16.5 cm
Qing court collection

The vase has an upright mouth, a long neck, a round belly, and a ring foot. The body is covered with greenish-blue celadon glaze. The exterior wall is decorated with various layers of designs, including wave patterns, *ruyi* cloud lappets, banana leaves, dragons amidst crested waves and clouds, etc. The decorative treatment is luxuriant and well composed. The exterior base is written with a six-character mark of Qianlong in seal script in three columns in underglaze blue.

As the belly of this type of vases is fashioned in the shape of a sphere, it is known as the "celestial-sphere vase". Such type of vases was first produced in the Yongle period of the Ming Dynasty, and continued in the Yongzheng and Qianlong period. They were represented among ware in underglaze blue, underglaze red, underglaze blue and red, rouge red enamels and underglaze blue, various colour glazes, and others.

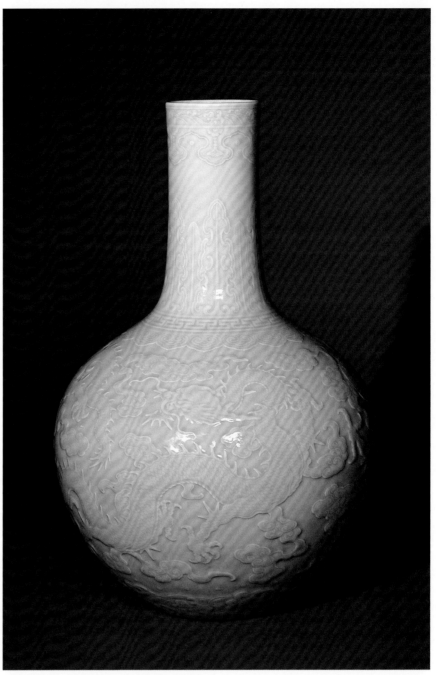

90

Hexagonal Fitting Vase
with openwork design of
peony scrolls in
greenish-blue celadon glaze

Qing Dynasty Qianlong period

Height 39 cm
Diameter of Mouth 10.4 cm
Diameter of Foot 14 cm
Qing court collection

The vase has two layers: the interior and exterior bodies. The exterior body is fashioned hexagonal in shape with a flared mouth, a slim long neck, a globular belly, and a slightly flared hexagonal ring foot. The body is covered with greenish-blue celadon glaze. The neck is decorated with carved and incised design of peony scrolls. The exterior base is written with a six-character mark of Qianlong in seal script in three columns in underglaze blue. Inside the exterior body is an interior bladder decorated with underglaze blue designs.

The production of this vase is complicated and the openwork structure is rendered with exquisite skills, reflecting the superb production skills at the time.

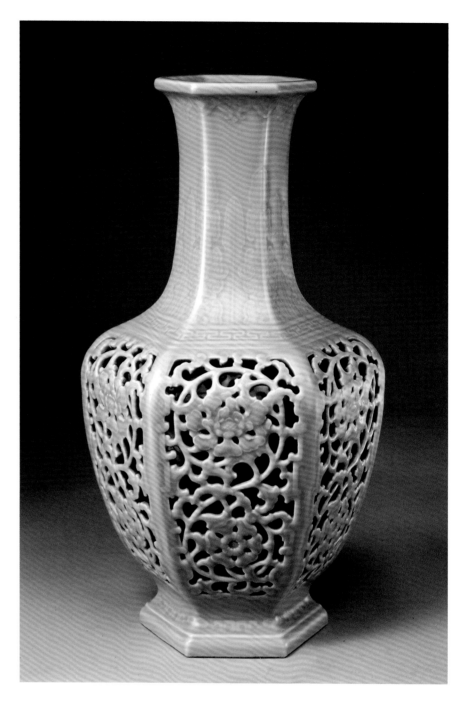

91

Jiaotai Vase

with carved design of *kui*-dragons and *ruyi* cloud patterns in relief in greenish-blue celadon glaze

Qing Dynasty　Qianlong period

Height 16 cm
Diameter of Mouth 6.9 cm
Diameter of Foot 8 cm
Qing court collection

The vase has a flared mouth, a short neck, a slanting shoulder, a hanging belly, and a ring foot. The body is covered with greenish-blue celadon glaze. The shoulder and the belly are decorated with carved design of *kui*-dragons in relief. The belly is further decorated with interlocking design of upright and inverted *ruyi* cloud patterns in openwork, symbolizing the auspicious attribute of *jiaotai* (harmony between the heaven and the earth). The exterior base is written with a six-character mark of Qianlong in seal script in three columns in underglaze blue.

In the book *I Ching*, there is a trigram of "the heaven and earth merge in harmony", which carries the attribute of "when the heaven and earth merge in harmony, the destiny would be smooth and lucky all along". With interlocking parts that fit harmoniously, the form of this vase is derived from such an auspicious attribute, and is named the "*jiaotai* vase" (harmony vase). According to the archive of the Qing court, this type of vases was an innovative form produced under the supervision of Tang Ying, Director General of the Imperial Kiln in the Qianlong period. The production process was rather sophisticated, in that after the vase was potted and still wet, it would be necessary to carve a gap in between the parts, decorate it with various designs, and glaze it. In packing the ware for firing in the kiln, potters would insert small clay beads in the gap between the upper and lower interlocking parts to avoid sticking together, and then remove the beads after firing in order to keep the gap open.

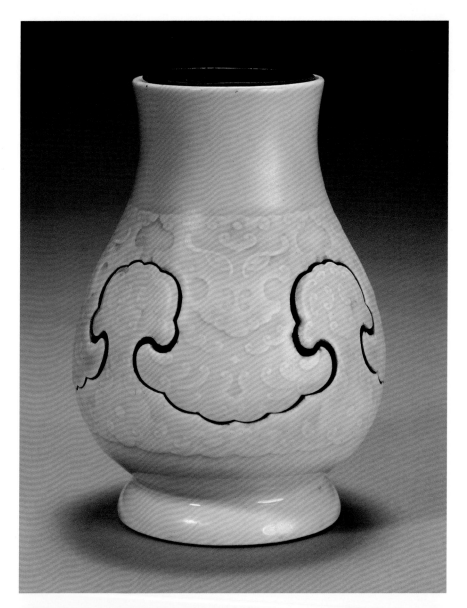

92

Luozi Zun Vase
with carved design of
knot-baskets in relief in
greenish-blue celadon glaze

Qing Dynasty Qianlong period

Height 16.6 cm
Diameter of Mouth 7.7 cm
Diameter of Foot 7 cm
Qing court collection

The *zun* vase has a flared mouth, a short neck, a round belly, and a ring foot. The body is covered with greenish-blue glaze. The belly is decorated with knot-basket patterns carved in relief. The exterior base is written with a six-character mark of Qianlong in seal script in three columns in underglaze blue.

Luozi refers to the traditional Chinese craft of fastening knots, as well as the net-shaped knot-basket used for storing strings for fastening knots, which is also commonly known as Chinese knots nowadays.

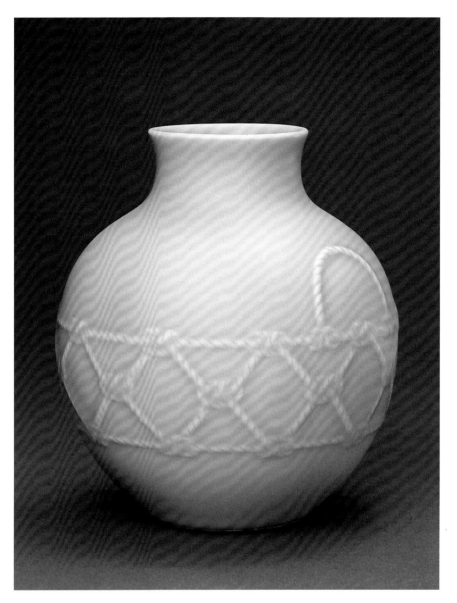

94

Waist-drum
in suffused glaze

Tang Dynasty

Length 58.9 cm
Diameter of Surface 22.2 cm

The waist-drum has wide drum faces and a slim waist. The body is covered with black glaze both in the interior and on the exterior. The exterior side is decorated with over ten suffused splashed patches with sky blue glaze and seven borders of string patterns in relief.

The waist-drum had various names such as the small waist-drum, the pole-drum, the beating drum, the *wei* drum, the second drum of Han drum, etc., which was introduced from the Western Territories. During performance, the two ends of the drum had to be bound with python skin for beating by hands or drum-sticks. In the Tang Dynasty, music and dance performances of the Western Territories were popular, and the waist-drums were popularly used in music performances. Various materials, such as porcelain or wood, were used for producing these drums. Kilns which produced this type of waist-drums in suffused glaze included the Lushan kiln, the Xiabaiyu kiln of Yu county, the Yaozhou kiln, the Jiaocheng kiln, and others, and this waist-drum was a product of the Lushan kiln, Henan. This waist-drum is not only a valuable artifact for the studying of ware in suffused glaze in the Tang Dynasty, but also for the study of the history of music in ancient China.

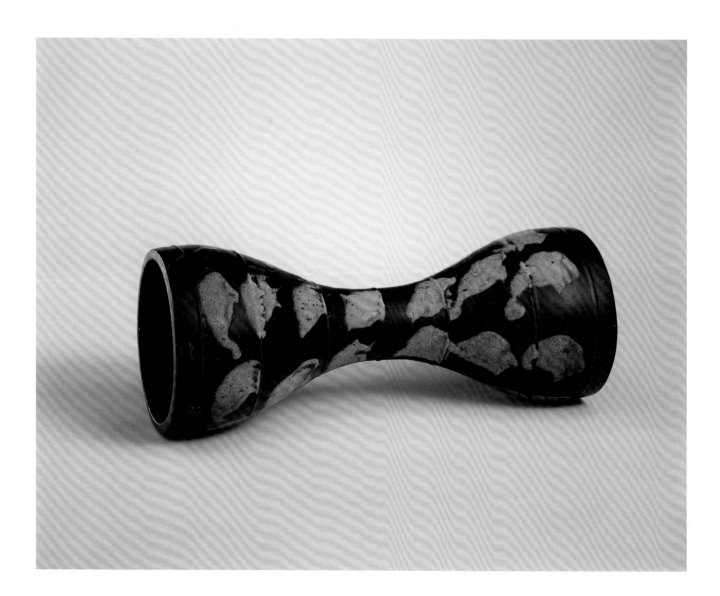

95

Washer
in the shape of a Manchurian catalpa leaf in Jun blue glaze

Shiwan ware
Ming Dynasty

Height 6.7 cm
Length 26.3 cm
Width 18.9 cm

The washer is fashioned in the shape of a Manchurian catalpa leaf with carved recess and relief leave veins. The rim of the leaf is further decorated with four blooming flowers in applique with seven buds. The body is covered with thick Jun blue glaze with raindrop-shaped onion white mottles.

The washer is thickly potted with a creative form and suffused glaze with colour gradations. The folded rim of the leaf resembles a leaf being blown by breeze with a touch of naturalism and charm.

The Shiwan kiln was located at the present Shiwan town of Foshan city, Guangdong, which was a famous provincial kiln in the Ming and Qing dynasties, and was most esteemed for producing imitated Jun ware.

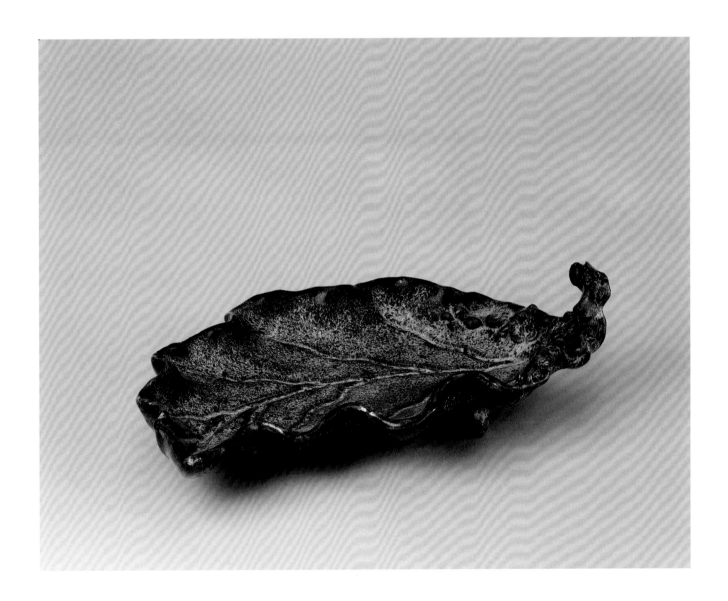

96

Zun Vase
with flanges in moon white glaze

Jun ware
Song Dynasty

Height 32.6 cm
Diameter of Mouth 26 cm
Diameter of Foot 21 cm
Qing court collection

The *zun* vase is modeled after the ancient bronze *zun* wine-container with a trumpet-shaped mouth, a flat globular belly, and a flared ring foot. The body is covered with moon white glaze with massive bubbles inside the glaze and palm eyes on the surface of glaze. Owing to the melting and dripping of glaze during high-temperature firing, the glaze turns thin at the flanges on the sides of the vase, exposing the yellowish-brown paste. The four sides of the neck, the belly, and the shank are decorated with flanges in applique. The interior wall of the ring foot is carved with the numeral "*san*" (three).

Jun kiln was one of the largest kilns in North China in the Song, Jin, and Yuan dynasties and located at the Yu city, Henan with the most representative kilns located near Juntai and Baguadong. In ancient Chinese legend, it was said King Dayu (Yu the Great) offered the throne to his son at Juntai from which the kiln was named "Jun kiln". Jun ware included celadon ware with molded designs, white ware with carved designs in black glaze, ware in black glaze, and others. The most distinctive type was the ware in opacified blue glaze, and the most elegant ware was the one covered with flambé glaze suffused in blue and purplish-red glaze.

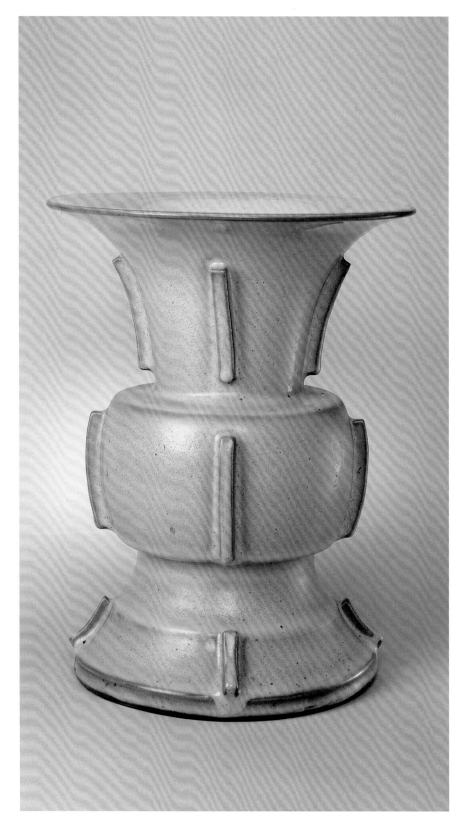

97

Pear-shaped Vase
in moon white glaze

Jun ware
Northern Song Dynasty

Height 27.5 cm
Diameter of Mouth 4.9 cm
Diameter of Foot 7 cm
Qing court collection

The vase (*Yuhuchun*) has a slightly flared mouth, a slim long neck, a slanting shoulder, a hanging belly, and a ring foot. The body is covered with moon white glaze and the rim of the ring foot is unglazed.

The glaze colour of Jun ware is opacified blue glaze with different tonal gradations, such as sky blue, sky green, moon white, and others. The glaze layer is thick and opaque which could cover the colour of the paste and various defects. Jun ware includes daily utensils such as bowls, plates, washers, jars, vases, incense-burners, pillows, the colour of which is mostly sky blue glaze. Some of them carry red or purplish-red patches, but few of them are fully glazed with rose purple or begonia red colour. As they were mostly used by common people, they were often known as "local (people) Jun ware". Jun ware had been very popularly produced in the Jin and Yuan dynasties, and its influence extended to various kilns in Henan, Hebei, Shanxi in North China, and even to some kilns in the Zhejiang province in South China, which produced imitated Jun ware.

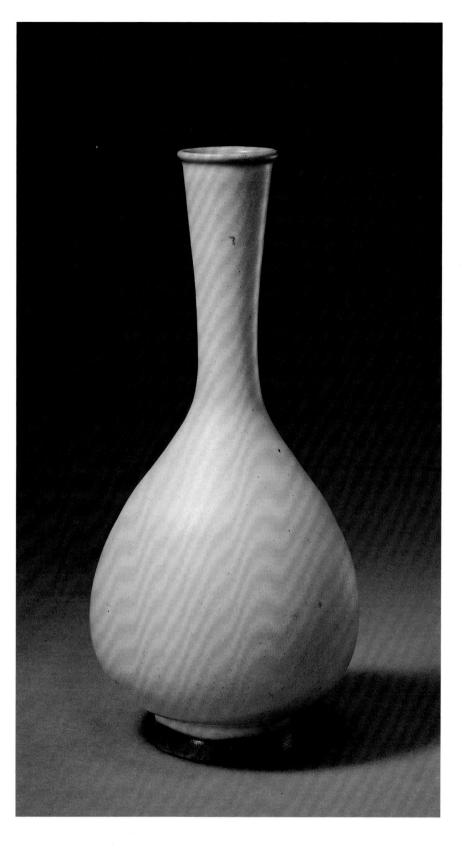

98

Flower Pot
in the shape of a spittoon in rose purple glaze

Jun ware
Northern Song Dynasty

Height 18.4 cm
Diameter of Mouth 20.1 cm
Diameter of Foot 12 cm

The flower pot is in the shape of a spittoon. It has a flared mouth, a long straight neck, a globular belly, and a high ring foot. The interior and exterior of the body are covered with different colour glazes. The interior mouth rim is glazed half and half in rose purple and sky blue, and the parts beneath are glazed with entwined flambé glaze in blue and purple. The part from the exterior mouth rim to the neck is glazed in sky blue with suffused splashes in rose red. The belly is principally glazed in rose red. The exterior base is covered with sesame brown glaze with five round holes for releasing water during firing, and is carved with the numeral "*liu*" (six).

The most exquisite Jun ware includes various decorative ware such as flower pots in different shapes, stands for flower pots, *zun* vases, and others, and the bases or interior sides are often carved with a Chinese numeral ranging from one to ten respectively. Traditionally it was attributed that such ware was produced exclusively in the period of Emperor Huizong for decorating the imperial garden "Mountain of Longevity and Majestic Peaks (genyue)", and thus was regarded as imperial ware known as guan Jun ware. Such imperial ware is noted for distinctive type forms and elegant glaze colours with tonal gradations and naturalistic flavour, which include rose red, eggplant aubergine, lilac purple, begonia red, and others. In recent years, experts and scholars have different views on the types and production periods of such Jun ware, and pose various dates attributing to the Jin Dynasty, Yuan Dynasty, or early Ming Dynasty, which need further studies.

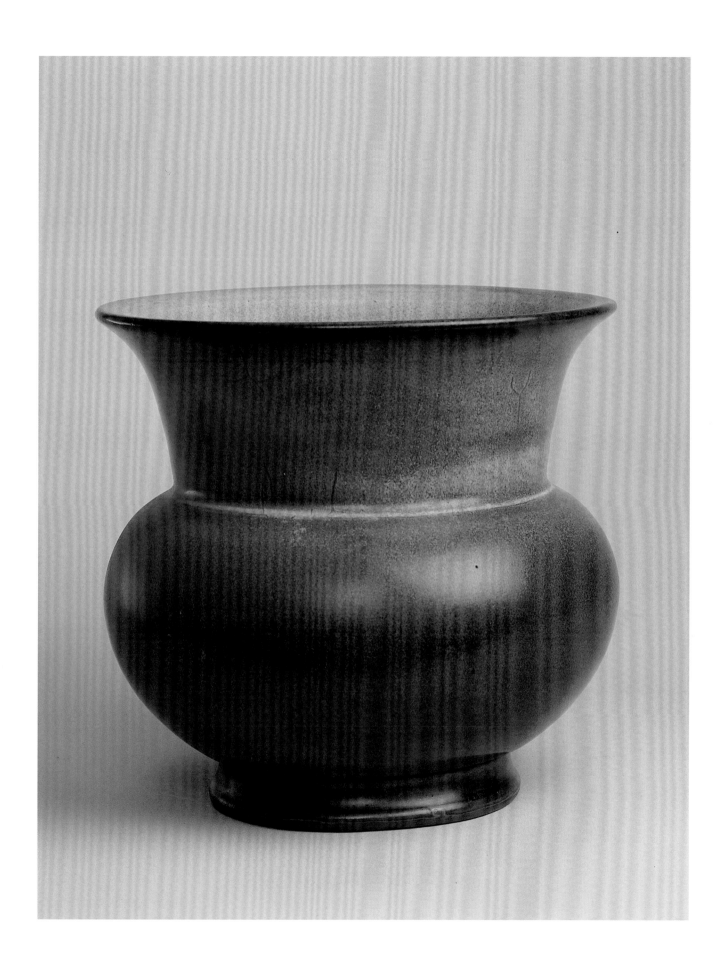

99

Foliated Flower Pot
in rose purple glaze

Jun ware
Northern Song Dynasty

Height 18.2 cm
Diameter of Mouth 26.7 cm
Diameter of Foot 13.3 cm
Qing court collection

The flower pot is in the shape of six foliated petals with a wide mouth, a folded rim on which is a small border in relief, a deep belly with the upper part wider and the lower part tapered, and a foliated low ring foot. The interior is covered with sky blue flambé glaze, and the exterior wall is covered with rose purple flambé glaze with bubbles and palm eyes on the glaze surface. The border of the mouth rim and the ribbed borders in the interior wall have a brownish tint, whereas the ribbed border under the foliated rim and the ribbed borders on the exterior wall has a purplish-white tint. The exterior base is covered with brownish glaze for protecting the paste and has five round holes for releasing water during firing (which are now blocked). It is carved with the numeral "*san*" (three).

The traditional high-temperature firing colour glaze is the celadon glaze with ferrous iron oxide as colorant. Potters of the Jun kiln first utilize copper oxide as colorant and after reduction firing, the glaze would turn into the copper red flambé glaze. The carved numerals on the Jun decorative ware indicate the size of the ware, ranging from the largest size with the smallest numeral, and thus the smallest numeral one represents the largest size. According to the archival documents of the Qing court, potters in the Qianlong period had imitated the original numeral on a vessel and added additional numerals, or modified the original numeral on the Jun ware collected by the Palace. Therefore it must be very careful to authenticate the numerals as to whether they were the original or were later added or modified on the extant decorative Jun ware collected by the Palace of the Qing Dynasty.

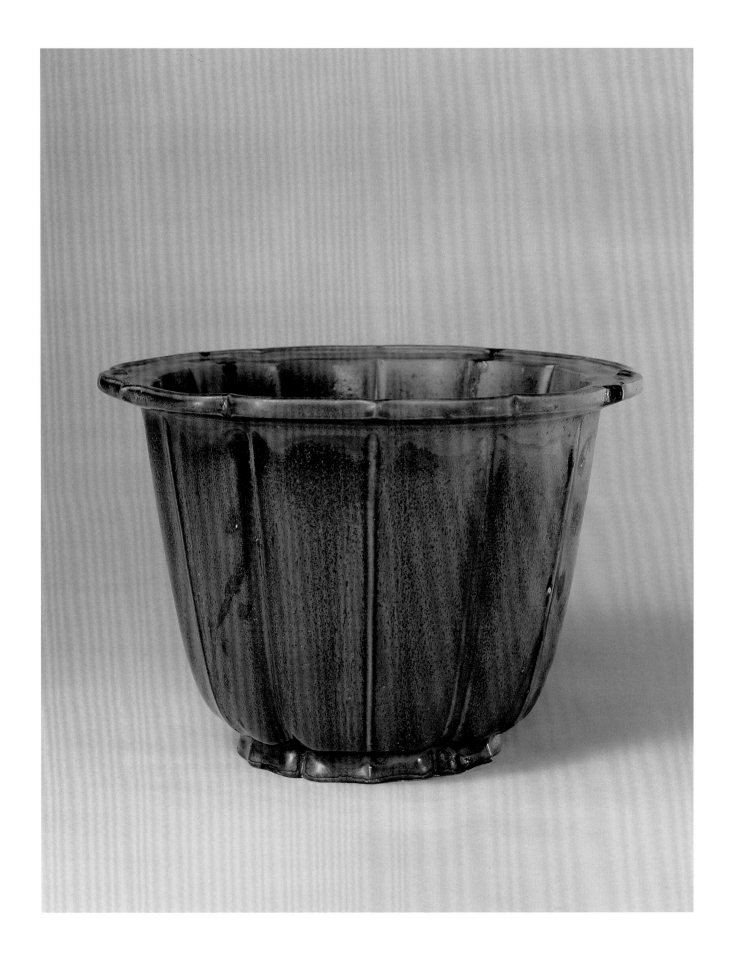

100

Flower Pot
in the shape of a begonia in rose purple glaze

Jun ware
Northern Song Dynasty

Height 14.7 cm
Diameter of Mouth 23.3 × 18.6 cm
Distance between Legs 8 cm

The flower pot is in the shape of a begonia with four petals. It has a wide mouth, a folded rim on which is a small border in relief, a deep belly with a wide upper part, and a contracted lower part, and it is supported by four legs in the shape of *ruyi* cloud patterns. The interior is covered with sky blue flambé glaze. The exterior is covered with rose purple flambé glaze with bubbles and palm eyes. The border of the mouth rim and the ribbed borders in the interior have a brownish tint, whereas the ribbed border under the folded rim and the ribbed borders on the exterior wall have a purplish-white tint. The greyish paste is exposed on the base of the four legs. The exterior base is covered with brownish glaze for protecting the paste and has a border of spur marks, five round holes for releasing water during firing. It is carved with the numeral "*si*" (four). The base of the flower pot is carved with the characters "*Chonghuagong*" (Chonghua Palaces) and "*jinzhao yucui yong*" of the Qing court.

According to *Qinggong Neiwufu Zaobanchu Ge Zuocheng Zuohuo Jiqingdang*, Emperor Qianlong had paid much attention to the colllection of decorative Jun ware. In the 11th year of the Qianlong period (1746), he ordered the craftsmen of the Department of Imperial Household to start carving the names of the palaces on and marking the display locations of these decorative objects. As found on extant ware, the format of carving was to put the name of the palace on the upper side from right to left, and the exact display location on the lower side vertically.

The Chonghua Palaces were located at the north of the six western palaces at the west avenue of the imperial court in the Forbidden City, which were two palaces listed in the five palaces at the west of the Qianqing Hall, and they were the residence of Emperor Qianlong when he was still a prince. After he assumed the throne, these two palaces were upgraded as the Chonghua Palaces.

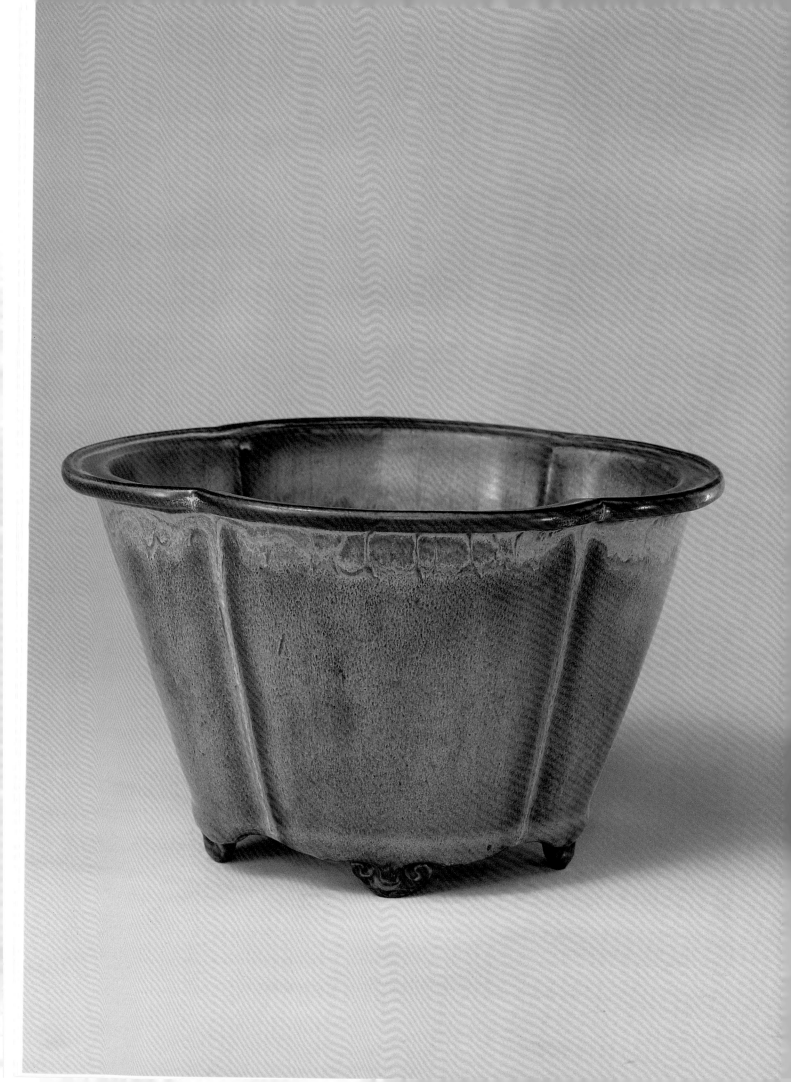

111

Vase

with a flat belly and design of
string borders in relief
in flambé glaze

Qing Dynasty Yongzheng period

Height 25.3 cm
Diameter of Mouth 7 cm
Diameter of Foot 11.7 cm
Qing court collection

The vase has a plated-shaped mouth, a slim long neck, a flat round belly, and a flared ring foot. The body is covered with shiny flambé blaze with colours of red, purple, blue, moon white, and others. On the brown glazed interior base are several irregular green glaze mottles. The neck is decorated with five borders of string patterns in relief, and the shoulder is decorated with two borders of similar patterns. The exterior base is engraved with a four-character mark of Yongzheng in seal script in two columns.

This vase is fashioned with an elegant and stern form. The glaze colours suffuse luxuriantly with the colours of red and blue splashing spontaneously like flames, which are respectively known as "flaming red" and "flaming blue" glazes.

With a firm foundation in imitation of Jun glazes, this innovative type of flambé glaze was first produced in the Imperial Kiln in Jingdezhen in the Yongzheng period. As the glaze contains various chemicals such as copper, iron, manganese, cobalt, titanium, and others, different colours would be produced after high-temperature reduction firing.

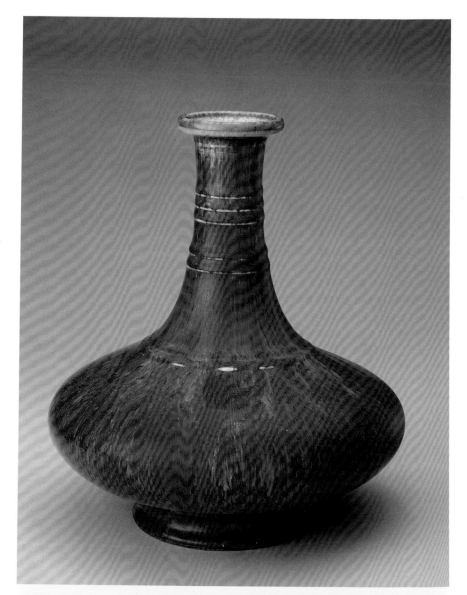

112

Vase
with tubular ears in flambé glaze

Qing Dynasty Yongzheng period

Height 33.3 cm
Diameter of Mouth 10.7 cm
Diameter of Foot 13.5 cm

The vase has an upright mouth, a long neck, a globular belly, and a flared ring foot. On the two symmetrical sides of the neck are two tubular ears. The interior of the vase is covered with sky blue glaze, and the exterior is covered with flambé glaze. The interior of the ring foot is covered with brown glaze with uneven colour. The exterior base is engraved with a four-character mark of Yongzheng in seal script.

The glaze colours on this vase are suffused in red and blue, which look like flames and represent the distinctive characteristic described as "It is in a single colour when packed into the kiln for firing, but after firing, ten thousand colours would come out".

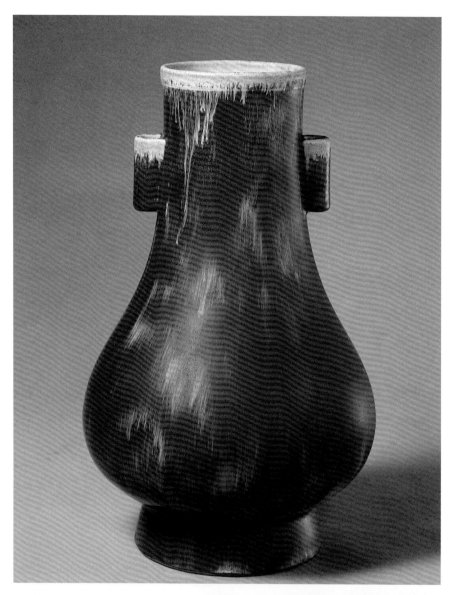

113

Gang Jar
in the shape of an alms bowl in flambé glaze

Qing Dynasty Qianlong period

Height 33.2 cm
Diameter of Mouth 31.2 cm
Diameter of Foot 20.7 cm

The *gang* jar is in the shape of a deep alms bowl with a contracted mouth, a round belly, and a ring foot. The interior of the jar is covered with celadon glaze, and the exterior is covered with flambé glaze with red as the principal colour, and with moon white, sky blue and other colours complementing each other. The interior of the ring foot is covered with brown glaze. The exterior base is engraved with a six-character mark of Qianlong in seal script in three columns.

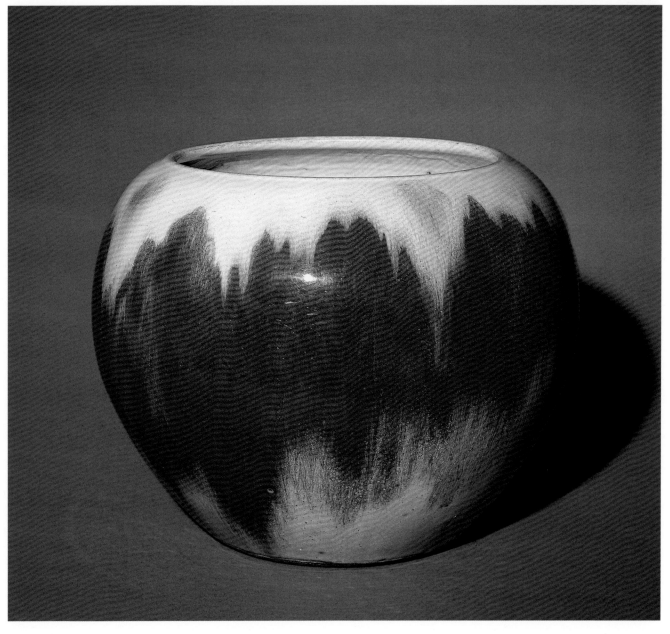

114

Xingyuan Vase
with tubular ears
in flambé glaze

Qing Dynasty Guangxu period

Height 25.8 cm
Diameter of Mouth 10.8 × 7.3 cm
Diameter of Foot 10.2 × 6.9 cm
Qing court collection

The *xingyuan* vase has a square mouth, a straight neck, a slanting shoulder, a globular belly, and a square ring foot. On the two symmetrical sides of the neck are two tubular ears. The area from the lower side of the mouth to the shoulder turns in a flattened angle. The body is covered with flambé glaze. The interior of the ring foot is unglazed. The exterior base is engraved with a six-character mark of Guangxu in regular script in two columns.

Such type of *xingyuan* vases was a traditional form in Chinese ceramics, and had been produced in every period since the Yongzheng period, which was commonly known as "square vases with tubular ears". "*Xingyuan* vase" was the term recorded in the court archive of the Qing Dynasty.

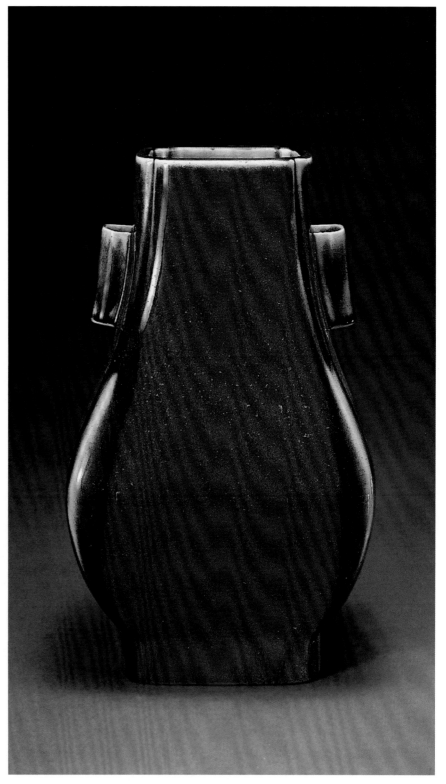

115

Vase
with a mouth in the shape of
lotus petals and ears with
design of animal masks
in robin's egg glaze

Qing Dynasty Yongzheng period

Height 32.2 cm
Diameter of Mouth 3.5 cm
Diameter of Foot 10 cm
Qing court collection

The vase has a mouth in the shape
of lotus petals, a slim long neck, a globu-
lar belly, and a ring foot. On the two
symmetrical sides of the shoulder are two
ears with design of animal masks. The body
is covered with robin's egg glaze. The neck
is decorated with a border of string patterns
in relief. The exterior base is engraved with
a four-character mark of Yongzheng in seal
script in two columns.

Robin's egg glaze was a new type
of glaze produced in the Imperial Kiln in
Jingdezhen in the Yongzheng period, Qing
Dynasty in imitation of Jun glaze fired in
low-temperature. The glaze was applied on
porcelain ware as well as on Yixing purple
clay ware. The basic feature was that the
blue glaze dripped into vertical bands with
deep red or blue mottles within the glaze.
After firing, purple-red, blue, green, moon
white, and other colours merged and suf-
fused together. Ware in robin's egg glaze
of the Yongzheng period was characterized
with reddish colour with a purplish tint,
which resembled the colour of ripe Chinese
sorghum (*gaoliang*) and thus was named
"Chinese sorghum-red" glaze.

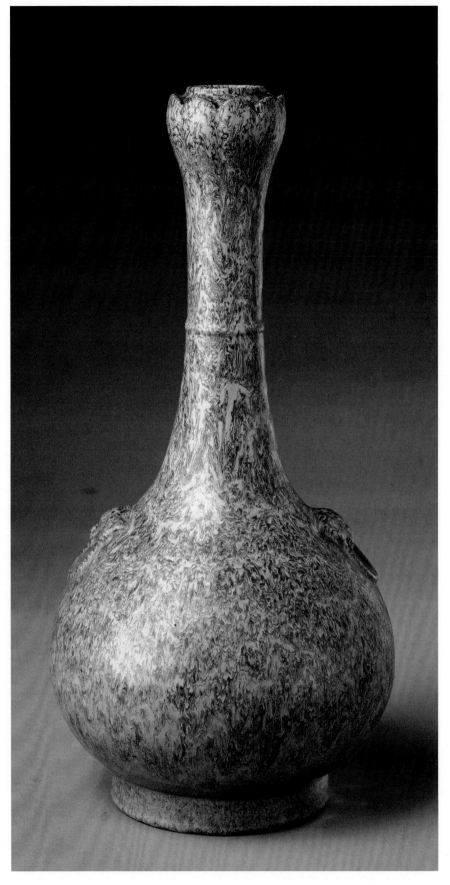

116

Vase
in the shape of *Cong*
with design of eight trigrams
in relief in robin's egg glaze

Qing Dynasty Qianlong period

Height 37.3 cm
Diameter of Mouth 8.6 cm
Diameter of Foot 12.1 cm
Qing court collection

The vase is fashioned in the shape of the ancient jade *cong* with a small mouth, a square belly, and a ring foot. The body is covered with robin's egg glaze. The four sides of the exterior wall are decorated with design of eight trigrams in relief. The exterior base is engraved with a six-character mark of Qianlong in seal script in three columns.

Porcelain ware in imitation of ancient jade *congs* was produced as early as the Song Dynasty. The Qing court followed the practice in the Ming Dynasty of using porcelain ware as sacrificial vessels and had produced a large amount of ware in imitation of ancient bronze and jade ware for use in imperial sacrificial ceremonies or for decorative purposes.

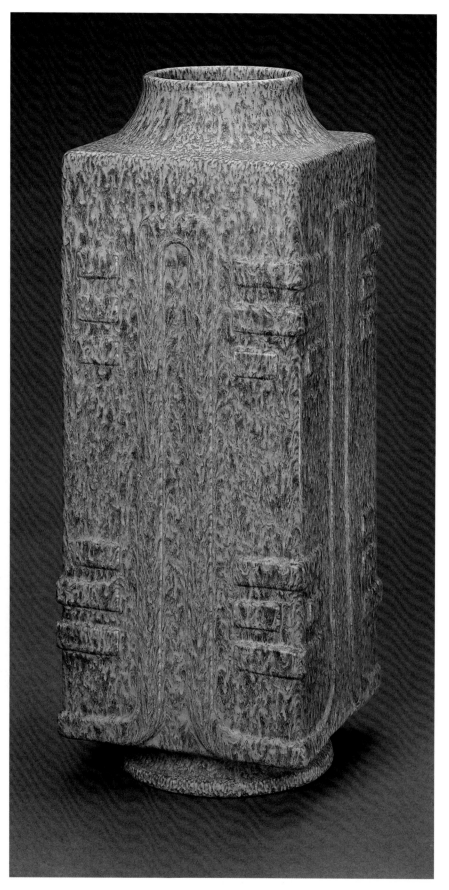

WARE IN WHITE GLAZE

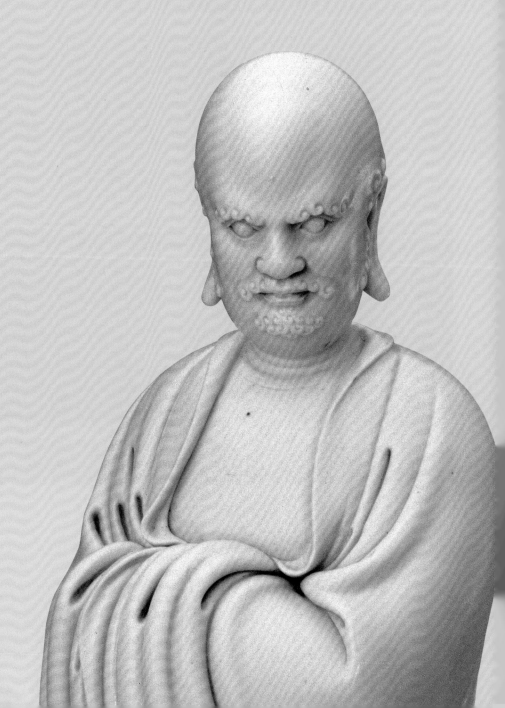

119

Jar
in white glaze

Sui Dynasty

Height 19.2 cm
Diameter of Mouth 9.7 cm
Diameter of Base 15.2 cm

The jar has a rimmed mouth, a short neck, a slanting shoulder, a deep belly, and a flat base. The paste is pure white and finely potted. The interior and exterior of the jar are covered with white glaze with glaze on the exterior wall stopping above the foot. The glaze with small ice-crackles is in pure white colour with perfect condition.

In the Sui Dynasty, potters paid much attention to the selection and grinding of porcelain pastes. The bodies of ware had become thinner with their forms finely potted and covered with pure and even white glaze. The production qualities of such ware were very close to those of the present day white glazed ware. The Palace Museum has collected two jars of this type, which best represent the high quality ware in white glaze of the Sui Dynasty.

The colour of Chinese ancient ware in white glaze is actually the colours of the slip and paste covered by transparent glaze. If the quality of the paste is fine and in pure white colour, then transparent glaze would be applied directly on it. Ware in white glaze produced in the Xing kiln, the Ding kiln, the Jingdezhen kiln and the Dehua kiln all belongs to this type. However, if the quality of the paste is not fine, then a layer of slip would be applied on the ware first, which would be covered with transparent glaze afterwards, as represented by the ware in white glaze produced in the Cizhou kilns.

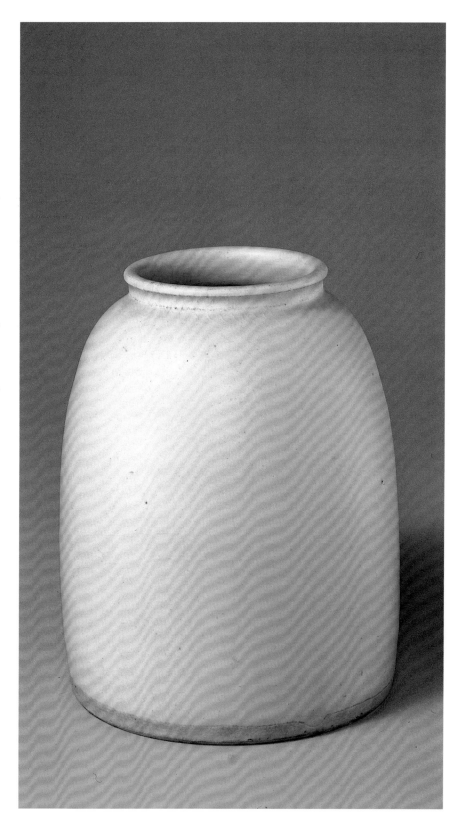

120

Vase
in white glaze

Xing ware
Tang Dynasty

Height 14.4 cm
Diameter of Mouth 6 cm
Diameter of Base 4.5 cm

The vase has a flared mouth, a short neck, a slanting shoulder, a contracted belly, and a flat base. The pure white paste is finely potted. The body is covered with transparent glaze with its surface pure and clear. The shoulder is carved and incised with two borders of string patterns.

This vase with an elegant and delicate form is finely potted and glazed in pure white with perfect condition. It is the only extant ware of its type and represents a rare and valuable piece. Among extant and unearthed pieces of Xing ware in white glaze, most are plates and bowls, and vases are quite rare. In the historical documents of the Tang Dynasty, Xing vases in white glaze were known as "*neiqiu* vases". In a poem *Thirty Rhymes to Mark Drinking of the Shenqu Wine,* Yuan Zhen, a poet of the Tang Dynasty, described them as "use *Jing* jade wine-cups with sculptured and carved decorations, as well as *neiqiu* vases that were finely fired and produced".

The Xing kiln was the most famous kiln for producing ware in white glaze in the Tang Dynasty. Its site was at the Neiqiu county, Xingtai city, Hebei. At that time, Xingtai was under the jurisdiction of Xingzhou, and therefore the kiln was known as the Xing kiln. It was recorded in the historical documents of the Tang Dynasty that "Xing ware was commonly used by both nobles and laymen", which revealed their popularity at the time. Xing ware in white glaze of the Tang Dynasty had also been excavated at Iraq, Ceylon, Pakistan, Japan, and Egypt, which showed that they were also exported overseas.

121

Pilgrim Flask
with a carved inscription "*Xuliushiji*" in white glaze

Xing ware
Tang Dynasty

Height 12.5 cm
Diameter of Mouth 2.2 cm
Diameter of Base 12.5 cm
Qing court collection

The flask has a low and flat body which is narrower at the upper part and wider at the lower part. On its top is a high overhead handle and on the two sides are a tube-shaped spout and a curved tail decoration. The white glaze has a greenish tint and stops just above the base. The base is unglazed, exposing the paste. The belly is decorated with three borders simulating sewn seams of a leather bag in "U" shape linking to the spout and the tail. The exterior base is engraved with four characters "*Xuliushiji*" on the left side.

The form of the Pilgrim flask derived from the leather bags used by the Khitan tribe in the North. In the Tang Dynasty, the court had close communication with various minority tribes including Khitan, and thus it was reasonable that the Xing kiln had been influenced by the nomadic culture. After the Khitans founded the Liao Kingdom, they had learnt the production techniques of ceramic production from China and established their own kilns with this type of pilgrim flasks produced as a significant form of Liao ware. Archaeological findings reveal that there were five types of pottery and porcelain pilgrim flasks, including flasks with a flat body and a single hole, a flat body with two holes, a flat body with an overhead handle, a round body with an overhead handle, and a low body with an overhead handle. As the form of the upper part of some of these flasks was modeled after a cock's comb or a stirrup, they were also known as "cock's comb flasks" or "stirrup flasks".

122

Vase
in the shape of a melon
with ring-shaped loops
in white glaze

Ding ware
Five Dynasties

Height 23.7 cm
Diameter of Mouth 7.6 cm
Diameter of Foot 10.1 cm

The vase has a flared mouth, a thick rim, a straight neck, a long round flattened belly in the shape of a four-lobed melon, and a flared ring foot. On the shoulder and the lower belly is a pair of ring-shaped loops for fastening strings respectively. The body is covered with pure and even white glaze. The rim at the base of the ring foot is unglazed.

The Ding kiln was the most reputed and influential kiln for producing ware in white glaze in North China in the Song and Jin dynasties. Its site was located at Quyang county, Hebei, which was under the jurisdiction of Dingzhou and thus named the Ding kiln. The production of Ding ware had started as early as the Tang Dynasty and was influenced by Xing ware. The production gradually suspended after the late Yuan Dynasty. Other than firing white ware, the kiln also produced ware in black glaze, brown glaze, green glaze, yellow glaze, and others with a wide variety of type forms, the majority of which was ware for daily use and decorated with incised, carved, molded, and gilt designs. In the Song Dynasty, the Ding kilns spread to Hebei, Shanxi, and other regions. Some kilns of the later periods also imitated Ding ware. In addition to domestic use, Ding ware was also used as imperial and official ware in the late Tang to the Jin Dynasty, and was exported overseas. Ding ware was unearthed in various countries and regions in Asia and North Africa.

123

Bowl
with the inscription
of *"yiding"* in white glaze

Ding ware
Five Dynasties

Height 6.8 cm
Diameter of Mouth 19.8 cm
Diameter of Foot 7.3 cm

The bowl has a wide mouth, a slanting straight wall, and a ring foot. The fine white paste is thinly potted. The interior and exterior of the bowl are covered with shiny and translucent white glaze. The exterior base is carved with two characters *"yiding"*.

The academic sector has different views on the meaning of *yiding*. Some experts opine that *yi* is an archaic style in writing the character *yang*, and thus *yiding* means "Ding ware from Quyang". Some opine that *yiding* means "Ding ware used for transaction". Others put forward that *yiding* is a mark similar to the inscription *"guan"* which refers to ware commissioned by the court, or that the character *yi* is a surname or refers to Yizhou.

Dozens of inscriptions have been found on extant Ding ware. One category was inscriptions incised or carved on glazed ware before firing, such as the inscriptions *"guan"*, *"xinguan"*, *"yiding"*, *"kuaiji"*, *"donggong"*, *"shangshiju"*, *"shangyaoju"*, *"shiguanju-zhengqizi"*, *"wuwangfu"*, etc., which were on the ware commissioned for production by the imperial court or local government offices. Another category was inscriptions associated with names of palaces, such as *"fenghua"*, *"fenghua"*, *"cifu"*, *"juxiu"*, *"jinyuan"*, *"deshou"*, and others. Most of the inscriptions of the latter category were incised or carved by craftsmen after the ware had been sent to the court. Ware with inscriptions was dated from the late Tang Dynasty, Five Dynasties to the Song and Jin dynasties, proving that the Ding kiln had produced ware for imperial and official use for over three centuries.

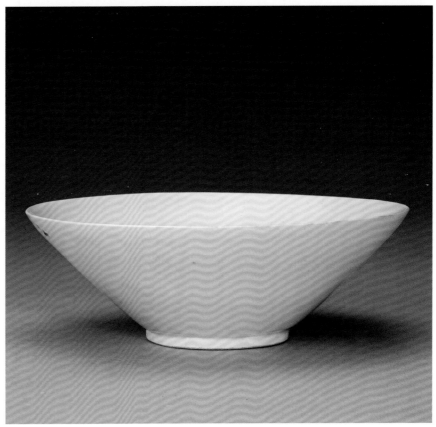

124

Meiping Vase
with carved and incised floral designs in white glaze

Ding ware
Song Dynasty

Height 37.1 cm
Diameter of Mouth 4.7 cm
Diameter of Foot 7.8 cm

The vase has a small mouth, a folded mouth rim, a short neck, a wide shoulder, a contracted belly flaring near the foot, and a ring foot. The body is covered with white glaze with a yellowish tint. Under the glaze are carved and incised designs, including chrysanthemum petals at the shoulder, lotus scrolls at the belly, and vertical banana leaves at the shank.

Most extant and unearthed pieces of Ding ware are plates and bowls, with fewer vases. *Meiping* vases with carved designs in white glaze are even rarer. This piece is one of the two vases collected by the Palace Museum.

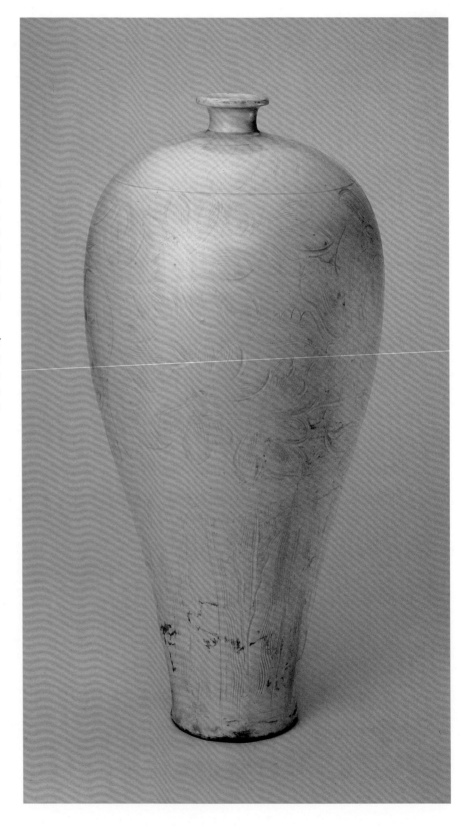

125

Vase
with a straight neck and
carved and incised design of
panchi-dragons
in white glaze

Ding ware
Northern Song Dynasty

Height 22 cm
Diameter of Mouth 5.5 cm
Diameter of Foot 6.4 cm
Qing court collection

The vase has a flat mouth with an everted rim, a slim long neck, a round belly, and a flared ring foot. The interior and exterior are covered with white glaze, with the rim of the ring foot unglazed. The belly is decorated with carved and incised design of two *panchi*-dragons flying in the clouds with a touch of vigour and liveliness.

Chi-dragons were a species of Chinese mythical beasts and those rendered with a curling body and a crawling posture were called *panchi*-dragons. *Panchi*-dragon designs appeared as early as on the bronze ware of the Shang and Zhou dynasties. With the favour of archaism in the Song Dynasty, *panchi*-dragons had become popular decorations on Song ceramic ware.

The white glaze of early Ding ware often carried a greenish tint, and later carried a yellowish tint resembling the soft colour and texture of ivory. Such a feature was due to the use of coal instead of wood sticks for firing, as well as the fact that the firing atmosphere in the kiln had changed from reduction firing to oxidizing firing, reflecting the emergence of an innovative firing technique employed by the kilns in North China at the time.

126

Pillow
in the shape of a child
in white glaze

Ding ware
Northern Song Dynasty

Height 18.3 cm
Length 30 cm
Width 11.8 cm
Qing court collection

The pillow is fashioned in the shape of a child reclining on bed, with his back serving as the pillow surface. The body is covered with white glaze with an ivory-yellowish tint. The exterior is unglazed and has two holes. The child wears a long robe with floral medallion designs, a vest outside, a pair of trousers, and a pair of soft boots. His two hands embrace and support the head with the right hand holding a brocade ribbon and the crossed legs lifting up. The sides of the bed are further decorated with carved design of *chi*-dragons, floating clouds and foliage scrolls.

This pillow is a well-known valuable extant Ding ware with the carved and sculptured designs rendered delicately and the posture of the child enlivened vividly, showing the exquisite decorative skills and artistic expressiveness of the potter. The image of the child is very similar to the depiction of children in the paintings *Children at Play in the Autumn Garden* and *Children Playing Acrobatic Games* by Su Hanchen (1094–1172), a well-known painter of the Northern Song Dynasty.

127

Cup-stand
with carved and incised design of key-fret patterns in white glaze

Ding ware
Northern Song Dynasty

Height 6.4 cm
Diameter of Mouth 10.5 cm
Diameter of Foot 8.8 cm
Qing court collection

The cup-stand is composed of two parts, including the supporting ring and the supporting tray. The ring is in the form of a bowl with an upright mouth and a deep curved belly. The tray has a wide mouth and a shallow curved belly. The mouth rim is inlaid with a copper ring with its colour changed due to oxidization. Under the tray is a ring foot with a flared base. The body is covered with white glaze. The interior and exterior sides of the supporting bowl are decorated with a border of key-fret patterns near the mouth rim respectively.

Cup-stands were used for supporting the tea cup or the tea bowl, which had appeared in the Eastern Jin Dynasty. Prior to the Tang Dynasty, both supporting stands for the tea cup or the wine bowl were fashioned with supporting rings on the trays, and it was difficult to differentiate which one was used for supporting tea cups or wine cups. In the Tang Dynasty, the custom of drinking tea had become more popular, and the height of the supporting ring of the cup-stand increased. In the Song Dynasty, the ring was fashioned in the form of a bowl, so that the cup could be stably put onto it. Such a change was due to the fact that warming wine was different from brewing tea. Warming wine would not make the wine too hot, and thus during drinking, it was enough to hold the wine-cup only. As a result, the stand should only have considerate height to make the wine-cup stand stable. However, in brewing tea, the tea would become very hot and it was necessary to hold the cup and the stand together at the same time. Thus a deeper supporting ring would facilitate the tea-cup to be put stably in the cup-stand. In the Song Dynasty, the custom of tea-drinking further changed, and it was necessary to use a water bottle to pour hot water into the cup and use a whisk to stir the tea inside; thus, a more stable bowl-shaped supporting ring was necessary to hold the cup firmly and stably.

128

Bowl
carved with pomegranate
sprays in white glaze

Ding ware
Northern Song Dynasty

Height 8.9 cm
Diameter of Mouth 18.6 cm
Diameter of Foot 7.8 cm
Qing court collection

The bowl has a slightly flared mouth, a deep curved wall, and a ring foot. The mouth is inlaid with a copper ring. The interior and exterior are covered with white glaze with an ivory-yellowish tint and tear marks. The interior wall of the bowl is plain. The exterior wall is carved with design of pomegranate sprays. As the pomegranate has numerous seeds, it has become an auspicious symbol of progeny and a popular decorative motif.

There was the practice of inlaid metallic rings to the rims of various vessels for protection purposes, which had already been used in the Western Han and Eastern Han dynasties. Such a technique was popularly used on the Ding ware of the Tang Dynasty and the Five Dynasties period. It served the function to protect and strengthen the mouth rims and also enhanced the decorative appeal of objects. Since the Northern Song Dynasty, there was a common practice to pile the ware upside down for firing, and thus the mouth rims were unglazed and coarse. To add metallic rings to the mouth rims would cover the coarse rims and remedy such a defect. However, some of the metallic rings on extant Ding ware were in fact added in the Qing Dynasty instead.

"Tear marks" was a defect of the glaze surface. During high-temperature firing, the transparent glaze would drip downwards and condense at the lower part of ware in the shape of candle-tears or protruding glass beads, resembling tears. Such a defect was often found on the porcelain ware of the pre-Tang periods, and it has been regarded as an important criterion for the authentication of genuine Ding ware of the Song Dynasty.

129

Washer
with molded design of *panchi*-dragons, floral sprays and a carved imperial poem of Emperor Qianlong in white glaze

Ding ware
Northern Song Dynasty

Height 4.3 cm
Diameter of Mouth 18.4 cm
Diameter of Foot 11.1 cm
Qing court collection

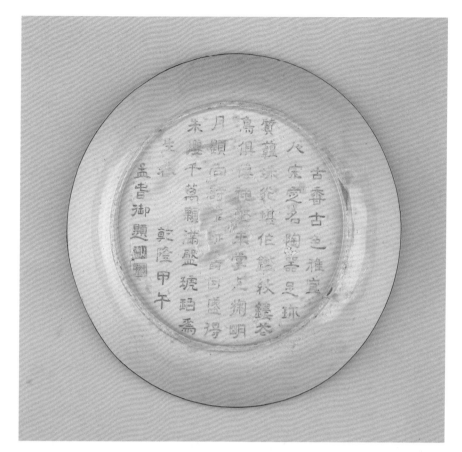

The washer has a wide mouth, a shallow belly, and a ring foot. The mouth rim is inlaid with a copper ring. The body is covered with shiny and translucent white glaze with a yellowish tint. The interior is decorated with molded design of *panchi*-dragons. The exterior wall has streaks and tear marks. The exterior base is carved with an imperial poem *In Praise of the Ding Plate* by Emperor Qianlong, and at the end of the poem is the inscription "written by the emperor in mid-Spring of *yiwei* year of the Qianlong period" and two seals "*huixin buyuan*" and "*dechongfu*". The *yiwei* year of the Qianlong period corresponded to the 40th year of the Qianlong period (1775).

Molded designs on Ding ware had first appeared in the mid-Northern Song Dynasty and matured in the late Northern Song Dynasty. The decorative designs were rendered with sophisticated pictorial treatments and clear layers with precise liner configurations and well-composed treatments. The decorative motifs were borrowed from the art of embroidery of Dingzhou, and as a result, they were exquisitely rendered with a touch of perfection, reflecting the high artistic standard at the time.

130

Plate
with molded design of
a dragon amidst clouds
in white glaze

Ding ware
Northern Song Dynasty

Height 4.8 cm
Diameter of Mouth 23 cm
Diameter of Base 11.2 cm

The plate has a wide mouth, a shallow curved wall, and a ring foot. Originally the mouth rim should have inlaid with a copper ring, which is now lost. The body is covered with white glaze with an ivory-yellowish tint. The interior base is decorated with molded design of a curling dragon with four claws with its head and tail linked and flying amidst clouds in a vigorous style.

Various techniques were used for decorating Ding ware, including sculptural modeling, incising, carving, molding, and gilt painting. In the early Northern Song Dynasty, Ding ware was mostly decorated with carved and incised designs. In the mid-Northern Song Dynasty, molding techniques had reached a state of full maturity, and they became more popular in the Jin Dynasty. Popular decorative motifs included flowers which were most commonly found, as well as dragons amidst clouds, animals and beasts, birds, waves, and fishes in considerable quantities.

131

Vase
with cut design of two tigers
on a sgraffito ground
in white glaze

Dengfeng ware
Song Dynasty

Height 32.1 cm
Diameter of Mouth 7.1 cm
Diameter of Foot 9.9 cm

The vase is in the shape of an olive with a flared mouth and a round rim, a short neck, a slanting shoulder, a globular belly, and a ring foot. The paste in reddish-brown colour is layered with pure white slip and covered with transparent glaze. The body is fully decorated with cut designs on a sgraffito ground. The major decorative motifs are two combating tigers. One tiger is standing up, showing its teeth and pulling out its claws, whereas the other tiger is about to strike it, against a background with rocks and plant clusters. Near the base are decorations of lotus lappets. The empty spaces in between the designs are fully stamped with small round circles which resemble the shape of pearls, and such a decorative pattern is known as sgraffito pearl ground. In between the incised designs and molded small circles, the slip is cut away with the paste in reddish-brown colour exposed. For the designs, the slip with white colour is kept, producing amusing colour contrasts on this ware.

This vase was produced in the Dengfeng kiln, Henan, in Song Dynasty, and is the only extant ware of its type.

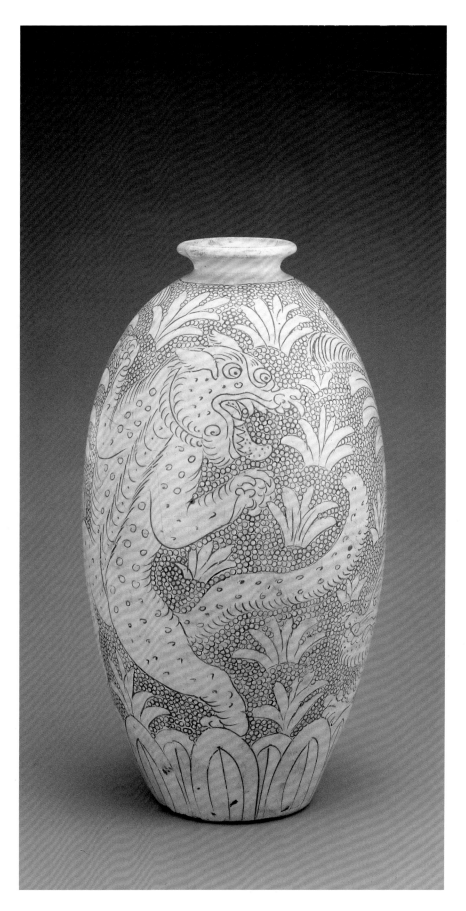

132

Jar
with cut design of
chrysanthemum scrolls
in white glaze

Dongyangyu ware
Northern Song Dynasty

Height 34.4 cm
Diameter of Mouth 16.5 cm
Diameter of Foot 12.5 cm

The jar has a rimmed mouth, a slanting shoulder, a deep belly, and a ring foot. It is layered with the white slip and then covered with transparent glaze. The exterior is carved with designs of flowers, leaves, chrysanthemum scrolls, key-fret patterns first, and then the slip layer outside the designs is cut away to expose the greyish-brown paste to produce an aesthetic effect of white decorations on a greyish-brown ground.

In the Liao, Song, and Jin dynasties, various kilns in Shanxi, Hebei, Henan, Inner Mongolia, and Ningxia in North China adopted a new practice of using slip or black glaze to cover the pastes which were not pure or clean enough, and then employed cut or carved designs in white glaze or black glaze for decoration to create a new decorative style. Among such ware, the one produced by the Dong-yangyu kiln was most reputed.

133

Gourd-shaped Vase
with carved and incised
design of lotus scrolls in
imitation of Ding ware
in white glaze

Ming Dynasty

Height 27.4 cm
Diameter of Mouth 2.7 cm
Diameter of Foot 9 cm
Qing court collection

The vase is in the shape of a gourd with an upright mouth, a narrow neck, a round belly, and a ring foot. The body is covered with white glaze with a yellowish tint and small ice-crackles. The exterior wall is incised with floral designs under the glaze, including a border of key-fret patterns on the neck and the contracted waist, lotus scrolls on the upper and lower belly, and *ruyi* cloud patterns on the shank.

The book *Jingdezhen Taolu* recorded that in the Longqing and Wanli periods of the Ming Dynasty, the potter Zhou Danquan was prolific in producing imitated Ding ware with refined quality. It is not definitive to attribute this piece as a product of the Zhou kiln; however, the refined quality of the ware provides useful reference for this type of imitated Ding ware.

134

Washer
with carved and incised design of twin fish amidst waves in imitation of Ding ware in white glaze

Qing Dynasty Kangxi period

Height 3.3 cm
Diameter of Mouth 25.2 cm
Diameter of Foot 19.5 cm
Qing court collection

The washer has a wide mouth, a folded rim, and a ring foot. The mouth is inlaid with a copper ring. The body is covered with white glaze. The interior base is carved and incised with twin fish amidst waves. The exterior wall is carved and incised with two borders of geometric patterns.

In terms of the form, glaze colour, and decorative designs, this washer is very close to the original Ding washers in white glaze of the Song Dynasty. Most of the imitated Ding ware in white glaze was produced in the Kangxi, Yongzheng, and Qianlong periods, among which, the imitated ware of the Kangxi period was most similar to the Ding ware in white glaze.

135

Vase
with four loops and design of
Indian lotuses in relief
in imitation of Ding ware
in white glaze

Qing Dynasty Qianlong period

Height 22 cm
Diameter of Mouth 7 cm
Diameter of Foot 6.5 cm
Qing court collection

The vase has a flared mouth, a short neck, a slanting shoulder, a belly tapering downwards, and a flared ring foot. The interior of the foot is potted in two tiers. The shoulder is decorated with four loops in the shape of *kui*-dragons. The body is covered with imitated Ding white glaze. The neck is decorated with a border of string patterns in relief. The belly is carved with lotus scrolls in relief. The exterior base is carved with a six-character relief mark of Qianlong in seal script.

On this vase, only the glaze is in imitation of Ding ware in white glaze. The form and decorative style show typical Qing styles, marking a distinctive characteristic of ware in imitation of Ding ware in the Qianlong period.

136

Covered Rectangular Incense-burner

with four legs,
animal-shaped ears
and design of *panchi*-dragons
in relief in imitation of Ding
ware in white glaze

Qing Dynasty Qianlong period

Height 11 cm
Diameter of Mouth 13 × 5.6 cm
Distance between Legs 8.6 × 5 cm
Qing court collection

The rectangular incense-burner has four column-shaped legs, and the two symmetrical sides of the body are decorated with two ears in the shape of animal masks holding rings. The flat cover is fitted into the body, and on top of which is a dragon medallion knob. The body is covered with imitated Ding white glaze. The exterior wall is decorated with *taotie* animal masks in relief.

This incense-burner is modeled in an archaic but delicate manner and the firing of which is quite difficult. It represents a refined piece of ware produced in the Imperial Kiln in the Qianlong period. This type of ware had already appeared in the bronze ware of the Shang and Zhou dynasties, and in the Qianlong period of the Qing Dynasty, they were imitated and produced with jade or ceramics.

137

Plate
with design of lotus scrolls
and molded mark *"Shufu"*
in egg white glaze

Jingdezhen ware
Yuan Dynasty

Height 5.3 cm
Diameter of Mouth 19.5 cm
Diameter of Foot 6.4 cm
Qing court collection

The plate has a wide mouth, a shallow curved wall, and a ring foot. The body is covered with egg white glaze with a greenish tint. The interior base and the wall are decorated with molded design of lotus scrolls with the characters *"shu"* and *"fu"* interspersed in between.

Egg white glaze was a new type of glaze produced in the Jingdezhen kiln in the mid and late Yuan Dynasty. It was a kind of alkali lime glaze with a lower content of calcium and a higher content of potassium and sodium. During high-temperature firing, the glaze would become more adhesive and after firing, the colour would lose transparency and become opaque with a light greenish tint, resembling the colour of a goose's egg, and thus was named "egg white glaze". As such glazed ware often bore the marks *"shu"* and *"fu"*, they were also named *"Shufu* glazed ware."

"Shufu" was an abbreviated term for *"Shumiyuan"* (Supreme Military Council) which was the highest military authority in the Yuan Dynasty. Ware with marks *"shu"* and *"fu"* was mostly commissioned by the government offices. Such ware included small cups, plates, bowls, etc. with stem-cups and bowls with folded waists the most representative. The interior of the ware was often decorated with molded designs such as lotus scrolls, chrysanthemums, and others. At the time, ware with marks *"shu"* and *"fu"* in egg white glaze was often imitated by the provincial kilns for domestic use as well as overseas markets.

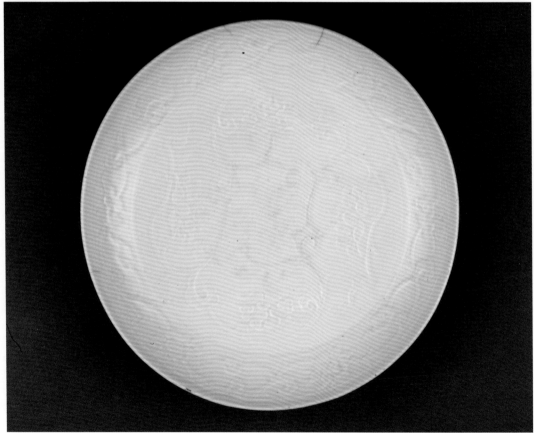

138

Plate
with design of a dragon
amidst clouds and molded
marks *"Taixi"*
in egg white glaze

Jingdezhen ware
Yuan Dynasty

Height 3.3 cm
Diameter of Mouth 17.8 cm
Diameter of Foot 11.4 cm

The plate has a wide mouth, a shallow curved wall, and a ring foot. The body is covered with egg white glaze with a greenish tint. The interior of the ring foot is unglazed, exposing the paste. The interior and exterior are decorated with molded designs. The interior base is decorated with molded design of a dragon with five claws amidst clouds. The interior wall is decorated with molded design of eight auspicious symbols and two characters *"tai"* and *"xi"* surrounded by foliage scrolls. The exterior wall is carved and incised with eighteen deformed lotus lappets.

This plate was a royal sacrificial ware of the Yuan Dynasty and had been submitted as a tributary vessel to the court by the Porcelain Bureau at Fuliang, Jingdezhen. *"Taixi"* was an abbreviated name for *"Taixiyuan"* (Council for Royal Sacrificial Ceremonies), which had been established in the first year of the Tianli period (1328) of Emperor Wenzong, with its name changed to *"Taixizongyinyuan"* in the next year. It was abolished in the sixth year of the Zhiyuan period (1340). Therefore, production of ware with marks *"tai"* and *"xi"* fell within these twelve years. Fuliang was the ancient name for Jingdezhen, and the Porcelain Bureau at Fuliang was an office founded by the Yuan government for the production of ceramic ware.

The eight auspicious symbols (*Bajixiang*) were new decorative motifs influenced by Tibetan Buddhism in the Yuan Dynasty. However, the combination of the eight auspicious symbols for decorating the interior wall of this plate was different from the standard combination with the wheel of the dharma, conch shell, victory banner, parasol, lotus flower, treasure vase, fish pair, and the endless knot in later periods, with the treasure vase replaced by a flaming pearl. This showed that the combination of these designs had not been standardized at the time.

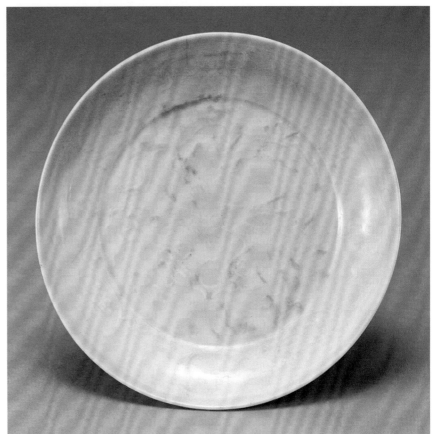

139

Meiping Vase
with incised design of lotus scrolls in sweet white glaze

Ming Dynasty Yongle period

Height 24.8 cm
Diameter of Mouth 4.5 cm
Diameter of Foot 10 cm

The *meiping* vase has a small mouth, a short neck, a wide shoulder, a contracted belly, a slightly flared shank, and a shallow ring foot. The body is covered with sweet white glaze with its sandy base unglazed. The exterior wall is carved and incised with three layers of incised designs of foliage scrolls, lotus scrolls, and floral sprays from top to bottom. Each layer of design is separated by a string border.

The sweet white glaze of this vase is pure, subtle, and translucent, and it represents a refined piece of Yongle imperial ware in sweet white glaze.

Sweet white glaze was developed from the white glaze on *Shufu* ware of the Yuan Dynasty and was first produced in the Imperial Kiln in the Yongle period of the Ming Dynasty. As the glaze colour was pure, translucent, and subtle visually, it was named "sweet white" glaze. This type of ware was highly reputed in the history of Chinese ceramics, and historical documents described it "as white as condensed fat oil, as pure as amassed layers of snow".

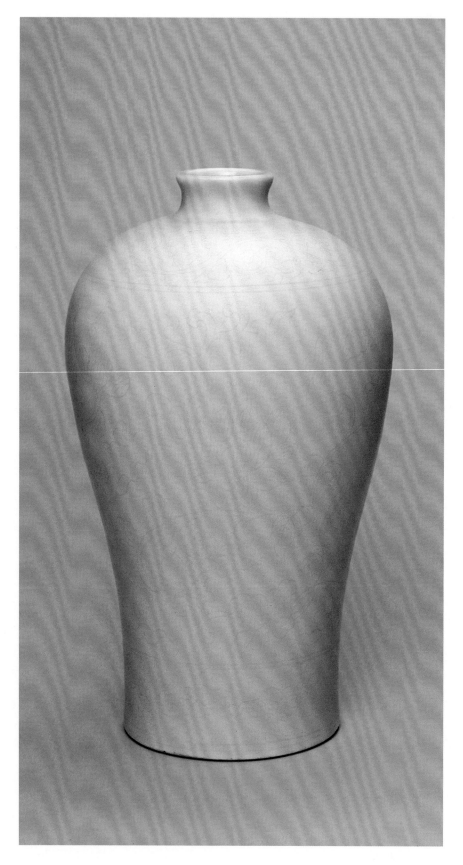

140
Monk's Cap Jug
in sweet white glaze

Ming Dynasty Yongle period

Overall Height 21 cm
Overall Length with Spout 15.5 cm
Diameter of Base 7.4 cm

The jug has a wide mouth, a globular belly, and a ring foot. Linear configurations in the shape of a ladder form a monk's cap-shaped rim. On one side of the mouth is a spout in the shape of a duck's bill, and on the other side is a curved handle in the shape of ribbon at the area between the neck and belly. The jug has a matching canopy-shaped cover on which is a round knob. On one side of the cover is a small round loop which could be fastened with strings to a round loop at the mouth of the jug. The body is covered with sweet white glaze.

Monk's cap jugs were first found in the ware in greenish-white glaze produced in Jingdezhen in the Yuan Dynasty, which had been used as a ceremonial vessel for Tibetan Buddhism. As the jug's mouth looked like a monk's cap, it was named the monk's cap jug. In the Yongle period, Ming Dynasty, the Imperial Kiln in Jingdezhen had produced many monk's cap jugs for the court for bestowing gifts to Tibetan monks.

141

Jar
with four loops in sweet white glaze

Ming Dynasty　Yongle period

Height 17.2 cm
Diameter of Mouth 10.7 cm
Diameter of Base 15.4 cm

The jar has an upright mouth, a short neck, a wide shoulder, a round globular belly, and a flat base. On the shoulder are four loops. The body is covered with sweet white glaze.

In the Yongle period, ware in sweet white glaze was commonly used in the court. In the excavation report on the Imperial Kiln site of the Ming Dynasty in Jingdezhen published in 1989, over 98% of the artifacts and shards unearthed at the ground layer of the former Yongle period were ware and shards in sweet white glaze. Such a mass production of sweet white ware might have been associated with the personal favour of Emperor Yongle.

142

Gourd-shaped Flask
with ears in the shape of
ribbons and carved and
incised design of
floral rosettes
in sweet white glaze

Ming Dynasty Xuande period

Height 32 cm
Diameter of Mouth 4.2 cm
Diameter of Foot 6.7 cm

The flask is in the shape of a gourd
with an upright mouth, a narrow neck, a
flat round belly, and a ring foot. At the
area between the neck and the belly are two
symmetrical ears in the shape of ribbons.
The body is covered with sweet white
glaze.

This type of flat flasks with ears in
the shape of ribbons was also known as
"*baoyue* vases" (precious moon vases
or embraced moon vases), which was a
new type form with Islamic influence. It
was first produced in the Imperial Kiln
in Jingdezhen in the Yongle period, and
more had been produced in the Yongle and
Xuande periods. In the Yongzheng and
Qianlong periods of the Qing Dynasty, the
Imperial Kiln had also produced imitations
of these flasks.

145

Monk's Cap Jug
in white glaze

Qing Dynasty Yongzheng period

Overall Height 19 cm
Diameter of Mouth 14.4 cm
Diameter of Foot 7.8 cm
Qing court collection

The jug has a wide mouth, a wide belly tapering downwards, and a ring foot. Linear configurations in the shape of ladders form a monk's cap-shaped mouth rim. On one side of the mouth is a spout in the shape of a duck's bill, and on the other side is a curved handle in the shape of a ribbon at the area between the neck and the belly. The jug has a matching canopy-shaped cover on which is a pearl-shaped knob. The body is covered with white glaze. The interior and exterior of the mouth are incised with two dragons under the glaze. The exterior belly and the surface of the cover are incised with two dragons in pursuit of pearls under the glaze. The exterior base is incised with a four-character mark "*langyinge zhi*" in regular script in two columns under the glaze.

Langyinge was the name of the residence of Emperor Yongzheng in the Yuanmingyuan Palace (Old Summer Palace) before he ascended the throne.

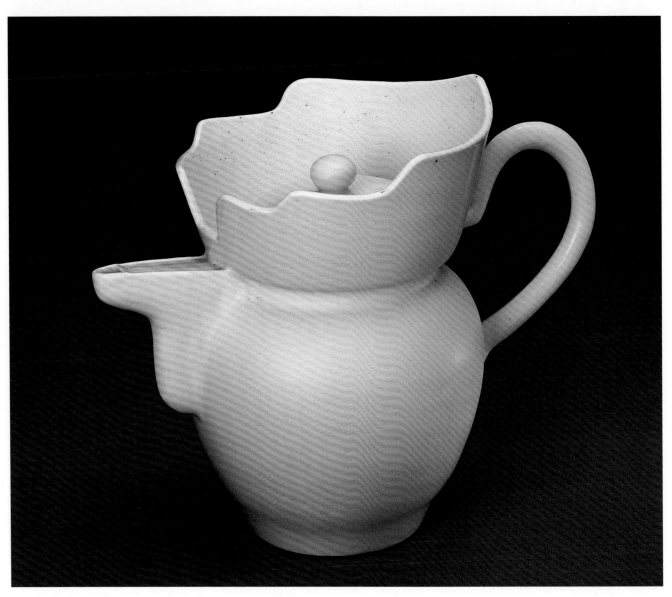

146

Vase
with a flower-shaped mouth and design of a flower of plantain lily in relief in white glaze

Qing Dynasty Qianlong period

Height 27.4 cm
Diameter of Mouth 9.3 cm
Diameter of Foot 8.5 cm
Qing court collection

The vase has a flower-shaped mouth, a long neck, a wide shoulder, a contracted belly, and a ring foot. The body is covered with white glaze. The exterior wall is decorated with flowers, leaves, and buds of plantain lily in relief. The exterior base is engraved with a six-character recessed mark of Qianlong in seal script in three columns under the glaze.

The form of this vase is creative and sophisticated which was first produced in the Qianlong period, reflecting skillful craftsmanship of the period.

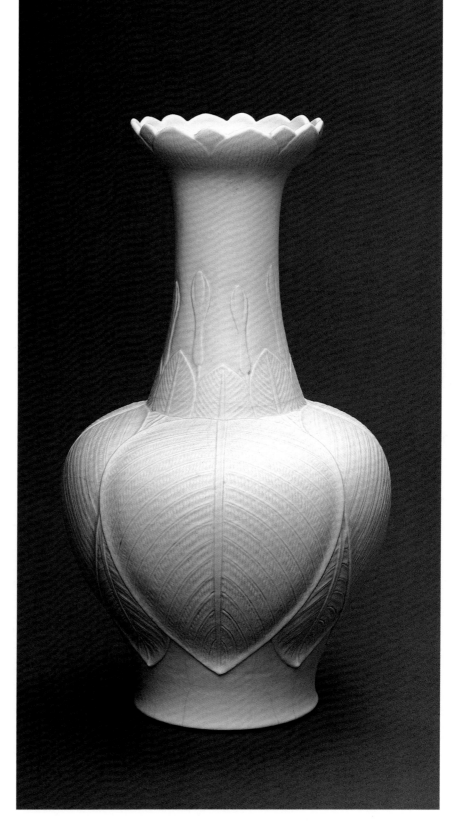

147

Incense-burner
in the shape of *ding* cauldron with three legs, two ears and design of *kui*-dragons in relief in white glaze

Dehua ware
Ming Dynasty

Height 25.4 cm
Diameter of Mouth 16.2 cm
Distance between Legs 13 cm
Qing court collection

The incense-burner is modeled after the ancient bronze *ding* cauldron with a rimmed mouth, a deep belly, and a round base with three column-shaped legs. On the two symmetrical sides of the mouth rim are two ears. The body is covered with white glaze with a yellowish tint. The belly is decorated with two borders of string patterns in relief, and in between are a ground with key-fret patterns and eight *kui*-dragons in four confronting pairs.

The glaze colour is white with a yellowish tint, resembling the colour of ivory, and is thus known as "ivory white" which is the typical glaze colour on Dehua ware of the Ming Dynasty.

The Dehua kiln was located at Dehua county, Fujian, and thus came its name. The kiln had started to produce celadon and white ware in the Song and Yuan dynasties and reached its zenith in the Ming Dynasty. It was a famous provincial kiln and was noted for producing ware in white glaze with the paste and glaze harmoniously matched. The shiny white colour looked like white jade, and was known as "ivory white", "pig's fat white", "onion root white", "*jian*-white", "China white", and others. Dehua ware in white glaze was the most representative of all Chinese white ware at the time and won the esteem as "mother of white glaze" in the world.

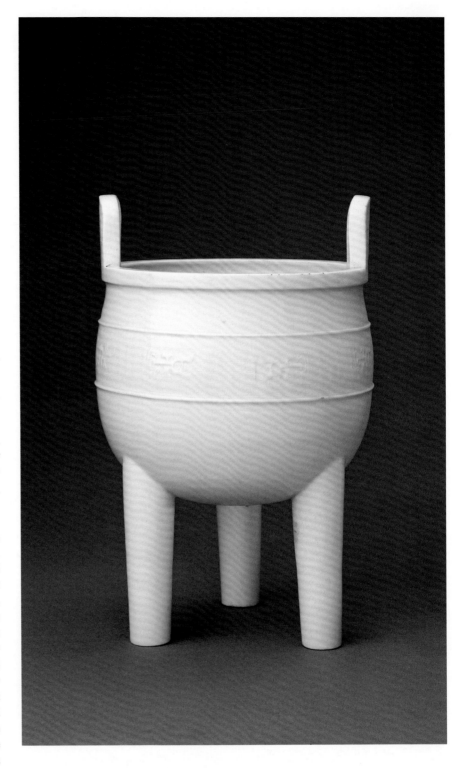

148

Meiping Vase
with carved and incised design of magnolias in white glaze

Dehua ware
Ming Dynasty

Height 33.5 cm
Diameter of Mouth 12 cm
Diameter of Foot 16.2 cm
Qing court collection

The *meiping* vase has a wide mouth, a round rim, a short neck, a wide shoulder, a round belly tapering downwards and flared near the foot, and a shallow wide ring foot. The body is covered with white glaze. The exterior wall is incised with magnolia sprays with strong branches and blooming or budding flowers from the shoulder downwards.

Compared with Ding white ware or Jingdezhen white ware, Dehua white ware of the Ming Dynasty was most noted for its distinctive translucent ivory white glaze. This vase is not only noted for its graceful and translucent glaze colour, but also for the elegantly fashioned form derived from traditional *meiping* vases. In particular, the magnolia flowers are depicted with a touch of delicacy and simplicity and match perfectly and harmoniously with this Dehua ware in white glaze.

149

Incense-burner
with three animal-legs,
ears in the shape of
chi-dragons and ancient
bronze decorative patterns
in relief in white glaze

Dehua ware
Ming Dynasty

Height 8.1 cm
Diameter of Mouth 10.3 cm
Distance between Legs 8.5 cm

The incense-burner is modeled after ancient bronze ware with a round mouth, a flat round belly, and a ring foot with three animal-legs below. On the two symmetrical sides of the incense-burner are two ears in the shape of *chi*-dragons. The body is covered with white glaze. The shoulder is incised with a border of flowers. The belly is decorated with several borders of string patterns in relief, and the exterior wall of the ring foot is incised with banana-leaf patterns.

The incense-burner was a major type form of Dehua ware of the Ming Dynasty. This incense-burner is fashioned with an archaic form and covered with translucent glaze, which exudes a sense of archaism and elegance and represents a refined piece of Dehua ware in white glaze.

150

Statue of Bodhidharma
in white glaze

Dehua ware
Ming Dynasty

Height 43 cm
Qing court collection

Bodhidharma is modeled with a strong body with his head slightly bowed, a wide forehead, deep eyes, a high nose, big ears, and a dense beard on the face. His two hands are holding in front of the chest. He wears a kasaya with two eyes looking forward and bare feet standing on a reed crossing a river with cresting waves. The body is covered with ivory white glaze. At the back is an engraved gourd-shaped mark with inscription "He Chaozong" in seal script.

Bodhidharma was a monk from South Sindhu (present day India). He arrived at China through the sea route in the late Southern Dynasties to pronounce Buddhism. Afterwards he crossed the Yangtze River to Luoyang and meditated at the Shaolin Monastery for nine years. Finally he had founded the Chan (Zen) Sect of Buddhism and became the first patriarch of the Sect.

He Chaozong (date unknown) was active in the Jiajing and Wanli periods of the Ming Dynasty, who was the most representative artist in producing porcelain statues. Several statues of Bodhidharma sculptured by him are extant, with this piece regarded as the most refined. He picked the Buddhist legend "Bodhidharma crossing the Yangtze River on a reed" and rendered the figure with enlivened facial expressions and details. His works blended the sentiment of the figures portrayed with artistic rendering in response to social favours at the time, marking the cultural coordinates of traditional Dehua porcelain sculptures.

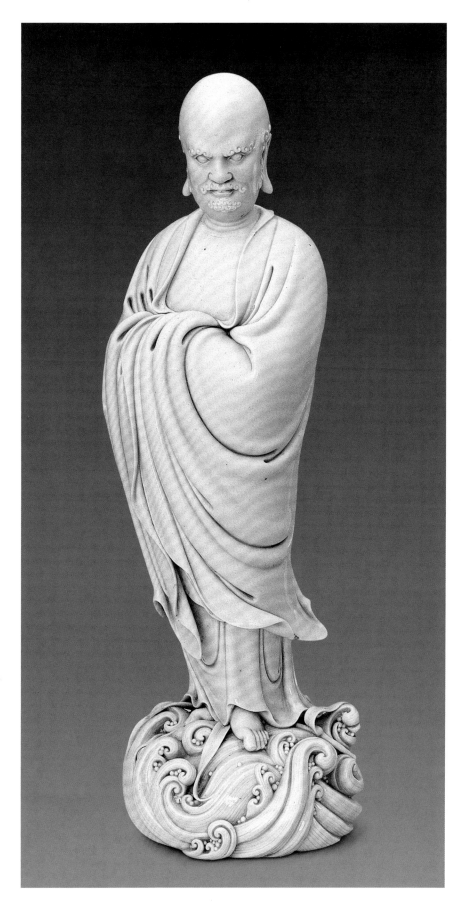

152

Meiping Vase
with carved and incised design of floral and foliage scrolls in *qingbai* greenish-white glaze

Jingdezhen ware
Northern Song Dynasty

Height 26.6 cm
Diameter of Mouth 5 cm
Diameter of Foot 8.5 cm

The vase has a small mouth with an everted rim, a short neck, a slanting shoulder, a belly contracted at the lower part, and a ring foot. The body is covered with greenish-white glaze. The belly is carved and incised with floral scrolls and a border of string patterns on the lower and upper side respectively.

Ware in greenish-white glaze produced in Jingdezhen in the Northern Song Dynasty was mostly plates, bowls, and ewers, with fewer vases. The paste of this vase is pure white and refined and covered with shiny and clear glaze. When knocked by a finger, the vase would give a clear sound. With over 1,000 years of history, this vase is still in a very good condition with bright colour, which is very rare and unusual.

Ware in *qingbai* greenish-white glaze was the most well-known ware produced in Jingdezhen in the Song and Yuan dynasties, and they had been also produced in large numbers in the provincial kilns in South China. Such ware often had pure and white pastes covered with transparent glaze with a colour between green and white, and thus was named "*qingbai*" (greenish-white) ware. In the recent hundred years, this type of ware was also known as "*yingqing*" (shadow-green), "*yinqing*" (hidden green), or "*yingqing*" (reflected green) ware in greenish-white glaze.

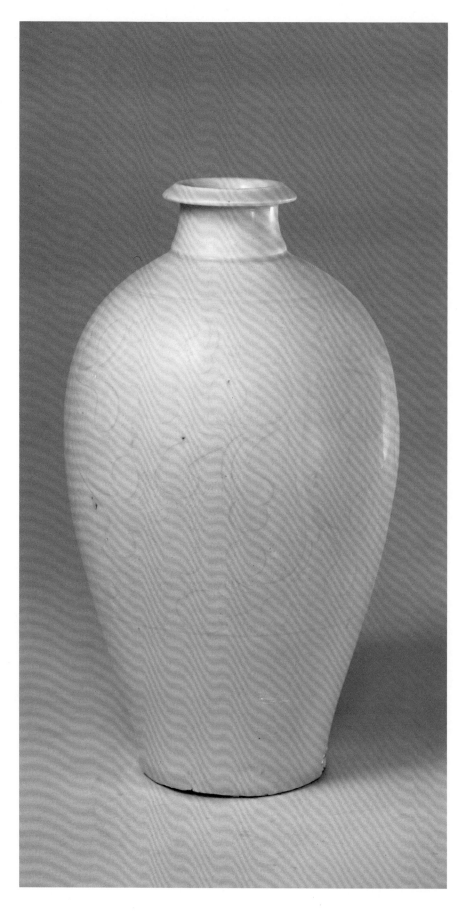

153

Ewer
with a warming bowl
in *qingbai* greenish-white glaze

Jingdezhen ware
Northern Song Dynasty

Overall Height 24 cm
Diameter of Bowl 17 cm
Diameter of Bowl's Foot 9.8 cm

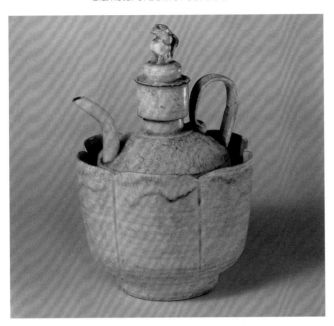

The ewer has an upright mouth, a slanting shoulder, a globular belly, and a ring foot. On the two symmetrical sides of the belly are a flat curved handle and a curved spout respectively. The ewer has a tube-shaped cover on which is a lion-shaped knob. The shoulder is carved and incised with floral scrolls. The warming bowl is modeled in the shape of six lobed petals with a deep curved belly and a ring foot. Both vessels are covered with greenish-white glaze. As the glaze would become less adhesive during high-temperature, it drips and turns into water green colour at the condensed area and turns to white colour at the area where the glaze runs thin.

When this ware was unearthed (it had been buried under the ground for a long time), the glaze surface had been eroded and lost its glare with traces of erosion and earth scars at the base.

This set of an ewer and a warming bowl was known as an ewer-bowl, a wine-container that was used for heating wine and keeping warm. Prior to the Yuan Dynasty, people usually drank rice wine with less alcoholic percentage. As wine would easily breed bacteria, it was necessary to heat wine before drinking. To put the ewer filled with wine into a bowl with hot water would keep the wine warm. Earlier examples of this type of ewer-bowls were unearthed at the tomb sites of the Later Zhou Kingdom of the Five Dynasties, and such ware had become very popular in the Northern and Southern Song dynasties.

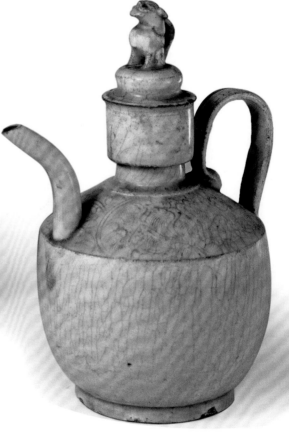

154

Pillow
in the shape of
two lions in *qingbai*
greenish-white glaze

Jingdezhen ware
Northern Song Dynasty

Height 15.5 cm
Length 17.5 cm

The pillow is comprised of three parts – the upper, middle, and lower parts, and is covered with even and pure greenish-white glaze. The pillow surface at the upper part is fashioned in the shape of *ruyi* cloud patterns and tilted on two sides. The surface is carved and incised with chrysanthemum scrolls and enclosed by two carved borders. The middle part is sculptured with two lions playing together. The lower part is an oval-shaped base stand.

Porcelain pillows were bedding utensils in summer in ancient China and had been popularly produced in the Northern and Southern Song, Jin, and Yuan dynasties. They were produced in large numbers by the kilns in North China. Among them, the Jingdezhen porcelain pillows in greenish-white glaze were credited for a soft, shiny, and translucent colour tone, which resembled green and white jades, and thus they were known as "jade pillows". In her ode *Zuihuayin*, Li Qingzhao, a woman poet of the Song Dynasty, mentioned that "Now it is the Chongyang Festival, with a jade pillow and a gauze wardrobe in the room, I feel coolness in the midnight". The term jade pillows described in the ode referred to a pillow in *qingbai* greenish-white glaze produced in the Jingdezhen kiln at the time.

155

Pear-shaped Vase
with carved and incised design of a dragon amidst clouds in *qingbai* greenish-white glaze

Jingdezhen ware
Yuan Dynasty

Height 32.1 cm
Diameter of Mouth 8.1 cm
Diameter of Foot 10.5 cm

The vase (*Yuhuchun*) has a trumpet-shaped mouth, a slim long neck, a slanting shoulder, a hanging belly, and a ring foot. The body is covered with *qingbai* greenish-white glaze, and the base and the rim of the ring foot are unglazed. The body is carved and incised with a dragon amidst clouds with several borders of string patterns on the upper and lower sides. The neck and the lower belly near the foot are incised with borders of banana leaves and lotus petals.

Most of the pillows in greenish-white glaze were plain, and if decorations were added, they were mostly incised and carved designs with occasional molded designs. Popular decorative motifs included flowers, plants, phoenix, children at play, waves, and clouds. The distinctive carving technique known as "half cut slip" designs was different from the carving techniques seen on the celadon ware produced in the Yue kiln and the Yaozhou kiln. Potters would hold the knife sideways to carve out lines with one side deeper and the other side shallower. As alkali glaze would become less adhesive during high-temperature firing and drip, the thickness of the glaze layer would change in accordance with the depths of the decorative designs and carved lines, with water green colour at the area where the glaze condenses and white colour at the area where the glaze runs thin. The finely potted paste was covered with transparent glaze in tonal gradations from green to white, exuding distinctive aesthetic appeal of light and shades, which won the esteem as "Yao (Jingdezhen) jade" ware.

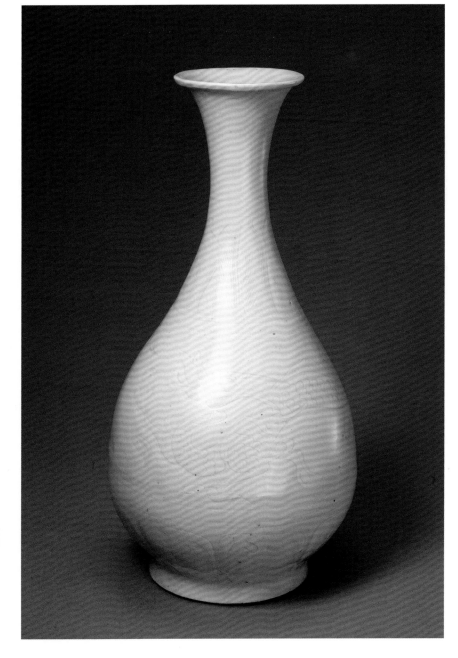

156

Pillow
in the shape of a silver ingot
with openwork design of
lotuses in *qingbai*
greenish-white glaze

Jingdezhen ware
Yuan Dynasty

Height 13 cm
Length 33.7 cm
Width 13 cm

The pillow is in the shape of a silver ingot with two sides higher and the middle part lower, and the cross-section is square in shape. The greyish-white paste is covered with greenish-white glaze with each of the two sides unglazed with a hole for releasing air during firing. The pillow surface is decorated with a panel of molded designs and the two vertical sides are decorated with openwork design of lotuses on the paste within a lozenge-shaped panel.

There were a wide variety of pillows in ancient China, including pillows in the shape of leaves, tigers, lions, silver ingots, child, *ruyi* clouds, rectangles, hexagons, octagons or with round waist, etc. To avoid bursting due to the rise of temperature during firing in the kiln, it was necessary to open holes on the two sides or the base of the pillow for releasing air. Sometimes remains of clay on the paste would drop into the pillow's body and could not be taken out after firing; thus when the pillow was shaken, it would give a sound when the remains inside the pillow hit against its wall. In general, the quality of ware in greenish-white glaze of the Yuan Dynasty could not match that of the Song Dynasty. Although this pillow is finely potted, the paste becomes heavy with quite a lot of impurities in the paste.

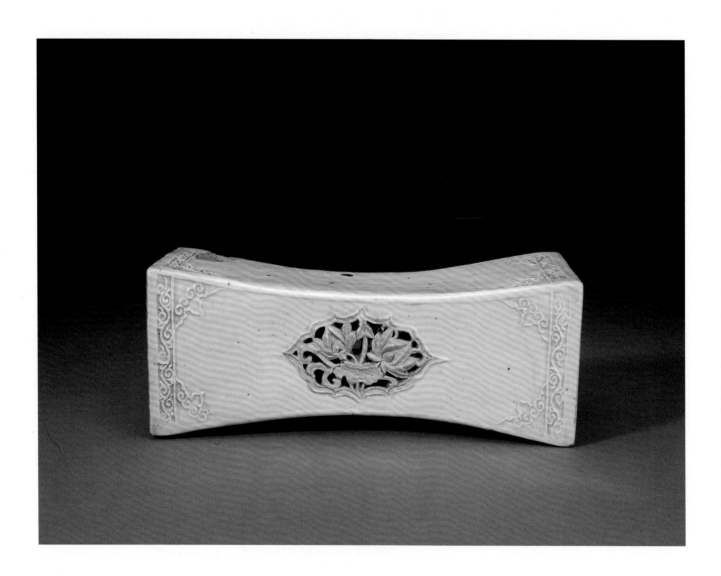

157

Bowl
with openwork design of
lotus scrolls in *yingqing*
greenish-white glaze

Ming Dynasty Yongle period

Height 6.1 cm
Diameter of Mouth 15.6 cm
Diameter of Foot 5 cm
Qing court collection

The bowl has a flared mouth, a curved belly, and a ring foot. The body is covered with greenish-white glaze. The exterior wall is incised with openwork design of lotus scrolls with six blooming lotuses under the glaze.

The paste of this bowl is thinly potted with transparent glaze and decorative designs barely visible in the glaze, exuding distinctive aesthetic appeal.

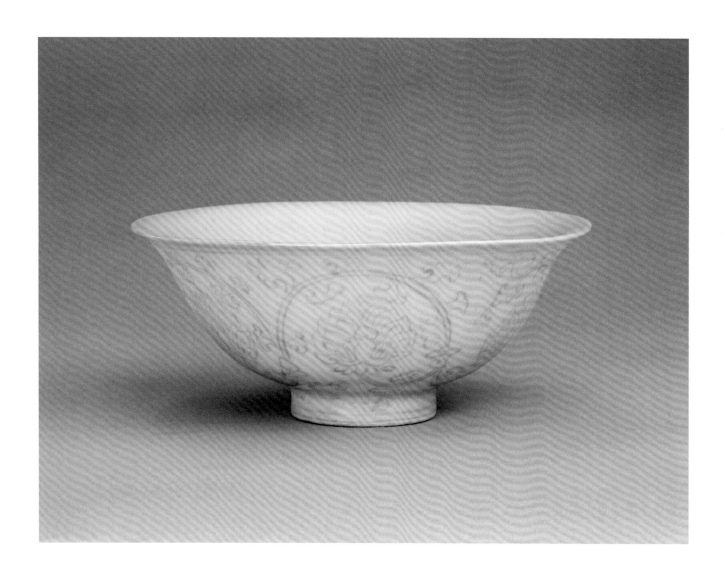

WARE IN BLACK GLAZE

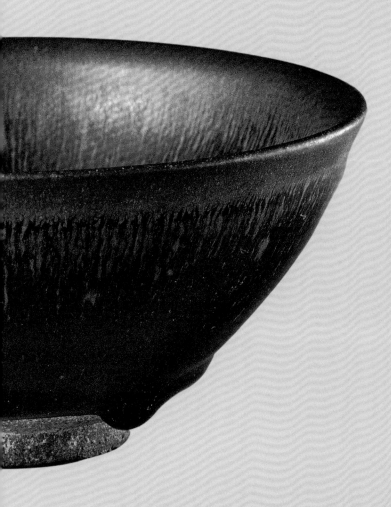

Ewer
with a chicken-head spout
and two loops
in black glaze

Deqing ware
Eastern Jin Dynasty

Height 18 cm
Diameter of Mouth 7.9 cm
Diameter of Base 10 cm

The ewer has a plated-shaped mouth, a narrow neck, a slanting shoulder, a globular body tapering downwards, and a ring foot. On one side of the shoulder is a spout in the shape of a chicken's head. On the opposite side is a curved handle linking to the plate-shaped mouth. On the other two symmetrical sides are two loops. The body is covered with uneven black glaze with a brownish-yellow tint at the area where the glaze runs thin. The base is unglazed with two large spur marks.

Chicken-head ewers were mostly produced in the Deqing kiln and the Yuhang kiln in Zhejiang in the Wei, Jin, and Southern and Northern dynasties. The shoulders of ewers with plate-shaped mouths were often decorated with animal heads, including the most popular design of chicken's heads, as well as ram's heads, buffalo's heads, tiger's heads, and others. Some of the animal-head shaped mouths were opened and directly linked through to the bodies of ewers, but most of which were for decorative purposes only. This type of ewers usually had a short neck, a round belly with a lower globular body in the early periods. In the later periods, the neck was elongated with the belly higher, revealing a touch of elegance and charm.

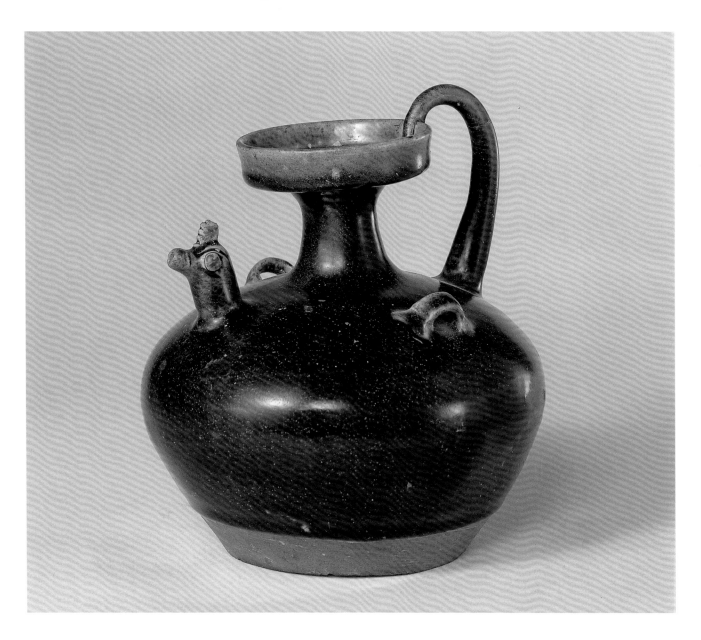

159

Rectangular Pillow
in black glaze

Tang Dynasty

Height 8.3 cm
Diameter of Surface 13.2 × 9.9 cm
Diameter of Base 12.3 × 9 cm

The rectangular pillow has a sloped surface with a lower front side and a higher back side. The greyish-white paste is covered with uneven blackish-yellow glaze. The base is unglazed, exposing the paste.

In the Sui, Tang, and Five Dynasties period, many kilns in North China also produced black ware in addition to white and celadon ware. The chemical components of black glaze, white glaze, and celadon glaze were basically the same, and the difference in glaze colours depended on the content of oxidized iron in the glaze. Black glaze would be produced if the content of iron in the glaze was over 5%. Celadon glaze would be produced if the content of iron in the glaze was around 3%, and white glaze if the content of iron in the glaze was 1% or below. As it was easier to mix the glaze, there was massive black ware produced with a wide variety of type forms. Most of the black ware was plain, but some was decorated on the glaze surface, for instance, with the application of crystallized oil spots. Ware in oil-spot glaze was seldom produced in the Tang Dynasty, but had been produced in large numbers in the Song Dynasty with high esteem and popularity.

160

Tea Bowl
in hare's fur black glaze

Jian ware
Song Dynasty

Height 5.8 cm
Diameter of Mouth 12.2 cm
Diameter of Foot 4.2 cm

The tea bowl has a wide mouth with a recessed border under the mouth rim, a deep curved wall, and a small ring foot. The interior and exterior are covered with black glaze, and the glaze at the exterior wall stops above the base. In high-temperature firing, the glaze at the mouth rim melted, dripped, and ran thin, showing a brownish colour. The glaze drips and condenses near the foot into tear marks. The surface of the glaze shows crystallized oxidized iron streaks, which look like hare's fur, and thus known as "hare's-fur glaze".

In the Song and Yuan dynasties, various kilns in Fujian, Sichuan, Jiangxi, Shandong, Henan, and Hebei had produced a large number of tea bowls in black glaze, which was closely associated with the practice of "competing tea" at the time. Among such ware, tea bowls in temmoku glaze, partridge's feather glaze, and hare's-fur black glaze produced in the Jian kiln at Jianyang county, Fujian were the most famous ware. The literati and scholars of the Song Dynasty, such as Huang Tingjian, Cai Xiang, and Mei Yaochen had much praised such ware in their writings and poems.

"Competing tea" was a practice in competing and ranking the quality of tea at the time, which had flourished in the Tang Dynasty and became very popular in the Song Dynasty, in particular among the wealthy literati and official classes. Participants selected the best of their collected tea for brewing and ranking in the competition.

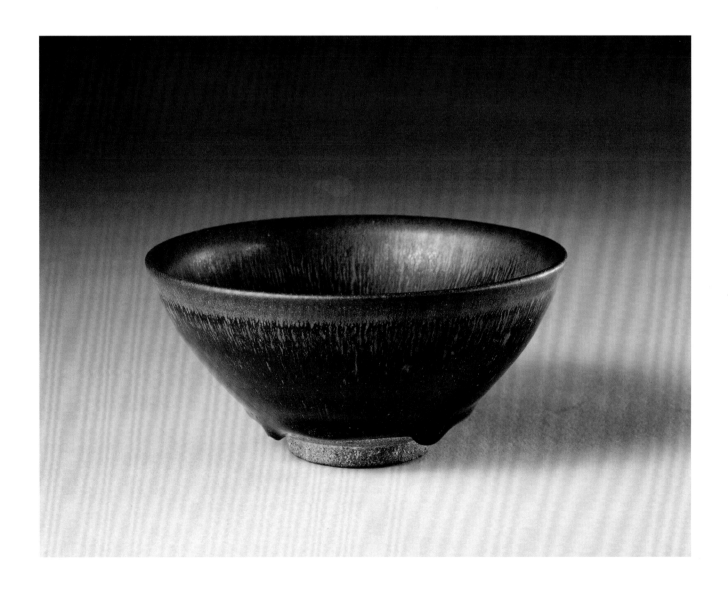

161

Pear-shaped Vase
in tortoise-shell black glaze

Jizhou ware
Song Dynasty

Height 12 cm
Diameter of Mouth 2.5 cm
Diameter of Foot 3.8 cm

The vase (*Yuhuchun*) has a flared mouth, a round rim, a slim long neck, a slanting shoulder, a hanging belly, and a shallow ring foot. The body is covered with black glaze and decorated with tortoise-shell mottles. The base is unglazed, exposing the paste.

Various types of vases with long necks had been produced in the Song Dynasty, which were closely associated with the practice of planting flowers, contemplating flowers, flower arrangement, and wearing flowers as ornaments. With the popular use of furniture items such as tables and chairs with a higher height, the display of flowers in vases had become an essential practice for decorating households. As they were put on tables or stools, small-sized ware was preferred. Song literati such as Chen Yuyi had described them in his poem, "A slanting floral spray in the small vase would bring colours of spring", and Yang Wanli described them as "Pouring snowy water into a small vase, it is not necessary to put in many flowers, only one or two slanting floral sprays would be pretty enough".

The site of the Jizhou kiln was located at the present day Yonghe town, Ji'an city, Jiangxi province, and thus it was named "the Yonghe kiln". Its production history dated back to the Five Dynasties. In the Northern and Southern Song dynasties, ware in black glaze produced there was closely associated with the one produced in the Jian kiln. The surface of glaze often carried brownish-yellow mottles, resembling the look of a tortoise-shell, and thus was named "tortoise-shell glaze". In addition, there were other distinctive decorative techniques such as paper-cut designs and applied leaf designs. The former was to paste paper-cut designs on the paste, and after glazing, the paper-cut designs would be removed, leaving only decorations on the ware. The latter was to erode the leaves first, and then paste the leaf veins on the biscuit.

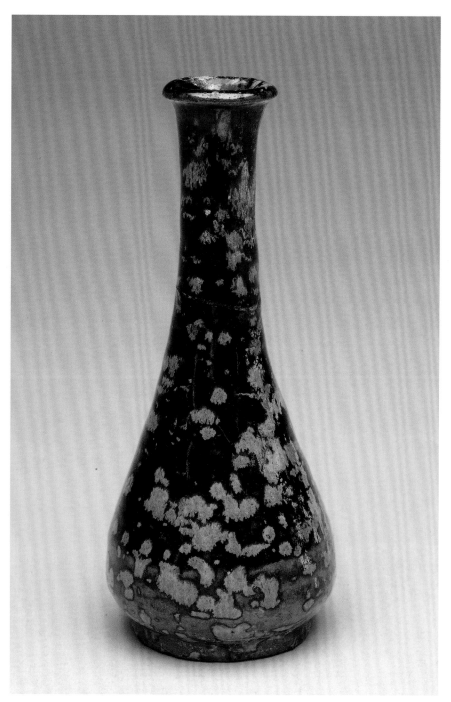

162

Tea Bowl
with pasted paper-cut design of plum blossoms in black glaze

Jizhou ware
Song Dynasty

Height 4.8 cm
Diameter of Mouth 11.5 cm
Diameter of Foot 4 cm

The tea bowl has a wide mouth with a recessed border under the mouth rim, a deep curved wall, and a ring foot. The exterior is covered with black glaze which stops above the foot. The interior is decorated with paper-cut designs of plum flowers, which look like fifteen plum blossoms falling on the tea bowl.

The decoration of "pasted paper-cut designs" in Chinese ceramic art represented a blending of the art of paper-cutting and ceramic decoration. As early as the Tang Dynasty, the Ding kiln had produced ewers with pasted paper-cut designs with yellow glaze and black glaze, although the production scale was rather limited. It was the Jizhou kiln of the Southern Song Dynasty that applied such pasted paper-cut designs on ceramic production on an extensive scale. The production technique was to paste paper-cut designs on the ware which was already glazed in black, and then apply another layer of yellowish-brown glaze onto it. Afterwards, the paper-cut designs would be peeled off with the ware fired in high temperature. Popular decorative designs included plum blossoms, flying phoenixes, floral sprays, plum blossoms with bamboo and mandarin ducks, and inscriptions such as "*jinyu mantang*" (jade and gold [wealth] filled the hall [household]) and "*changming fugui*" (longevity and wealth).

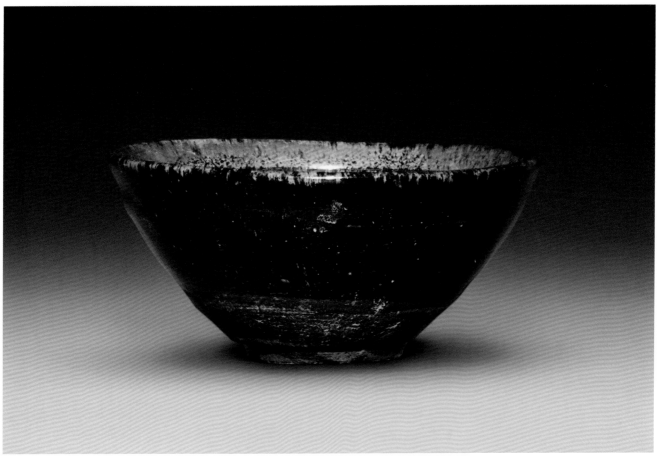

163

Tea Bowl
with a flared mouth
in tortoise-shell black glaze

Jizhou ware
Song Dynasty

Height 4.7 cm
Diameter of Mouth 14.9 cm
Diameter of Foot 3.6 cm

The tea bowl has a flared mouth, a slanting straight wall, and a small ring foot. The interior and exterior are covered with tortoise-shell black glaze. The ring foot is unglazed.

The practice of people of the Song Dynasty using such types of tea bowl in black glaze was closely associated with the custom of tea drinking at the time. In the Song Dynasty, tea drinking had become very popular, and tea cakes were produced by mixing fresh tea leaves with spices. Before drinking, the tea cake would be grinded into tea powder, and during brewing, tea powder would be mixed into soft paste and put inside the tea bowl. After that, hot water would be poured into the bowl. At the same time, a whisk was used to stir the tea powder and water until milky-white bubbles appeared, and then the tea together with powder would be drunk together. Tea bowls with a wide mouth and a small base would facilitate easy drinking without leaving any residue in the bowl. In competing tea, the criteria would be that the longer the white bubbles lasted in the bowl the better, and if water traces first appeared on the bowl, then the participant with that bowl of tea would lose the game. In using ware in black glaze, it would be easier to observe the colour of tea and identify the timing of appearance of water traces, thus tea bowls of this type would be preferred for usage. In order to hold the tea bowl and maintain its stability, the tea bowl stand was also used together, and both the bowl and stand would be held together with the hand for drinking tea.

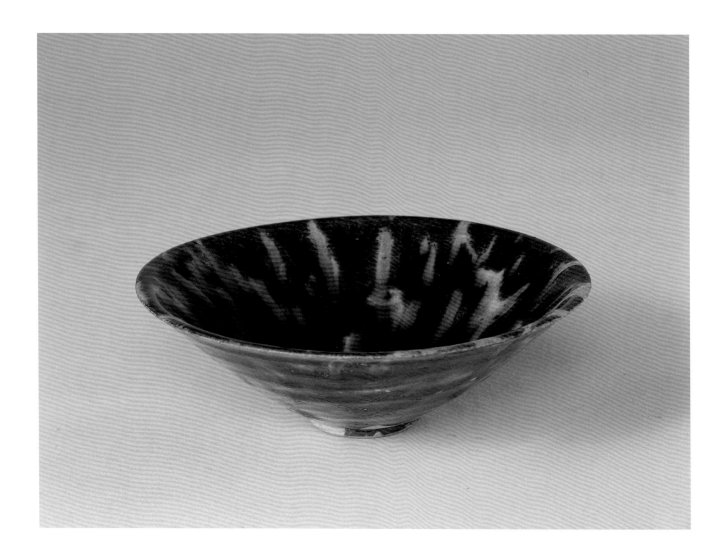

164

Meiping Vase
with cut and incised design of
peony sprays in panels
in black glaze

Ciyaopu ware
Western Xia Dynasty

Height 38 cm
Diameter of Mouth 5 cm
Diameter of Foot 10 cm

The *meiping* vase has a small mouth with an everted rim, a short neck, a flat shoulder, a long round belly, and a ring foot. The rather coarse paste is yellowish-brown in colour. The exterior wall is covered with black glaze. The belly is decorated with cut and incised design of peony sprays in panels on a ground with wave patterns.

This *meiping* vase was produced in the Ciyaopu kiln of the Western Xia Kingdom, the site of which was located at the Ciyaopu town, Ningxia Muslim Autonomous Region, Ningxia. The kiln had produced white ware, black ware, brown ware, ware in tea-dust glaze, ware with cut and incised designs in white glaze, ware with cut and incised designs in black glaze, and others. On the white ware and ware with cut and incised designs in black glaze, the design of floral sprays was often enclosed within panels on a ground incised with wave patterns, which was a distinctive characteristic of ware with cut and incised designs produced in the kiln.

165

Jar
with cut and incised foliage
scrolls in black glaze

Jin Dynasty

Height 17 cm
Diameter of Mouth 13.5 cm
Diameter of Foot 9.5 cm

The jar has a rimmed mouth, a slanting shoulder, a globular belly, and a ring foot. In the interior, only the mouth is covered with black glaze. The exterior wall is covered with black glaze with the exterior base unglazed. The body is decorated with cut and incised designs, including deformed key-fret patterns on the shoulder and foliage and floral scrolls on the belly.

The form of this jar is thickly and fabulously potted with bright and shiny black glaze like black lacquer. The cut and incised designs are rendered in a consummate manner with the greyish-white ground contrasting with the black glazed designs. Judged from the quality of the paste and glaze, it should have been produced in a kiln in Shanxi in the Jin Dynasty.

In the past, a lot of ware of the Jin Dynasty had been grouped and dated to the Song Dynasty, and experts opined that no refined ware was produced in the Jin Dynasty. Later with excavation of a large amount of Jin ceramic ware, the academic sector had developed new understanding of Jin ware. Kilns in North China, such as the Ding kiln, the Yaozhou kiln, the Jun kiln, the Cizhou kiln, the Zibo kiln, the Datong kiln, the Hunyuan kiln, the Jiexiu kiln, the Changzhi kiln, and others still continued their production with distinctive styles and features in the Jin Dynasty, among which there was no lack of fine and quality ware.

166

Incense-burner
with three legs and two ears with applique design of a dragon amidst peonies in black glaze

Qing Dynasty Shunzhi period

Height 18 cm
Diameter of Mouth 23.4 cm
Diameter of Foot 26 cm

The incense-burner has a wide mouth, a short neck, a globular belly, a contracted base, and three animal-head shaped legs beneath. On the shoulder are two vertical ears. The interior and exterior of the incense-burner are covered with black glaze. The exterior wall is decorated with applique designs, including foliage scrolls on the two ears, *ruyi* cloud patterns on the mouth rim, and a dragon amidst peonies on the belly. On one side of the belly is the carved mark "*shunzhi wunian bayue jiri shi* (one character indecipherable) *san* (one character indecipherable)". *Shunzhi wunian* (the fifth year of the Shunzhi period) corresponded to the year 1648.

167

Brush-holder
with gilt design of landscapes
and *Ode of Red Cliff*
in mirror black glaze

Qing Dynasty Kangxi period

Height 15.5 cm
Diameter of Mouth 18.5 cm
Diameter of Foot 18.6 cm

The brush-holder has its size of mouth and base similar, a round mouth, a straight wall, and a flat base. The interior is covered with white glaze and the exterior with mirror black glaze. There are gilt decorations over the glaze. Although the gold colour has faded, the decorative designs are still traceable. On one side is the design of landscapes and figures within a panel with flattened angles, and on the other side is gilt design written with the *Ode of Red Cliff*. At the end of the Ode is the inscription, "*jichousui, zhongdongyue, youlu houchibifu*" (written with the *Latter Ode of Red Cliff* in the middle winter month in the year *Jichou* on the right). The exterior base is covered with white glaze with an unglazed ring in the centre, which is a mark left by a gasket during firing.

The year *jichou* corresponded to the 48th year of the Kangxi period (1709) when Lang Tingji (1663–1715), the Governor of Jiangxi, served as the Director General of the Imperial Kiln to supervise the production of imperial ware. The ware produced in the Imperial Kiln during his service was highly esteemed as "Lang ware".

Mirror black glaze was produced from mirror black clay and fired in the Imperial Kiln in Jingdezhen, which had the characteristic of shiny and bright black colour resembling black lacquer. It had been first fired in the Chenghua period of the Ming Dynasty, and there were two types of ware in mirror black glaze produced in the Imperial Kiln of the Qing Dynasty, including ware with white-glazed designs on a mirror black ground and ware with gilt designs on a mirror black ground, both of which were representative refined ware in black glaze.

168

Stem-cup
with gilt design of
dragons amidst clouds
in black glaze

Qing Dynasty　Yongzheng period

Height 9 cm
Diameter of Mouth 7 cm
Diameter of Foot 5.9 cm
Qing court collection

The cup has a flared mouth, a deep curved belly tapering to the base, and a hollow high stem underneath. The interior is covered with white glaze, and the exterior is covered with black glaze on which are gilt designs. The belly is decorated with two dragons in pursuit of a pearl, and the foot is decorated with crested waves. The interior foot is covered with white glaze and written with a six-character mark of Yongzheng in regular script in underglaze blue from right to left around the foot.

In the 13th year of the Yongzheng period (1735), Tang Ying (1682–1756), Director General of the Imperial Kiln, compiled the book *Taocheng Jishi* which mentioned that "Imitated mirror-blue glaze was newly produced with two types, namely ware with white designs on a black ground and ware with gilt designs on a black ground". This cup belongs to the latter type of ware with gilt designs on a black ground.

WARE IN RED GLAZE

169

Pear-shaped Ewer
with carved and incised design of a dragon amidst clouds in bright red glaze

Ming Dynasty Hongwu period

Overall Height 12.5 cm
Diameter of Mouth 3.5 cm
Diameter of Foot 5.3 cm

The ewer is in the shape of a pear with a wide mouth which further widens downwards, a round belly, and a ring foot. On the symmetrical sides of the belly are a curved spout and a curved handle. It has a matching canopy-shaped cover on which is a round pearl-shaped knob. On the sides of the cover and the area linking the mouth rim and the handle is one small ring loop respectively for fastening strings to keep the cover in position. The body is covered with high-temperature fired copper red glaze. The interior of the ring foot is covered with greenish-white glaze. The belly is decorated with the incised design of a five-claw dragon amidst clouds with an awl.

This ewer was formerly dated to the Yuan Dynasty; however, the form and modeling of the base and the foot of pear-shaped ewers of the Yuan Dynasty unearthed were different from this ewer. The form of this ewer, as well as its size, is rather similar to the unearthed ewers with carved and incised design of peonies in white glaze of the Hongwu period, Ming Dynasty. The stylistic design of the dragons on this ewer is also similar to the dragon designs of the imperial underglaze blue ware of the Hongwu period, and thus it should be dated to the Hongwu period of the Ming Dynasty instead.

170

Stem-bowl
with molded and incised design of dragons amidst clouds in bright red glaze

Ming Dynasty Hongwu period

Height 14 cm
Diameter of Mouth 14.6 cm
Diameter of Foot 4.8 cm

The bowl has a flared mouth, a curved belly, and a thin base with a hollow stem foot underneath. The body is covered with high-temperature fired copper red glaze, and the interior of the high stem foot is covered with greenish-white glaze. The interior centre of the bowl is incised with a border of cloud patterns with an awl. The interior wall is decorated with molded design of two dragons with five claws chasing each other and interspersed by two cloud patterns with similar stylistic rendering.

This bowl was previously dated to the Yuan Dynasty. With the progressive development of archaeological findings and studies, experts identified a large amount of ware which had been formerly dated to the Yuan Dynasty, and authenticated such ware as imperial ware dated to the Hongwu period of the early Ming Dynasty. Compared with the similar type of stem-bowls produced in the Yuan Dynasty, the paste of this bowl becomes thinner with the base slimmer as well. In particular, the decorative designs of clouds and dragons are basically the same as the design of clouds and dragons on the imperial porcelain shards unearthed at the site of the former palace of the Ming Dynasty at Nanjing, thus it should be dated to the Hongwu period of the Ming Dynasty instead.

171

Plate
with molded and
incised design of
dragons amidst clouds
in bright red glaze

Ming Dynasty Hongwu period

Height 3.2 cm
Diameter of Mouth 19.4 cm
Diameter of Foot 11.9 cm

The plate has a flared mouth, a
shallow curved wall, and a ring foot. The
interior and exterior are covered with high-
temperature fired copper red glaze, and
the interior of the ring foot is unglazed.
The interior wall of the plate is incised
with design of dragons amidst clouds with
the centre incised with three auspicious
cloud patterns arranged in the shape of the
Chinese character "*pin*" (品) with an awl
and the wall decorated with molded design
of two dragons with five claws chasing
each other and interspersed by two cloud
patterns with similar stylistic rendering.
The glaze runs thin at the relief lines of
the molded designs with the white paste
exposed.

A similar specimen of imperial ware
with the same stylistic designs of this plate
was unearthed at the site of the palace of
the Ming Dynasty at Nanjing, providing
dating reference for this plate.

The incising decorative technique of
this plate was first introduced in the early
Ming Dynasty. An awl or a similar tool was
used to incise the designs with precise lines
which were then covered with glaze for
firing.

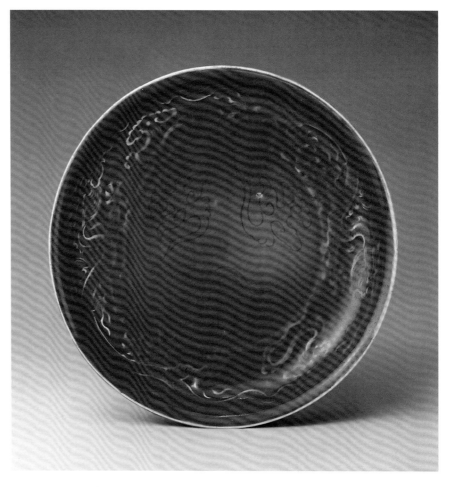

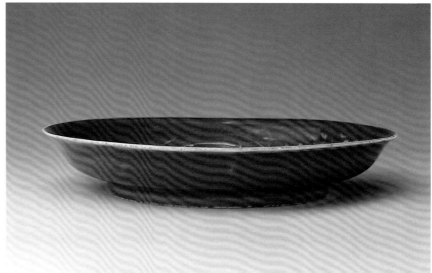

174

Monk's cap Jug
in bright red glaze

Ming Dynasty Yongle period

Height 20 cm
Diameter of Mouth 16.1 cm
Diameter of Foot 17.2 cm
Qing court collection

The jug has a wide neck, a slanting shoulder, a globular belly, a thin base, and a ring foot. The mouth rim is fashioned in the shape of a ladder to form the mouth rim in the shape of a monk's cap. On one side of the mouth rim linking to the neck is a ribbon-shaped curved handle, and on the other side is a spout groove in the shape of a duck's bill. The jug has a matching canopy-shaped cover on which is a round pearl-shaped knob. At the rim of the cover and the back of the mouth is a small ring loop respectively for fastening strings. The exterior wall of the jug is covered with pure, brilliant, and shiny bright red glaze. The interior of the ring foot and the jug are covered with white glaze.

As the mouth of the jug looks like a monk's cap, such jugs are known as monk's cap jugs which are vessels of Tibetan Buddhism. In the Yongle and Xuande periods of the Ming Dynasty, the Imperial Kiln in Jingdezhen had produced a large number of these jugs for bestowing on Tibetan Buddhist monks as gifts. There was ware with underglaze blue designs, sweet white glaze, bright red glaze, clearing-sky blue glaze, sprinkled blue glaze, and others. Some was also written or incised with Tibetan scripts. In the Kangxi period of the Qing Dynasty, the Imperial Kiln in Jingdezhen had produced imitated monk's cap jugs of the Xuande period. Although the glaze colour was close to the original, the form was rather clumsy instead.

175

Washer
in the shape of a hollyhock
in bright red glaze

Ming Dynasty Yongle period

Height 3.8 cm
Diameter of Mouth 15.9 cm
Diameter of Foot 13 cm
Qing court collection

The washer is fashioned in the shape of a hollyhock with ten petals and has a flared mouth, a shallow body, a straight wall, and a ring foot. The body is covered with bright red glaze. At the mouth rim and ribbed flower petals on the wall of the belly where the glaze melts and drips, the pure white paste is exposed. The interior of the ring foot is covered with white glaze.

176

Bowl
with gilt design of dragons amidst clouds in bright red glaze

Ming Dynasty Yongle period

Height 8.8 cm
Diameter of Mouth 20.9 cm
Diameter of Foot 9 cm

The bowl has a flared mouth, a deep curved belly, and a ring foot. The body is covered with bright red glaze, and the interior of the ring foot is covered with greenish-white glaze. The interior and exterior walls are decorated with gilt design of two dragons in pursuit of a pearl. Near the foot of the exterior wall is gilt design of lotus lappets.

To decorate ceramic ware with painted designs with gold powder was known as "gilt designs". Such a decorative technique was first used on Ding ware of the Northern Song Dynasty. In the Yuan Dynasty, gilt designs were often used to decorate ware in blue glaze. In the Ming Dynasty, gilt designs were applied extensively on various ware, and the technique had reached full maturity. Most of the decorative designs were dragons amidst clouds.

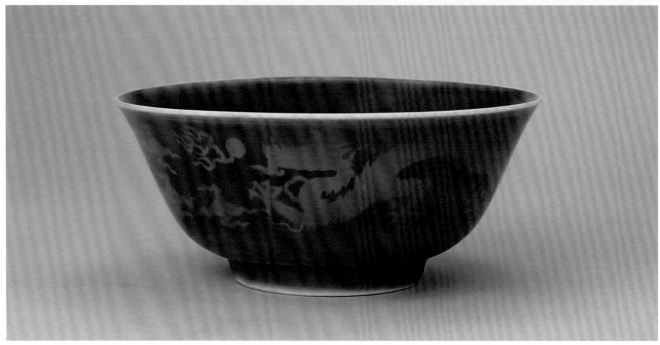

177

Bowl
in bright red glaze

Ming Dynasty Xuande period

Height 8 cm
Diameter of Mouth 18.9 cm
Diameter of Foot 8 cm
Qing court collection

The bowl has a flared mouth, a deep curved belly, and a ring foot. The body is covered with bright red glaze, and the interior of the ring foot is covered with greenish-white glaze. The exterior base is written with a six-character mark of Xuande in regular script in two columns within a double-line medallion in underglaze blue.

Xuande period marked the splendour of producing ware in bright red glaze in the Ming Dynasty. There were a wide variety of type forms, and in addition to bowls, plates, and stem-cups, there were also washers, incense-burners, *meiping* vases, monk's cap jugs, sauce pots, pear-shaped vases, and others. Some of the ware was not decorated, and some was decorated with incised or gilt designs.

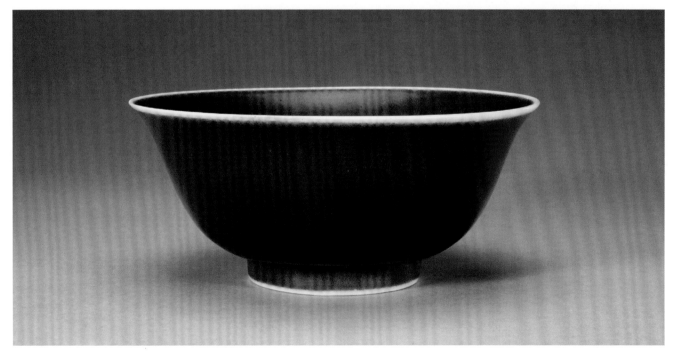

178

Plate
with bright red glaze on the exterior and white glaze in the interior

Ming Dynasty Chenghua period

Height 5 cm
Diameter of Mouth 20.9 cm
Diameter of Foot 13.5 cm

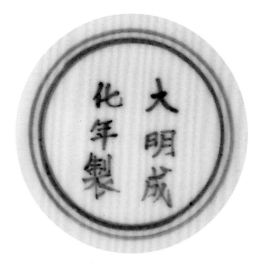

The plate has a wide mouth, a shallow curved belly, a base slightly recessed, and a ring foot. It is rather thickly potted with the interior wall and the interior of the ring foot covered with white glaze. The exterior wall is covered with bright red glaze, and owing to the melting and the dripping of the glaze during firing, the white paste is exposed on the mouth rim. The exterior base is written with a six-character mark of Chenghua in regular script in two columns within a double-line medallion in underglaze blue.

Extant ware in bright red glaze of the Chenghua period is very rare and valuable, as represented by this plate.

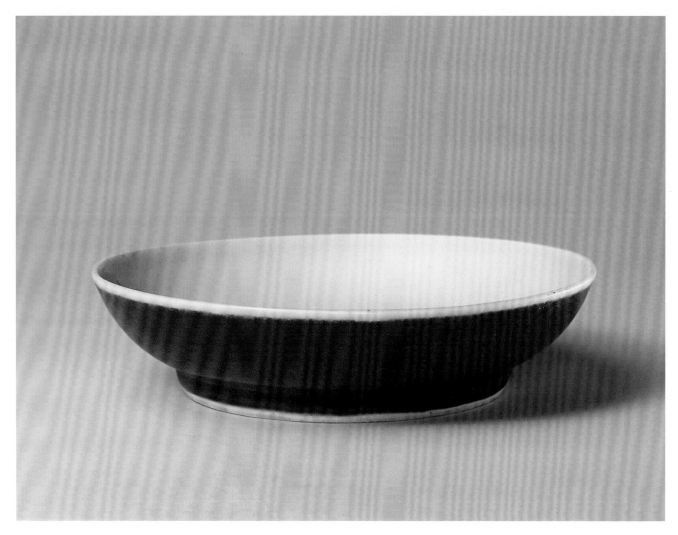

179

Plate
with bright red glaze on the exterior and white glaze in the interior

Ming Dynasty Zhengde period

Height 4.9 cm
Diameter of Mouth 20.3 cm
Diameter of Foot 13.1 cm

The plate has a wide mouth, a shallow curved wall, and a rather high ring foot. The interior wall and the interior of the ring foot are covered with white glaze. The white glaze on the ring foot has a greenish tint. The exterior wall is covered with bright red glaze with deep red streaks owing to the dripping of glaze during firing. The white paste is exposed on the mouth rim, forming a translucent white border.

The production of ware in bright red glaze had reached its zenith in the Yongle and Xuande periods, and the firing technique of this type of ware was gradually lost afterwards because production quantity reduced and the quality could not match that produced in the preceding periods. This plate was fired in the mid-Zhengde period (1506–1521) which was 100 years later after the Yongle and Xuande periods, but the brilliant bright red colour could still be achieved, which was very rare.

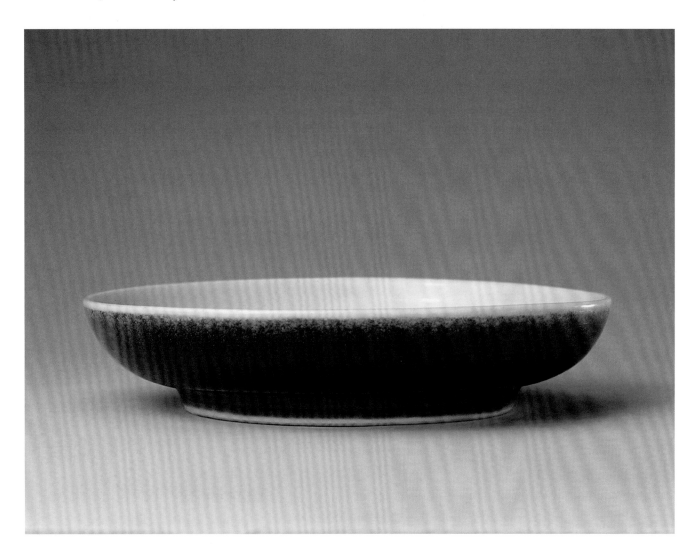

180

Plate
with design of fish reserved in
white on a bright red ground
on the exterior and
covered with white glaze
in the interior

Ming Dynasty Zhengde period

Height 3.5 cm
Diameter of Mouth 15.4 cm
Diameter of Foot 8.9 cm
Qing court collection

The plate has a wide mouth, a shallow
curved wall, and a ring foot. The interior is
covered with white glaze, and the exterior
is covered with bright red glaze. The red
glazed ground of the exterior wall are
decorated with four fish reserved in white
with the fish's gills, fins, and tails finely
incised and carved. The interior of the
ring foot is covered with greenish-white
glaze. The exterior base is written with a
four-character mark of Zhengde in regular
script in two columns within a double-line
medallion in underglaze blue.

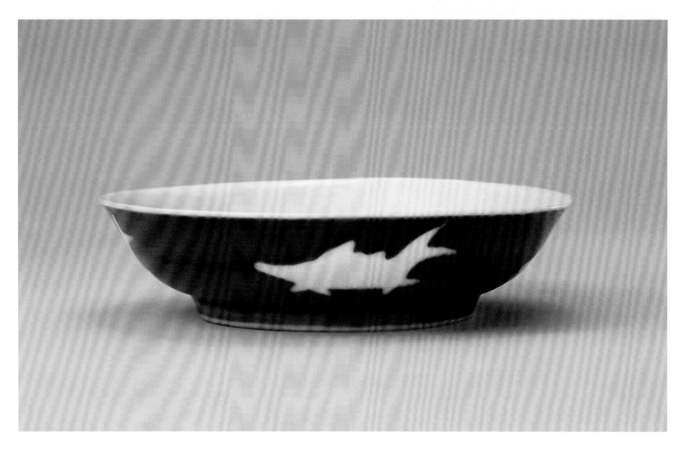

181

Brush-stand
in the shape of a goose
in bright red glaze

Ming Dynasty Jiajing period

Height 5.8 cm
Length 13.5 cm
Width 6 cm
Qing court collection

The brush-holder is fashioned in the shape of a goose reclining sideways with the body covered with bright red glaze. The glaze runs thin on the ribbed areas, exposing the white paste. The flat base is unglazed.

In the Jiajing period (1522–1566), the court had repeatedly ordered the production of ware in bright red glaze. However, as the firing technique was lost, ware in low-temperature fired iron red glaze, which was easier to handle, had been produced as an alternative. Although the bright red glaze on this brush-stand is not as brilliant as that of the Yongle and Xuande periods, it is still a fine and valuable piece of its type produced at the time.

182

Meiping Vase
in sky-clearing red glaze

Qing Dynasty Kangxi period

Height 24.2 cm
Diameter of Mouth 3.4 cm
Diameter of Base 7.8 cm

The vase has a small mouth, a short neck, a wide shoulder, a belly tapering downwards and flared at the base, and a base in the shape of a jade *bi* disc. The body is covered with sky-clearing red glaze, and the base is covered with white glaze and written with a six-character mark of Kangxi in regular script in two columns in underglaze blue.

The production of ware in sky-clearing red glaze marked the revival of firing ware in high-temperature fired copper red glaze, the firing technique of which had been lost since the mid Ming period, in the Imperial Kiln in Jingdezhen in the Kangxi period of the Qing Dynasty. High-temperature fired copper red glazes of the Kangxi period included sky-clearing red, *langyao*-red, and cowpea red glaze, each with its own distinctive colour and characteristics. The surface of sky-clearing red glaze was even and thick with a deep and subtle red colour, and the glaze was often applied to sacrificial vessels, stationery, and daily utensils.

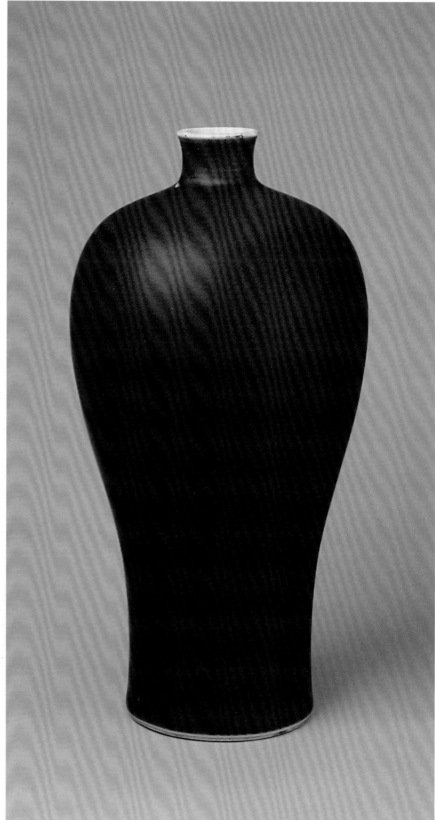

183

Pear-shaped Vase
in sky-clearing red glaze

Qing Dynasty Yongzheng period

Height 23.5 cm
Diameter of Mouth 7.5 cm
Diameter of Foot 9 cm
Qing court collection

The vase (*Yuhuchun*) has a flared mouth, a small neck, a globular hanging belly, and a ring foot. The body is covered with sky-clearing red glaze, and the interior of the ring foot is covered with white glaze. The exterior base is written with a six-character mark of Yongzheng in regular script in three columns within a double-line medallion in underglaze blue.

Sky-clearing red glaze belongs to the type of high-temperature fired copper red glaze. It has oxidized copper as colourant, and the glaze is directly applied to the raw paste and fired in high-temperature reduction firing atmosphere in the kiln.

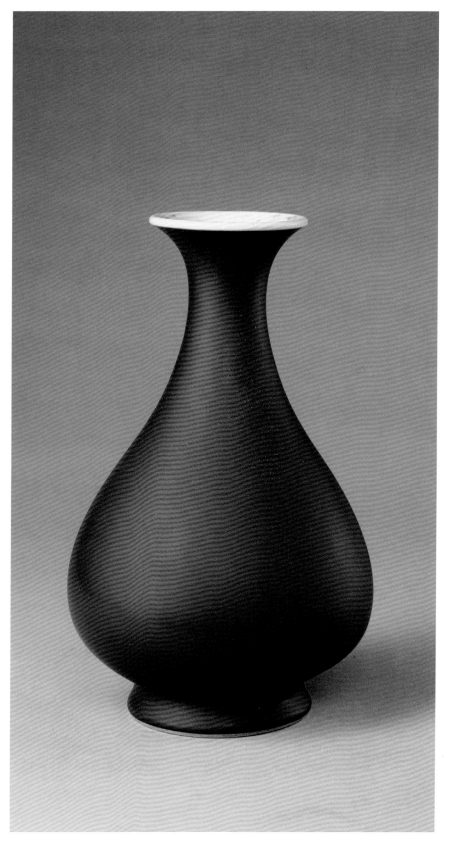

184

Bladder Vase
in sky-clearing red glaze

Qing Dynasty　Yongzheng period

Height 27.8 cm
Diameter of Mouth 3.5 cm
Diameter of Foot 8 cm
Qing court collection

The vase has a small mouth, a slim long neck, a hanging belly, and a ring foot. The interior wall and the interior of ring foot are covered with white glaze with the exterior wall covered with sky-clearing red glaze. The exterior base is written a six-character mark of Yongzheng in regular script in two columns within a double-line medallion in underglaze blue.

Imperial ware of the Yongzheng period had been noted for its delicate form and shiny and translucent glaze, and the monochrome ware of the period was most esteemed. This vase is finely potted with pure glaze colour, representing a refined piece of ware in sky-clearing red glaze.

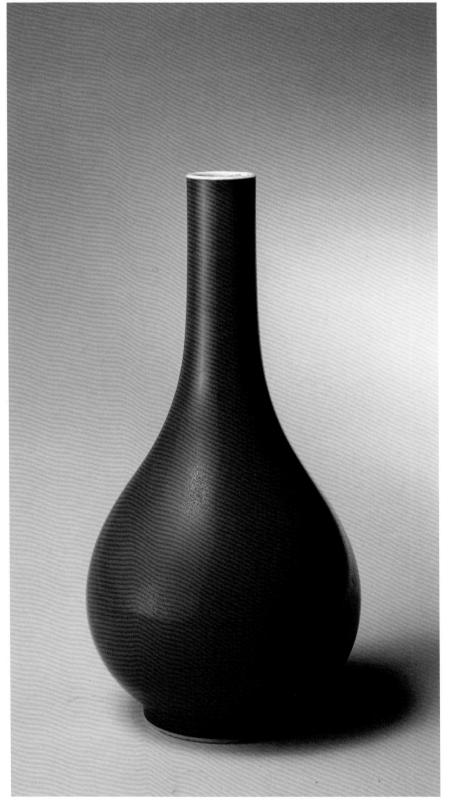

185

Celestial Sphere-shaped Vase
in sky-clearing red glaze

Qing Dynasty Qianlong period

Height 16.5 cm
Diameter of Mouth 3 cm
Diameter of Foot 4.5 cm
Qing court collection

The vase has an upright mouth, a slim long neck, a globular belly, and a ring foot. The interior wall of the vase and the interior of the ring foot are covered with white glaze. The exterior wall is covered with sky-clearing red glaze.

The pure sky-clearing red glaze matches harmoniously with the elegant form of the vase, representing the vigorous style of imperial Qianlong ware.

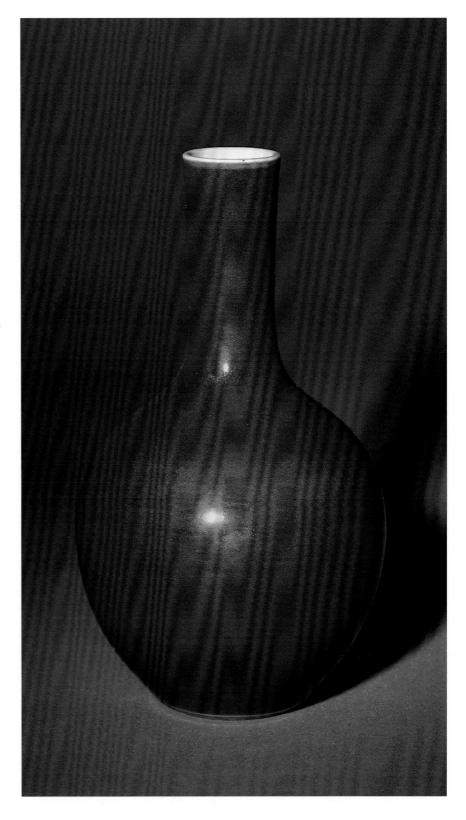

186

Pear-shaped Vase
in sky-clearing red glaze

Qing Dynasty Tongzhi period

Height 29.5 cm
Diameter of Mouth 9.4 cm
Diameter of Foot 10.8 cm
Qing court collection

The vase (*Yuhuchun*) has a flared mouth, a narrow neck, a hanging belly, and a ring foot. The interior wall and the interior of the ring foot are covered with white glaze. The exterior wall is covered with sky-clearing red glaze. The exterior base is written with a six-character mark of Tongzhi in regular script in two columns in underglaze blue.

This type of ware in sky-clearing red glaze belonged to the type of "regular tributary ware" which had been regularly produced annually for the use of the court. Other than this type of ware, there were commissioned ware, commissioned sacrificial ware, tributary ware, and others. The reign of Tongzhi (1862–1874) lasted for thirteen years, and since the suppression of the Taiping Rebellion in the third year of the Tongzhi period, social stability was temporarily restored without serious upheavals. At the time, the Imperial Kiln in Jingdezhen resumed its annual production, but since the reign was rather short, the scale of production was limited.

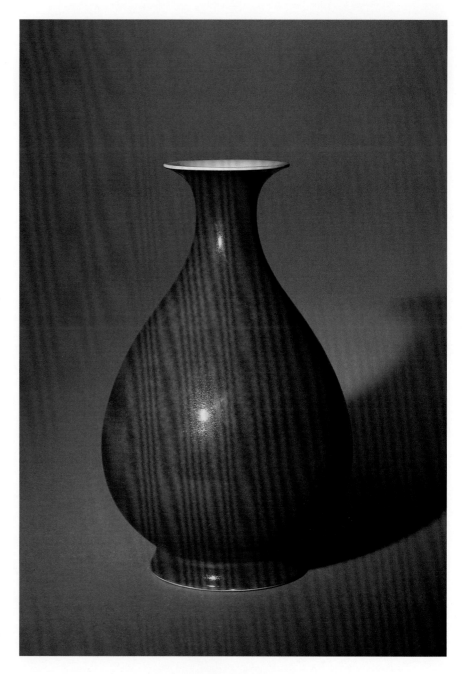

187

Guanyin *Zun* Vase
in *langyao*-red glaze

Qing Dynasty Kangxi period

Height 45.5 cm
Diameter of Mouth 12.7 cm
Diameter of Foot 14.4 cm
Qing court collection

The *zun* vase has a flared mouth, a neck slimmer at the middle and wider at the upper and lower side, a wide shoulder tapering downwards and flared near the foot, and a ring foot. The exterior is covered with *langyao*-red glaze. The interior of the vase and the interior of the ring foot are covered with white glaze. The white glaze inside the ring foot has a yellowish tint and small ice-crackles, which is commonly known as the "rice-soup base".

The term Guanyin *zun* vase came from its shape which looked like Guanyin (Avalokitesvara) standing elegantly, and such type of vases was a typical type of Kangxi ware in *langyao*-red glaze, as well as a popular type form of Kangxi ware.

From the 44th to the 51st year of the Kangxi period (1705–1712), Lang Tingji, Governor of the Jiangxi province, was appointed as the Director General of the Imperial Kiln in Jingdezhen for the production of imperial ware which had been highly esteemed and known as "the Lang kiln". Among the ware, the one glazed in ruby-red was the best, and such a red glaze was known as "*langyao*-red" glaze. The characteristics of ware in *langyao*-red glaze included elegant forms, thick glaze layers with a brilliant and shiny colour tone, and small ice-crackles. The ware did not bear any reign marks. There were two types of glazes on the bases of such ware. Other than the "rice-soup base", there was another type of bases glazed in green colour, which was known as the "apple green base" or the "apple base".

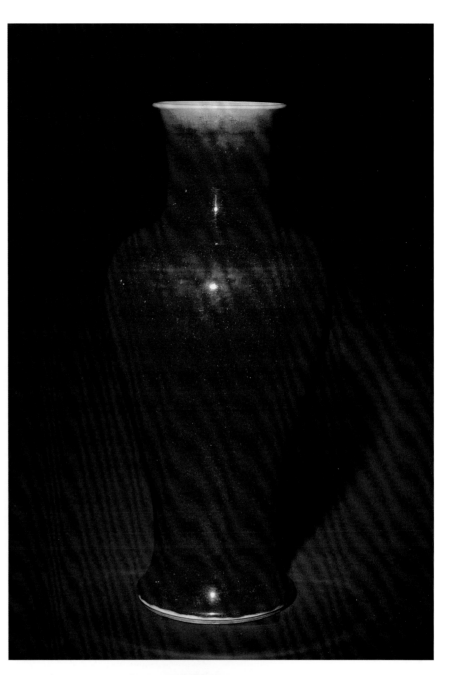

194

Vase
with design of chrysanthe-
mum petals in relief
in cowpea red glaze

Qing Dynasty Kangxi period

Height 20.3 cm
Diameter of Mouth 5.2 cm
Diameter of Foot 4.2 cm
Qing court collection

The vase has a flared mouth, a slim long neck, a slanting shoulder, a belly tapering downwards, and a ring foot. The body is covered with translucent and soft cowpea red glaze with tonal gradations of pink colour and small green mottles. The mouth rim exposes the white paste. The interior of the ring foot is covered with white glaze. The lower belly near the base is decorated with a border of elongated chrysanthemum petals in relief. The exterior base is written with a six-character mark of Kangxi in regular script in three columns in underglaze blue.

Cowpea red glaze was a kind of high-temperature fired copper red glaze newly created in the Kangxi period by the potters of the Imperial Kiln in Jingdezhen basing on the foundation of producing imitated ware in bright red glaze of the Xuande period, Ming Dynasty, which enjoyed the same esteem together with *langyao*-red glaze. As the colour was soft and subtle like the colour of cowpeas, it was named cowpea red glaze.

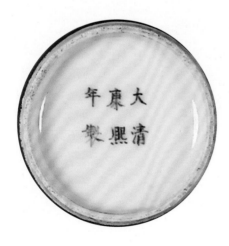

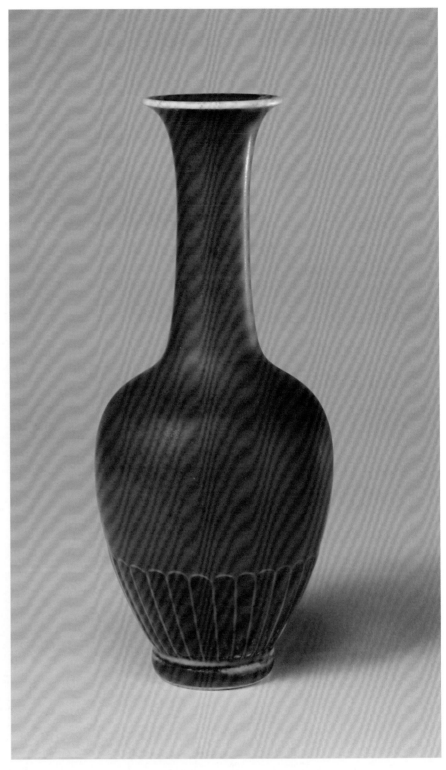

195

Turnip-shaped Vase
in cowpea red glaze

Qing Dynasty Kangxi period

Height 19.8 cm
Diameter of Mouth 3.2 cm
Diameter of Foot 4 cm
Qing court collection

The vase (*Laifu*) has a flared mouth, a slim long neck, a wide shoulder, a belly tapering downwards, and a ring foot. The interior of the vase and the ring foot are covered with white gaze. The exterior is covered with shiny and translucent cowpea red glaze. The area linking the neck and the shoulder is decorated with three borders of string patterns in relief. The exterior base is written with a six-character mark of Kangxi in regular script in three columns in underglaze blue.

Cowpea red glaze has different colour tone gradations. Those with a dense and brilliant colour tone are known as "*da-hongpao*" (grand red robe). Those with soft and subtle colour tones are known as "*wawamian*" (baby's face), "*taohuapian*" (peach-blossom petal), "*guifeise*" (colour of imperial concubine). Some with green mottles are known as "*taidianlü*" (moss green) or "*meirenji*" (smile of a beauty).

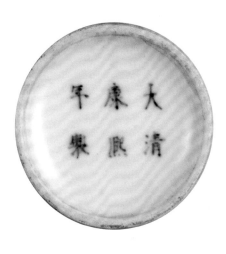

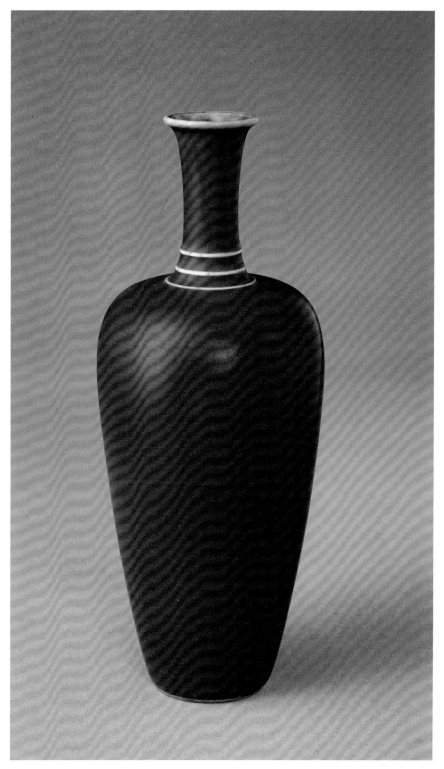

196

Willow-leaf Shaped Vase

in cowpea red glaze

Qing Dynasty Kangxi period

Height 15.5 cm
Diameter of Mouth 3 cm
Diameter of Foot 2 cm
Qing court collection

The vase has a flared mouth, a slim long neck, a slanting shoulder, a belly tapering downwards, and a deep ring foot. Both the interior and exterior are covered with cowpea red glaze with green mottles spreading over the belly. The white paste is exposed near the base. The interior of the ring foot is covered with white glaze. The exterior base is written with a six-character mark of Kangxi in regular script in three columns in underglaze blue.

The vase has a slim body and is shaped like a willow leaf, and is thus known as "willow-leaf shaped vase".

In general, there was no large size cowpea red ware produced in the Kangxi period, and most of the ware was vases, *zun* vases, washers, boxes, etc. The exterior bases were often written with a six-character reign mark of Kangxi in underglaze blue.

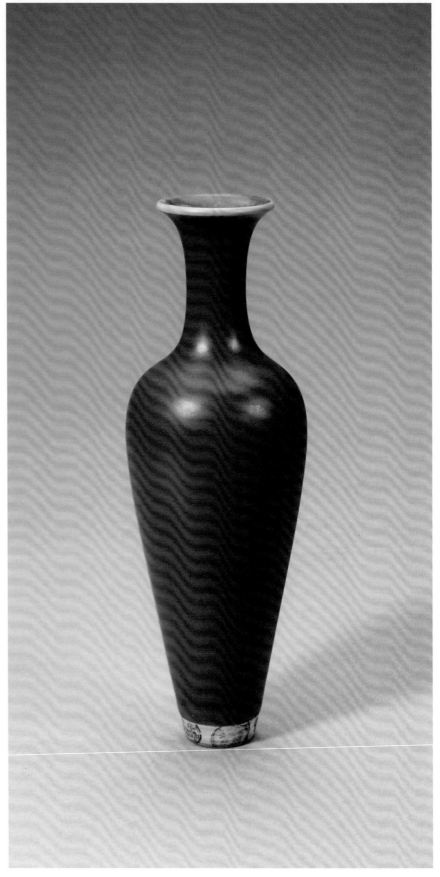

197

Semi-spherical Water-pot
with carved and incised design of *chi*-dragons in cowpea red glaze

Qing Dynasty Kangxi period

Height 8.1 cm
Diameter of Mouth 3.4 cm
Diameter of Foot 12.3 cm
Qing court collection

The water-pot (*Taibai Zun*)has a flared small mouth, a short neck, a slanting shoulder, a semi-spherical belly, and a shallow ring foot. The interior of the water-pot and the interior of the base are covered with white glaze. The exterior wall is covered with cowpea red glaze with green mottles in deep and light colours spreading over the glaze surface. The belly is decorated with three incised medallions of *chi*-dragons which are rendered vividly under the glaze with a touch of vigour. The exterior base is written with a six-character of Kangxi in regular script in three columns in underglaze blue.

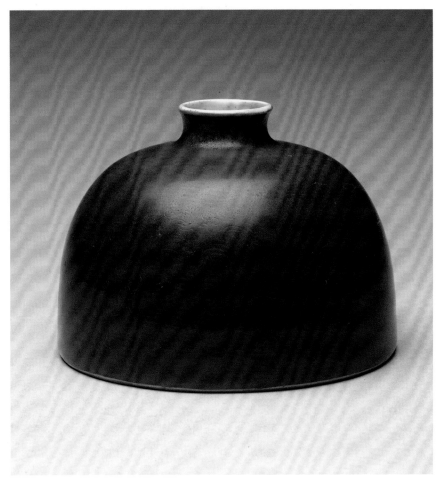

198

Gong-shaped Washer
in cowpea red glaze

Qing Dynasty Kangxi period

Height 3.9 cm
Diameter of Mouth 8.2 cm
Diameter of Foot 7.5 cm

The washer is in the shape of a gong musical instrument and has a contracted mouth with the diameter similar to the base, a curved wall, and a ring foot. The interior of the washer and the ring foot are covered with white glaze. The exterior is covered with cowpea red glaze with green mottles spreading over the surface. The exterior base is written with a six-character mark of Kangxi in regular script in three columns in underglaze blue.

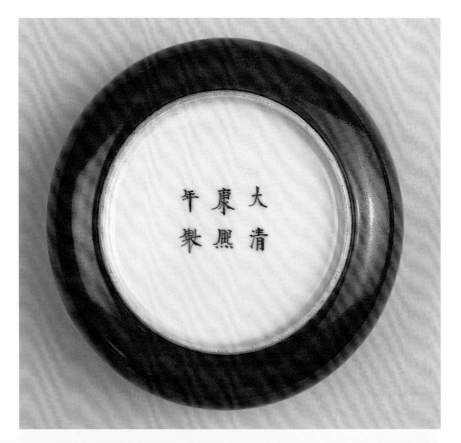

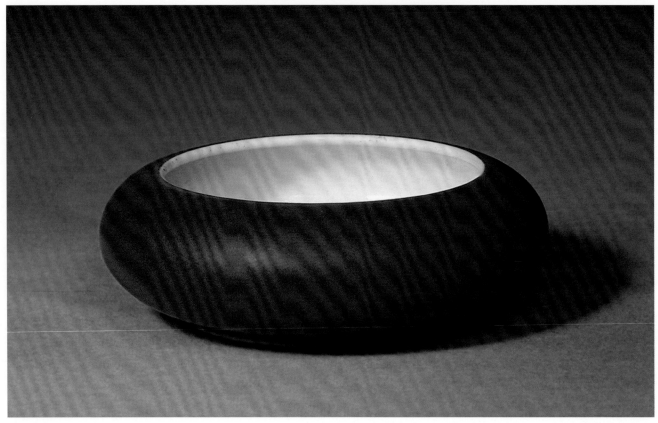

199

Seal Paste Box
in cowpea red glaze

Qing Dynasty Kangxi period

Height 3.5 cm
Diameter of Mouth 6.5 cm
Diameter of Foot 3.7 cm
Qing court collection

The box has a round mouth, a shallow belly, and a ring foot. The slightly convex surface fits with the box. The exterior wall is covered with cowpea red glaze. The interior of the box and the ring foot are covered with white glaze. The exterior base is written with a six-character mark of Kangxi in regular script in three columns in underglaze blue.

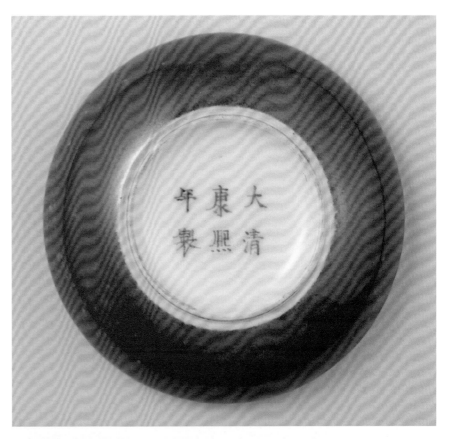

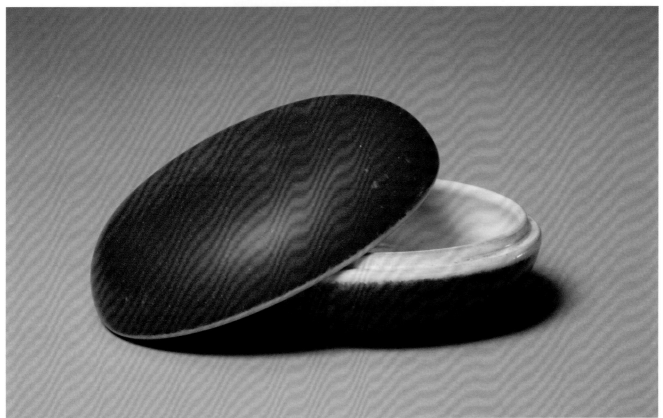

202

Vase
with a flared mouth,
ring-shaped handles and
design of butterflies in *fencai*
enamels in coral red glaze

Qing Dynasty Qianlong period

Height 19.8 cm
Diameter of Mouth 4.6 cm
Diameter of Foot 6 cm

The vase has a flared mouth, a slim long neck, a wide shoulder tapering downwards to the belly, and a slightly flared high ring foot. On the two symmetrical sides of the shoulder are two handles in the shape of butterflies holding rings painted with *fencai* enamels. The interior of the vase and the ring foot are covered with white glaze, whereas the exterior wall is covered with coral red glaze.

In the Qianlong period, ware in coral red glaze was not only produced in monochrome, but was also combined with various painted designs in colour glazes or enamels, revealing the trendy decorative style at the time, as represented by this vase.

203

Stem Cup
in rouge red glaze

Qing Dynasty Yongzheng period

Height 3.2 cm
Diameter of Mouth 3 cm
Diameter of Foot 1.7 cm
Qing court collection

The cup has a small mouth, a deep curved belly, a thin base, and a high hollow stem slightly flared. The interior of the cup and the stem foot are covered with white glaze, and the exterior is covered with rouge red glaze. The interior of the stem foot is written with a six-character mark of Yongzheng in regular script in underglaze blue from right to left.

The small cup is delicately fashioned, and the glaze is pure. It is a refined piece of its type in rouge red glaze produced in the Yongzheng period.

Rouge red glaze was a kind of low-temperature fired red glaze using colloidal gold as the colourant. The colourant was imported from Europe, thus it was called "western golden red" or "western red", and in the West it was commonly called "rose pink" or "rose red". It was also known as "rouge red" as the colour resembled the colour of rouge.

204

Bowl
in rouge red glaze

Qing Dynasty Yongzheng period

Height 4.3 cm
Diameter of Mouth 10 cm
Diameter of Foot 3.7 cm
Qing court collection

The bowl has a flared mouth, a deep curved belly, and a ring foot. The interior of the bowl and the ring foot are covered with white glaze, and the exterior wall is covered with rouge red glaze. The exterior base is written with a six-character mark of Yongzheng in regular script in two columns within a double-line medallion in underglaze blue.

Porcelain ware in rouge red glaze was first produced in the Kangxi period, and continued in the Yongzheng, Qianlong, Jiaqing, and Guangxu periods, with Yongzheng period producing the largest number with finest quality. Type forms produced in Yongzheng period included vases, jars, plates, bowls, cups, and dishes, all thinly fashioned with a touch of delicacy and gracefulness. Most of the ware was covered with white glaze in the interior, with the exterior glazed in rouge red, and only a small number was glazed in rouge red in the interior and on the exterior.

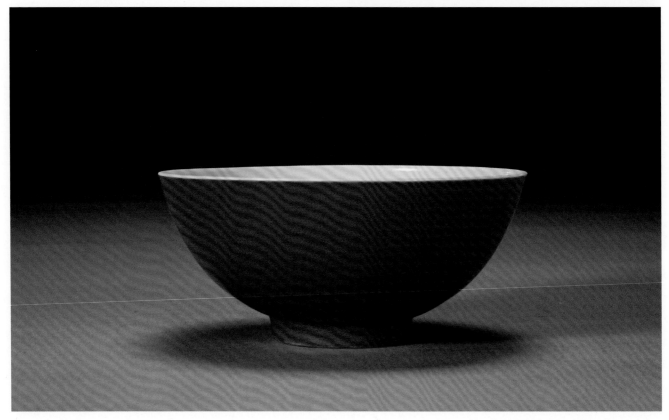

205

Plate
in rouge red glaze

Qing Dynasty Yongzheng period

Height 2.9 cm
Diameter of Mouth 15 cm
Diameter of Foot 9.3 cm

The bowl has a flared mouth, a shallow curved wall, and a ring foot. The interior of the plate and the ring foot are covered with white glaze. The exterior wall is covered with rouge red glaze. The exterior base is written with a six character mark of Yongzheng in regular script in two columns within a double-line medallion in underglaze blue.

Rouge red glaze manifests deep and light colour tones, while the deep tone is named "purplish-rouge", the light tone is named "pinkish-red", and even the lighter tone is named "light pink".

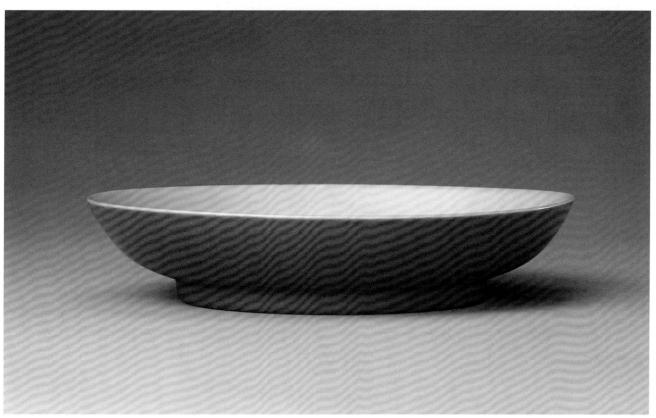

206

Hanging Wall-vase
with two ears
in rouge red glaze

Qing Dynasty Qianlong period

Height 27.4 cm
Diameter of Mouth 6.6 × 3.1 cm
Diameter of Foot 8 × 3.5 cm

The wall-vase is in the shape of a vase cut in half and has a mouth in the shape of a flower, a slim long neck, a globular belly tapering downwards to the base, and a stand with imitated wood texture glaze beneath. On the two symmetrical sides of the neck are two handles in the shape of *chi*-dragons. The back of the vase is flat and covered with white glaze, and has a recessed groove and a round hole for hanging on the wall. The front side of the vase is covered with rouge red glaze. The exterior base is covered with imitated wood texture glaze and written with a six-character gilt horizontal mark of Qianlong in seal script from right to left.

This wall vase is a new creative type form and is covered with even and pure glaze, which is a fine piece produced in the Imperial Kiln in the Qianlong period.

Hanging wall vases produced in the Qianlong period came in a variety of forms, which included *zun* vases, vases, jugs, and jars, and were often produced in pairs. Colours included various monochrome glazes, colour enamels, underglaze blue, *wucai* enamels, *yangcai* enamels, sky-clearing blue glaze, red glaze, and white glaze as well as colour glazes imitating the ware produced by the five famous kilns including Ru, Guan, Ge, Ding, and Jun of the Song Dynasty.

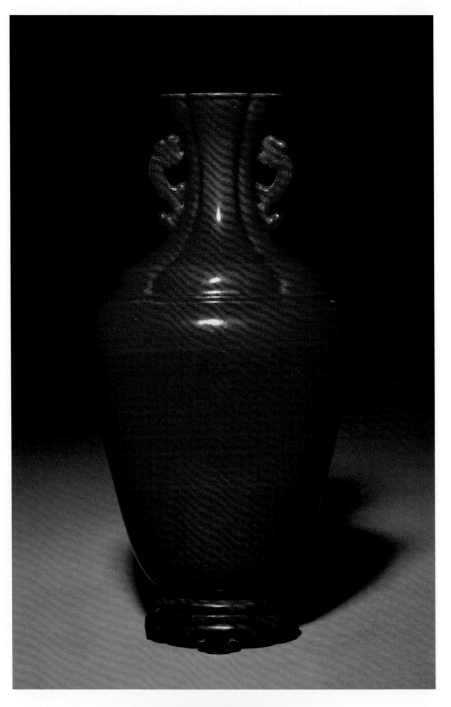

207

Meiping Vase
in rouge red glaze

Qing Dynasty Yongzheng period

Height 19.5 cm
Diameter of Mouth 2.2 cm
Diameter of Foot 6.7 cm

The *meiping*-vase has a small garlic-head mouth, a short neck, a wide shoulder, and a belly tapering downwards to a flared ring foot. The exterior wall is covered with rouge red glaze. As the colour is light and translucent, it is commonly called "rouge red water" glaze. The interior of the ring foot is covered with white glaze, and the exterior base is written with a six-character mark of Yongzheng in regular script in two columns within a double-line medallion in underglaze blue.

Produced with impeccable craftsmanship, the vase is gracefully fashioned and covered with charming pinkish-red glaze highlighted on the pure white glazed background.

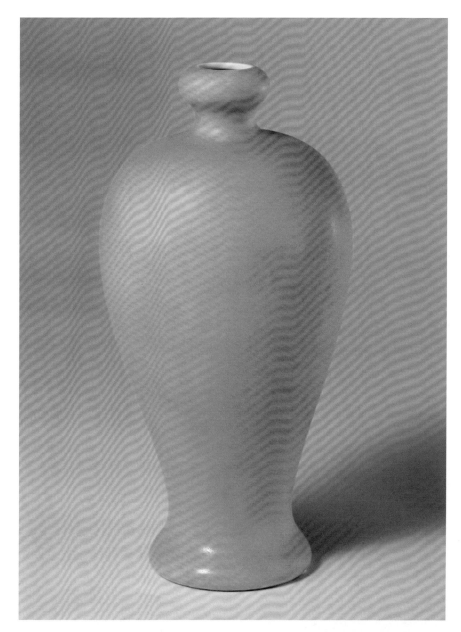

WARE IN YELLOW GLAZE

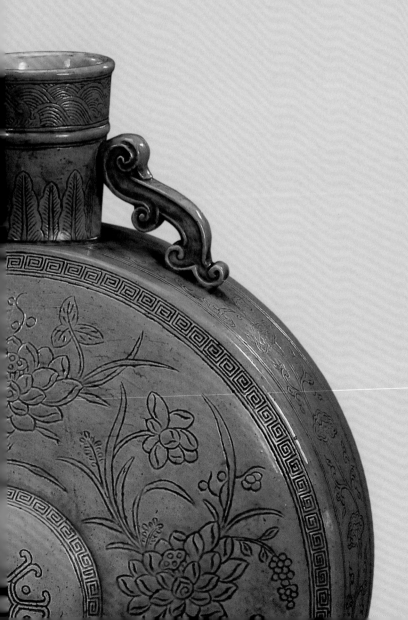

208

Pottery Jar
with design of a hunting scene in relief in brownish-yellow glaze

Eastern Han Dynasty

Height 25 cm
Diameter of Mouth 9.8 cm
Diameter of Foot 10.2 cm

The jar has a flared mouth, a round rim, a narrow neck, a wide shoulder, and a globular belly tapering downwards to a flat base. On the two symmetrical sides of the shoulder are two ears in the shape of animal-head handles. The greyish clay paste is covered with low-temperature fired lead brownish-yellow glaze on the exterior with the paste exposed at the base. The shoulder is decorated with a hunting scene in relief with a hunter riding on a horse and pulling his arrow to shoot amidst a landscape setting in which there are beasts such as tigers, goats, deer, horses, and birds.

This vase was an unearthed artifact, and after long periods of burial, the jar had been weathered by water and soil with marks of erosion and rust.

Pottery ware in low-temperature fired lead glaze was one of the representative ceramic ware of the Han Dynasty and had been popularly produced in the Yellow River Delta regions and North China. The paste of the ware was potted with clay and then applied with a layer of oxidized iron as fluxing agent and with oxidized iron or copper as colourant. After fired in a low temperature of around 800°C, the glaze would turn into brownish-yellow or grassy green colour. This type of pottery ware was burial objects. The "*sancai*" (three-colour) ware of the Tang Dynasty was developed from the production of this type of ware. As such ware had been buried under the ground for a long time, the glaze was eroded and weathered with a silvery-white coating on the surfaces, hence the name "silver glazed pottery ware".

209

Vase
with a flared mouth
in yellow glaze

Shouzhou ware
Sui Dynasty

Height 20.5 cm
Diameter of Mouth 5.5 cm
Diameter of Foot 6.2 cm

The jar has a flared mouth, a wide rim, a slim long neck, a slanting shoulder, a globular belly, and a flared ring foot. The greyish white paste is covered with a layer of pure white slip. The interior and exterior of the vase are covered with yellow glaze which stops above the base on the exterior wall, and there are bubbles inside the uneven layer of glaze.

The vase is modeled after the vase with a washer-shaped mouth of the Northern Dynasties with a plain body, which is quite rare among Zhou ware of the Sui Dynasty. The glaze is not pure due to immature skills in firing yellow glaze in the period.

The Shouzhou kiln had started its production in the mid to late Northern and Southern Dynasties, progressively developed in the Sui and mid-Tang Dynasty, and suspended in the late-Tang Dynasty. Its kiln sites were located in the present area around Huainan and Fengyang counties of the Anhui province. Huainan kiln was the major kiln of the Shouzhou kilns. Since it was under the jurisdiction of Shouzhou in the Tang Dynasty, it was named "the Shou zhou kiln". Pottery ware produced in the Shouzhou kiln in the Sui Dynasty was mainly ware in celadon glaze with a yellowish tint. Glaze often stopped just above the base and had a glassy quality with small ice-crackles on the surface.

210

Rectangular Pillow
in yellow glaze

Shouzhou ware
Tang Dynasty

Height 8 cm
Length 18 cm
Width 12.5 cm

The pillow is rectangular in shape with round corners and a sloped surface with the front side higher and the back side lower. The greyish white paste is covered with pure white slip and yellow glaze. The glaze is thin and even with glassy quality, and the base is unglazed, exposing the paste.

The Shouzhou kiln in the Tang Dynasty mainly fired ware in yellow glaze, as well as ware in black, tea-dust, and brownish-red glazes. In *The Classic of Tea* written by Lu Yu in the Tang Dynasty, he called such ware Shouzhou yellow ware, and listed the Shouzhou kiln as one of the six reputed kilns in the Tang Dynasty. Most of the ware in yellow glaze was covered with slip first and glazed on the exterior wall with the glaze stopped above the base. The uneven glaze with different thicknesses had deep and light colour variations, defect of glaze peeling off, and appearance of brownish mottles around the mouth rims. Popular ware with period characteristics included ewers with short spouts and pillows. Decorative designs were rendered with carving, molding, and molding with applique techniques, etc. Yet plain ware without decorations was most popularly produced at the time.

211

Jar
incised with knitted bamboo patterns in yellow glaze

Tang Dynasty

Height 15.7 cm
Diameter of Mouth 6.3 cm
Diameter of Foot 9.5 cm

The jar has a flared mouth, a round rim, a short neck, a wide shoulder, a globular belly, and a flat base. The greyish paste is covered with white slip and yellow glaze. The glaze is thin with parts peeled off and the paste is exposed at the base. The body is carved and incised with knitted bamboo patterns. On the shoulder and near the base are two incised borders of string patterns respectively.

The jar has a fabulous body and is covered with pure glaze, representing a fine piece of low-temperature fired ware in yellow glaze of the Tang Dynasty.

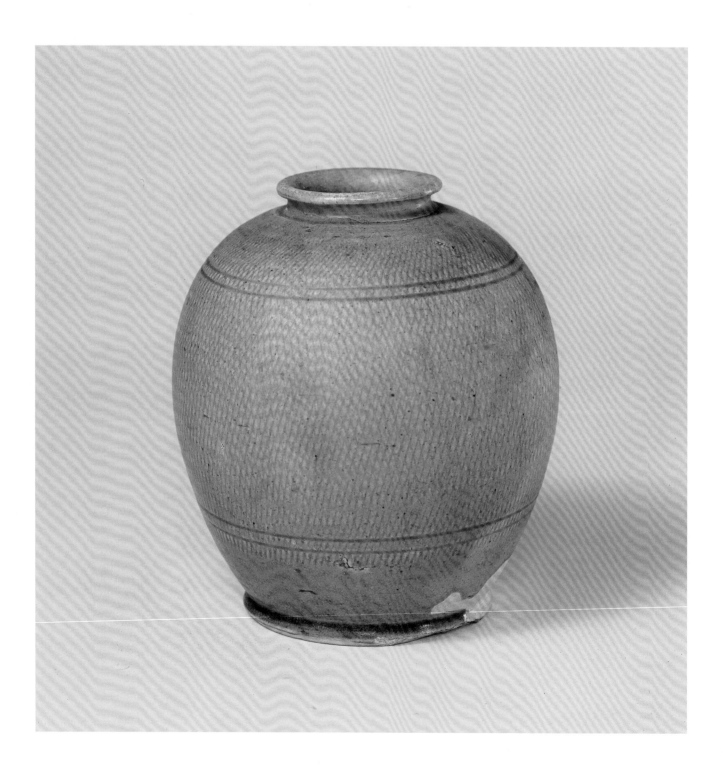

212

Phoenix-head Vase
in a flower-shaped mouth in yellow glaze

Liao Dynasty

Height 38.1 cm
Diameter of Mouth 9.7 cm
Diameter of Foot 7.6 cm

The vase has a mouth in the shape of a flower-shaped cup and has a slim long neck, a slanting shoulder, and a belly tapering downwards to a flared high ring foot. The greyish-white paste is covered with white slip and low-temperature fired yellow glaze with an uneven surface that stops above the base. The neck, the shoulder, and the area near the ring foot are carved and incised with borders of string patterns. The neck is modeled in the shape of a phoenix's head with a sharp and curved beak, symmetrical eyebrows and eyes on sides, and feathers protruding at the back.

The vase is a representative piece of ware in yellow glaze produced in the Liao Dynasty. Its form is modeled after the phoenix-head vases of the Tang Dynasty. Ware in yellow glaze produced in the Liao Dynasty had a wide range of colour gradations, mostly turning to brownish-yellow with pure yellow glaze rather rare and unusual.

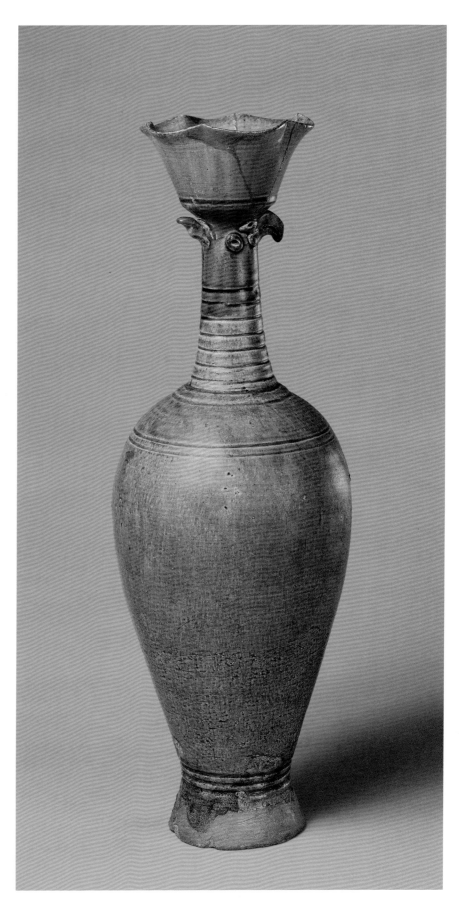

213

Plate
in *Jiaohuang*-yellow glaze

Ming Dynasty Chenghua period

Height 3.9 cm
Diameter of Mouth 14.8 cm
Diameter of Foot 9.2 cm

The plate has a flared mouth, a shallow curved wall, and a ring foot. The interior and exterior are covered with yellow glaze, and the interior of the ring foot is covered with white glaze. The exterior base is written with a six-character mark of Chenghua in regular script in two columns within a double-line medallion in underglaze blue and carved with a character "*tian*" (sweet) in regular script.

This type of ware was known as "*jiaohuang*" (pouring yellow) glaze referring to ware glazed with the pouring technique. Ware in this new type of transparent yellow glaze with oxidized iron as colourant and oxidized lead as fluxing agent was first produced in the Hongwu period of the Ming Dynasty and continued in the Xuande and Chenghua periods and thereafter. There were stringent regulations on the production and usage of yellow glazed ware, which was only confined to dining ware used by the emperor and empress or sacrificial vessels. This plate marked with the character "*tian*" (sweet) was likely to be used for containing desserts in the palace.

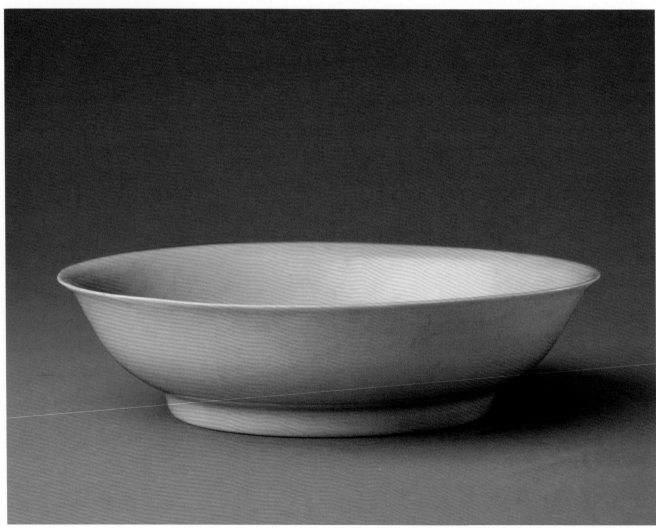

214

Zun Vase
with bull-head shaped handles and
gilt borders of string patterns
with *Jiaohuang*-yellow glaze

Ming Dynasty Hongzhi period

Height 32 cm
Diameter of Mouth 19 cm
Diameter of Base 17.5 cm
Qing court collection

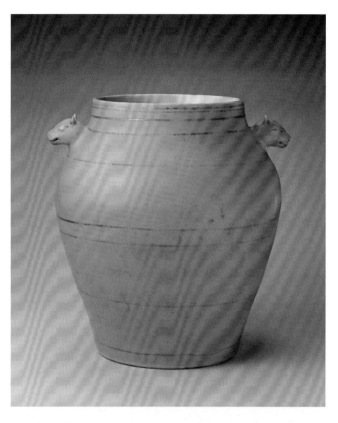

The *zun* vase has a wide mouth, a short neck, a slanting shoulder, and a globular belly tapering downwards to a flat base. On the two symmetrical sides of the shoulder are two handles in the shape of bull's heads. The interior of the vase is covered with white glaze and the exterior is covered with yellow glaze. The base is unglazed. The exterior wall is decorated with nine gilt borders of string patterns from top to bottom.

Ware in yellow glaze produced in the Ming Dynasty was mostly plates and bowls, whereas *zun* vases were fewer and confined to the Hongzhi period only. In addition to vases with handles in the shape of bull's heads, there were also vases with ribbon-shaped handles or without handles.

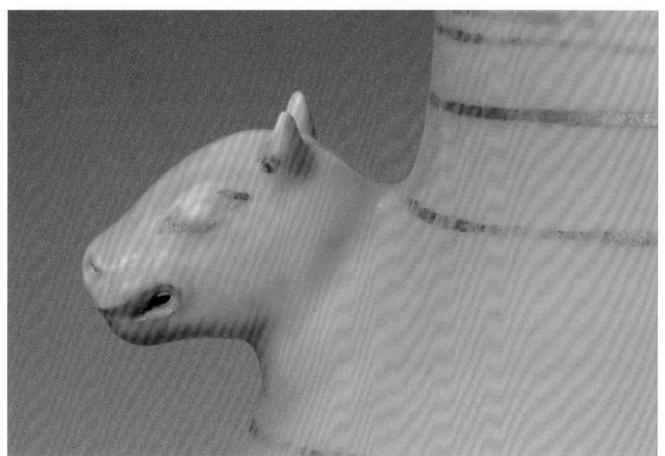

215

Zun Vase
with design of gilt borders of
string patterns
in *Jiaohuang*-yellow glaze

Ming Dynasty Hongzhi period

Height 32.3 cm
Diameter of Mouth 19.8 cm
Diameter of Base 18 cm
Qing court collection

The *zun* vase has a wide mouth, a short neck, a slanting shoulder, and a globular belly tapering downwards to a convex base. The interior is covered with white glaze, and the exterior is covered with yellow glaze. The base is unglazed. The exterior wall is decorated with design of seven gilt borders of string patterns.

In addition to this type of ware in yellow glaze, there was also similar ware in blue glaze, which was for court use as sacrificial vessels.

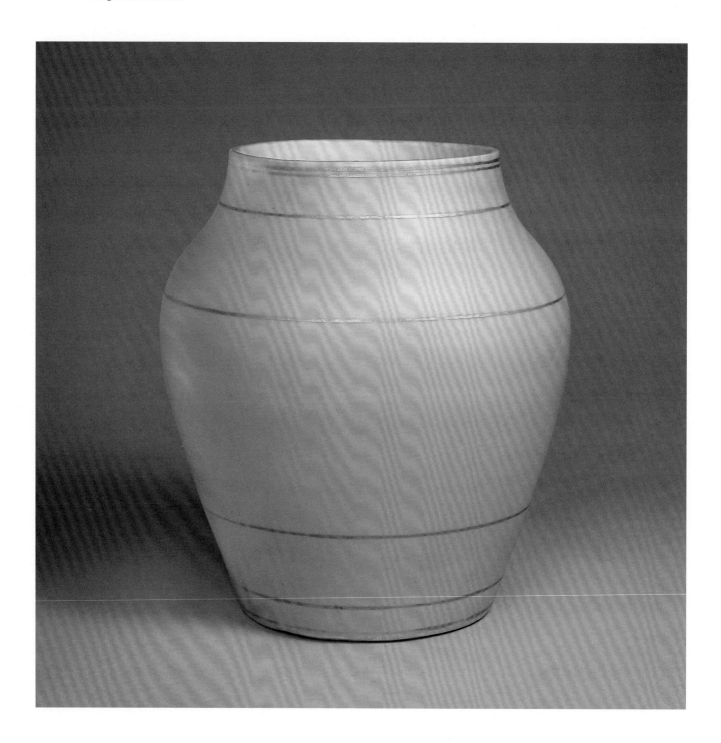

216

Jue Wine-cup
with gilt designs
in *Jiaohuang*-yellow glaze

Ming Dynasty Zhengde period

Height 16.3 cm
Largest Diameter of Mouth 13.3 cm
Distance between Legs 5.2 cm
Qing court collection

The *jue* wine-cup is modeled after bronze *jue* wine-cups and has a long round mouth, a tail, a spout, two vertical columns on the mouth, a deep belly with a joint flange in relief, and a small flat base with three legs beneath. The body is covered with yellow glaze and decorated with gilt designs, but most of which have peeled off. On two symmetrical sides of the belly are decorations of animal masks in relief.

Porcelain *jue* wine-cups were sacrificial vessels for court use in the Yuan, Ming, and Qing dynasties.

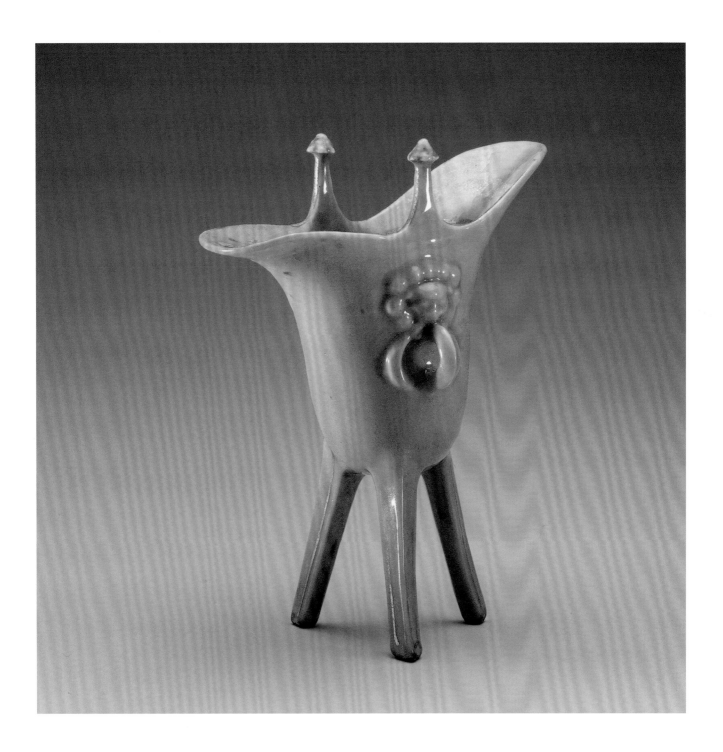

217

Jar
with carved and incised design of phoenixes and cranes flying amidst flowers in *Jiaohuang*-yellow glaze

Ming Dynasty Jiajing period

Height 28.5 cm
Diameter of Mouth 10.6 cm
Diameter of Foot 14.9 cm
Qing court collection

The jar has a rimmed mouth, a short neck, a slanting shoulder, a globular belly tapering downwards, and a ring foot. On the belly is a joint ridge in relief. The body is covered with yellow glaze. The exterior wall is incised with designs of cloud patterns on the neck, flying cranes on the shoulder, phoenixes and cranes flying amidst flowers on the belly, and banana leaves near the base. The exterior base is engraved with a six-character mark of Jiajing in regular script in two columns within a double-line medallion.

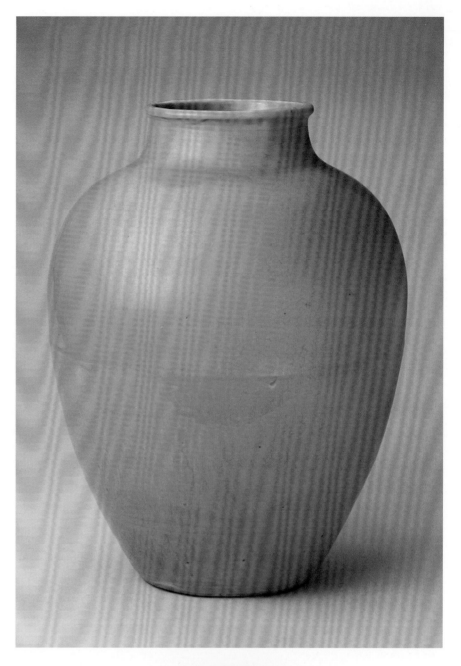

218

Bowl
in *Jiaohuang*-yellow glaze

Ming Dynasty Wanli period

Height 6 cm
Diameter of Mouth 14.7 cm
Diameter of Foot 5.4 cm
Qing court collection

The bowl has a flared mouth, a deep curved belly, and a ring foot with the base slightly sunken. The body is covered with yellow glaze, and the interior of the ring foot is covered with white glaze. The exterior base is written with a six-character mark of Wanli in regular script in two columns within a double-line medallion in underglaze blue.

The mark at the base of this bowl is written in underglaze blue with a dense and deep colour tone, which shows that Mohammedan cobalt blue and locally produced *shiziqing* cobalt blue materials have been mixed in writing the reign mark.

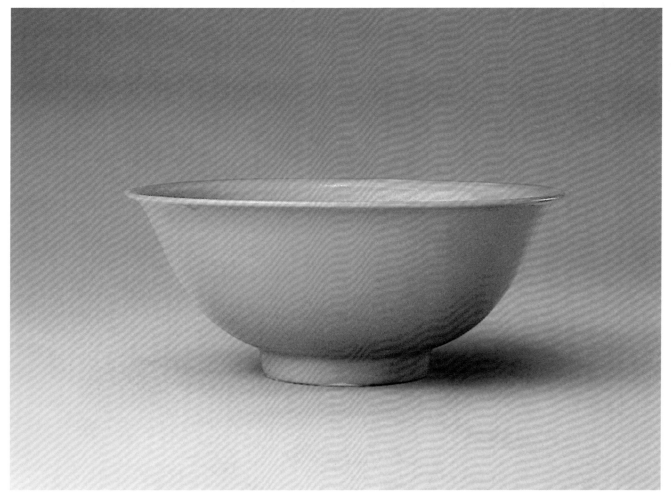

219

Large Plate
with carved and incised design of dragons amidst clouds in *Jiaohuang*-yellow glaze

Qing Dynasty Kangxi period

Height 7.2 cm
Diameter of Mouth 41 cm
Diameter of Foot 26.1 cm
Qing court collection

The bowl has a flared mouth, a foliated rim, a curved wall, and a ring foot. The body is covered with yellow glaze, and the interior of the ring foot is covered with white glaze. Both the interior and exterior walls are decorated with incised designs. The interior wall is decorated with floral sprays, whereas the exterior wall is decorated with dragons flying amidst clouds. The exterior base is written with a six-character mark of Kangxi in regular script in two columns within a double-line medallion in underglazed blue.

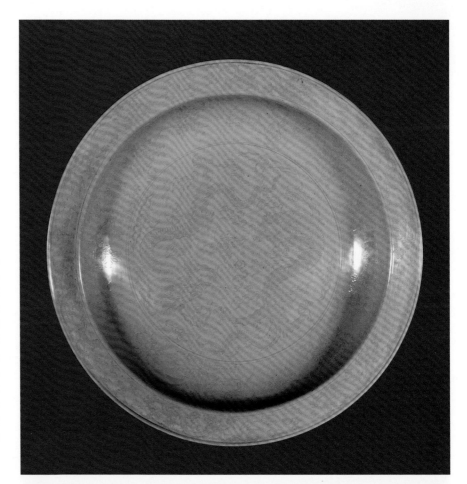

220

Baoyue Flask

with two looped-handles in the shape of ribbons and carved and incised design of lotuses in *Jiaohuang*-yellow glaze

Qing Dynasty Qianlong period

Height 52 cm
Diameter of Mouth 8.5 cm
Diameter of Foot 18 × 13.5 cm
Qing court collection

The flask has a straight mouth, a narrow neck, a globular belly, and a ring foot. On the two symmetrical sides between the neck and the belly are two handles in the shape of ribbons. The body is covered with yellow glaze and decorated with incised designs under the glaze. The neck is decorated with waves and banana leaves with a border of string patterns in relief. The belly is decorated with floral scrolls and *lingzhi* fungi. The front side is convex in shape like a cake and is decorated with deformed floral rosettes known as *bao-xiang* flower rosettes with two borders of decorations of lotuses and key-fret patterns outside.

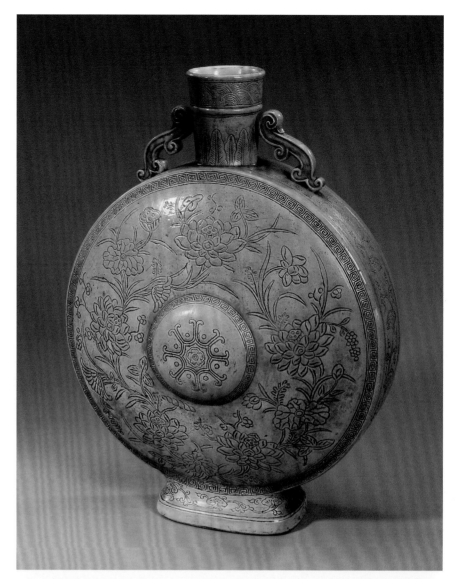

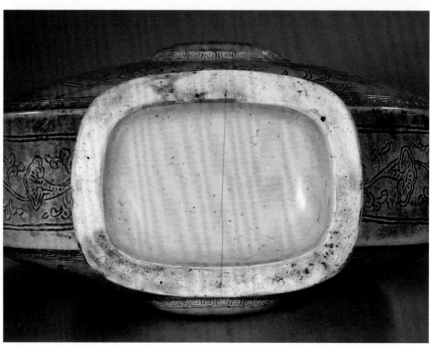

221

Spittoon
in *Jiaohuang*-yellow glaze

Qing Dynasty Daoguang period

Height 9 cm
Diameter of Mouth 8.5 cm
Diameter of Foot 5.7 cm
Qing court collection

The spittoon has a flared mouth, a straight neck, a globular belly, and a ring foot. The interior wall and the interior of the ring foot are covered with white glaze. The exterior wall is covered with yellow glaze. The exterior base is written with a four-character mark of "*Shendetang zhi*" in iron red glaze in double columns.

A spittoon was a type of ware for daily usage in the Qing court. Shende Tang (Shende Studio) was a cluster of buildings in the Yuanmingyuan Palace (Old Summer Palace), which had been built in the tenth year of Daoguang period (1830), and completed in the following year. It was the residence of Emperor Daoguang when he stayed in the Yuanmingyuan Palace (Old Summer Palace), and it was also the place where he passed away. Ware with the marks of Shende Tang was produced in the Imperial Kiln in Jingdezhen exclusively for the use of Emperor Daoguang, and the quality was as refined as the one marked with the reign marks of Daoguang.

222

Flower Pot
with carved and incised design of peonies in *Jiaohuang*-yellow glaze

Qing Dynasty Guangxu period

Height 20.5 cm
Diameter of Mouth 30.8 cm
Diameter of Foot 20 cm
Qing court collection

The flower pot has an everted rim, a straight wall, and a ring foot. The base has two round holes for releasing water. The interior is covered with white glaze whereas the exterior wall is covered with yellow glaze and decorated with carved and incised designs under the glaze. The mouth rim is incised with floral scrolls, and the belly with incised design of peonies. The exterior base is incised with a four-character mark of "*Tihedian zhi*"in seal script in two columns.

This flower pot was produced in the tenth year of the Guangxu period (1884) in the Imperial Kiln in Jingdezhen based on the drawings issued by the court, exclusively for the celebration of Empress Dowager Cixi's 50th birthday. It should have a matching tray.

Tihedian was the rear hall of Yikun Palace, one of the six West Palaces in the Forbidden City. In the ninth year of the Guang Xu period (1883), the court spent 630,000 silver taels to rebuild the Chuxiu Palace for the residence of Empress Dowager Cixi in celebration of her 50th birthday in the coming year. In the renovation project, the gate and front wall of the Chuxiu Palace were removed, and the wall of Yikun Palace at the southern end of the Chuxiu Palace was knocked down for building a new hall named Tihedian to allow access from the Chuxiu Palace to the Yikun Palace.

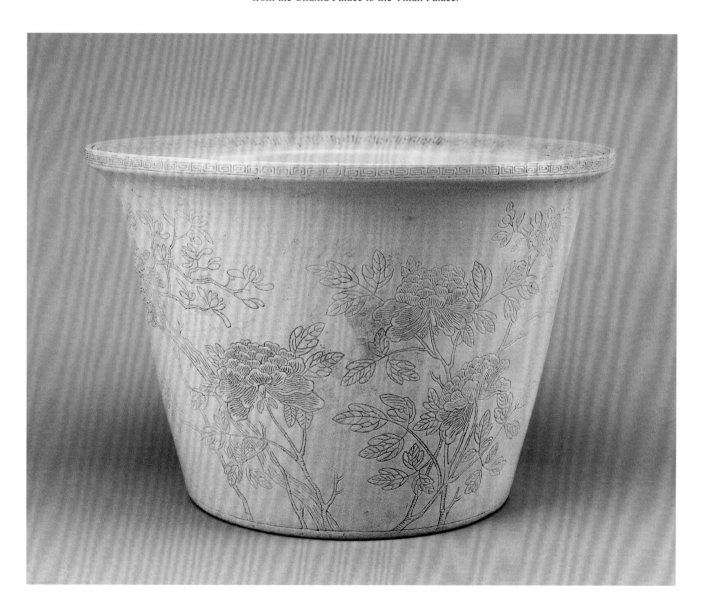

223

Cup
with two *chi*-dragon ears
and design of
panchi-dragons in relief
in light yellow glaze

Qing Dynasty Kangxi period

Height 3.6 cm
Diameter of Mouth 5.4 cm
Diameter of Foot 2 cm
Qing court collection

The cup has a flared mouth, a deep curved wall, and a ring foot. On the two symmetrical sides of the belly are two ears in the shape of *chi*-dragons. The body is covered with light yellow glaze and the interior of the ring foot is covered with white glaze. The belly is decorated with two borders in relief, in-between which are decorations of *panchi*-dragons carved in relief. The exterior base is written with a six-character mark of Kangxi in regular script in two columns within a double-line medallion in underglaze blue.

This was a wine-cup for imperial use and should have a tray in light yellow glaze to form a set. The centre of the tray should also have a round ridge to keep the cup in position.

Light yellow glaze was first produced in the Imperial Kiln in Kangxi period. As it used oxidized antimony as colourant instead of the colourant of oxidized iron for the yellow glazed ware, the colour had become lighter, and thus it got its name as "light yellow glaze". As its light yellow colour resembled egg-yolks or lemons, it was also known as "egg-yolk yellow glaze" or "lemon yellow glaze". The book *Taocheng Jishi* named it "western yellow" because antimony was imported from Europe before the sixth year of the Yongzheng period.

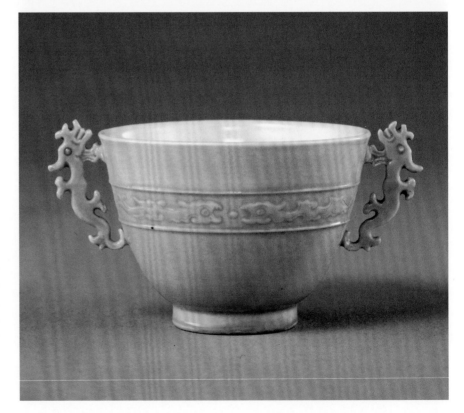

224

Willow-leaf Vase
in light yellow glaze

Qing Dynasty Yongzheng period

Height 14.6 cm
Diameter of Mouth 3.3 cm
Diameter of Foot 1.7 cm
Qing court collection

The vase has a flared mouth, a small neck, a slanting shoulder, a contracted belly tapering downwards, and a ring foot. The body and the interior of the ring foot are covered with light yellow glaze. The exterior base is incised with a six-character mark of Yongzheng in seal script in three columns.

Ware in light yellow glaze produced in the Yongzheng period was mostly smaller in size, such as vases, plates, bowls, cups, and dishes. With a small size which complemented the soft colour, such ware was noted for a touch of delicacy and charm.

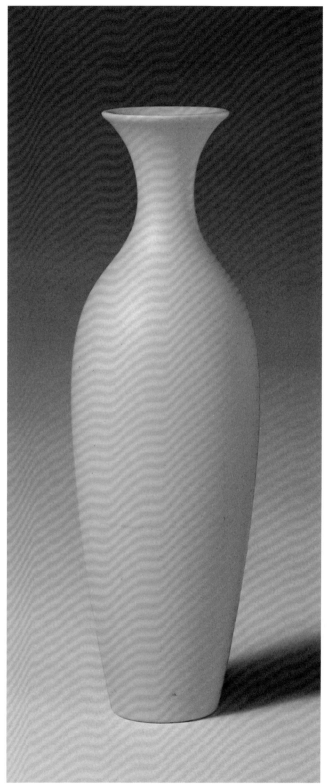

225

Plate
in light yellow glaze

Qing Dynasty Yongzheng period

Height 2.8 cm
Diameter of Mouth 13.3 cm
Diameter of Foot 8 cm

The cup has a flared mouth, a curved belly, and a ring foot. It is light and is thinly potted with hard paste. The interior and exterior are covered with light yellow glaze, and the interior of the ring foot is covered with white glaze. The exterior base is written with a six-character mark of Yongzheng in regular script in two columns within a double-line square in underglaze blue.

226

Covered Box
with seven-compartments in light yellow glaze

Qing Dynasty Qianlong period

Overall Height 12 cm
Diameter of Mouth 18 cm
Diameter of Foot 10.6 cm
Qing court collection

The box has a wide mouth, a shallow curved belly, and a ring foot. The box has seven compartments in the shape of flower petals. The cover of the box is decorated with three borders of string patterns with a ring-shaped knob on the top. The interior of the box, the cover, and the ring foot are covered with white glaze, and the exterior of the box is covered with soft, even, and pure light yellow glaze. The exterior base is written with a six-character mark of Qianlong in seal script in three columns in underglaze blue.

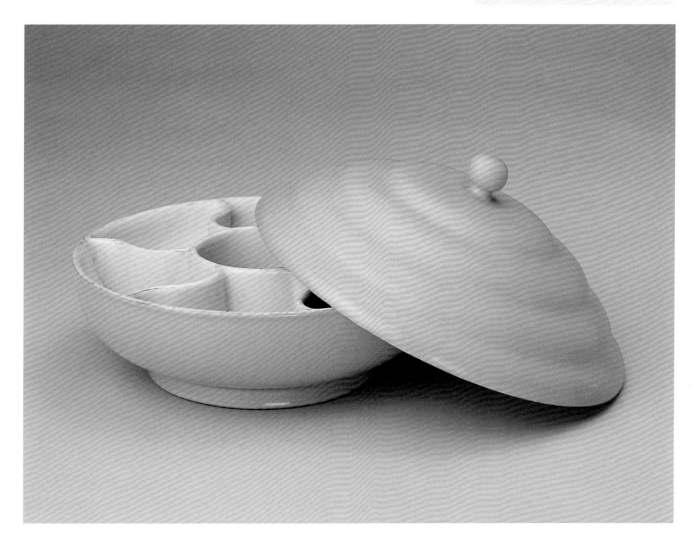

227

Brush-holder
in imitation of the bamboo
brush-holder with design of
landscapes and figures
in yellow glaze

Qing Dynasty Daoguang period

Height 13.4 cm
Diameter of Mouth 15.2 cm
Diameter of Foot 15 cm

The brush holder is cylindrical in shape with a round mouth, a straight wall, and a slightly flared ring foot, and the sizes of the mouth and the foot are similar. The body is covered with yellow glaze with the exterior wall carved with distant mountains, a courtyard, cottages, bamboos and rocks, and figures, showing an idyllic scene of village life. The exterior base is engraved with a four-character mark of Daoguang in regular script in two columns.

In the Daoguang period of the Qing Dynasty, a fashion to imitate bamboo carvings was popular and led to the emergence of a group of craftsmen who excelled in carving porcelain ware in the style of bamboo carvings. This brush-pot is skillfully carved with a touch of realism and exquisiteness, representing a refined piece of work in imitation of bamboo carvings.

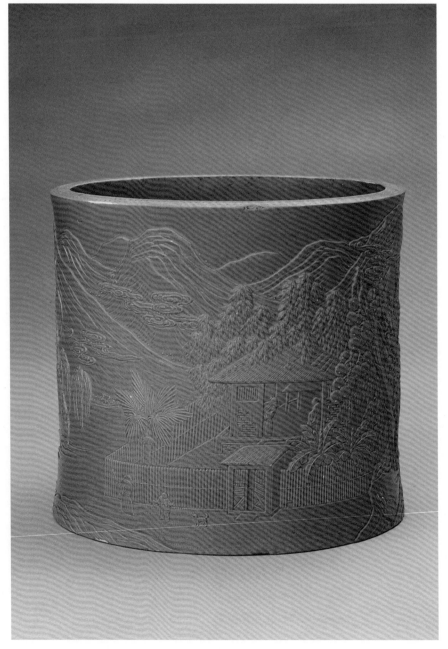

228

Bowl
with design of dragons amidst clouds reserved in white in rice yellow glaze

Qing Dynasty Kangxi period

Height 8.5 cm
Diameter of Mouth 19.5 cm
Diameter of Foot 7 cm

The bowl has a flared mouth, a slanting wall, and a ring foot. The interior and exterior are covered with rice yellow glaze, and the interior of the ring foot is covered with white glaze. The exterior wall is decorated with design of dragons amidst clouds reserved in white. The exterior base is written with an imitated six-character mark of Chenghua in regular script in two columns within a double-line medallion in underglaze blue.

In the Kangxi period, the court had required that ware produced in the Imperial Kiln should not bear reign marks of the Kangxi period. As a result, imitated marks of the Xuande, Chenghua, Hongzhi, Jiajing, and Wanli periods of the Ming Dynasty were written or inscribed on the Kangxi imperial ware instead.

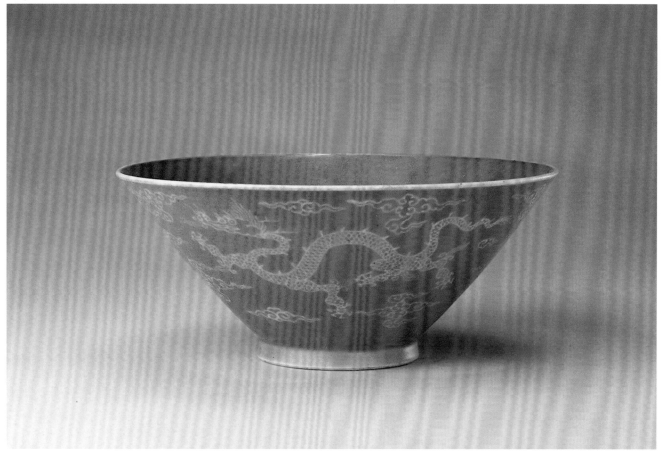

229

Bowl
in rice yellow glaze

Qing Dynasty Yongzheng period

Height 3.8 cm
Diameter of Mouth 11.8 cm
Diameter of Foot 4.2 cm
Qing court collection

The bowl has a flared mouth, a deep curved wall, and a ring foot. The interior and exterior are covered with rice yellow glaze, and at the rim where the glaze runs thin, the white paste is exposed. The interior of the ring foot is covered with white glaze. The exterior base is written with a six-character mark of Yongzheng in regular script in two columns within a double-line medallion in underglaze blue.

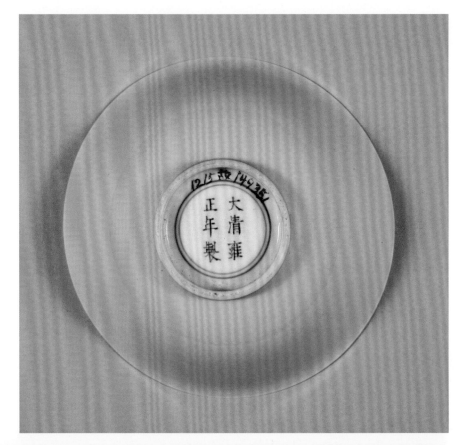

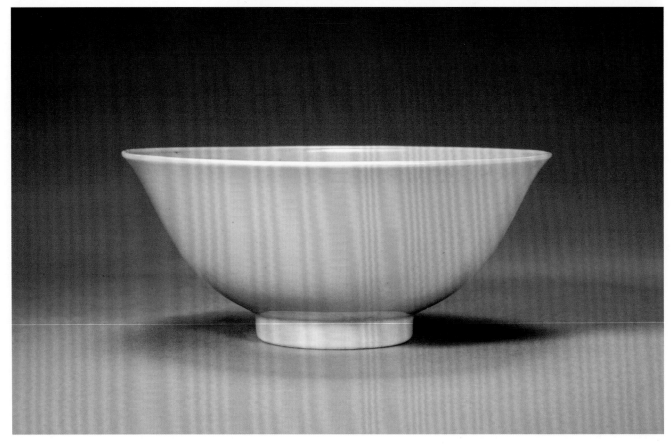

WARE IN BLUE GLAZE

230

Jar
in blue glaze

Tang Dynasty

Height 9.5 cm
Diameter of Mouth 4.3 cm
Diameter of Base 4.5 cm

The jar has an upright mouth, a round rim, a wide shoulder, a globular belly tapering downwards, and a flat base. The body is covered with blue glaze with dense colour with some areas turning to lighter colour or with flambé effect.

Ware of the Tang Dynasty covered with low-temperature fired blue glaze was quite rare and unusual. This type of glaze used oxidized cobalt as colourant and oxidized lead as fluxing agent with the cobalt materials probably imported to China through the ancient Silk Road. Ware of the Tang Dynasty with the whole body glazed in blue was very valuable with high artistic merits.

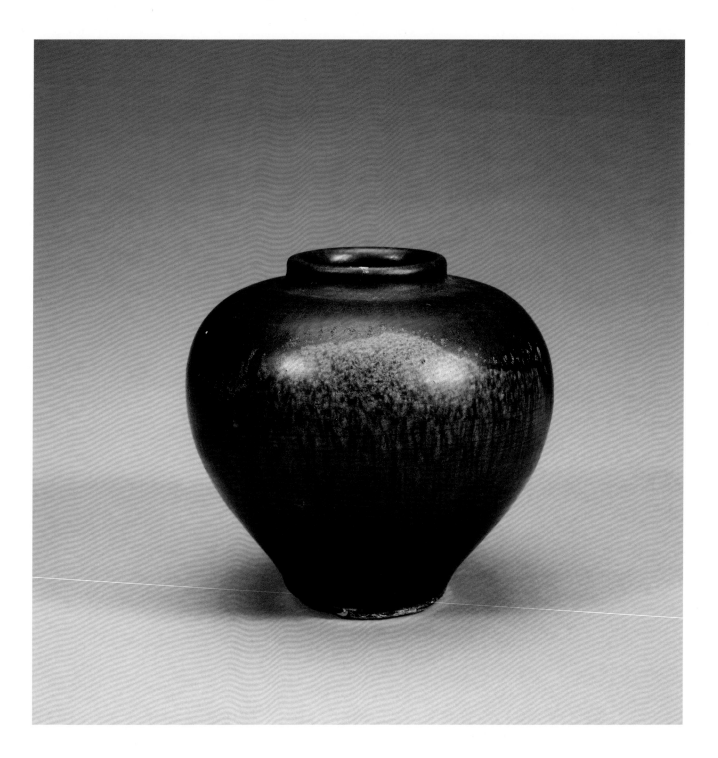

231

Yi Washer
with gilt design in blue glaze

Yuan Dynasty

Height 4.5 cm
Overall Length with Spout 4.3 cm
Diameter of Base 8.5 cm
Unearthed in a cellar at Baoding,
Hebei in 1964

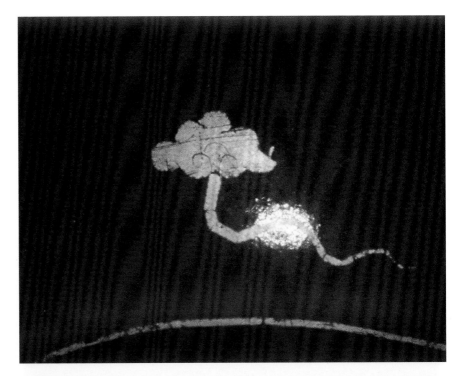

The washer is in the form of a shallow bowl with a shallow curved wall and a flat base. On one side is a groove spout with a small round loop underneath. The interior and exterior are covered with high-temperature fired blue glaze, yet on the mouth only the rim of the spout is glazed with the other parts of the rim unglazed, exposing the paste. The exterior base is unglazed, exposing the paste. The interior wall is decorated with five floating clouds, and the interior of the base is decorated with floral sprays enclosed by a gilt single-line medallion.

Yi washers were for washing purposes in ancient China and most of them were metal ware. Porcelain washers were popularly produced by various kilns in the Yuan Dynasty, in particular in the Jingdezhen kiln with various glazes including underglaze blue, underglaze red, greenish-white, blue, and others with this piece representing the best quality. According to Chapter 58 "*Zazao*" (Miscellanious Products) in the book *Yuandian Zhang*, there was a court order issued in the eighth year (1271) of the Zhiyuan period of the Yuan Dynasty that the practice of applying gilt design on porcelain ware was forbidden since then, thus extant and unearthed ware with gilt designs of the Yuan Dynasty is very rare. This washer with gilt designs and blue glaze is the only known piece extant, which is extremely valuable.

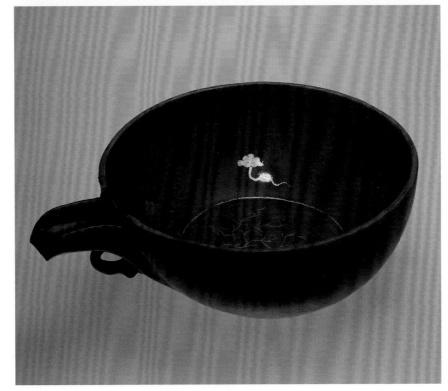

232

Plate
with dragon design reserved in white in blue glaze

Yuan Dynasty

Height 1.1 cm
Diameter of Mouth 16 cm
Diameter of Foot 14 cm
Qing court collection

The plate has a folded rim, a shallow wall, and a flat base. The interior and exterior are covered with high-temperature fired blue glaze, and the exterior base is unglazed. The interior centre of the plate is covered with blue glaze and decorated with a ferocious dragon with a slim neck, three claws and a head soaring up sculptured with white slip in applique.

High-temperature fired cobalt blue glaze was newly produced in the Jingdezhen kiln in the Yuan Dynasty, which was also the forerunner of sky-clearing blue glaze in the Ming Dynasty. This plate is a representative piece covered with blue glaze and decorated with designs reserved in white of the Yuan Dynasty. In addition to this type of small plates, other forms such as *meiping* vases, jars, ink stone boxes, *yi* washers, and foliated plates had also been produced, and decorated with designs of dragons, waves, flying geese, phoenixes, horses in the sea, *lingzhi* fungi, and others.

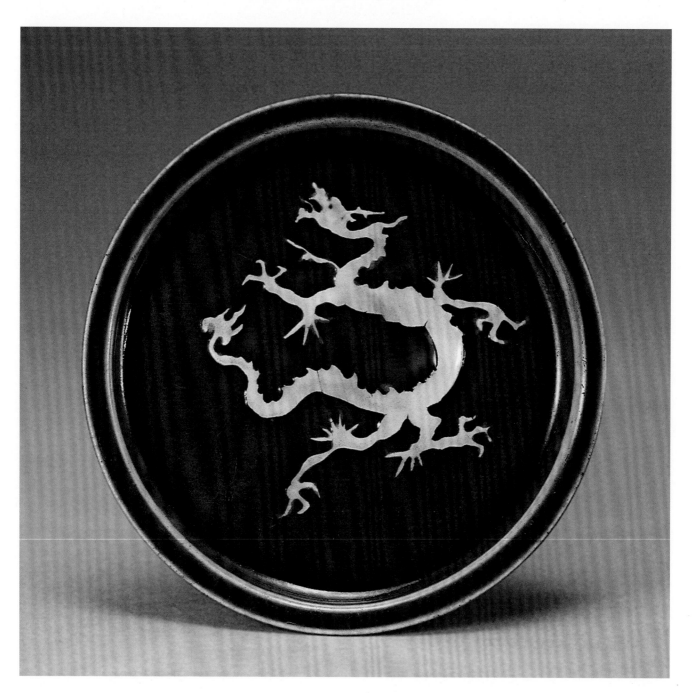

233

Plate
with design of
fish reserved in white
in sky-clearing blue glaze

Ming Dynasty Xuande period

Height 4 cm
Diameter of Mouth 19.2 cm
Diameter of Foot 12.7 cm
Qing court collection

The plate has a flared mouth, a shallow curved wall and a ring foot. The interior and exterior are covered with sky-clearing blue glaze. The interior centre and the exterior wall are decorated with design of fish swimming amidst lotuses in a pond rendered with white slip. The exterior base is written with a six-character mark of Xuande in regular script in two columns within a double-line medallion in underglaze blue.

Porcelain ware with designs reserved in white on a blue glazed ground produced in the Xuande period of the Ming Dynasty was progressively developed from the foundation of the Yuan Dynasty, with decorative designs carved and painted in a more delicate manner, and the type forms and decorative motifs being increased. Plates with imitated design of fish, flowers, and lotuses reserved in white of the Xuande period had also been produced in the Jingdezhen Imperial Kiln in the Kangxi period of the Qing Dynasty, but the artistic merits and rendering could not match those of the Xuande ware.

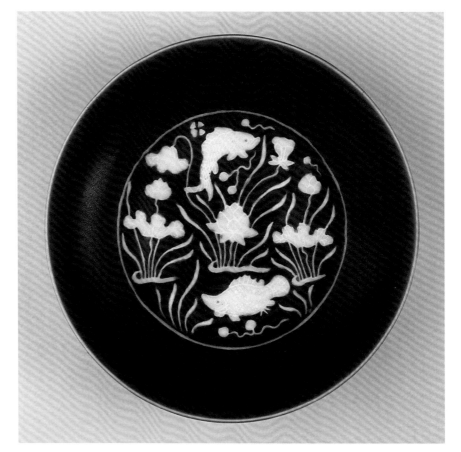

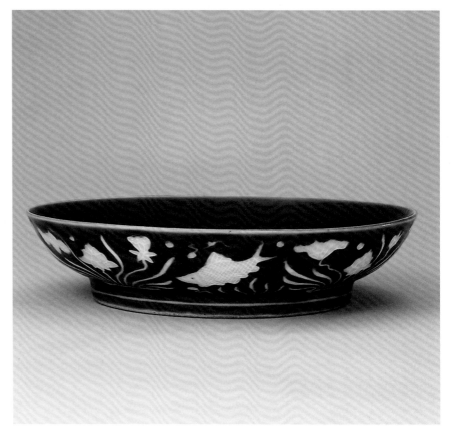

234

Plate
with molded and
incised design of
dragons amidst clouds
in sky-clearing blue glaze

Ming Dynasty Xuande period

Height 4.5 cm
Diameter of Mouth 20 cm
Diameter of Foot 12.2 cm

The plate has a flared mouth, a shallow curved wall, a ring foot, and a sunken base. The interior and exterior are covered with sky-clearing blue glaze. At the mouth rim where the glaze runs thin, the white paste is exposed, and orange-peel marks are found on the glaze surface. The interior of the ring foot is covered with white glaze. The interior wall is decorated with molded design of dragons in pursuit of a pearl. The exterior base is written with a six-character mark of Xuande in regular script in two columns within a double-line medallion in underglaze blue.

This plate is a representative piece of the ware in sky-clearing blue glaze produced in the Xuande period. In the Ming and Qing dynasties, ware in sky-clearing blue glaze produced in the Imperial Kiln in Jingdezhen in the Xuande period was of the best quality with the glaze colour pure and brilliant that resembled the colour of sapphire, which was also reputed as "sapphire blue glaze".

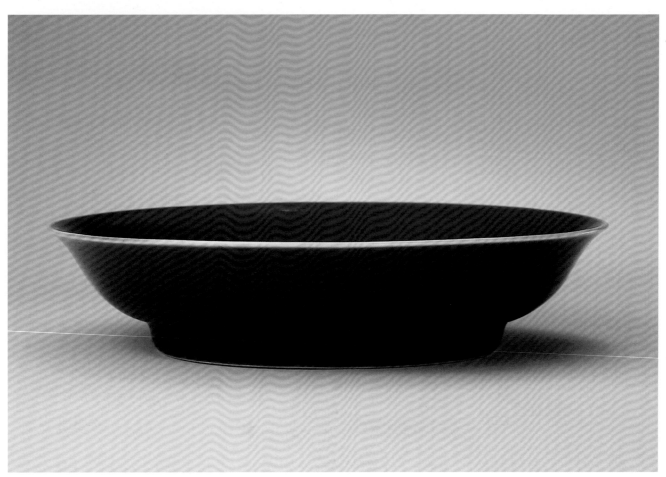

235

Zun Vase
with two ears and
design of bulls in gilt
in sky-clearing blue glaze

Ming Dynasty Hongzhi period

Height 32.2 cm
Diameter of Mouth 16.5 cm
Diameter of Foot 18.5 cm
Qing court collection

The *zun* vase has a wide mouth, a short neck, a slanting shoulder, a globular belly tapering downwards, a flared shank, and a shallow ring foot. On the two symmetrical sides of the shoulder are two ears for fastening strings. The interior is covered with white glaze, and the exterior is covered with sky-clearing blue glaze, whereas the base is unglazed. The exterior wall is decorated with gilt designs, including two bulls on the belly and several gilt borders of string patterns near the rim and on the shoulder and the shank. The two ears are also outlined in gilt.

This type of *zun* vases had also been produced in yellow and deep aubergine glaze in the Hongzhi period, which was used as sacrificial ware.

236

Three-legged Incense-burner
with design of dragons reserved in white
in sky-clearing blue glaze

Ming Dynasty Wanli period

Height 8.5 cm
Diameter of Mouth 17 cm
Distance between Legs 15 cm

The incense-burner has a contracted mouth, a globular belly, and a concave base with three legs beneath. The interior of the incense-burner and the exterior base are covered with white glaze, with the bases of the three legs unglazed, exposing the white paste. The exterior wall is covered with sky-clearing blue glaze. The belly is decorated with three dragons sculptured with white slip in relief. The dragons have slim bodies with the postures enlivened with swiftness and vividness. The exterior base is written with a six-character mark of Wanli in regular script in two columns in underglaze blue.

237

Alms Bowl
in sky-clearing blue glaze

Qing Dynasty Yongzheng period

Height 11.9 cm
Diameter of Mouth 13.8 cm
Qing court collection

The deep bowl is in the shape of an alms bowl with a contracted mouth, a globular belly, a chicken-heart-shaped round base, and a concave foot. It has a matching round cover. The exterior of the bowl and the cover is covered with sky-clearing blue glaze, whereas the interior of the bowl and the exterior base are covered with white glaze. The exterior base is written with a four-character mark of Yongzheng in regular script in two columns within a double-line medallion in underglaze blue.

238

Meiping Vase
in Mohammedan
blue glaze

Ming Dynasty　Jiajing period

Height 27.4 cm
Diameter of Mouth 3.8 cm
Diameter of Foot 8.6 cm
Qing court collection

The *meiping* vase has a small mouth, a short neck, a slanting shoulder, a belly tapering downwards, and a ring foot. The body is covered with Mohammedan blue glaze which condenses near the base and turns to purplish-blue colour. The interior of the ring foot is unglazed, exposing the paste.

The form is finely potted and covered with shiny and translucent glaze. Though there is no reign mark, judged from its form and glaze quality, this piece should have been produced in the Imperial Kiln in Jingdezhen in the Jiajing period. Mohammedan blue glaze was a kind of high-temperature fired cobalt blue glaze first produced in the Jiajing period of the Ming Dynasty.

239

Covered Glue Bottle
with gilt designs and
snow-flake blue glaze

Qing Dynasty Kangxi period

Height 6.2 cm
Diameter of Mouth 3 cm
Diameter of Foot 3.3 cm
Qing court collection

The glue bottle has a slightly contracted mouth, a straight neck, a flat globular belly, and a ring foot. On the symmetrical sides of the mouth are recessed grooves for storing copper spoons. It has a matching flat round cover with an everted rim. The body is covered with snow-flake blue glaze and decorated with gilt designs. The neck is decorated with *ruyi* clouds and bead patterns, and the belly and the cover with painted design of flowers. The interior of the ring foot is covered with white glaze.

Glue bottles were a kind of stationery for containing glue.

240

Plate
in the shape of a lotus flower with gilt design and snow-flake blue glaze

Qing Dynasty Kangxi period

Height 4.5 cm
Diameter of Mouth 23 cm
Diameter of Foot 11 cm

The plate is in the shape of a lotus flower with eight petals and has a wide mouth, a shallow curved wall, and a ring foot. The interior and exterior are covered with snow-flake blue glaze and decorated with gilt designs. Each lotus petal on the exterior wall is written with a character "*shou*" (longevity), and each lotus petal on the interior wall is painted with a phoenix. The mouth rim is unglazed.

241

Fish Bowl
in lapis blue glaze

Qing Dynasty Yongzheng period

Height 23.6 cm
Diameter of Mouth 36 cm
Diameter of Foot 26 cm

The bowl has a rimmed mouth, a deep curved belly tapering downwards to a relief section near the foot, and a ring foot. The body is covered with lapis blue glaze with the interior of the ring foot unglazed. The exterior base is engraved with a six-character mark of Yongzheng in seal script in three columns.

This fish-bowl is large in size and firing of it is rather difficult. Other than decorative purposes, the bowl could also be used as a fish bowl or for planting lotuses.

Lapis blue glaze is a kind of high-temperature fired cobalt blue glaze with green, blue, and white mottles on the surface. It is named lapis blue glaze as the colour resembles the colour of lapis stone.

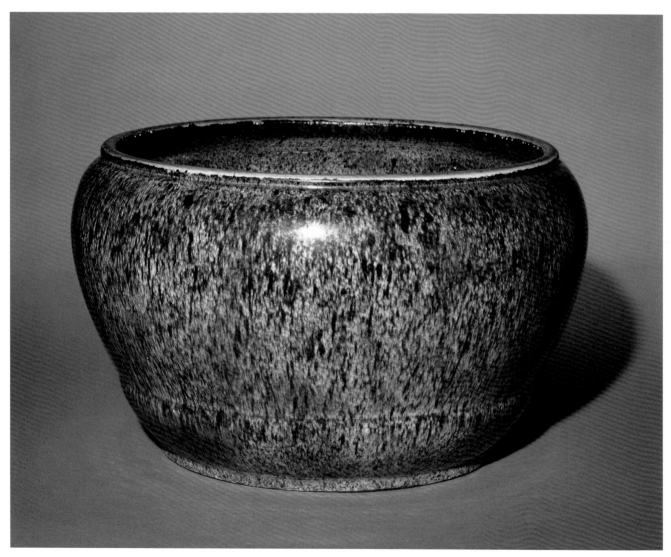

242

Meiping Vase
in sky blue glaze

Qing Dynasty Kangxi period

Height 21 cm
Diameter of Mouth 3.9 cm
Diameter of Foot 5.9 cm
Qing court collection

The vase has a flared mouth, a short neck, a wide shoulder, a belly tapering downwards, and a slightly flared base with a two-tiered ring foot. The interior and exterior are covered with sky blue glaze, and the interior of the ring foot is covered with white glaze. In the middle of the neck is a border of a string pattern in relief, and on the two symmetrical sides of the shoulder are two semi-circular ring patterns. The exterior base is written with a six-character mark of Kangxi in regular script in three columns in underglaze blue.

Sky blue glaze was a kind of high-temperature fired glaze which used oxidized cobalt as colourant and was first produced by the Jingdezhen Imperial Kiln in the Kangxi period of the Qing Dynasty. It was so-named as its light and soft blue colour resembled the colour of clear blue sky. Ware in sky blue glaze was characterized by even and stable colour tones with a touch of softness and gracefulness and was also highly reputed together with ware in cowpea red glaze.

243

Zun Vase

with ears in the shape of
chi-dragons and carved
and incised design of
animal mask patterns
in sky blue glaze

Qing Dynasty Kangxi period

Height 22.5 cm
Diameter of Mouth 11.9 cm
Diameter of Foot 11.7 cm
Qing court collection

The *zun* vase has a flared mouth,
a narrow neck, a hanging belly, and a flared
high ring foot. On the two symmetrical
sides of the neck are two ears in the shape
of *chi*-dragons. The interior of the vase and
the ring foot are covered with white glaze.
The exterior wall is covered with sky blue
glaze. The body is incised with various
designs such as *kui*-dragons, phoenixes,
taotie animal-masks, key-fret patterns,
etc., in imitation of decorative designs on
ancient bronze ware. The exterior base
is written with a six-character mark of
Kangxi in regular script in three columns in
underglaze blue.

Starting from the Kangxi period, ware
in sky blue was produced nearly in every
period afterwards, with the largest production
scale and highest esteem in the Kangxi,
Yongzheng, and Qianlong periods.

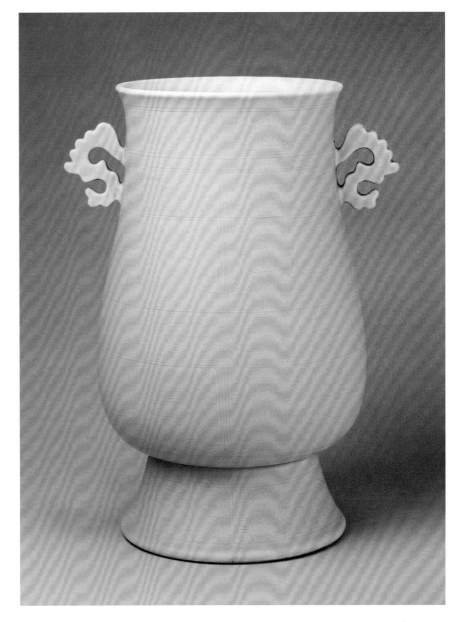

244

Decagonal Bowl
with design of grapes in underglaze red in sky blue glaze

Qing Dynasty Yongzheng period

Height 11.5 cm
Diameter of Mouth 25.2 cm
Diameter of Foot 14.9 cm

The bowl is in the shape of a decagon and has a wide mouth, a round rim, a slanting wall, a lower belly contracted to a flat base, and a ring foot. The base of the foot is fashioned smoothly in the shape of the back of a loach fish. The interior of the bowl, the exterior wall, and the interior of the ring foot are covered with sky blue glaze, while each of the ten sides of the decagonal exterior wall is painted with a bunch of grapes in underglaze red. The exterior base is written with a six-character mark of Yongzheng in seal script in three columns in underglaze blue.

The grape designs on the bowl are painted with copper red and highlighted by the sky blue glazed ground, and the designs exude a charm of freshness. The purplish-red of the underglaze red and sky blue match harmoniously with a touch of gracefulness.

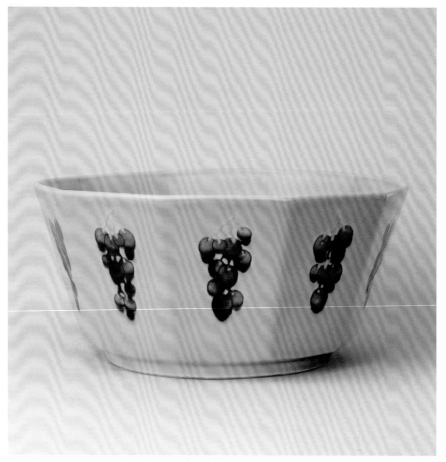

245

Vase
in sky blue glaze

Qing Dynasty Qianlong period

Height 29 cm
Diameter of Mouth 11.8 cm
Diameter of Foot 14 cm

The vase has a flared mouth, a contracted neck, a slanting shoulder, a belly tapering downwards, and a ring foot. The interior and exterior of the vase and the ring foot are covered with sky blue glaze. The exterior base is written with a six-character mark of Qianlong in seal script in three columns in underglaze blue.

This vase is fashioned in an archaic style, which has been used as a decorative object or flower vase.

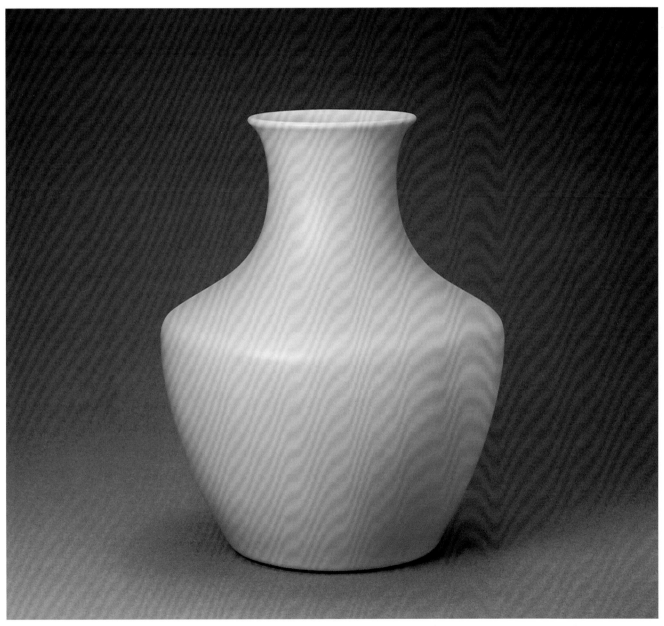

WARE IN AUBERGINE GLAZE

246

Zun Jar
with looped-ears
and gilt designs
in deep aubergine glaze

Ming Dynasty Hongzhi period

Height 28 cm
Diameter of Mouth 16 cm
Diameter of Base 14.5 cm
Qing court collection

The *zun* jar has a wide mouth, a short neck, a slanting shoulder, a contracting belly, and a concave base. On the two symmetrical sides of the shoulder are two looped-ears for fastening strings. The body is covered with deep aubergine glaze. The neck is decorated with a gilt border of string patterns, and near the base are two gilt borders of string patterns. The ears are also decorated with gilt designs.

This type of *zun* jars had also been produced in the Hongzhi period in yellow and sky-clearing blue glaze and was sacrificial vessels used by the court.

Aubergine glaze was first produced in the mid-Ming Dynasty and was quite popular in the early Qing Dynasty. It was a kind of low-temperature fired glaze with oxidized manganese as colourant, and the metallic materials such as iron and cobalt in the glaze also gave mixed colour effects. Colour tones varied from light to dark with the dark colour resembling the colour of ripe eggplants, and the light colour resembling the colour of unripe eggplants.

247

Plate
with carved and
incised design of
dragons amidst clouds
in deep aubergine glaze

Qing Dynasty Shunzhi period

Height 4.3 cm
Diameter of Mouth 24.6 cm
Diameter of Foot 15.8 cm
Qing court collection

The plate has a flared mouth, a shallow curved wall, and a ring foot. The interior and exterior are covered with deep aubergine glaze and the interior of the ring foot is covered with white glaze. The interior wall, the exterior wall, and the interior base are carved and incised with dragons amidst clouds. The exterior wall near the foot is incised with lotus lappets. The exterior base is written with a six-character mark of Shunzhi in regular script in three columns within a double-line medallion in underglaze blue.

Among extant ware with the same forms produced in the Shunzhi period, there were plates in yellow glaze.

248

Covered *Zun* Jar
with ears in the shape of
bull's heads
in deep aubergine glaze

Qing Dynasty Kangxi period

Height 34.5 cm
Diameter of Mouth 16 cm
Diameter of Base 14 cm
Qing court collection

The *zun* jar has a wide mouth, a short neck, a slanting shoulder, a belly tapering downwards, and a concave base. On the two symmetrical sides of the shoulder are two ears in the shape of bull's heads. The jar has a matching canopy-shaped cover with a pearl-shaped knob. The exterior and the cover are covered with deep aubergine glaze.

The jar is modeled after the *zun* jars with ears in the shape of bull's heads produced in the Hongzhi period of the Ming Dynasty, which has been used as a sacrificial vessel by the court.

249

Bladder Vase
in deep aubergine glaze

Qing Dynasty Yongzheng period

Height 26 cm
Diameter of Mouth 3.3 cm
Diameter of Foot 7.5 cm
Qing court collection

The vase has a straight mouth, a long neck, a slanting shoulder, a hanging belly, and a ring foot. The body is covered with deep aubergine glaze, and the interior of the ring foot is covered with white glaze. The exterior base is engraved with a four-character mark of Yongzheng in seal script in two columns.

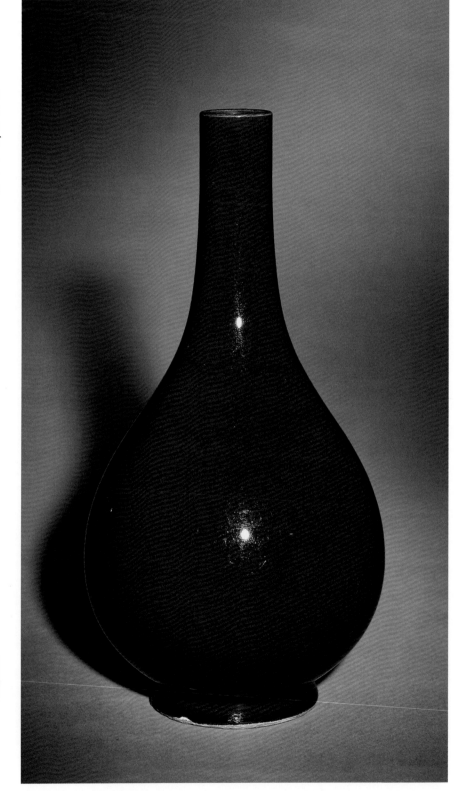

250

Vase
with a flared mouth
in deep aubergine glaze

Qing Dynasty Qianlong period

Height 28.3 cm
Diameter of Mouth 8.5 cm
Diameter of Foot 9.3 cm
Qing court collection

The vase has a flared mouth, a slim long neck, a wide shoulder, a wide belly tapering downwards, and a flared ring foot. The body is covered with deep aubergine glaze which condenses at the base and turns into black colour. The interior of the ring foot is covered with brown glaze.

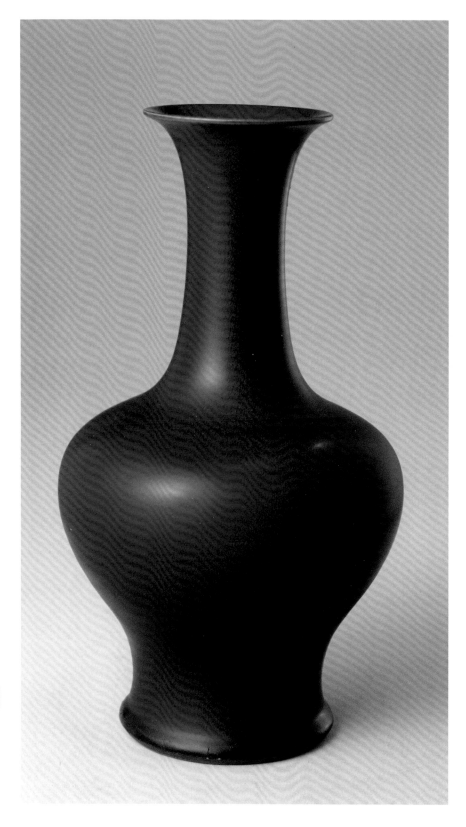

289

251

Bowl
with carved and
incised design of
dragons amidst clouds
in light aubergine glaze

Ming Dynasty Wanli period

Height 7.3 cm
Diameter of Mouth 15 cm
Diameter of Foot 5.5 cm
Qing court collection

The bowl has a flared mouth, a deep
curved belly, and a ring foot. The interior
of the bowl and the ring foot are covered
with white glaze. The exterior wall of the
bowl is covered with light aubergine glaze
and carved with two dragons in pursuit
of a pearl amidst clouds with an awl. The
exterior wall of the ring foot is carved
with key-fret patterns with an awl. The
exterior base is written with a six-character
mark of Wanli in regular script in three
columns within a double-line medallion in
underglaze blue.

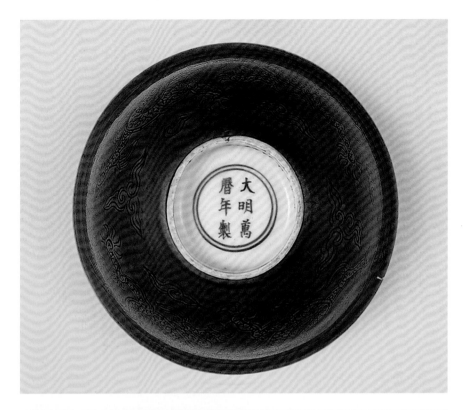

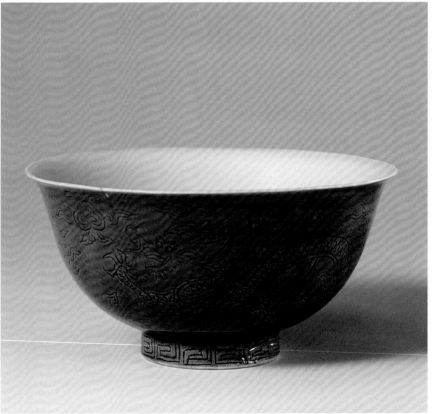

252

Plate
with carved and incised
design of pomegranate sprays
in light aubergine glaze

Qing Dynasty Yongzheng period

Height 3.5 cm
Diameter of Mouth 15.8 cm
Diameter of Foot 10.2 cm
Qing court collection

The plate has a flared mouth, a shallow
curved wall, and a ring foot. The interior and
exterior of the plate are covered with light
aubergine glaze. The interior of the ring foot
is covered with white glaze. The exterior
wall is carved with pomegranate scrolls with
an awl. The exterior base is written with a
six-character mark of Yongzheng in regular
script in two columns within a double-line
medallion in underglaze blue.

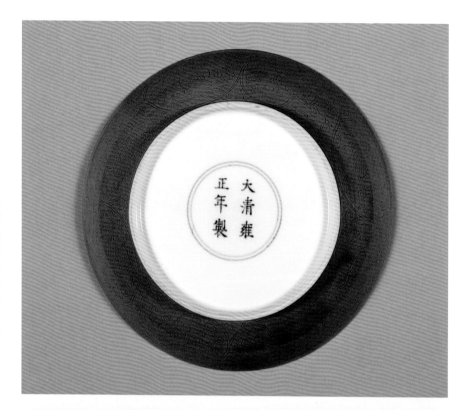

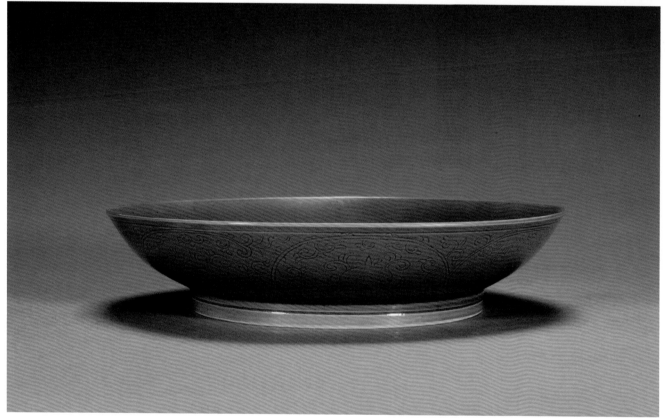

WARE IN GREEN GLAZE

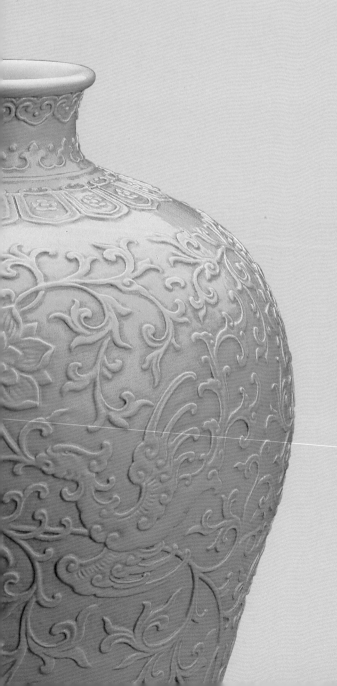

253

Water-pot
in *langyao*-green glaze

Qing Dynasty Kangxi period

Height 4 cm
Diameter of Mouth 4.9 cm
Diameter of Foot 3.2 cm
Qing court collection

The plate has a rimmed mouth, a flat globular belly, and a ring foot. The exterior wall is covered with apple green glaze, and the interior is covered with red glaze. The interior of the ring foot is covered with white glaze.

This water-pot in green glaze is a variegated piece accidentally produced by the Lang kiln while firing ware in red glaze. The green glaze in apple green colour on the exterior wall has been caused by accidental oxidization after firing, with the original red glaze retained in the interior wall. Extant ware of this type is very rare and such ware is even more esteemed than the ware in *langyao*-red glaze.

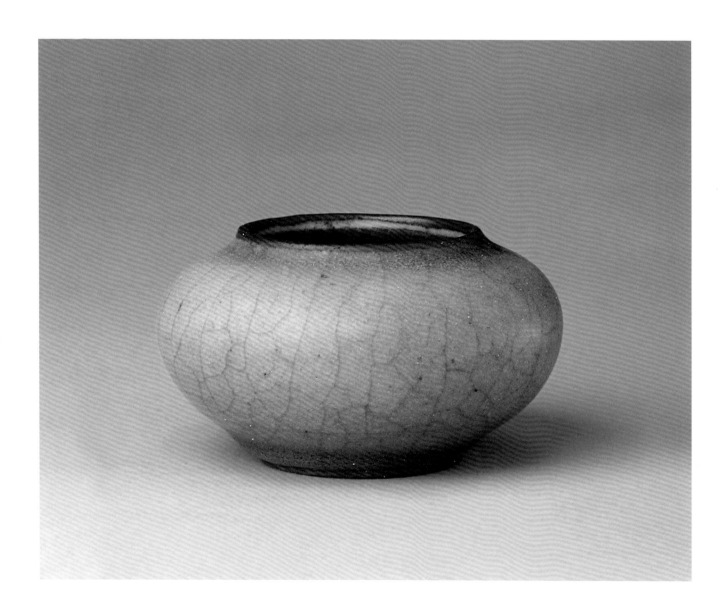

254

Bowl
in peacock green glaze

Ming Dynasty Zhengde period

Height 6.6 cm
Diameter of Mouth 16.2 cm
Diameter of Foot 6.5 cm
Qing court collection

The bowl has a flared mouth, a deep curved wall, a slim base, and a ring foot. The interior of the bowl and the ring foot are covered with greenish-white glaze. The exterior wall is covered with peacock green glaze. Near the base are incised designs of upright lotus petals under the glaze.

Although this bowl has no reign marks, judged from its typical shape in vogue in the Zhengde period and the characteristic of applying greenish-white glaze inside the ring foot, it should be a piece of imperial ware dated to the Zhengde period of the Ming Dynasty. Ware in peacock green glaze was first produced in the Xuande period, and continued in the later periods, with the ware of the Zhengde period most esteemed.

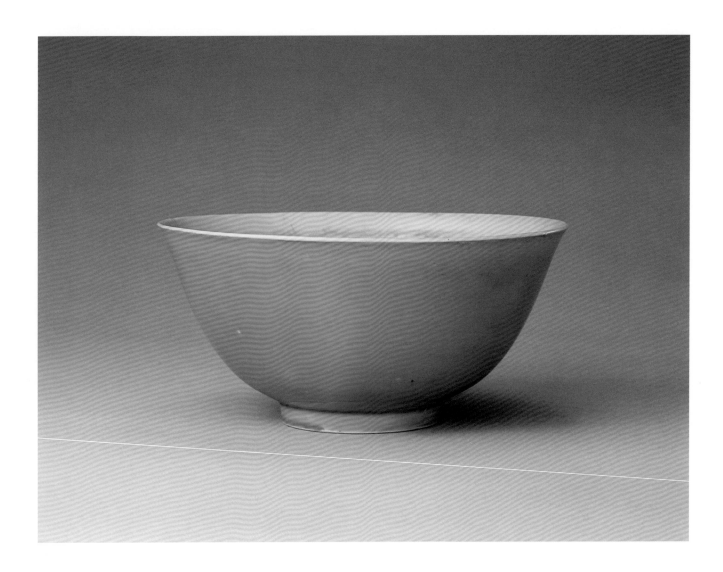

255

Gu Vase
in peacock green glaze

Qing Dynasty Kangxi period

Height 27.5 cm
Diameter of Mouth 19.9 cm
Diameter of Foot 7.5 cm
Qing court collection

The *gu* vase has a flared and trumpet-shaped mouth, a slim long neck, a slightly globular belly, and a long shank which is flared near the ring foot. The interior and exterior of the vase are covered with peacock green glaze with ice-crackles on the surface. The upper and lower belly are carved and incised with two borders of string patterns respectively.

The vase is modeled after ancient bronze ware with simple decorations and pure glaze colour. It is a refined decorative object.

Peacock green glaze is known as "*falü*"(imitated green), "*facui*" (imitated emerald-green), "jade glaze", or "auspicious emerald green glaze", which is a kind of mid-temperature fired glaze with oxidized copper as colourant and potassium nitrate as fluxing agent. As the colour is in bright and shiny green, which resembles the colour of peacock feathers, it is known as "peacock green glaze". The Imperial Kiln in Jingdezhen in the Kangxi period had produced a large quantity of ware in peacock green glaze with over dozens of type forms at the time.

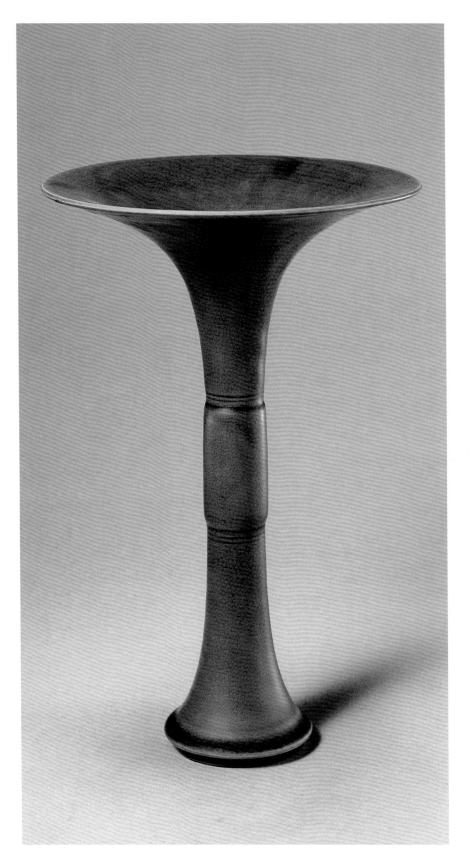

256

Three-legged Flower Pot Basin
in the shape of a water-chestnut flower in peacock green glaze

Qing Dynasty Yongzheng period

Height 7 cm
Diameter of Mouth 23.8 cm
Diameter of Foot 11 cm
Qing court collection

The flower pot basin is fashioned in the shape of a blooming water chestnut flower with a foliated rim, a shallow curved wall, and a flat base. The exterior base is decorated with a relief border along the foliated shape of the basin, and beneath are three legs in the shape of *ruyi* clouds. The interior and exterior of the basin are covered with peacock green glaze.

This basin is covered with pure peacock green glaze and it represents a refined piece of ware of its type produced in the Imperial Kiln in the Yongzheng period.

257

Zun Vase
with elephant-shaped ears
and imitated designs of
ancient bronze ware in relief
in peacock green glaze

Qing Dynasty Qianlong period

Height 25 cm
Diameter of Mouth 12.7 cm
Diameter of Foot 14.5 cm
Qing court collection

The *zun* vase has a slightly flared flat mouth, a short neck, a slanting shoulder, a globular belly, and a flared high ring foot. On the two symmetrical sides of the shoulder are two elephant-shaped ears. The body is covered with peacock green glaze. The exterior is decorated with various imitated designs of ancient bronze ware in relief, whereas the neck is decorated with banana leaves in which are cloud and thunder patterns forming the ground. The belly and shank are decorated with *kui*-dragons on a ground with cloud and thunder patterns.

258

Pottery Jar
with animal-headed ears
and design of
string patterns in relief
in green glaze

Eastern Han Dynasty

Height 42 cm
Diameter of Mouth 17.3 cm
Diameter of Foot 19 cm
Qing court collection

The jar has a flared mouth, a narrow
neck, a slanting shoulder, a globular belly,
and a flat high foot. On the two symmetrical
sides of the shoulder are two animal-headed
ears. The greyish clay body is covered with
low-temperature fired green lead glaze. The
shoulder is decorated with string patterns
in relief, and the neck is pierced with an
imperial poem of Emperor Qianlong.

259

Flask
with looped-ears and carved design of tribal dances in relief in yellowish-green glaze

Northern Dynasties

Height 12.2 cm
Diameter of Mouth 3.1 cm
Diameter of Foot 4.9 cm

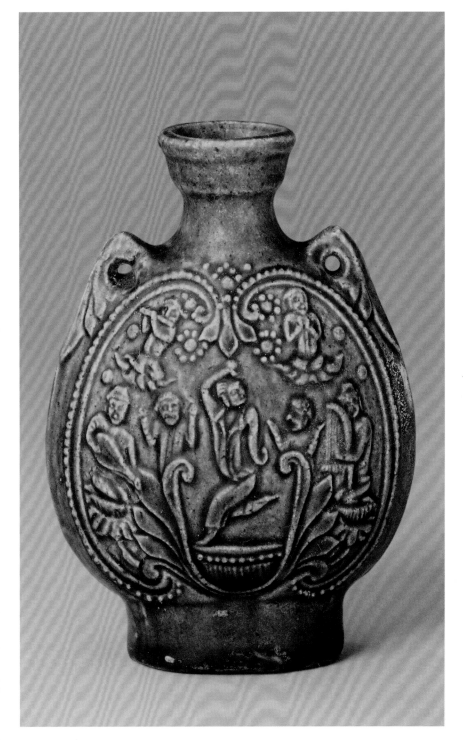

The flask has a slightly flared mouth, a short neck, a slanting shoulder, a flat belly, a high foot, and a flat base. On the two symmetrical sides of the shoulders are two looped-ears for fastening strings. The coarse paste is covered with uneven yellowish-green glaze with three spur marks on the base. On the front and back sides are the molded design of foreigners dancing, which is enclosed by bead patterns and acanthus patterns. The figure at the centre is standing on a floral pedestal, and is surrounded by a group of musicians sitting and playing musical instruments such as *pipa*, harp, and flute. The foreigner figures are wearing costumes of the west territories with narrow sleeves and dresses opening at the front, and they are characterized by the physical facial features of the tribes in the western territories.

The flask is exquisitely fashioned with designs exuding an exotic flavour, reflecting close cultural communication between China and the West. The form of this flask is modeled after the type of the fashionable flasks of the Byzantine Empire (Eastern Roman Empire), with designs rendered in bas-relief. The decorative style resembles the hammered and pierced design of the silver ware of the Sassanid Empire in Persia. On the front and back sides of the flask are decorations of bead chains, acanthus and music and dance performances introduced from West Asia. The way that the musician holds the *pipa* horizontally for playing reveales that *pipa* is a foreign musical instrument with four strings and a crocked neck imported from Persia.

260

Pillow
with carved and
incised banana leaves
in watermelon green glaze

Jizhou ware
Southern Song Dynasty

Height 9 cm
Length 26.5 cm
Width 22 cm

The pillow is pentagonal-shaped with round corners, a sloping surface higher at the front, and lower at the back with the centre slightly recessed. The body is covered with uneven watermelon green glaze with the paste exposed on the base. A line border is incised along the shape of the surface of the pillow to form a frame, in which are four carved and incised banana leaves. The upper and lower sides of the pillow are carved and incised with lines, and the centre is decorated with molded design of circles.

This type of pillows in green glaze was a typical type of ware produced in the Jizhou kiln in Jiangxi, and their bases were often stamped with marks such as "Shujia" (Shu Factory), "Liujia" (Liu Factory), "Guojia" (Guo Factory), "Chenjia" (Chen Factory), etc., reflecting that there were many kilns in the Jizhou regions at the time and they had to compete each other with their factory marks stamped on the products for marketing. According to historical records of the Song Dynasty, an old master surnamed Shu and his daughter Shu Jiao were famous potters of a kiln factory in Jizhou, who were very reputed at the time. Archaeologists had excavated pieces with the mark "*Shujia Ji*" (Factory of the Shu Family) in the site in Jizhou kiln, and testified these records in history.

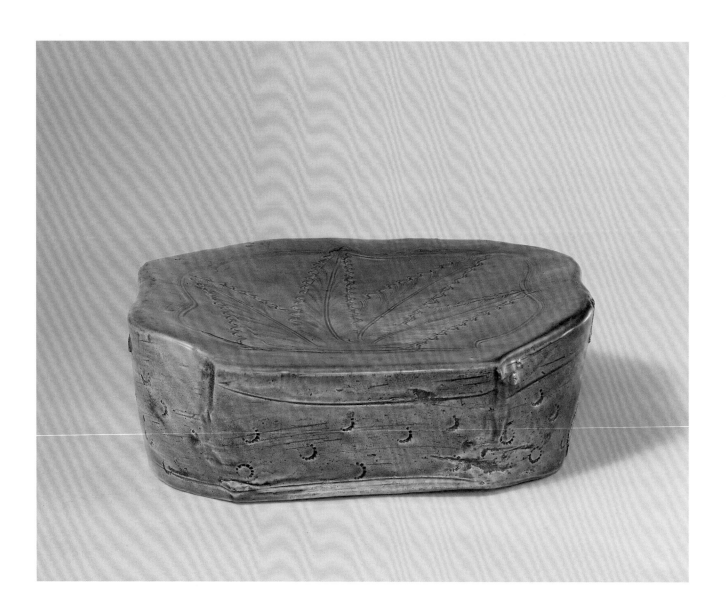

261

Jar
decorated with carved and incised phoenixes in watermelon green glaze

Ming Dynasty Jiajing period

Height 11.2 cm
Diameter of Mouth 14.1 cm
Diameter of Foot 8 cm
Qing court Collection

The jar has a flared mouth, a wide neck, a belly tapering downwards, and a flared ring foot. The interior and exterior are covered with watermelon green glaze, and the interior of the ring foot is covered with greenish white glaze. The exterior wall is incised with design with an awl, and the neck and the belly are decorated with two flying phoenixes amidst clouds. The lower belly is decorated with lotus petals, and the exterior of the ring foot is decorated with foliage scrolls. The exterior base is written with a six-character mark of Jiajing in regular script in two columns within a double-line medallion in underglaze blue.

Watermelon green glaze is a kind of glaze with oxidized iron as colourant. It was first fired in the Xuande period in Jingdezhen Imperial Kiln, and it was produced in various dynasties afterwards but only with small quantity. The ware produced in the Jiajing period was the most acclaimed, which appeared in various forms such as plates, bowls, jars, and vases. The glaze was often pure and incised with designs with an awl. The exterior base of this *zun* vase was covered with lustrous and shiny greenish-white glaze with period characteristic.

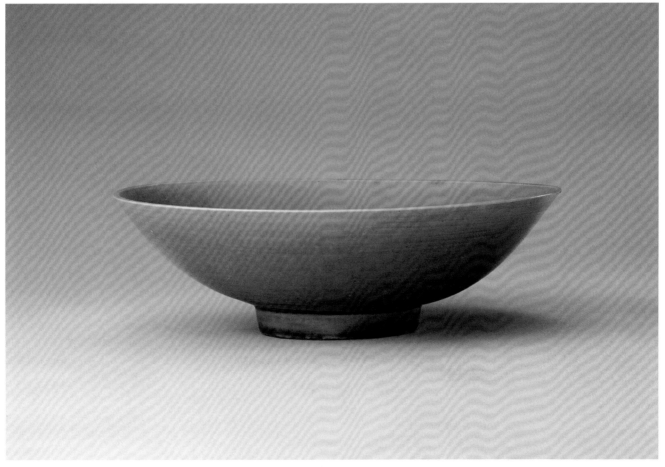

262

Plate
with carved
and incised dragons
and phoenixes amidst eight
auspicious symbols
supported by lotus sprays
in watermelon green glaze

Qing Dynasty Yongzheng period

Height 3.2 cm
Diameter of Mouth 14.7 cm
Diameter of Foot 8.6 cm
Qing court collection

The plate has a flared mouth, a shallow curved wall, and a ring foot. The interior and exterior are covered with watermelon green glaze and carved and incised with various designs under the glaze with an awl. The interior centre is carved and incised with dragons and phoenixes and medallions in which there are the characters "*shou*" (longevity), and the exterior wall is carved and incised with the eight auspicious symbols including the wheel of the dharma, conch shell, victory banner, parasol, lotus flower, treasure vase, fish pair, and the endless knot. The interior of the ring foot is covered with white glaze. The exterior base is written with a six-character mark of Yongzheng in regular script in two columns within a double-line medallion in underglaze blue.

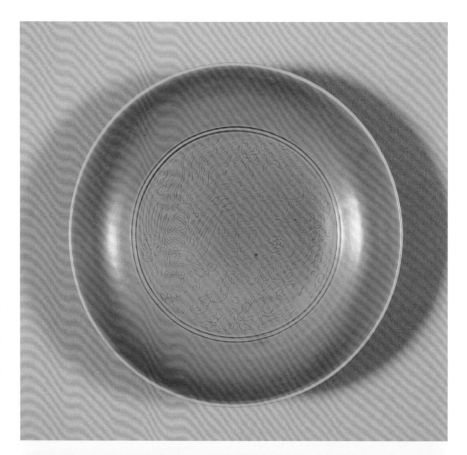

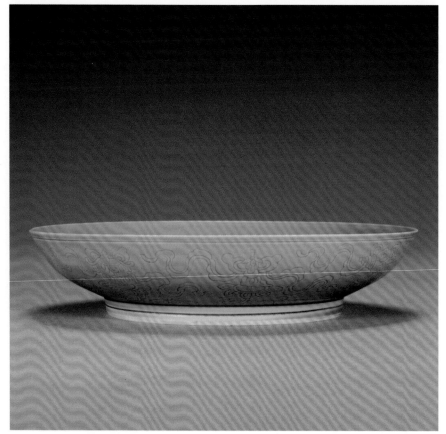

263

Set of Cup and Plate
with carved and incised design of *panchi*-dragons in lake-water green glaze

Qing Dynasty Kangxi period

Cup: Height 3.5 cm
Diameter of Mouth 5.7 cm
Diameter of Foot 2.4 cm

Plate: Height 1.6 cm
Diameter of Mouth 12.7 cm
Diameter of Foot 10 cm

The cup has a flared mouth, a deep curved belly, and a ring foot. On the two symmetrical sides of the cup are two halberd-shaped ears. The interior of the cup and the ring foot are covered with white glaze, and the exterior wall is covered with lake-water green glaze with four carved and incised *panchi*-dragons under the glaze. The exterior base is written with a six-character mark of Kangxi in regular script in two columns within a double-line medallion in underglaze blue.

The plate has a flared mouth, a shallow curved wall, and a ring foot. At the interior centre is a groove in relief for holding the cup. The interior and exterior of the plate are covered with lake-water green glaze, and the interior of the ring foot is covered with white glaze. The interior centre is carved and incised with two *panchi*-dragons under the glaze. The exterior base is written with a six-character mark of Kangxi in regular script in two columns within a double-line medallion in underglaze blue.

Sets of cups and plates were commonly produced in the Imperial Kiln in the Kangxi period, but most of them were ware in yellow glaze. This set of wine vessels in lake-water green glaze are delicately fashioned with a soft and subtle colour tone, representing a refined piece of Kangxi imperial ware. Judged from the writing style of the mark, it should have been produced by the Lang kiln in the late Kangxi period.

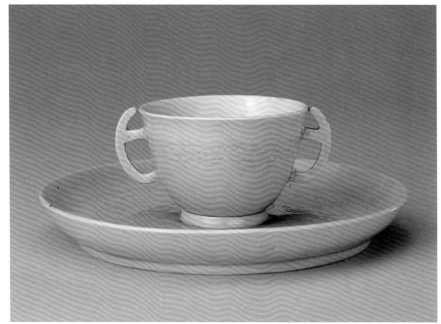

264

Vase

with a garlic-head shaped mouth, *ruyi* cloud-shaped ears and carved design of floral scrolls in relief in onion green glaze

Qing Dynasty Yongzheng period

Height 26.3 cm
Diameter of Mouth 5.3 cm
Diameter of Foot 11 cm
Qing court collection

The vase has a garlic-head shaped mouth, a small neck, a round globular belly, and a ring foot. On the two symmetrical sides of the mouth and the shoulder are two ears in the shape of *ruyi* cloud patterns. The interior of the vase and the ring foot are covered with white glaze, and the exterior wall is covered with onion green glaze. The mouth and the belly are decorated with lotus scrolls in relief, the middle section of the neck is fashioned in the shape of a bamboo trunk, and the shoulder is carved with two borders of string patterns in relief with foliage scrolls in relief in between. Below the border of the string are designs of *ruyi* cloud patterns. The exterior base is written with a six-character mark of Yongzheng in seal script in three columns in underglaze blue.

Vases with *ruyi* cloud-shaped ears were first created in Imperial Kiln in Jingdezhen in the Yongzheng period with the form gracefully and elegantly fashioned, which were represented also in ware with designs in underglaze blue, *fencai* enamels, *doucai* enamels, or in bluish-green glaze, imitated Ru celadon glaze, and onion green glaze.

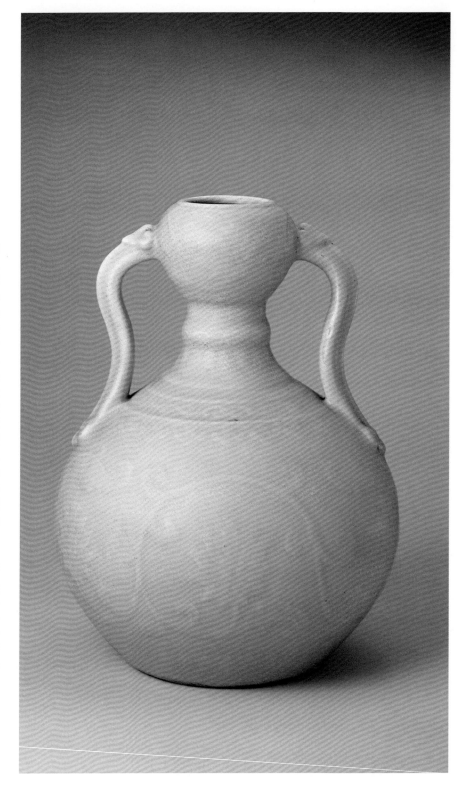

Bowl
in okra green glaze

Qing Dynasty Yongzheng period

Height 5.5 cm
Diameter of Mouth 11.3 cm
Diameter of Foot 4.4 cm
Qing court collection

The bowl has a flared mouth, a deep curved belly, and a ring foot. The interior of the bowl and the ring foot are covered with white glaze, and the exterior wall is covered with okra green glaze. The exterior base is written with a six-character mark of Yongzheng in regular script in two columns within a double-line medallion in underglaze blue.

The bowl is fashioned with a stern form with soft and subtle glaze colour. Judged from the writing style of the mark and the form, the bowl carries the stylistic legacy of the Kangxi period and should have been produced in the Yongzheng period.

Okra green glaze used oxidized copper as colourant, and it was so named as the colour resembled okra. This type of glaze was first produced in the Imperial Kiln in Jingdezhen in the Yongzheng period, and was seldom produced thereafter.

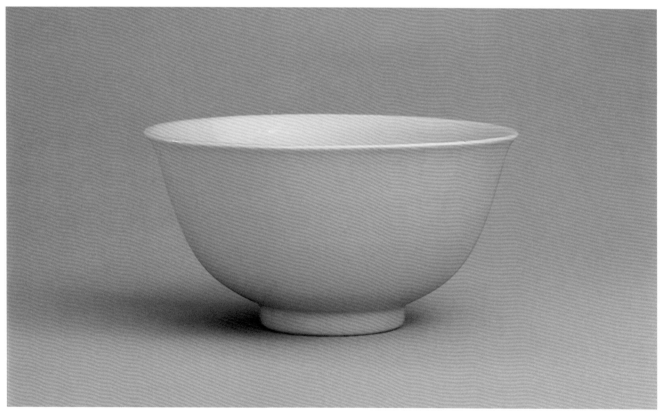

266

Plate
with carved and incised
design of waves and
key-fret patterns
in turquoise green glaze

Qing Dynasty　Yongzheng period

Height 3 cm
Diameter of Mouth 16.2 cm
Diameter of Foot 9.6 cm

The plate has a flared mouth, a shallow curved wall, and a ring foot. The interior of the plate and the ring foot are covered with white glaze, and the exterior wall is covered with turquoise green glaze. The exterior wall is carved with two borders of string patterns in relief, whereas the area near the mouth rim is incised with key-fret patterns, and near the base are decorations of wave patterns in relief. The exterior base is written with a six-character mark of Yongzheng in regular script in two columns within a double-line medallion in underglaze blue.

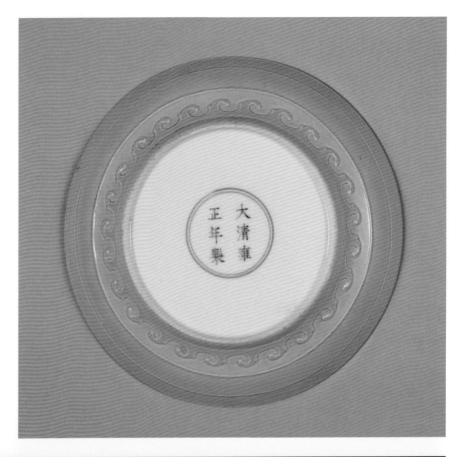

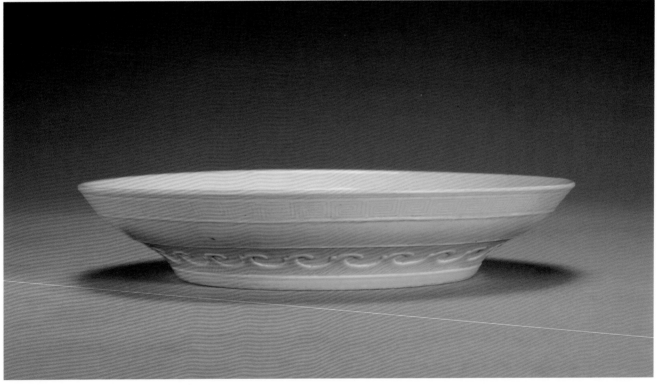

267

Meiping Vase
with carved design of
phoenixes amidst
lotuses in relief
in turquoise green glaze

Qing Dynasty Qianlong period

Height 30.5 cm
Diameter of Mouth 6 cm
Diameter of Foot 10.5 cm
Qing court collection

The *meiping* vase has a rimmed mouth, a short neck, a wide shoulder, a belly tapering downwards, and a ring foot. The body is covered with turquoise green glaze. The exterior wall is decorated with various designs in relief including *ruyi* cloud patterns and wave patterns on the neck, lotus lappets on the shoulder, phoenixes amidst lotuses on the belly, and *ruyi* cloud patterns and lotus lappets on the shank. The exterior base is carved with a six-character mark of Qianlong in seal script in three columns in relief.

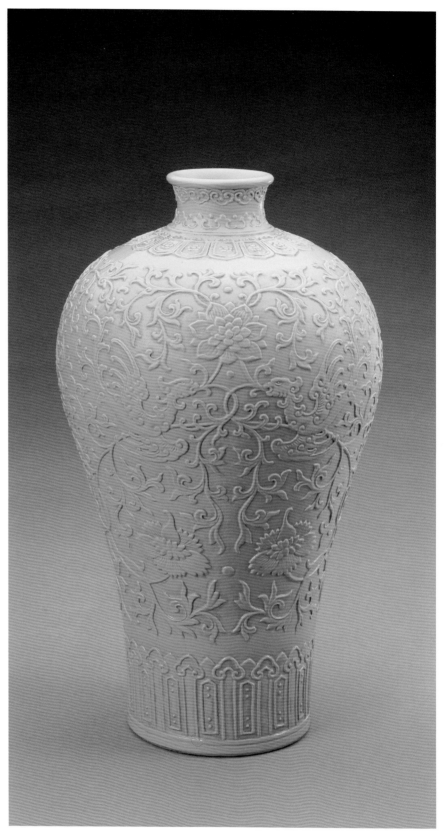

268

Zun Vase

in the shape of a lantern
with carved design of
dragons amidst clouds and
waves in relief
in turquoise green glaze

Qing Dynasty Qianlong period

Height 43 cm
Diameter of Mouth 11.7 cm
Diameter of Foot 13.4 cm
Qing court collection

The *zun* vase has a flared mouth, a short neck, a slanting shoulder, a tubular belly, and a ring foot. The body is covered with turquoise green glaze, and the exterior wall is carved with design of dragons amidst clouds and waves in relief. The exterior base is carved with a six-character mark of Qianlong in seal script in three columns in relief.

As the form of this *zun* vase is fashioned in the shape of a Chinese lantern, it is known as the lantern *zun* vase.

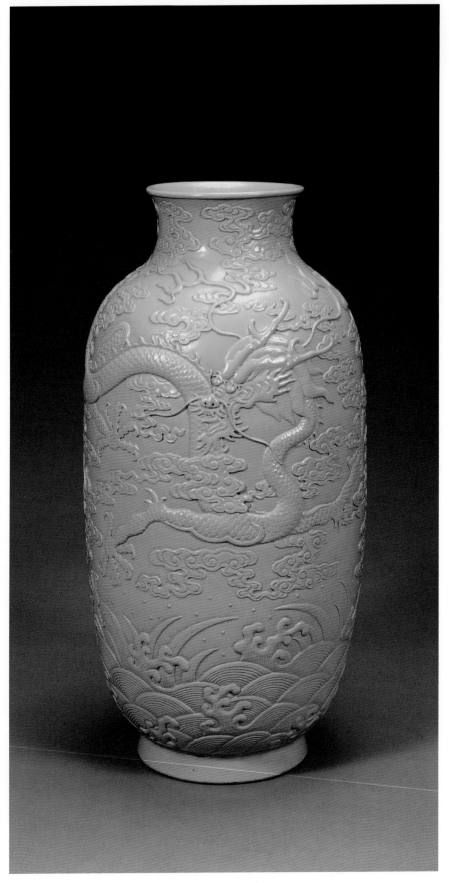

269

Flower Pot Basin
in the shape of a bundled bamboo trunk
in turquoise green glaze

Qing Dynasty Daoguang period

Height 15.7 cm
Diameter of Mouth 23.1 cm
Diameter of Foot 18.3 cm

The flower pot basin has a flared mouth, a slanting wall, and a ring foot. At the centre of the exterior base is a round hole for releasing water. The interior and exterior of the basin are covered with turquoise green glaze, and the interior of the ring foot is covered with white glaze. The exterior base is written with a four-character mark of "*Yangxing Xuan*" (Studio of Self-cultivation) in two columns in underglaze blue.

This flower pot basin is skillfully modeled after bamboo flower pot basins in a naturalistic manner. Ware in imitation of bamboo ware was popularly produced in the Imperial Kiln in the Daoguang period, and was glazed with turquoise green glaze or yellow glaze.

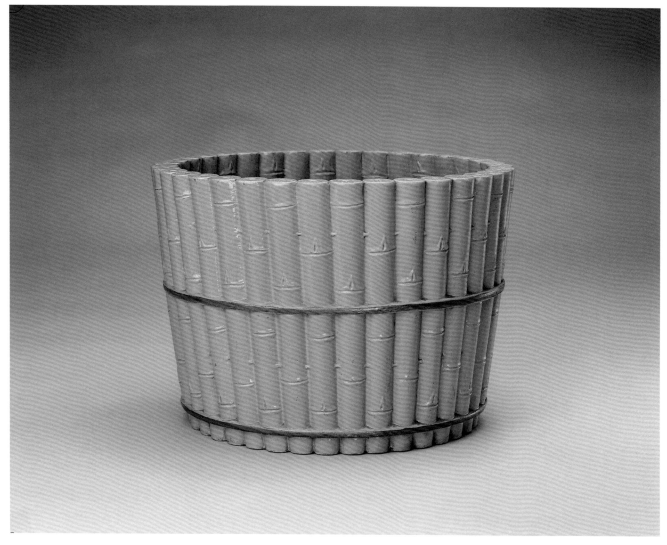

270

Bowl

with okra green glaze on the exterior and turquoise green glaze in the interior

Qing Dynasty Guangxu period

Height 7 cm
Diameter of Mouth 15.4 cm
Diameter of Foot 6 cm
Qing court collection

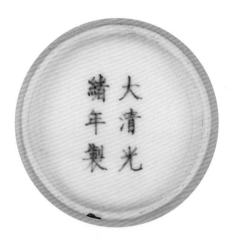

The bowl has a flared mouth, a deep curved belly, and a ring foot. The interior is covered with turquoise green glaze, and the exterior is covered with okra green glaze. The interior of the ring foot is covered with white glaze. The exterior base is written with a six-character mark of Guangxu in regular script in two columns in underglaze blue.

This bowl is very rare as it is glazed in different colours on the exterior and in the interior with turquoise green and okra green glaze respectively on the same ware, which exudes a touch of colour contrasts with brilliance in a distinctive manner.

Both of these two types of green glazes have oxidized copper as colourant, but the fluxing agents are different. The term turquoise green glaze is so named as its colour looks like natural turquoise stones, and the term okra green glaze comes from its colour which looks like the colour of okra.

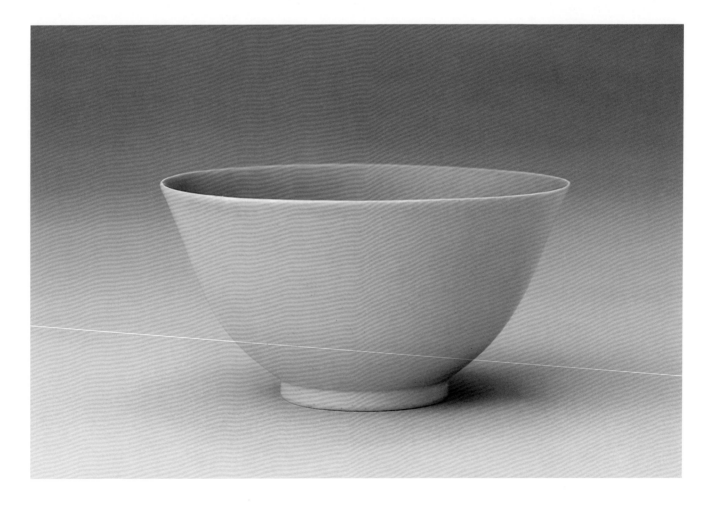

WARE IN BROWN GLAZE

273

Zun Vase
with designs of egrets and
lotuses reserved
in white on a ground
in brown glaze

Ming Dynasty Jiajing period

Height 12 cm
Diameter of Mouth 12.6 cm
Diameter of Foot 6.7 cm

The *zun* vase has a wide mouth, a contracted neck, a globular belly, and a ring foot. The interior is covered with white glaze. The exterior wall and the interior of the ring foot are covered with brown glaze. The exterior wall is decorated with a lotus spray on one side and an egret on the other side, which are reserved in white on a ground in brown glaze. The decorative design carries an auspicious attribute of continuous success in civil service examinations.

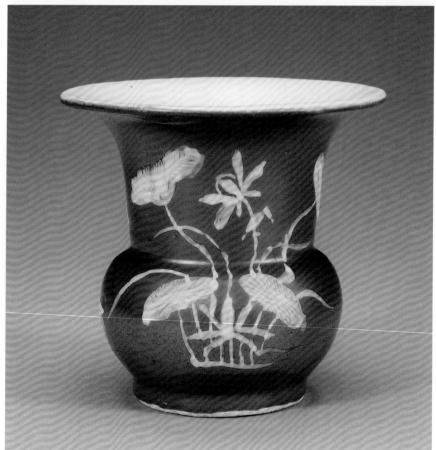

274

Meiping Vase

with design of flowers
in a flower pot reserved
in white on a ground
in brown glaze

Ming Dynasty Wanli period

Height 26.5 cm
Diameter of Mouth 5 cm
Diameter of Foot 9.3 cm
Qing court collection

The vase has a rimmed mouth, a short neck, a wide shoulder, a belly tapering downwards, and a ring foot. The interior and exterior are covered with brown glaze. The belly is decorated with design of flower clusters in a flower pot reserved in white.

This *meiping* vase is fashioned with a heavy and stable form with a thick paste and a wide base. The production of ceramic *meiping* vases had started in the Sui and Tang dynasties, became very popular in the Song, Liao, Jin, and Western Xia dynasties, and continued in subsequent dynasties. This type of vases had become one of the most stylized type forms of ceramic ware in the history of Chinese ceramics.

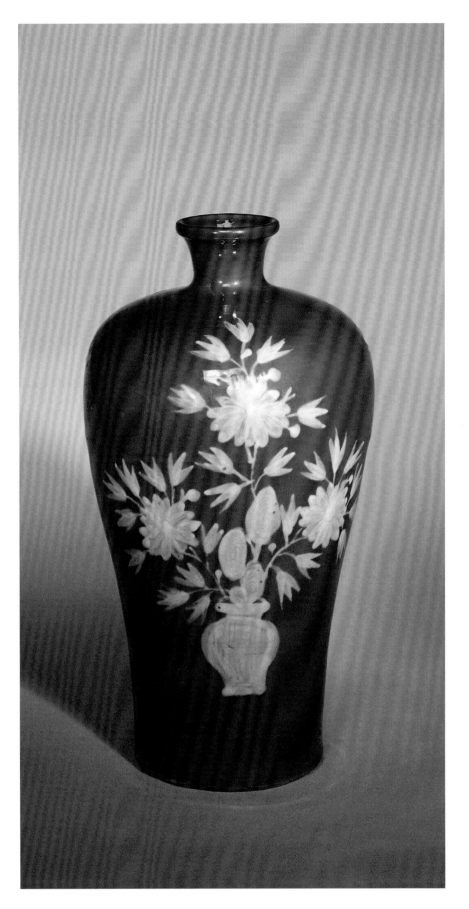

275

Block-shaped Bowl
in brown glaze

Qing Dynasty Kangxi period

Height 6 cm
Diameter of Mouth 12.5 cm
Diameter of Foot 6.9 cm
Qing court collection

The bowl has an upright mouth, a deep curved belly, and a ring foot. The interior and exterior are covered with even, pure, and shiny brown glaze. The interior of the ring foot is covered with white glaze. The exterior base is written with a six-character mark of Kangxi in regular script in two columns within a double-line medallion in underglaze blue.

A wide repertoire of bowls in different shapes in brown glaze were produced in the Imperial Kiln in Jingdezhen in the Kangxi period. Other than bowls in brown glaze, there were also a variety of bowls with underglaze blue and iron red designs produced in the period.

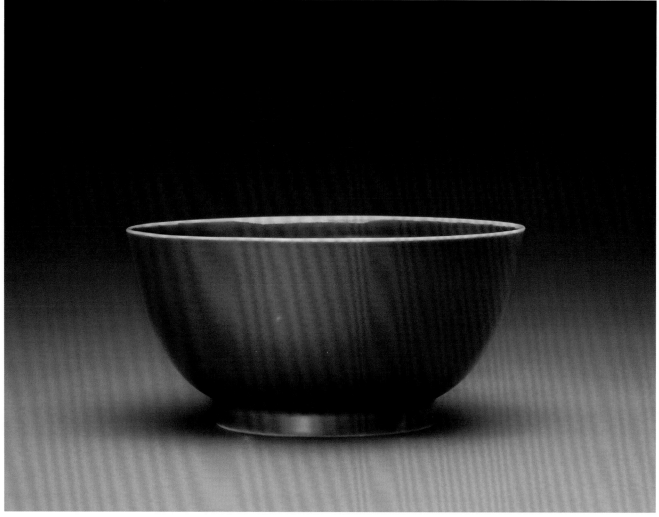

276

Lobed Vase
in the shape of a melon and with applique gilt design of peaches in brown glaze

Qing Dynasty Qianlong period

Height 21.3 cm
Diameter of Mouth 5.2 cm
Diameter of Foot 7.2 cm
Qing court collection

The vase is fashioned with three lobes and has a flared mouth, a long neck, a round belly, and a flared ring foot. The interior is covered with turquoise green glaze. The exterior wall and the interior of the ring foot are covered with brown glaze. The neck and the shoulder are decorated with applique sculptural designs of peach branches, peaches, and *lingzhi* fungi in *fencai* enamels. The belly is decorated with gilt design of chrysanthemum scrolls. The exterior base is engraved with a six-character mark of Qianlong in seal scripts in three columns.

Decorative designs of chrysanthemums, peaches, and *lingzhi* fungi are collectively known as the "*lingzhi* fungus and immortals celebrate longevity" and carry the auspicious attribute and blessing of long life.

The production of imperial ware in the Imperial Kiln in Jingdezhen in the Qianlong period had reached a state in pursuit of luxuriance and elegance with the decorative motifs more complicated and technical rendering sophisticated. Various decorative techniques were often applied together at the same time on a ware.

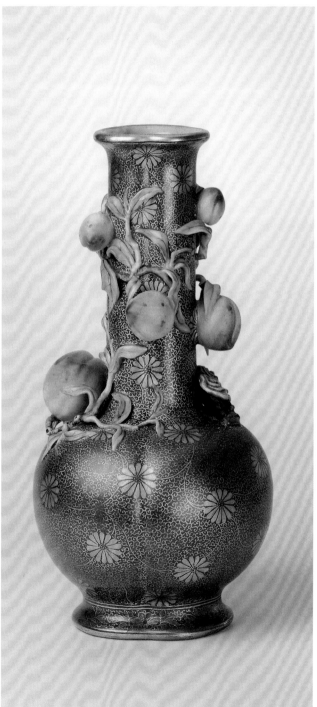

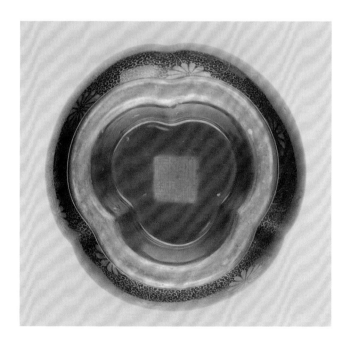

WARE IN *CHANGGUAN* GLAZE

277

Flower-watering Pot
with design of chrysanthemum petals in relief in *changguan* glaze

Qing Dynasty Yongzheng period

Height 26 cm
Diameter of Mouth 4.9 cm
Diameter of Foot 8.8 cm
Qing court collection

The flower-watering pot has a flared mouth with a spout on one side, a long neck, a wide shoulder, a globular belly tapering downwards, and a ring foot. The body is covered with yellowish-green *changguan* glaze. The middle part of the neck protrudes like a bamboo trunk, and the joining area between the neck and the shoulder is decorated with three borders of string patterns in relief. The shoulder and the lower belly are decorated with upright and inverted chrysanthemum petals in relief respectively. The exterior base is engraved with a four-character mark of Yongzheng in seal script in two rows.

Imperial flower-watering pots of the Yongzheng period had two types: either with or without handles. They were found in underglaze blue ware or ware covered with *changguan* glaze. This flower-watering pot is modeled with a graceful and elegant form with soft and subtle colour tones, representing a refined piece of ware of its type of the Yongzheng period.

Changguan glaze was a kind of high-temperature fired crystallized iron and magnesium glaze produced in the Qing Dynasty. The book *Nanyao Biji* mentioned that such ware was fired at the Chang Imperial Kiln in Zhili and thus was named *changguan* ware. In the early Qing Dynasty, the Imperial Kiln in Jingdezhen had already started to imitate such ware with a superior production standard.

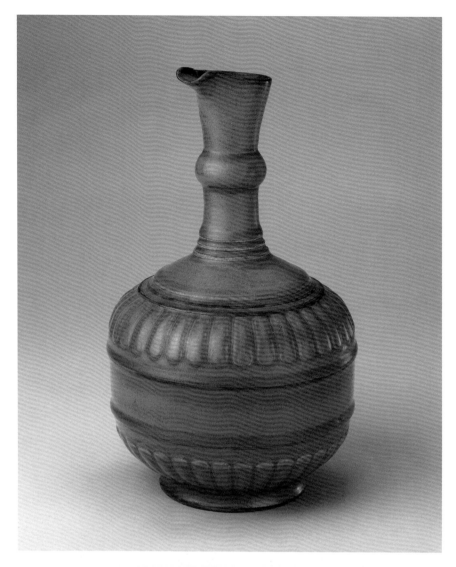

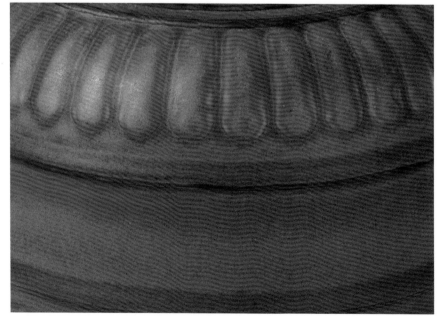

278

Zun Vase
with ears in the shape of bulls in *changguan* glaze

Qing Dynasty Qianlong period

Height 51 cm
Diameter of Mouth 24.5 × 19 cm
Diameter of Foot 26.7 × 21 cm
Qing court collection

The *zun* vase has a slightly flared oval mouth, a wide neck, a globular belly, and a flared ring foot. On the two symmetrical sides of the neck are two ears in the shape of bulls. The body is covered with *changguan* glaze and decorated with band patterns. The exterior base is engraved with a six-character mark of Qianlong in seal script in three columns.

Owing to the variations during firing, *changguan* glaze has various colour tones such as "crab-shell green" which is similar to the colour of crab shells, "eel yellow" which is similar to the colour of fish bellies, and "tea-dust" which is similar to the colour of grounded tea leaves. The glaze colour of this *zun* vase belongs to tea-dust glaze. Ware in tea-dust glaze was popular in the Yongzheng and Qianlong periods of the Qing Dynasty.

279

Vase
with a straight neck in *changguan* glaze

Qing Dynasty Jiaqing period

Height 19 cm
Diameter of Mouth 4 cm
Diameter of Foot 7.6 cm

The vase has a plate-shaped mouth, a straight neck, a globular belly, and a flared ring foot. The body is covered with *changguan* glaze. The mouth, the foot, and the neck are decorated with string patterns in relief. The exterior base is engraved with a six-character mark of Jiaqing in seal script in three columns.

Ware in *changguan* glaze produced in the Imperial Kiln in Jingdezhen in the Jiaqing period followed the style of Qianlong ware. The colour was archaic and subtle with small sparkles of crystallized iron and magnesium, which looked like morning stars. The light colour of glaze on the string patterns in relief at the mouth, the foot, and the neck of this vase contrasts with the deeper colour of glaze on the body with variations in a palette of softness and subtleness, which creates strong decorative appeal.

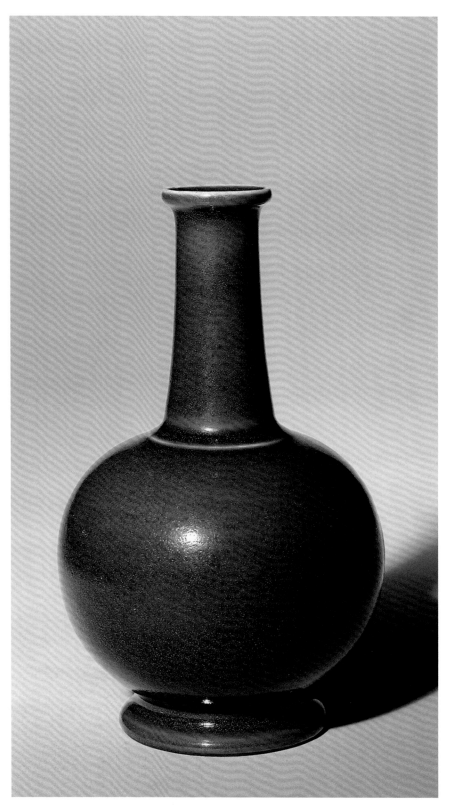

280

Incense-burner
with animal-mask shaped ears
in *changguan* glaze

Qing Dynasty　Xianfeng period

Height 7.7 cm
Diameter of Mouth 11.7 cm
Diameter of Foot 9.6 cm

The incense-burner has a flared mouth, a flat rim, a deep curved belly, and a ring foot. On the two symmetrical sides of the belly are two ears in the shape of animal-masks. The body is covered with translucent bluish-green *changguan* glaze in which there are sparkled yellowish crystallized mottles. The exterior base is engraved with a six-character of Xianfeng in seal script in three columns.

Although ware in *changguan* glaze had continuously been produced after the Qianlong period, fine ware was not much, among which ware produced in the Xianfeng period was of better quality. The ware of the Xianfeng period reflected a pursuit of the antique styles of the Yongzheng and Qianlong ware. In addition to incense-burners, there were flattened square vases, *meiping* vases, etc.

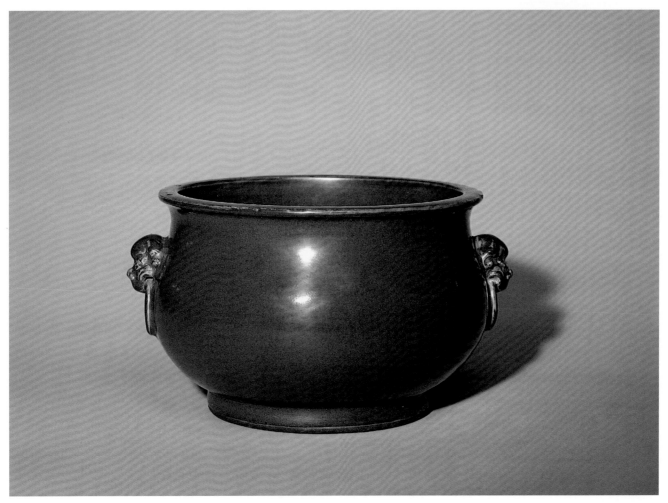

281

Incense-burner
with three legs, animal-mask shaped ears and
design of drum nails in *changguan* glaze

Qing Dynasty Guangxu period

Height 24.7 cm
Diameter of Mouth 16.8 cm
Distance between Legs 16.2 cm

The incense-burner has a round mouth, flat rims, a flat base, and three column-shaped legs beneath. On the rim are two upright ears and on the two symmetrical sides of the belly are two ears in the shape of animal masks. The body is covered with yellowish *changguan* glaze with sparkled yellow mottles on the glaze surface. The area near the mouth rim is decorated with two borders of drum nails in relief. The exterior base is engraved with an eight-character mark "*Guangxu dingwei Yuhai tang fang*" (Imitated by the Yuhai Studio in the *dingwei* year of the Guangxu period). The *dingwei* year corresponded to the 33rd year of the Guangxu period (1907).

The form of this incense-burner is potted with a creative and innovative form in pure glaze colour, representing a refined piece of ware in *changguan* glaze of the late Qing period.

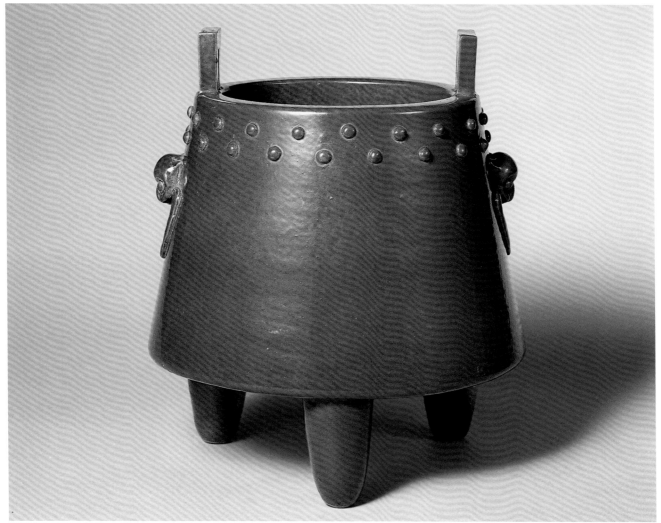

282

Zun Vase
in two loops
in iron-rust glaze

Qing Dynasty Yongzheng period

Height 23 cm
Diameter of Mouth 11.3 cm
Diameter of Foot 11.6 cm

The *zun* vase has a flared mouth, a short neck, a wide shoulder, a tapering belly, and a flared high ring foot. On the two symmetrical sides of the shoulder are two loops. The body is covered with iron-rust glaze. The shoulder is decorated with two borders of string patterns in relief. The exterior base is engraved with a four-character mark of Yongzheng in seal script in two rows.

Iron-rust was a new type of crystallized iron glaze produced in the Yongzheng period. After firing, the colour would become purplish-black with sparkled mottles, with the shiny surface looking like iron, and it was thus named "iron-rust" glaze. The type forms included cups, plates, *zun* vases, vases, incense-burners, and others, which were mostly ware in smaller sizes.

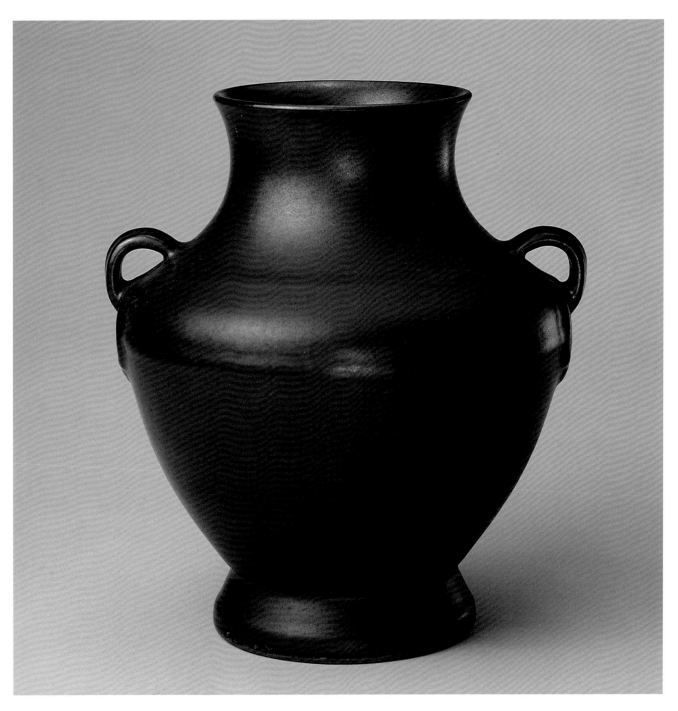

WARE IN OTHER GLAZES

283

Vase
with holes for fastening a
ribbon in glaze
in imitation of ancient jade

Qing Dynasty Yongzheng period

Height 27.2 cm
Diameter of Mouth 8.8 cm
Diameter of Foot 11 cm
Qing court collection

The vase has a rimmed mouth, a long
neck, a slanting shoulder, a hanging belly,
and a ring foot. On the two symmetrical
walls of the foot are two holes for fastening
a ribbon. The body is covered with cinna-
bar glaze in imitation of ancient jade. The
exterior base is engraved with a four-
character mark of Yongzheng in seal script
in two columns.

This type of high-temperature fired
glaze in imitation of ancient jades was
newly produced in the Imperial Kiln in the
Yongzheng period, which used crystallized
iron glaze with cinnabar-brown colour and
patches on the glaze surface, simulating
permeated marks of minerals on unearthed
ancient jades.

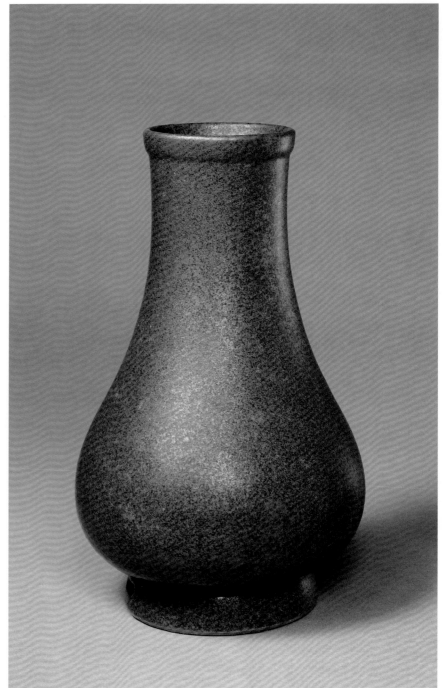

284

Plate
with character "*shou*" (longevity)
medallions held by *chi*-dragons in blue enamel
in gilt glaze

Qing Dynasty Kangxi period

Height 6 cm
Diameter of Mouth 20.5 cm
Diameter of Foot 12.3 cm

The plate has a flared mouth, a curved wall, and a ring foot. The interior of the plate and the interior of the ring foot are covered with white glaze. The exterior is covered with gilt glaze as the ground, on which are decorations of three medallions with the character *shou* (longevity), each held by two *chi*-dragons painted in blue enamel. The exterior base is written with a six-character mark of Kangxi in seal script in two columns.

This plate is tidily fashioned with elaborated colour glazed designs, and the gilt colour is brilliant. The decorative motif carries auspicious attributes and blessings for wealth and longevity, and the ware should have been used for festive occasions or birthdays of the emperor or empress.

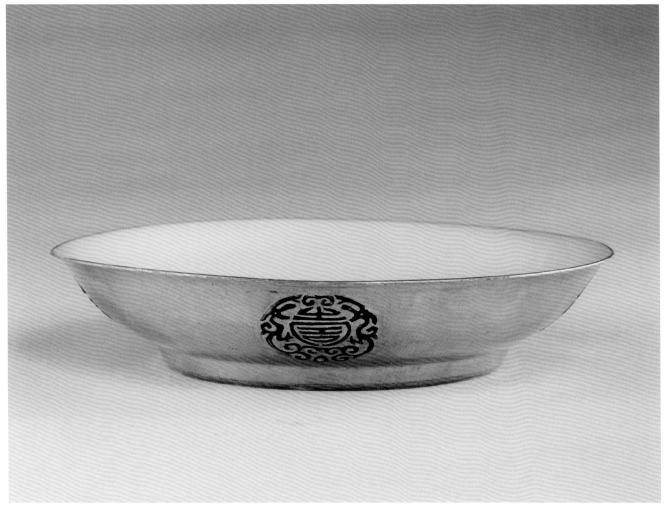

285

Covered Incense-burner
with three legs in glaze in imitation of bronze

Qing Dynasty Qianlong period

Overall Height 30.5 cm
Diameter of Mouth 20.7 cm
Distance between Legs 10 cm
Qing court collection

The incense-burner is modeled after the shape of ancient bronze *ding* cauldron with a square rimmed mouth, two vertical ears on the mouth rim, a short neck, a flat round belly, a flat base, and three legs in the shape of animal legs beneath. On the interior side of each of the three legs is a hole for releasing air during firing. The incense-burner has a matching canopy-shaped cover on which is a knob in the shape of *lingzhi* fungi. The body is covered with imitated bronze glaze, or muddy-gold glaze, with shiny glare. The neck is decorated with wave patterns, the two sides of the belly with *ruyi* cloud-shaped panels in relief, in which are two *chi*-dragons respectively. The ground in between the panels is decorated with carved design of bats in relief. The surface of the cover is sculptured with design of *chi*-dragons holding the character "*shou*" (longevity) and carved design of bats in relief. The mouth rim is engraved with a horizontal six-character mark of Qianlong in seal script from right to left.

This incense-burner is modeled with a touch of archaic flavour, and the colour of the imitated bronze glaze is very close to ancient bronze ware. The decorative motifs carry the auspicious meaning of wealth and longevity. The skillful craftsmanship reveals the high production standard of the Imperial Kiln in Jingdezhen in the Qianlong period.

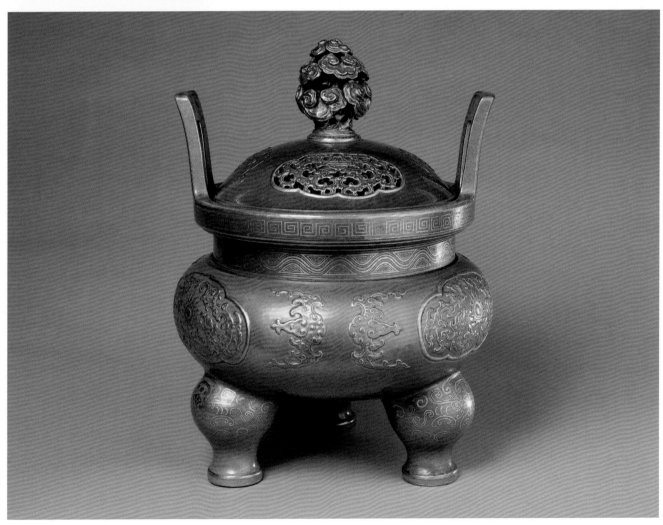

286

Covered Bowl
with design of chrysanthemum petals and gilt imperial poems in glaze in imitation of red lacquer ware

Qing Dynasty Qianlong period

Overall Height. 10.2 cm
Diameter of Mouth 10.3cm
Diameter of Foot 4.5 cm
Qing court collection

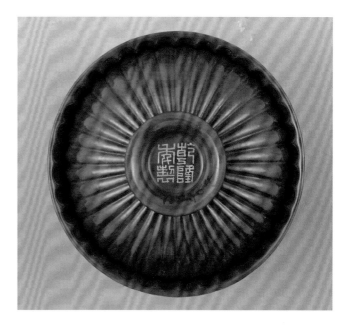

The bowl is fashioned in the shape of a chrysanthemum with a flared mouth, a relief ridge inside the mouth rim, a deep curved belly, and a ring foot. The bowl has a matching half-spherical shaped cover on which is a ring-shaped knob. The body is covered with even and brilliant glaze imitating red lacquer. The interior base of the bowl and the interior top side of the cover are decorated with gilt design of imperial poems of Emperor Qianlong written in clerical script, and at the end of the poem is an inscription "*Qianlong bingshenchun yuti*" (inscribed by Emperor Qianlong in the spring of the year *bingshen*). The exterior base and the interior of the knob are written with a four-character gilt mark of Qianlong in seal script in two columns respectively. The year *bingshen* corresponded to the 41st year of the Qianlong period (1776).

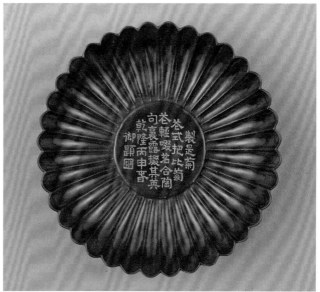

The Palace Museum has collected a covered bodiless lacquer bowl in the shape of chrysanthemum petals, which has the same size, form, decorations of poems and dates, and marks as this bowl, which should have been the original work that was imitated by this piece. In the Qianlong period, the Imperial Kiln in Jingdezhen had produced many types of ware in imitation of various crafts with colours and textures very similar to the originals, which revealed the superb craftsmanship of ceramic artists and potters of the Imperial Kiln in Jingdezhen.

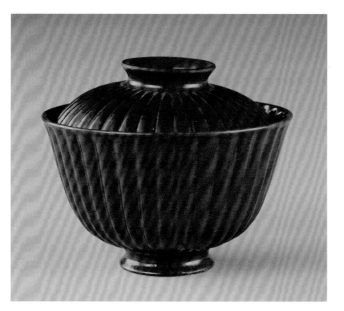

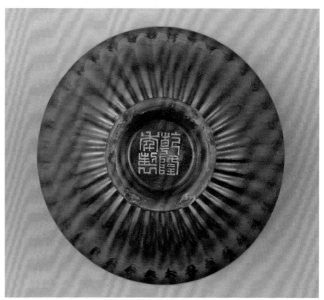

287

Shallow Bowl
with brocade ground of jujube flowers in glaze in imitation of carved red lacquer ware

Qing Dynasty Qianlong period

Height 4.5 cm
Diameter of Mouth 13.1 cm
Diameter of Foot 8.2 cm
Qing court collection

The bowl has a flared mouth, a shallow curved wall, and a foot in the shape of jade *bi* disc. The interior is covered with gilt glaze. The exterior wall and the base of the foot are covered with imitated red lacquer glaze with seven spur marks on the foot. The exterior wall is carved with key-fret patterns near the mouth rim. The belly is carved with a brocade ground of jujube flowers, and the area near the foot is decorated with chrysanthemum petals.

This type of bowls was first created in imitation of carved red lacquer ware in the Qianlong period. In terms of the form, carving techniques, and colours, this type of imitated ware was very close to the original carved red lacquer ware, reflecting the superb craftsmanship at the time.

288

Flower-basin
with gilt design of floral and fruit sprays in glaze in imitation of wood textures

Qing Dynasty Jiaqing period

Height 7.8 cm
Diameter of Mouth 13.4 cm
Diameter of Foot 11.4 cm

The flower-basin has a flared mouth, a contracted waist, and a ring foot. The body is covered with glaze in imitation of wood textures. The exterior wall is painted with design of various floral and fruit sprays including peaches, grapes, chrysanthemums, and others, and it is decorated with two borders of string patterns in relief. The whole piece resembles the form of a truss.

This type of ware in glaze in imitation of wood textures was first produced in the Imperial Kiln in Jingdezhen in the Yongzheng period of the Qing Dynasty, and was continuously produced in the Qianlong, Jiaqing, and Daoguang periods. The colours and textures of the imitated glaze were very close to original wood, revealing the high skills and craftsmanship at the time.

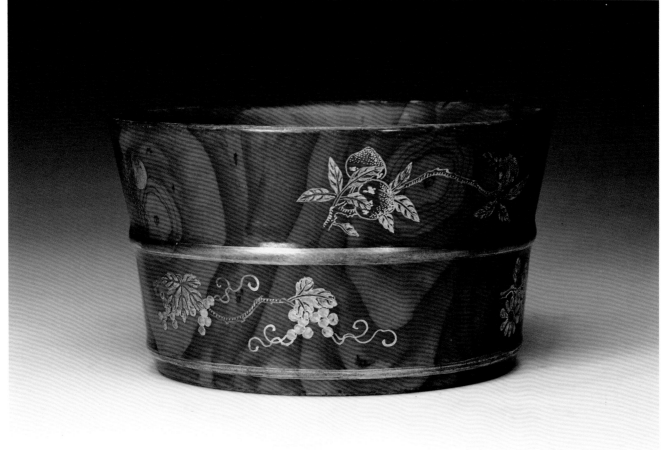

289

Incense-burner
in the shape of a drum in
glaze in imitation of marble

Qing Dynasty Qianlong period

Height 8.5 cm
Diameter of Mouth 7 cm
Distance between Legs 4 cm
Qing court collection

The incense-burner has a contracted
mouth, a globular belly, a base in the shape
of jade *bi* disc, and three legs underneath.
The body is covered with glaze in imitation
of marble. Under the mouth and near the
foot is one border of design of drum nails
in relief respectively. The middle part of
the belly is decorated with a border of
string patterns in relief. The base is written
with a four-character gilt mark of Qianlong
in seal script within a single-line square.

Glaze in imitation of marble was a
type of low-temperature fired glaze popular
in the Qianlong period. Various types of
colours simulating marble and stones were
first applied on fired white glazed ware and
then fired a second time in low temperature
in a furnace. Extant ware is mostly small
objects imitating the originals closely.

290

A Set of Twelve Plates
in the shape of a chrysanthemum in
twelve monochrome glazes

Qing Dynasty Yongzheng period

Height 3.3 cm
Diameter of Mouth 17.8 cm
Diameter of Foot 11.3 cm
Qing court collection

This set of twelve plates is fashioned in the form of the chrysanthemum with the same diameter and size. Each of the plate has a wide mouth, a shallow curved wall, and a ring foot. They are covered with twelve types of glazes including white, watermelon green, lake-water green, onion green, yellow, egg-yolk yellow, rice yellow, sky blue, snow-flake blue, rouge red, brown, and lotus root pink. The interior of the ring foot of each plate is covered with white glaze. The exterior base of each of the plate is written with a six-character mark of Yongzheng in regular script in two columns within a double-line medallion in underglaze blue.

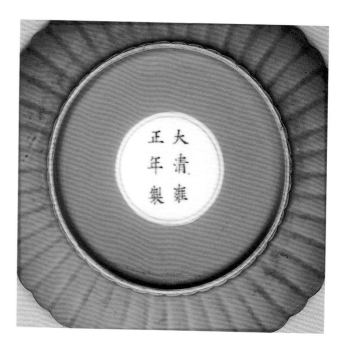

According to *Qinggong Neiwufu Zaobanchu Ge Zuocheng Zuohuo Jiqingdang*, column "chronicles of affairs", it was recorded that "On the 27th day of the 12th month (of the 11th year of the Yongzheng period), Nian Xiyao, Director of the Department of Imperial Household, sent his servant Zheng Tianci to submit twelve plates in the shape of a chrysanthemum (each plate with one colour)...The Emperor required that, 'Send them to the Imperial Workshop of production with forty pieces of each colour to be produced.' By imperial order". This record revealed that the Imperial Kiln in Jingdezhen produced such imperial ware for court use at the order of Emperor Yongzheng.

Dynastic Chronology of Chinese History

Xia Dynasty	Around 2070 B.C.—1600 B.C.
Shang Dynasty	1600 B.C.—1046 B.C.
Zhou Dynasty	
Western Zhou Dynasty	1046 B.C.—771 B.C.
Eastern Zhou Dynasty	770 B.C.—256 B.C.
Spring and Autumn Period	770—476 B.C.
Warring States Period	475 B.C.—221 B.C.
Qin Dynasty	221 B.C.—206 B.C.
Han Dynasty	
Western Han Dynasty	206 B.C.—23A.D.
Eastern Han Dynasty	25—220
Three Kingdoms	
Kingdom of Wei	220—265
Kingdom of Shu	221—263
Kingdom of Wu	222—280
Western Jin Dynasty	265—316
Eastern Jin Dynasty Sixteen States	
Eastern Jin Dynasty	317—420
Sixteen States Periods	304—439
Southern and Northern Dynasties	
Southern Dynasties	
Song Dynasty	420—479
Qi Dynasty	479—502
Liang Dynasty	502—557
Chen Dynasty	557—589
Northern Dynasties	
Northern Wei Dynasty	386—534
Eastern Wei Dynasty	534—550
Northern Qi Dynasty	550—577
Western Wei Dynasty	535—556
Northern Zhou Dynasty	557—581
Sui Dynasty	581—618
Tang Dynasty	618—907
Five Dynasties Ten States Periods	
Later Liang Dynasty	907—923
Later Tang Dynasty	923—936
Later Jin Dynasty	936—947
Later Han Dynasty	947—950
Later Zhou Dynasty	951—960
Ten States Periods	902—979
Song Dynasty	
Northern Song Dynasty	960—1127
Southern Song Dynasty	1127—1279
Liao Dynasty	907—1125
Western Xia Dynasty	1038—1227
Jin Dynasty	1115—1234
Yuan Dynasty	1206—1368
Ming Dynasty	1368—1644
Qing Dynasty	1616—1911
Republic of China	1912—1949
Founding of the People's Republic of China on October 1, 1949	